D1478917

SIMPSON

IMPRINT IN HUMANITIES

The humanities endowment
by Sharon Hanley Simpson and
Barclay Simpson honors
MURIEL CARTER HANLEY
whose intellect and sensitivity
have enriched the many lives
that she has touched.

UW Library BOOK SALE

The publisher and the University of California Press
Foundation gratefully acknowledge the generous support
of the Simpson Imprint in Humanities.

Alef Is for Allah

Alef Is for Allah

Childhood, Emotion, and Visual Culture
in Islamic Societies

Jamal J. Elias

UNIVERSITY OF CALIFORNIA PRESS

University of California Press, one of the most
distinguished university presses in the United States,
enriches lives around the world by advancing scholarship
in the humanities, social sciences, and natural sciences. Its
activities are supported by the UC Press Foundation and
by philanthropic contributions from individuals and
institutions. For more information, visit www.ucpress.edu.

University of California Press
Oakland, California

© 2018 by The Regents of the University of California

Library of Congress Cataloging-in-Publication Data

Names: Elias, Jamal J., author.
Title: Alef is for Allah : childhood, emotion, and visual
 culture in Islamic societies / Jamal J. Elias.
Description: Oakland, California : University of
 California Press, [2018] | Includes bibliographical
 references and index. |
Identifiers: LCCN 2017028635 (print) |
 LCCN 2017034828 (ebook) | ISBN 9780520964402
 (ebook) | ISBN 9780520290075 (cloth : alk. paper) |
 ISBN 9780520290082 (pbk. : alk. paper)
Subjects: LCSH: Child development—Social aspects—
 Middle East—Cross-cultural studies. | Muslim
 children—Religious life—Middle East—Cross-cultural
 studies. | Visual perception—Cross-cultural studies. |
 Children in mass media—Social aspects—Turkey—
 Case studies. | Children in mass media—Social
 aspects—Pakistan—Case studies. | Children in mass
 media—Social aspects—Iran—Case studies. |
 Emotions—Social aspects.
Classification: LCC HQ792.M628 (ebook) | LCC HQ792.
 M628 E45 2018 (print) | DDC 305.23088/297—dc23
LC record available at https://lccn.loc.gov/2017028635

Manufactured in China

27 26 25 24 23 22 21 20 19 18
10 9 8 7 6 5 4 3 2 1

But children, I submit, cannot be fooled. They can only be betrayed by adults, not fooled—for adults, unlike children, are fooled very easily, and only because they wish to be.

—James Baldwin

IPS/Jackson, 210 American Dr, Jackson, TN. 38301-7716

Page	Date	Account
1 of 1	4/27/2018	70860

CUSTOMER SERVICE
IPS: 800-343-4499
Consortium: 800-283-3572
PGW: 800-788-3123
Fax: 800-351-5073

Order	PO
16652105	DR1804242420373

B UCP SCHOLARLY REVIEW COPIES
I 155 GRAND AVE
L STE 400
L OAKLAND CA 94612-3764
T
O

Customer SAN

631760X

S H
I I P
T
O

LAUREN BOSC
UNIV OF WINNIPEG
515 PORTAGE AVE
WINNIPEG, MB R3B 2E9

Ticket: 9SP5P098

Return Address: IPS
193 Edwards Dr
Jackson TN 38301
Attn: Returns

PO Number / Imprint	Description / ISBN-13 (110 or SKU)	Ordered Qty	Shipped Quantity	Price	Percent Disc.	Net Amount
DR1804242420373	Alef Is for Allah 9780520290082	1	1	43.95		

SUMMARY

DO NOT pay from this packing slip. This shipment consists of invoices listed below. Claims for lost shipment, damage, or shortage must be made within 30 days of receipt. Prices are subject to change without notice.

Shipped Via	Total Qty	No. L/I	No. Ctns	Weight (Lbs.)
UPS MI ECONOMY BLEND	1	1	1	1.50

ML01 - 17040V01

Contents

Illustrations

Preface on Transliteration and Conventions

I have used a simplified system of rendering the major Islamic languages used in the research and writing of this book into English. Personal names and terms from languages written in the Latin script (notably, Turkish) retain their own orthography. For other languages such as Arabic, Persian, or Urdu, I have not used any diacritical marks or special characters in personal names, with the exception of the Arabic *hamza* and *'ayn*. For book titles, technical terms, and the like, I use a simplified system of transliteration that resembles the schemes favored in academic writing and that is familiar to scholars of the Islamic world, although I have taken liberties in the direction of ease of reading. In particular, transliteration of Persian, Urdu, Punjabi, and Pashto departs from using a singular pattern of transcribing Arabic letters in favor of being more representative of the actual pronunciation. The major exceptions are the *iẓāfat,* for which I use *i* instead of *e,* and the use of *w* for the *waw* even when it would be pronounced as a *v.* Colloquial Persian is not standardized to look like the written language. I trust that specialists in Islamic and Middle Eastern studies will have no trouble identifying the original words, and it will make things easier for others.

Quotations from the Qur'an appear with chapter and verse numbers separated by a colon. The quotation from James Baldwin on the frontispiece is from "Dark Days," in *The Price of the Ticket: Collected Non-Fiction, 1948–1985* (New York: St. Martin's, 1985), 662.

Acknowledgments

Several names stand out among the many friends and colleagues who have contributed to the birthing of this book, although I am sure I have overlooked many more. I would like to thank (in alphabetical order) Shahzad Bashir, Mehmet Darakçıoğlu, Jürgen W. Frembgen, Maria R. Heim, Cem Kızıltuğ, Ahmet Kuyaş, Elizabeth Perez, Kishwar Rizvi, Leila Rouhi, İrvin C. Schick, Sarah Pierce Taylor, and Mahnaz Yazdani. Ali Karjoo-Ravary, Göktuğ Taner, and Devin Chavira helped me with research at various points in the project. I am grateful to Andy Rotman and David Morgan for their thoughtful comments on the manuscript. The research and publication of this book have been supported generously by the School of Arts and Sciences and the Walter H. Annenberg Chair in the Humanities at the University of Pennsylvania.

Most of all, I would like to thank Mehrin Masud-Elias. Without her encouragement, support, and sympathy this book would have been completed with immeasurably less enjoyment.

Of Children, Objects, and Seeing

An Introduction

This is a book about children. To be more precise, it is about how adults imagine children in idealized forms in order to give meaning to the individual and collective realities of the present and to aspire for a better tomorrow.

The existence of childhood as a natural and universal condition is taken as a matter of faith in most sections of society in the developed and developing worlds. Such views of idealized childhood are held even in the face of unavoidable evidence that many (perhaps even the majority) of children in the world do not share in the privileges of this idealized childhood. Simultaneously with its representation as a specific, universal human condition, childhood is also juxtaposed to adulthood as a time of ease and of freedom from worry and obligation—an age-defined moment pregnant with possibilities that adulthood leaves unfulfilled. This book uses visual images of children to explore these arrays of adult concerns in specific contexts. In so doing, it delves into questions of broader relevance concerning the nature of emotion and its relationship to religion and society, and of how visual and material culture are instrumental in constructing concepts of individual, community, and nation, as well as of gender and age.

In my treatment of children and childhood and the visual materials that depict them, I make no attempt to engage in definitive or narrow interventions on the nature of emotion or religion, of the place of religion in society, or of how children actually are and should be treated.

My concern in this book is with the ways in which representations of childhood construct individual human behavior and sociocultural ideas through the evocation of emotion. As I argue and demonstrate over the course of several chapters, emotion must be viewed as a broad category under which one can index concepts of morality, ethics, and politics, as well as aspirational acts and ideas at individual and collective levels. In their visual representation, children and childhood become an important site in which attitudes toward society and the purpose of the human condition become articulated.

STUDYING CHILDREN

If the normal study of history and society—as endeavors focused on the actions and behaviors of adults—is fraught with difficulty, studying the place of children is even more so. Children and childhood are invested with complex and contradictory significances, qualities, meanings, and motivations. This is done by adults who define children and whose representations remain the principal ways through which we comprehend the participation of children in society. Childhood is itself a construct of adult design, a label denoting a period not simply of biological juvenescence in the course of human life but rather of an idealized state of being that is markedly different from that of normative (that is, adult) humans. Childhood is simultaneously an idealized, romantic construct and one that constrains children in a diminished human status in which they are denied legal rights afforded adults in the same society. Idealized children—innocent, sweet, cute, and adorable—are reflections of adult concerns about their own state, bearing little resemblance to real children who vacillate between innocence and awareness, morality and immorality, cruelty and kindness, foolishness and wisdom, and so on.

There are many reasons for why adults idealize and romanticize childhood. The obvious one is nostalgia for an individual and collective past. But beyond that, there lies a spectrum of possible motivations to the construction of childhood. Adults view themselves as the finished product of human biology and psychology; in comparison, they see children as unfinished human beings who have yet to complete their journey to social, psychological, and moral completion. It may also be the consequence of a social or biological condition, in that adults have limited memories of their own childhoods. Whatever the cause, our early lives are largely absent from our conscious memories, and what one does remember is often recollected like a film, something that hap-

pened to another and to which we are detached spectators.[1] Adults, for the most part, are cut off from the emotional experiences of their own childhoods; our own recollections of our childhoods are a salad tossed with fragments of memory and emotion from our own experiences mixed with those of others, and dressed with what we've been told about ourselves by older members of our families.

For their part, of course, children see themselves neither as incomplete nor as unsocialized. Nor do they live sheltered and innocent lives shielded from the ominous aspects of the world or devoid of troublesome emotions and desires of their own. In addition to the often ignored fact that children are actors themselves rather than detached spectators or passive objects of social construction, the process of fashioning an idealized childhood also ignores that children make active choices to manipulate their environment, other children, and adults, and in acting as sophisticated consumers.

This book is not about children so much as it is about childhood, and not about the child as much as it is about adults. Nevertheless, it should be obvious to even the casual observer that children and adults seem to think and behave differently, and therefore it stands to reason that the emotional, political, and consumerist choices made by children in buying books, toys, and other moral or religious materials ostensibly targeted at them might be different from the choices made by adults. And similarly, representations of children in visual materials signify something different to adults than they do to children. An important motive for studying children and childhood, therefore, is to get a more comprehensive understanding of the nature of human society and the forces that shape it, in part because children display a different aspect of human behavior than do adults, and partly because children and childhood are central preoccupations of adults as they go about shaping human environments at all levels.

THE THINKING CHILD

Much of the research on childhood as a psychologically and biologically determined stage of human life has occurred in the global North, and especially in Europe and North America. Many questions concerning the universal applicability of such findings remain unanswered, especially with regard to the impact of society on the psychological development of the child. The dominant discourse treats as universal the manner and order in which children acquire competencies. Widely

held theories maintain universal standards of what is necessary for a so-called proper childhood, and psychological theories that lay out and explain the emotional and intellectual stages experienced by children on their journey to adulthood have been instrumental in shaping global ideas concerning the nature of children and of childhood.[2] The concept of biologically determinable, fixed developmental stages is now broadly accepted in Muslim-majority societies, resulting in the view of child development as a universal experience in which physical age, as distinct from sociocultural factors, is the determinant of mental skills and competence. As a result, children are viewed as passive and helpless against the forces of biology, and therefore inevitably and inactively in need of whatever adults consider to be necessary for their successful development, including their socialization.[3]

A detailed discussion of current scholarship on child development is not relevant to my project; instead, I will provide a few brief examples of studies representing influential understandings of the nature of children, their thinking and emotions. In contrast to the biological approach to child development alluded to above (and which is often traced back to Jean Piaget), a behavioralist approach (after Leo Vygotsky) suggests that children "develop competencies through their relationships with other individuals, entailing a contextual and culturally specific understanding of children's maturation."[4] It therefore seems probable, from such a perspective, that differences in child-rearing practices and other social factors would result in psychological variations among children, which would have consequences for how they deal with circumstance and, equally importantly, how they view the state of childhood, its limits and responsibilities, and its relationship to adulthood.

This nature-versus-nurture debate carries on among specialists in child development and psychology, with many continuing to advocate universalist theories on the nature of childhood that have ramifications for attitudes toward reading, playing, art, and many other things. They help shape beliefs concerning the diminished nature of children relative to adults, including the hypothesis that children are innocent of intentional meanings when they act as narrators or think up stories, and that they don't allow meaning to shape their narratives.[5]

A similar biological developmental perspective also pertains to children's understanding of fantasy and their susceptibility to advertising. According to some research, biological age seems to be the determining factor in children's responses to advertising, especially in the early years when they are still shifting the ways in which they process information.

It was argued some decades ago (and the theory continues to hold scholarly sway in the societies at the center of this book) that children between the ages of two and eleven are most vulnerable to advertising because their cognitive structures are still in a formative stage and therefore they are more sensitive to external factors. This holds especially true for those under seven, when children are increasingly controlled by symbolic relationships and images, and make judgments about things that they will retain in the future.[6]

A child's ability to discriminate between reality and fantasy is also regarded as directly related to biological age, such that children under five years old are thought to have trouble differentiating between humans and animated characters.[7] This has direct bearing on their belief in imaginary characters and monsters and their management of emotion. In one study, children of approximately four, five, and seven years old were made to listen to scenarios of a lone child or one accompanied by another person (a mother, father, or friend) who then encounters what looks like a real or imaginary fear-inducing creature. The child participants in the experiment were then asked to explain the intensity of fear experienced by the child in the scenario and to suggest coping strategies. The experiment's results showed age-related differences in the children's judgments concerning the intensity of fear that would be experienced in a specific scenario, and also an increased understanding among the older children that one's mind has the capacity to reduce as well as to induce fear, particularly where imaginary creatures are concerned. But, as one grows older, one's ability to manipulate one's environment through the imagination also decreases according to this study, in the sense that, at the same time as children become better able to remind themselves that scary monsters are not real, they also become less able to transform a scary ghost into a friendly one in their minds.[8]

Similar experiments have been conducted on the ability of children to create and identify emotions in visual images, with varying results. In one study, children in the first, fourth, and seventh grades were required to deliberately modify their drawings of a tree to depict it as happy or sad. The older children utilized a great number of strategies to represent emotion—including referencing themes of death and illness, the passage of time and seasons, and the process of aging. A second study looked at children in the second, fourth, and sixth grades; they were given the same assignment as the children in the first study, and were also administered a standard test of visual metaphor comprehension (the Metaphoric Triads Test). This group also connected emotion to themes of illness, aging,

and death, as well as through drawing a tree in different shapes and sizes. In a third study, preschool children were shown twelve especially made drawings that depicted emotions thematically (for example, using a thunderstorm to represent anger), and another twelve in which abstract qualities (such as colors or lines) were used. Of all the various combinations, these children had the biggest problems identifying sad items drawn abstractly, although for all other possibilities their ability to identify emotions was only "above chance levels,"[9] meaning that they were never particularly accurate in linking emotion to visual images.

This discussion of approaches to child psychological and emotional development is by no means intended to be exhaustive; it is offered to demonstrate the range of thinking on the subject in some aspects of the social sciences that have been picked up in current scholarship on these topics in the Islamic world. Other research on the thinking and behavior of young children suggests that children and adults think somewhat differently, especially in the degree to which fantasy and reality coexist in their lives, but that this difference is not qualitative but rather is based on the presence or absence of cumulative experience—in other words, it is environmentally and socially determined. The greater propensity of children to fantasize is apparent even from casual observance of young children at "pretend" play. Children begin pretending toward the end of their second year, and their participation in pretend play peaks just before they enter school, only to decrease between the ages of five and eight.[10] Studies also estimate that between 25 percent and 65 percent of children have imaginary friends, a phenomenon that peaks between the ages of three and eight, and tends to disappear by ten.[11]

There is a difference between fantasizing, thinking about fantasy, and fantastical thinking, the last of which can be seen as synonymous with magical thinking, wherein causal relationships between two objects or events do not follow conventional laws or principles. Fantastical (and magical) thinking is sometimes viewed disparagingly either as lacking any governing principles of action or else as based in misconceptions or ignorance of empirically known natural laws. However, one might argue that it is not always ignorance but rather a willful desire to believe something different that determines fantastical thinking. Studies suggest that children see wishing as a process that is both mental and magical, as well as one requiring skill or expertise. In other words, children do not believe that wishing alone can accomplish what they desire, but that it exists in some relationship to skill.[12] For children over the age of four, their fantastical thinking does not appear to be the result of an

inability to separate fantasy from reality. Instead, they are reliant on idiosyncratic systems of thinking about causality, in which the fantastical or extraordinary plays a larger role than it does in the thinking of most adults (although there is no shortage of examples one can provide in which adults think wishfully and nonrationally).

Despite the move toward understanding child psychology and development in experientially and socially shaped terms rather than purely biological ones (including Freudian models of drive-ridden egos, preoedipal and oedipal stages, and the like), biological determinism pervades much of cultural thinking as it pertains to children. Bourdieu's theories of individual participation in society rely on such an understanding, when he understands the socialization of children in terms of "a narcissistic organization of the libido in which the child takes himself as an object of desire to another state in which he orients himself towards another person, thus entering the world of object relations."[13] Bourdieu sees this process as involving the "sacrifice of self-love," implying that the entire enterprise of socialization and participating in society is some sort of loss of self.[14] Of course, his concern is not with individual psychic development but with social processes and the dynamics of the *habitus,* but it is interesting, nonetheless, that Bourdieu seems to be minimizing the importance of individuality and individualized exercises of making meaning in his formulation of a theory that explains social reproduction and transformation.

This all goes to show that, while children are legitimate and distinct actors in their own right whose biological juvenescence results in social and psychological circumstances that make them act differently from adults, adults make effective choices in imagining children that are motivated by adult needs and concerns. And very often, adults have an investment in impressing these imagined constructions upon children in order to make the latter partners in a comprehensive social understanding of the nature of childhood. This book uses visual images of children to explore these arrays of adult concerns in specific contexts. In so doing, it delves into issues of broader relevance concerning the nature of emotion and its relationship to religion, and of how visual and material culture is instrumental in constructing ideas of the individual, society, and nation, as well as of gender and age.

MY METHOD

I undertake this task by focusing on visual representations of specific and defined sorts in three modern, Muslim-majority societies, these

being the nation-states of Turkey, Iran, and Pakistan. I analyze the use of images of children in Turkish home-schooling religious books, religious posters in Pakistan, and books, posters, and postage stamps from Iran. The data is chosen to develop ideas concerning the role of childhood and children as locations of enacted emotion, both individual and societal, the implications of which are teased out from the examples discussed. Each of the three case studies is designed to highlight one category of visual artifacts of importance to my project, although the phenomena emphasized in each chapter are found in the other cases: there are homeschooling books in Iran and Pakistan, national ideologies pervading textbooks in Pakistan and Turkey, and religious posters of various kinds are to be found in Turkey and Iran. The construction of case studies is designed to highlight theoretical issues in three contexts as a means of reinforcing my argument, not to suggest that the phenomena are exclusive.

The choice of contexts is determined partly by the nature and availability of visual materials featuring children and partly by the contiguity of the countries as societies, which promises a degree of commensurability between them. Turkey, Iran, and Pakistan have their differences, but they lie on a historical and cultural continuum of what can be called Persianate (or Turco-Persianate) cultures, which lends them certain similarities in matters of religion and society. By this I refer to the shared aspects of language, literature, aesthetics, court culture, intellectual traditions, and administrative institutions that brought together the Islamic communities of much of Central and South Asia, the Iranian plateau, and Anatolia and the Balkans from the thirteenth to the nineteenth centuries. In the case of Turkey, Iran, and Pakistan, the trajectories by which they came to be nation-states, through to the latter part of the last century and the beginnings of this one, also invite comparison, albeit with the full acknowledgment that these are three very distinct national cultures.

All three nation-states (like many others in the world) are strongly ideological, but they differ in how specific ideologies are implemented in society, which in and of itself makes a joined study of childhood, religion, and visual culture fruitful at levels beyond the local and descriptive. All three are multiethnic states, and all three have been shaped to a large degree by their encounters with colonial empires and a continuing strategic, military, and political engagement with global powers. But where there are important similarities, there are also great differences, and in certain important ways two of the countries sometimes resemble each other more than the third. Thus, although modern Tur-

key and Iran are more similar to each other in terms of infrastructure and education than they are to Pakistan, Turkey and Pakistan are religiously more similar, having predominantly Sunni populations—with almost exactly the same ratio of Sunnis to Shi'is (roughly 80 percent Sunni, 20 percent Shi'i), although the majority of their Shi'i population belongs to different sects. Their ratio of Sunnis to Shi'is is an almost exact corollary of that in Iran; Pakistan's and Iran's Shi'i populations are mostly of the same sect, with the Shi'is of Pakistan maintaining very close ties to Iranian religious authorities and organizations. All three societies have a deep-seated belief in the existence of charismatic religious authority and *baraka* (*bereket* in Turkish, *barkat* in Persian and Urdu), a topic I address briefly in chapter 6.

Iran's distinctiveness is most apparent due to its formal religious difference and long history as a monarchical state in almost exactly the same borders as it possesses today. Furthermore, religious visual art occupies a place in the public religious culture of Iran that is unrivaled in Turkey and Pakistan (or any other Muslim-majority country for that matter). As I discuss briefly below, there is a varying degree of ambivalence concerning the propriety of religious images among Sunnis, a fact that has measurable impact on the use of images in both Pakistan and Turkey. Although Iranian society is not without its own rules concerning visual representation, and much of the Iranian material presented in this book would not be objectionable purely on representational grounds in the other two countries, these images are inseparable from the broader visual regime of Iranian society and, as such, arguably are significantly different from posters and picture books from Pakistan and Turkey in the meanings they hold and responses they elicit within their own visual regime.

All three states have a history of strong ties with the West. These are primarily strategic rather than cultural and collapsed into hostility in the case of Iran almost four decades ago; state-level ties with the West remain strong in the cases of Turkey and Pakistan, although with substantial ambivalence from most concerned parties. In other examples of similarities and differences, in contrast to the (imagined) historical stability of Iran as a national entity, both Turkey and Pakistan are modern creations—residual states carved from imperial entities of the nineteenth century and early twentieth, and with a population formed through large-scale migration of Muslims into the country and of non-Muslims out of them. Both states promote an explicit narrative of nationhood, formed on land that is not the ancestral home of its

imagined national people and whose founding fathers (Mustafa Kemal Atatürk and Mohammad Ali Jinnah) were natives of towns outside the countries' present borders. Both are republics with a strong military, which has played decisive roles in forming ideology and governing the country and which, at some point, invited the participation of religious forces in national formation as a means of counteracting perceived threats from secularist, democratic, and subnational actors.

I do not provide lengthy histories or sociological surveys of the countries in question—these are readily available elsewhere. I include such information only insofar as it supplies a context within which to deliver convincing analysis of the questions that inform this project. Rather than try to construct each society as a scopic regime or a comprehensive visual sensorium, I look at the specific contexts as possessing their own sophisticated and polyvalent attitudes toward religious and consumer culture, as well as toward visuality. Each society could be disaggregated as well, since individuals and communities exhibit difference in attitudes and behaviors among themselves and across time. Through the window provided by specific types of visual material, I attempt to excavate various aspects of human attitudes, aspirations, emotions, and acts, seeing in sociocultural forces and events a lived, religious engagement with objects, other people, and the environment. In so doing, I am not trying to disassemble the grand projects of secularization that have been so influential in shaping modern thought and society, including in the Islamic world. On the contrary, I take for granted the existence of pious communities and, following Judith Butler, I believe that such communities establish norms which are both stabilized and destabilized through their reformulations across time, and therefore that they constantly engender meaning.[15]

THE AESTHETIC SOCIAL IMAGINATION

When thinking about a social system in which human beings individually and collectively interact with visual objects—through creating them, making consumer choices regarding them, and interacting with them in ways that further ideological formations and socioreligious, political understandings—one must necessarily think in aesthetic terms. But here I make a distinction between aesthetics as a nonutilitarian form of contemplation of art and what I am terming the *aesthetic social imagination*. In either model, aesthetics functions as an essential aspect of human experience and not as a disposable luxury connected to the idle appreciation of art. In the words of Virginia Postrel:

Aesthetics is the way we communicate through the senses. It is the art of creating reactions without words, through the look and feel of people, places, and things. Hence, aesthetics differs from entertainment that requires cognitive engagement with narrative, word play, or complex intellectual allusion. While the sound of poetry is arguably aesthetic, the meaning is not. Spectacular special effects and beautiful movie stars enhance box-office success in foreign markets because they offer universal aesthetic pleasure; clever dialogue which is cognitive and culture-bound doesn't travel well. Aesthetics may complement storytelling, but is not itself narrative. Aesthetics shows rather than tells, delights rather than instructs. The effects are immediate, perpetual, and emotional.[16]

The term *aesthetics* is used in enough nonspecific ways that I am forced to define what I mean by traditional aesthetics. Very briefly, aesthetics came about as an area of Western philosophy in the middle of the eighteenth century. The first major figure to articulate the field, Alexander Baumgarten, saw it as a sphere of sensory perception that he referred to as "lower cognitive faculties."[17] He argued that traditional philosophical concerns with conceptual thinking and rationality ignored swathes of human experience, what has been referred to as "the whole of our sensate life together—the business of affections and aversions, of how the world strikes the body on its sensory surfaces, of that which takes root in the gaze and the guts and all that arises from our most banal, biological insertion into the world."[18] Thus in its origins, aesthetics was concerned with the material experiences grounded in the sensate body and with the emotional and affective responses they encompass and engender.

Along the way aesthetics, as a field of inquiry that started out exploring sensory and embodied forms of experience in relation to the material world, became refined into a form of thought focused on the contemplation of fine art, with the broad spectrum of human experience reduced to the disinterested contemplation of beauty. This development was not accidental, since explicit within the formative phase of modern aesthetics was the understanding that certain varieties of experience are superior to others. In particular, the contemplation of beauty is superior to idleness and boredom, since it is presumed to be morally uplifting as compared to boredom, which reflects failures of moral vigilance and self-discipline.[19] Simultaneously, experience and sensation are frustratingly difficult to describe in words except through analogy and exemplification. This form of description occurs effectively in art, thereby leading aesthetics as a field directly into the realm of fine art and reconstituting it as a form of art theory. Baumgarten maintained that sensory impressions, emotions, and fantasies were not fitting subjects

with which philosophers should occupy their time. The human experience of life needs to be lifted above such base sensory and fantastical preoccupations, implying that the concerns of aesthetics are ultimately ones of moral improvement, in which aestheticians after Baumgarten are preoccupied with refining human perception and sensation. Aesthetics becomes the pursuit of goodness and virtue, through the contemplation of all that is best and most beautiful in art and literature.[20]

Such questions define Kant's writings on aesthetics, which are ultimately concerned with the sublimely beautiful. Explicit in these concepts of aesthetics is the belief that true beauty is enduring and engenders virtue, and that the sensory experiences of appreciating beauty are superior to and distinct from those of quotidian experience or those elicited by interacting with everyday objects. Being distinct as a category of human production and contemplation—and also because it embodies a moral purpose—beauty must necessarily possess recognizable, reproducible, and stable properties. In other words, it must be formal and lend itself to systematic analysis and description.

One can make a case for a more experientially grounded notion of aesthetics even in the instance where one is concerned with the experiencing of beauty. Viewed from many religious perspectives—and certainly the ones that dominate in Islamic cultures—beauty and goodness exist in all things, including imperfect ones. Religious reactions to sensory inputs are themselves aesthetic, in that they do not rest contemplatively in the present but, rather, anticipate knowledge to be revealed in the future, as a consequence of which a religious gaze can be referred to as an "apocalyptic glance."[21] Such a religious aesthetic is different from the concept of disinterested aesthetic contemplation that lies at the heart of Kantian aesthetics, wherein the contemplation of beauty constitutes a noninstrumental form of enjoyment. Things—art and literature mostly—are beautiful in this view for the very reason that their purposes for existence are intrinsic to them rather than due to some utilitarian use to which they might be put (and which could conceivably cease to exist, thereby rendering them obsolete). Unfettered by any utilitarian or instrumental needs of the viewer, the beautiful object exists only to be the object of contemplation. From a Kantian perspective, it is the object's representation in the imagination that is the subject of this disinterested aesthetic contemplation, not the physical object itself, which, after all, can never fully escape its humdrum existence.

A concern with beauty plays a major part in much of the premodern Islamic writing on aesthetics. This holds true especially for Islamic

philosophy, which bears a strong mark of Platonic and Aristotelian thought. Medieval Islamic philosophical writings argue for an intimate connection between beauty and aesthetics, asserting that beautiful visual objects provide a taste of heavenly beauty to come and have the ability to evoke love in the viewer. For Muslim thinkers (as for Plato), beauty is moral in nature rather than purely aesthetic and therefore is inseparable from virtue.[22] The Qur'an also addresses beauty on many occasions, and is itself considered the epitome of beauty. The importance of beauty is also upheld by a famous saying attributed to Muhammad in which he declares: "God is beautiful and He loves beauty." As is discussed in chapter 6, the commonest Arabic words for beauty are closely linked etymologically and in usage to words for goodness and virtue. And in most Islamic philosophical thought, beauty is primarily moral and based on a harmony of physical and moral qualities. The encyclopedic thinker Ibn Khaldun (d. 1406 CE) twinned moral and physical beauty when he asserted that the sensory perception of beauty "harmonizes with the cognitive soul, which enjoys perceiving that which is in harmony with itself" in much the same way that the souls of lovers meet and blend together. He goes on to declare that the "perfection of proportion and setting are the quintessence of beauty in everything."[23] He makes his point clearly in the following passage:

> Agreeable sensations of vision and hearing are caused by harmonious arrangement in the forms and qualities of [the things seen or heard]. This impresses the soul as harmonious and is more agreeable to it.
>
> If an object of vision is harmonious in the forms and lines given to it in accordance with the matter from which it is made, so that the requirements of its particular matter as to perfect harmony and arrangement are not discarded—that being the meaning of beauty and loveliness whenever these terms are used for any object of sensual perception—that [object of vision] is then in harmony with the soul that perceives [it], and the soul thus feels pleasure as the result of perceiving something that is agreeable to it. . . . Thus every man desires beauty in the objects of vision and hearing, as a requirement of his nature.[24]

One important problem with the philosophical aesthetics of disinterested contemplation is that it ignores the majority of human experiences, emotions, and behaviors in the way that it lauds apophatic (transcendent and ineffable) concepts of experience over cataphatic (immanent and experiential) ones.[25] If one were to accept that only the disinterested contemplation of beauty is legitimate in aesthetics, then one would be discombobulated and threatened by the many unstable

and somatic ways in which human beings seek out and respond to every-day images. Lessing, Burke, and others make this very point when they see everyday images as signs of a religious, sexual, and social "other" and therefore deserving of derision as well as of fear. The derision results from a belief that nonartistic images are unevocative and powerless, an inferior order of signs compared to fine art. The fear is from the knowledge that these signs have a valency that affords agency to the societies and individuals who believe in and interact with them, as a result of which these supposedly inferior signs gain potency. It is a realization that no stable system of theories of art and aesthetics can either fully explain or contain the power of images in society at large and that, ultimately, objects are first and foremost not the subject of disinterested aesthetic contemplation but part of a web of sociocultural experience that is mediated, accessible, and popular, existing in myriad ways that remain unpredictable.[26]

In actual fact, aesthetics—as it operates in society—does not rely on a detached and disinterested form of pleasure; it is the very fact that it entails an emotional response that makes aesthetics relevant to human life. Aesthetic response is a vital affective force in society that possesses real power by generating emotional and sensory reactions that go on to shape future expectations and motivate human beings—individually and collectively—to seek out further experiences of a similar aesthetic nature. The power of the visual object in society is directly dependent on an aesthetic social imagination that engenders experiential commonalities and connects aspirations, understandings, and anxieties to the allure of visual objects. Conceived in this way, aesthetics is an expansive concept that aims to recover its broad meaning from before developments in philosophy that have reduced it to the contemplation of beauty.

In this project, I attempt to rehabilitate the notion of aesthetics from before it made a turn to art in the Europe of the eighteenth century, and to reconnect it to the Aristotelian term *aisthesis,* which explicitly refers to perception and embodied experience. The aesthetic social imagination is engendered by a variety of aesthetic practices, but it is expressed most clearly through the presence of and interaction with the broad array of consumer objects found in all societies, which engender a variety of affective allegiances. Visual objects and material goods have the capacity to evoke sensory responses, or to captivate. "As elements of aesthetic experience, they do not just provide evocations of times past or moral reckonings, but affective sense of space, literally territories of feeling."[27]

Such a concept of aesthetics allows for a broad relationship to morality and virtue, in the sense that emotion itself is almost impossible to conceive of without a moral component—cruelty, hurt, disgust, and disdain all carry moral colorings, as do kindness, happiness, admiration, and love.[28] An aesthetic social imagination also possesses a natural relationship with politics and the orderings and dispositions of society, although it is not one that allows for predictable outcomes and tightly structured systems of persuasion. Instead, the aesthetic social imagination operates at the level of an amorphous sphere of activity and interaction in which human beings cannot help but be drawn to and interact with their material and visual environments.

That the pervasive social functions of visual and material objects are often trivialized in discussions about art, culture, and religion is not at all surprising. Aside from the project of philosophical aesthetics outlined briefly above, dominant strains of Islam, Christianity, and Judaism (as well as other religious systems) tend to deemphasize the physical, material, and somatic relative to the ethereal, metaphysical, and intellectual. In a European context, much of the Enlightenment project attempted to safeguard true art from popular religion and its messy materialities and emotional excesses. Not just the Enlightenment but the Protestant Reformation and other religious reformist movements incorporated substantial antimaterial and antipopulist elements. In similar fashion, the majority of Islamic reform movements of the last two centuries have valorized the nonmaterial over the material, seeing the latter as related to superstition, exploitive religious practices, and antior premodernity. Despite—and also because of—the ways in which religious thinkers and movements relevant to this study show discomfort concerning the place of visuality and materiality, it remains important to address the subject briefly.

LOOKING AND SEEING

Visual images—their nature, their function, and viewers' reactions to them—have been studied extensively in a number of disciplines. A few aspects of visuality require discussion in the present context: issues of religion, arts, and visual culture, especially as they relate to Islam; the matter of how we can confidently treat images as sources of sociocultural information; and the argument that vision and seeing must be understood as somatic, embodied, and inextricably linked to all the other senses. The implications of the last point for the nature of human

experience, emotion, and affective responses are so great that I have devoted the next chapter to the subject.

The status of visual images in Islam remains one of the most misunderstood aspects of the religion and of cultures associated with it. Controversies over images in modern times contrast strikingly with a rich artistic culture of figural human representation in painting and other arts. A lengthy discussion of the place of visual imagery in Islamic societal history is beyond the scope of this book. I have dealt with questions of visuality in Islamic history elsewhere and therefore will only address questions of representation in Islamic society as they pertain to the project at hand.[29]

There is no one position on the place of religious images in Islamic society or religion that holds true across time and geography. In fact, specific societies often display conflicting attitudes toward religious visual art, and particularly toward representational art. This is largely due to the fact that the use of religious visual images is not theorized in Islamic history, in the sense that there have never been historical moments of sustained debate about the nature and place of visual images. The same applies to didactic images and their use. Instead, controversies involving images—in the past as in the present—arise and are dealt with on an ad hoc basis as part of the sociopolitical use of images. It is these dynamic factors that continue to determine issues of iconoclasm in modern Islamic societies and the protests over visual representations of Muhammad and other Muslim figures in European satirical media.

The complex place of visual representation in Islamic history notwithstanding, it is an observable fact that the majority of modern Islamic societies and denominations have embraced a position of strong opposition to representational religious art. This is much more true of Sunni communities than Shi'i ones, and covers a spectrum from total tolerance of representations in religious contexts, to an acceptance of everything other than images of religious heroes, to an antipathy toward representations of human beings, to a blanket opposition to all figural representation.

The fact remains that religious materials directed at children frequently use images to make them more appealing, and the proliferation of audiovisual media has meant that there are religious programs specifically intended for children that are unabashedly representational and are accepted unproblematically by the majority of the Muslim populations in which they circulate. Perhaps the best-known example of such a work is the graphic novel *The 99*, which was launched in 2006 by a

Kuwaiti entrepreneur with an interest in writing children's books. The series takes its name from the Islamic belief that God has ninety-nine most beautiful epithets that describe divine qualities. Each of the heroes of the comic series takes his or her name from one such divine quality, which serves as a superpower that gets amplified when individual heroes join together in triads. *The 99* faced opposition from some quarters because the reference to God's names was understood by critics as a form of representing God visually, but the majority of the comic's readership didn't seem to find the association problematic.[30] *The 99* was lavishly produced in print and received international acclaim, but moved to an electronic format after only five issues and continued production until 2013 (for a total of thirty-five issues), accompanied by an array of related consumer goods.[31]

A more recent example of didactic Islamic visual media intended for children is found in the Pakistani cartoon series *Burka Avenger*. It features a school teacher who changes into a very ninja-like burqa-clad superhero in order to fight against the forces of evil, personified by a villainous cleric who tries to keep the population benighted and a feudal lord who prevents them from being educated so that they remain ignorant of their rights. The Urdu series has won several international awards, is dubbed into at least six languages, and is broadcast in Pakistan, India, and Afghanistan in addition to being available online.[32] Less controversial than *The 99*, *Burka Avenger* flips the paradigm of religious representation by using the veil as a costume—as distinct from a symbol of empowerment—and pitting the burqa-clad superhero as an icon of good moral values against a corrupt view of traditional religion.

Both these cases raise the issue of how to represent Islamic religious subjects visually. Aside from these two examples, a number of strategies are employed to reconcile the use of images with societal proscriptions, be they explicit or implicit. The problem of visual representation is most severe with religious texts, and the easiest way to avoid controversy is either to not use images at all, to avoid representing human beings, or to not depict important religious personages such as the Prophet. Each of these choices constitutes a differently restrictive notion of the permissibility of images. In many contexts, there is a clear understanding that younger children have greater pedagogical need for pictures, and so age-graded sequences of children's religious books often demonstrate a decreasing use of images in progressively higher-level books. This is very much the case for government-approved Pakistani religious textbooks produced by the publisher Ferozsons: the first-year book uses

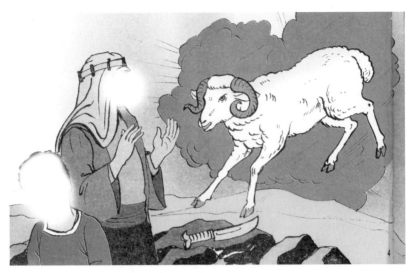

FIGURE I. Illustration of the Abrahamic Sacrifice, from Mürşide Uysal [n.d.], *Peygamberimizin Hayatı, 1: Hz. Muhammed'in Doğumu* (Istanbul: Uysal Yayınevi), 4.

images to illustrate good behavior as well as historical religious stories, but by the third year the painted illustrations accompanying religious stories are gone and have been replaced with actual photographs of the Ka'ba and its sanctuary.[33]

The Turkish case displays a much broader range of representational strategies than does the Pakistani one, in part because Turkish society is more permissive regarding religious representation in general. Some books, such as those written by the respected author of children's religious books M. Yaşar Kandemir and published in the "Dinim Serisi" (My Religion) series of Damla Press, are lavishly illustrated with paintings of human beings, animals and plants, but refrain from representing either venerated religious figures or specific religious events (such as those mentioned in the Qur'an or from Muhammad's life). Even so, many conservative religious bookstores refuse to carry Kandemir's books because they are considered inappropriate on account of their illustrations.[34] Other texts depict well-known moments in religious history complete with people, but make a point of not depicting religious heroes such as Muhammad, earlier prophets, or their families. This holds true for books whose illustrations are done in traditional, realistic styles as well as the more recent publications that follow the aesthetics of cartoons, comics, anime, and manga. As an example of the first kind,

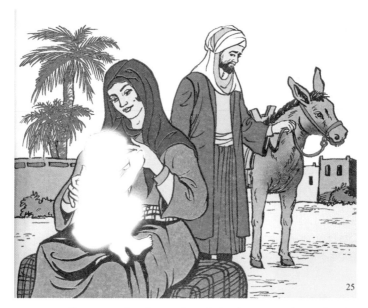

FIGURE 2. Illustration of Muhammad as a baby, from Mürşide Uysal [n.d.], *Peygamberimizin Hayatı, 1: Hz. Muhammed'in Doğumu* (Istanbul: Uysal Yayınevi), 25.

the many books by Mürşide Uysal on the life of the prophet Muham-mad, earlier prophets, and episodes from the Qur'an rely on effacement techniques used in Ottoman painting: figure 1 depicts the moment of Ibrahim's (Abraham's) sacrifice of his son and the substitution of a ram. Both Ibrahim's and Isma'il's faces have been effaced, although the rest of their bodies appear intact, including young Isma'il's hair.

In the case of illustrations of an infant Muhammad in the arms of his wet nurse, Halima, such as the one in figure 2, and also ones depicting him later in his life, his entire body is effaced to the degree that it is obvi-ous from the illustrations that the figure of Muhammad was only drawn as an empty outline before being blotted out further in white. Note, however, that Halima, who is venerated among Muslims as one of the early heroes close to the Prophet, is shown with her face uncovered.

Among the Turkish children's books surveyed for this project, repre-sentational strategies strongly correlate both with the publisher and with the illustrator of the book. Thus the above examples from a book published by Uysal Press and written by Mürşide Uysal, a prolific writer of children's and women's religious books and a frequent guest on women's religious television shows, is characteristic of other books by

the same publisher. In contrast, books from the large and dynamic Timaş Press, and particularly the work of the illustrator Cem Kızıltuğ (of which examples appear in chapter 5), not only do not depict religious figures but use highly stylized comic forms to represent people, animals and even other things that would not be judged objectionable by most viewers even if they were depicted realistically.

VISUALITY AND RELIGION

Issues related to visual representation encountered in the Islamic world are by no means unique to it, in that religious representation, broadly defined, raises questions of whether there is something distinct to the religious image or the religious uses of images, of how images are deployed, how they impact the viewer, and how this impact is understood or perceived. Two obvious points to ponder are whether there are culturally specific ways of seeing, and if religion requires its own categories for understanding visuality and sensory systems. The first question is easy to answer in the affirmative—as I explore at length in the next chapter, sociocultural constructions are essential to the expression and understanding of perception, sensation and emotion. The latter question is more difficult to address: religion is a problematic category for a number of reasons, not least of which is that it is inherently unstable, referring simultaneously to systematic ideological systems, atomized and multivalent beliefs, and a range of individual and cultural practices, all of which are in a state of constant flux relative to each other at the very same time that religious practitioners argue for the category's inherent, timeless immutability.

The study of religion in the Western academy takes a number of different attitudes toward the existence of religion as a discrete phenomenon. On the one hand, the fact that human beings tend to exhibit beliefs and practices across time and culture that seem recognizable and comparable, even similar, mitigates in favor of an underlying human characteristic or behavioral system that is rightly called *religion*. Contrary to scholars who argue for a transcendental quality to religion, even if one considers the *religious* to be behavioral (as scholars with a sociological bent from Durkheim and Weber on down have done), *religion* and *religiosity* remain categories to contend with in the study of human society. It is not only scholars like Rudolph Otto who see a fascinating, incomprehensible force outside of the human person as the location of the religious, or like Mircea Eliade who argue for an essential unity to the religious by juxtaposing

seemingly commensurate human behaviors in the physical world. Even scholars who study social and material phenomena frequently see religion as powerful in its own right, "other than man and yet related to him," and residing in objects outside the individual.[35]

Absent any satisfactorily comprehensive definition of religion, I take a functionalist, social, sensory and psychological approach to the subject. For my purposes here, religion should be understood to be the multivalent and impermanent systems of behavior and belief in which human beings participate as individuals and as members of societies. I do not concern myself with truth claims or meanings, but with the manifestations of belief and ideology in visual, written and emotive forms, through which (paraphrasing Robert Orsi) the invisible is made visible.[36]

The implications of such an understanding of religion on visual art are far reaching because it locates the relationship of visual culture outside debates over sacrality and secularization or topics such as iconicity and iconoclasm, and centers it instead in the area of human experience.[37] Visual materials serve many purposes in a system of this sort, such that they do not lend themselves to morphological categorization—among other things, they can be aesthetic (in the senses outlined above), generators of meaning or affirmation, or they can be icons, talismans and other objects imbued with religious functions. They can also be tokens and instruments of aspiration and other emotions, explicit reminders to good behavior, or gestures toward a better future as might be called "wish images."[38]

Underlying any discussion of visuality lurks a tension between the properties—even agency—of the object that is seen, and the power and understanding of the viewer. I place the visual object in a broader framework of material culture and its concern with objects, visual and otherwise. The viewer belongs at the center of such a discussion as the interpreter and agent, acting both on her own and as a participant in broader sociocultural processes. Vision and visuality center on the viewer whose act of viewing must be located in that individual's embodied personhood. David Morgan categorizes religious ways of seeing under the concept of the "gaze," a visceral way of seeing for which he provides a morphology of types.[39] Morgan discusses the human being both as the viewer and as the object of the gaze, which he sees as synonymous with a visual field or way of seeing. The major thesis of his detailed study is that seeing is, first and foremost, embodied, and cannot be uncoupled from the body or the other senses, an important point that he stresses by referring to somatic visuality in all its forms as the "embodied eye."

It is the concept of seeing as an embodied act—conscious or otherwise—that defines my notion of visuality in this book. That the physical act of seeing (and the accompanying process of perception) is embodied like the other senses—perhaps even somatic, despite the participation of the mind in the process of visual perception—should not need much explanation. But even in a broader sense, vision occurs in the body; individuals make complex interpretive choices concerning what to look at and what they have seen, and they react based on prior experiences and sociocultural conditioning. My assertion that visuality is embodied in this sense is to say that it is a multisensory phenomenon as well as an emotional one, in that we feel *through, about,* and *from* the visual, as we do with other senses and emotional experiences.

The nature of emotion, feeling, and affect as they relate to sociocultural attitudes and more narrowly to attitudes toward children and their representation is addressed in the next two chapters. Here I would like to underline briefly the embodied nature of experience as a conceptual structure that allows us to think about the visuality of lived experience and its relationship to circulated objects such as children's books and posters in a way that focuses on the human being in relation to visual material objects. Merleau-Ponty lucidly highlighted the importance of embodiment and its relationship to the world around it through his concept of prereflective bodily consciousness, claiming that the body itself is the instrument of comprehension in the perceived world, in that all material and other objects are woven into the body's fabric.[40] The implication of such a view is that human beings exist neither sensationally nor perceptionally independent of the material and visual worlds that impinge upon them and upon which they act. The material and sensory world is not something independent of us that awaits our perception, but rather is *what* we perceive.[41]

Merleau-Ponty drives home the unstable relationship between the human being, perception, materiality, and objects by giving the example of a blind man's stick: "The blind man's stick has ceased to be an object for him, and is no longer perceived for itself; its point has become an area of sensitivity, extending the scope and active radius of touch, and providing a parallel to sight. In the exploration of things, the length of the stick does not enter expressly as a middle term: the blind man is rather aware of it through the position of objects than of the position of objects through it."[42]

The implication of a comprehensively embodied concept of visuality and the consequent placement of vision in a network of the senses is to

render untenable the idea that the *visual* exists apart from the *material* or the *sensory*. It rules out the possibility of treating visual objects in society as part of a scopic regime, even of one that we acknowledge to be contextual and varied.[43] Vision, like the other senses and feelings, is part of an embodied sensorium joining human beings with the material and imaginal objects around them.

OBJECTS AND AGENCY

Objects are difficult to study and discuss, in large part because writing and discussion per force treat their subjects as "a text or as a language, as something that represents something else, and that is there to be interpreted."[44] Nevertheless, a number of social-scientific fields (not the least of them cultural anthropology through the works of Alfred Gell and Bruno Latour) have made substantial advances in our ability to comprehend the amorphous but pervasive power of objects. At its broadest, one can think of objects as everything apart from human organisms with which the latter interact in some way. Talal Asad has suggested that "the power of things—whether animate or inanimate—is their ability to act within a network of enabling conditions. . . . Feeling, remembering, hoping are as physical as they are mental."[45] In this sense, society and politics themselves become vitally material through the capacity of objects "to act as quasi agents or forces with trajectories, propensities, or tendencies of their own."[46]

To say that material and visual objects have power is not to suggest that they have abilities or sentience all their own that they use autonomously. Rather, it implies that objects have agency in the complex web of interactions that joins them to other objects and beings. They possess an emotive force, allowing them to function as sites of activity and negotiation, such that they participate in the construction of meaning and in shaping social relations.[47] Visual and material objects possess what might be referred to as an "affecting presence," which they gain in no small part through their interrelation with human life events, social processes, and cultural systems.[48] Linked to the human beings with whom it interacts, the object functions as a perfect mirror because it reflects back to the human being not some objectively real image of things as they are, but a *desired* one.[49] It is for this reason that we are invested in the perceptible things in our environment, since everything that we wish for that we cannot find in ourselves or in our existing human relationships or past interactions with objects we invest as

potentialities in other objects. In so doing, objects become locations of emotion, or at least the means to them: "Objects become 'happiness means.' Or we could say they become happiness pointers, as if to follow their point would be to find happiness. . . . Groups cohere around a shared orientation toward some things as being good, treating some things and not others as the cause of delight."[50] If objects and images make us happy or affirm us in particular ways, we are drawn to them and react in a particular way; if they make us sad or upset us, we might avoid them or invest them with a different set of emotive qualities. It is these properties of objects, and of visual objects in particular, as means and signifiers of collective and individual emotion and aspiration that inform much of my thinking in this project.

ON STRUCTURE AND METHOD

This books proceeds in three parts, these being the establishment of a theoretical frame concerning human beings, their emotions and affects as they exist in an embodied sociocultural and historical frame, followed by the analysis of specific data, followed by a conclusion. Some of the theoretical discussion has been attempted in the current chapter, while specific issues of emotion and affect as well as the implications of recognizing emotion as culturally and socially grounded are explored at length in chapter 2. This is followed by two chapters that build upon the methodological framework in order to explore important sociocultural ideas, including notions of childhood, innocence, and cuteness; education and socialization; and gendering children and its implications. The second part contains three chapters, each of which comprises a case study from the contemporary Islamic world that serves as the principal context by which to illustrate one or more important points of broader relevance. The discussion on Turkey in chapter 5 focuses on children's religious books for homeschooling and general edification, and serves as the platform from which to explore cuteness and its social implications. The second case study in chapter 6 is of popular religious posters in Pakistan. It continues the exploration of cuteness introduced in the previous chapter, linking it to aesthetic and ethical concerns of beauty, goodness, and virtue. The final case examined in chapter 7 is that of parastatal visual materials in Iran, in particular children's books referring to the Iran-Iraq war produced by paramilitary organizations, propaganda posters, and postage stamps. In addition to issues raised in the previous two chapters, chapter 7 explores the ways in which gender

intersects with conceptions of childhood and adulthood, questions of martyrdom and sacrifice, and the connections between these important topics. Each of these chapters starts with a brief historical outline of the nation with a specific focus on the subjects under discussion. In all cases, the most productive point of entry into understanding societal attitudes toward childhood is the history of education, and this receives priority in my treatment over discussions of political history and religion. My purpose is not to provide comprehensive histories of the societies from which the data is drawn, but to furnish the minimum information necessary to create an informed context in which to frame my discussion.

The final chapter brings together the various problems and strains of thought raised in the previous chapters, demonstrating the interrelatedness of questions of age and gender, the idealization of children and childhood, the relationship between cuteness and innocence as well as between beauty and virtue, and the centrality of emotion, aspiration, and affect as sociocultural and religious forces.

It may be productive to think of objects as they interact with human beings across time not as having lives, but as possessing itineraries. The concept of an itinerary helps excise notions of an object possessing its own autonomous existence, and instead emphasizes the journey through which the object interacts with human beings in sociohistorical spaces. One way to understand the social role of the object is to conceive of it as an index, by which I mean a sign that points to something else.[51] Objects, and visual objects in particular, might resemble an intended prototype, but they can also indicate something directly or by association. For example, a fire alarm indicates fire, smoke, heat, emergency, and the necessity of exiting a building equally well. It also evokes emotional responses of fear and anxiety, and may trigger a flight response. The index certainly indicates something, but what that is cannot be discerned easily nor is it necessarily a singular thing; nor do we have access to reliable systems of deductive reasoning that assures us of an accurate interpretation of one value to the index.[52]

The lack of precise, causative relationships between observed phenomena and their affective consequences manifested in human individuals and societies is a frustrating problem that plagues this project, as it does the majority of visual and material cultural studies. I am relying in my analysis on a process suggested by Alfred Gell, believing that *abduction,* rather than *deduction, communication,* or *translation,* helps explain the agency of material objects most effectively.[53] In doing so,

I am emphasizing the phenomenon of object-agency and, secondarily, the dynamic relationship between human beings and objects. I employ the concept of *abduction* as a means of avoiding the trap posed by comfortable reliance on familiar modes of inference or terminology. By *abduction* I mean "to abduce," which constitutes the form of reasoning in which we can abduce a *possible*—but not an *actual* or *definite*— agent or effect. For example, if I see that a favorite plant in my garden is drooping, I can abduce that it needs watering. My abduction may be incorrect, however, since the agent behind the drooping plant might be excessive heat, lack of light or nutrition, a disease or a parasite, or perhaps even something else.[54]

In analyzing the role of objects and images in society—especially in the context of how they represent and elicit emotion and affect—one would do well to consider the commonality of objects within a theoretical framework that gives primacy to *agency, transformation,* and *causation.* My purpose behind studying the role of the visual object in relation to emotional responses is not to construct symbolic relationships between texts, images, and social forces, but to understand how human beings function in society. I remain unclear on whether visual and material objects possess extractable and stable meanings or even if objects have the sort of epistemic and corporeal integrity that would allow them to be contemplated, understood, and acted upon and through in a stable manner. Such questions of the extractability and nature of meaning in objects are particularly relevant in a study of emotive objects and their relationship to human beings at an individual and societal level. I address this problem through taking the preconditions for abductive reasoning seriously, and by directing much of my focus to the subject of emotion and affect, rather than the specificity of objects or people.

Abduction might seem like a less rigorous way of reasoning than deduction or others, but it has undeniable strengths and forms the basis of most scientific thinking. Abduction allows one to analyze and experiment when one doesn't have access to all data or causal relationships, this being the situation in which one finds oneself much of the time. Its efficacy rests on knowing as much contextually relevant information as one can about something or a situation before one attempts to abduce an answer. In the example of the plant above, it is my knowledge of plants and my garden, previous observations about the impact of the lack of water, knowledge of when last I fertilized the plant, awareness of the absence of pests, and so on that lead me to abduce that I need to water my plant. A similar system of reasoning can be applied to the

visual culture of the societies discussed in this book by accessing as much contextually relevant information as one can on each society, its national context, the impact of religion and education, and the broader structures, forces, and histories of Islamic societies in order to make informed abductions about the role of the visual culture of childhood in sociocultural and religious formations.

The second methodological window through which I contemplate my subject is to place emotion at the center of my study, shifting the focus from objects and people to the active agency of emotion, feeling, and affect. In a sense, this form of analysis treats emotions as objects of human manufacture (albeit often unintentional ones), and thus recognizes them as the location of human meanings and motivations.

CHAPTER 2

Emotion and Its Affects

The ubiquitousness of emotions, feelings, and aspirations might suggest that understanding and communicating them would be straightforward. In point of fact, it is extremely difficult. At a societal level, a substantial portion of artistic production and appreciation, consumer advertising and consumption, and propaganda and politicking relies on eliciting emotional reactions, and is motivated to a greater or lesser degree by the emotions and aspirations of the agent responsible for a specific artifact or idea. But the prediction of emotion remains no less a dark art than its interpretation, keeping advertisers and political advisors employed. Matters of emotion and aspiration—their evocation, recognition, and afterlives in terms of how they shape individuals and society—are central to this book, which necessitates a discussion of the subject of emotion and affect. The academic investigation of emotion has a long history and—especially in the context of the study of affect, but also in psychology, neuroscience, and their reception in the humanities—it is a notably popular subject today. In the following pages I will trace a brief and tangled history of the study of emotion in the Western academy, outlining concepts of affect and the shortcomings of affect theory, as a way of laying the groundwork for my ideas of how we might use emotion and affect in scholarship on visual culture as well as history.

The study of emotions and feelings forms part of the construction of late antique philosophical notions of selfhood, and therefore finds itself located centrally in Islamic and European thought. In Platonic and Aristo-

telian conceptions (both of which had an immeasurable impact on shaping Islamic ideas concerning the relationship of the mind and the body), emotions are viewed ambivalently as urges that need to be disciplined and harnessed through some process of education that allows them to function in the greater cause of forming a better human being.[1] Love and virtue constitute central aspects of emotion as it is conceived in Islamic thought, both as forms of emotion and as motivators and pure forms of religious expression, which finds a prominent place in Sufi thought and practice; these important issues are touched on in later chapters.

Classical and medieval philosophical and religious antecedents notwithstanding, the modern study of emotion is nested within the development of modern disciplines of academic inquiry, in particular in twentieth-century scholarship in psychology, anthropology, literature, and, more recently, an intersection of clinical and humanistic studies. It should be noted, however, that almost a century and a half ago William James published an important article on the subject in which he argued that human mental states were inseparable from our bodily forms. "If we fancy some strong emotion, and then try to abstract from our consciousness of it all the feelings of its characteristic bodily symptoms, we find we have nothing left behind, no 'mind-stuff' out of which the emotion can be constituted, and that a cold and neutral state of intellectual perception is all that remains."[2] At the time, his point ran counter to much thinking based on dichotomies of body and mind, and presaged crucial ideas regarding emotion and affect that shape the methodologies used in this book.

IN SEARCH OF UNIVERSAL EMOTIONS

The fundamental division separating most modern theories of emotion is between what one might term *universalism* and *social constructivism*. Although both positions, broadly conceived, have long pedigrees, social constructivism is linked to sociology and cultural studies, which underwent major strides forward beginning in the 1980s. Universalist attitudes concerning the nature of emotion derive from a number of sources: a general sentimental desire to believe in the essential commonality of all human beings ("we are all the same, if you prick us, do we not bleed?"); the appeal of science and the related influence of cognitive psychological and neuroscientific inquiries into the biological bases of emotions; and certain anthropological and linguistic theories. The concept of emotional universality is challenged strongly by much

social-scientific research; nevertheless, many scholars who champion universalistic theories—even though they acknowledge that emotions might be understood differently—maintain that emotions possess unchanging, culturally transcendent, and transhistorical bases. "Fear in the face of the enemy would therefore be common to [everyone across time and space], and accompanied by the same physical signs: raised pulse, dilated pupils, thumping heart, cold sweat."[3]

Perhaps the most pervasive contemporary arguments in favor of the existence of universal emotions come from writings at the intersection of the humanities and sciences. Several scholars, notable among them Jan Plamper and Ruth Leys, have critiqued the trend among some humanists and humanistic social scientists to use clinical research on the brain to back up their own theoretical claims. Plamper, in particular, criticizes what he characterizes as a casual borrowing from the neurosciences on the part of a variety of social scientists who are interested in the study of emotion, and he lays out in detail the reasons why such a method is problematic and unpersuasive.[4] In brief, there are problems of method as well as of intended outcome in using clinical data for humanistic arguments. Without addressing whether or not laboratory methods of assessing brain activity and electrical impulses actually measure something the average person might call an "emotion," scientific method and humanistic method are very different in the way they approach the generation of new knowledge. Humanistic scholarship—for the most part—is based on establishing control over the previous scholarship in the field and making incremental advancements to collective knowledge. New knowledge is conceived of either as placing one's imprint on a new archive of data or else as making innovative changes in methodology. In all cases, the desired goal is to have one's own contribution stand for a substantial period of time as the authoritative statement on the subject. In contrast, scientific research is based on testing hypotheses, using experiments either to disprove or prove previous hypotheses, and fully expecting many of one's hypotheses to be proven wrong or incomplete in a very short time. While the most respected of humanistic research is published in books that become classics in their fields, taking a long time to publish and (it is hoped) even longer to knock off the reference shelf, scientific research appears in articles that are published in a close temporal relationship with the findings they present, almost like reports on ongoing research.

These differences of method have substantial impact on the effectiveness with which humanistic scholars can take advantage of scientific

research: the technical nature of research findings written by scientists for others in their field is difficult for humanists to follow, and consequently very few of them actually read the articles in which scientists present their research. Instead, they rely on books written by scientists, relevant examples of which are the works of Antonio Damasio and Joseph LeDoux, both of whom have been very influential in shaping the ideas of several social-scientific and humanistic scholars of emotion and affect theory.[5] But such books, interesting and informative as they might be, are intended as trade paperbacks and are demonstrably successful in that regard. They can be found on the self-help shelves of bookstores, a point that is obvious from the title of LeDoux's recent *Anxious: Using the Brain to Understand and Treat Fear and Anxiety* (2015), or from the marketing comments for Damasio's *Self Comes to Mind: Constructing the Conscious Brain* (2012), whose published praise includes quotations from V. S. Naipaul and Yo-Yo Ma. That humanistic and social-scientific scholars—who would consider quoting the equivalent book in their own field tantamount to professional suicide—happily reference popular books wedding science and humanistic research points as much to the prestige of science as it does to the methodological shortcomings of the scholars in question.

After neuroscience, cognitive psychology has been notably influential in the construction of some recent humanistic and social-scientific theories of emotion. In particular, the work of Paul Ekman has been significant in promoting the theory of universal basic emotions. His ideas in this regard have changed over time, but the key element is his position that all people in all cultures have eight basic emotions that manifest themselves in mutually recognizable ways: happiness, anger, disgust, fear, sadness, and surprise. What these terms might be in languages other than English—or even whether a particular language has an equivalent concept—has no bearing on Ekman's theory, since for him emotions do not occur in language but are physically manifested in the face. "For every basic emotion there is a corresponding unmistakable facial expression which no one is capable of concealing. If someone sets out to deceive or when 'display rules' (in Ekman's terminology) prohibit the display of basic emotions, micro-expressions always give them away."[6]

Ekman's theories of emotion as universally and uncontrollably manifested in facial expression have been very influential in ways that have happy, lucrative consequences for their author, since the promise that one can read any human being's mood and intentions is of value in business negotiations, sales, law enforcement, and several other arenas.

Ekman consults with such paying clients through the Paul Ekman Group (its slogan: "Teach yourself to read the emotions of those around you").[7] At the same time, his research has been resoundingly discredited in many academic circles for several reasons. Not the least of these is a methodology that is deeply flawed in a number of ways, such as the use of simulated (rather than authentic) facial expressions, the lack of control groups, limiting the range of facial emotional expressions, and a generally tautological approach, in the sense that the pictures shown to subjects were already an artificially select sample because Ekman only included in his experiment photographs in which he himself recognized so-called basic emotional expressions.[8]

One important example of the way in which universalist theories of emotion find their way into the study of humanities—and of visual culture in particular—is in the work of the respected art historian David Freedberg.[9] Freedberg is a self-professed convert to Ekman's theory of universal basic emotions as expressed in the face, which for Freedberg means that paintings can convey emotions accurately and reliably across time and culture: "Forms of direct and unmediated response (provisional labels for a variety of immediate and unconscious responses) offer a way of thinking about the continued hold of a centuries-old work of art on contemporary viewers, even in the absence of any particular knowledge or conscious recollection of its subject."[10] Elsewhere he states: "[W]hen we see the gamut of emotions that are so poignantly registered both by the tears on the faces of protagonists of this drama and by the movements of their hands and limbs, we have an immediate sense of the muscular forces that drive these expressions of emotion."[11] More recently, Freedberg has worked with the neuroscientist Semir Zeki, coiner of the term *neuroaesthetics* and designer of experiments that study responses to so-called great works of art, a project Freedberg shares with some other art historians who maintain that there is a scientific basis to the unbounded aesthetic and emotional appeal of "great art."[12]

In the face of a variety of anthropological, philosophical, and psychological arguments to the contrary, a persistent claim for the universality of some basic emotions is made by scholars even outside the neurosciences. Arguing on linguistic grounds, Anna Wierzbicka has challenged both the notion that emotions are culturally constructed and neuroscientific ideas of emotional universality. She also criticizes theories that suggest basic emotions are expressed and communicated through facial expressions but she does not question the universality of emotions themselves. Instead, Wierzbicka proposes that there is a cul-

turally universal metalanguage of emotion, which she refers to as the Natural Semantic Metalanguage (NSM). Her project is, in part, to affirm philosophical ideas of innate emotion proposed by thinkers such as Franz Boas, going back to Gottfried W. Leibniz and as far as René Descartes.[13] Her concept of the Natural Semantic Metalanguage seeks to "distinguish the essential from the optional, to capture the invariant, and to break complex concepts into maximally simple ones, relying exclusively on independently established conceptual primes and lexico-grammatical universals."[14] She posits the following as a possible canon of linguistically grounded universal emotions:

1. All languages have a word for FEEL.

2. In all languages, some feelings can be described as "good" and some as "bad" (while some may be viewed as neither "good" nor "bad").

3. All languages have words comparable, though not necessarily identical in meaning, with *cry* and *smile;* that is words referring to bodily expression of good and bad feelings.

4. In all cultures people appear to link some facial gestures with either good or bad feelings, and in particular, they link the raised corners of the mouth with good feelings . . . whereas turned down corners of the mouth or a wrinkled nose appear to be linked with bad feelings.

5. All languages have "emotive" interjections (i.e. interjections expressing cognitively based feelings).

6. All languages have some "emotion terms" (i.e. terms designating some cognitively based feelings).

7. All languages have words linking feelings with (i) the thought that "something bad can happen to me," (ii) the thought that "I want to do something," and (iii) the thought that "people can think something bad about me," that is words overlapping (though not identical) in meaning with the English words afraid, angry, and ashamed.

8. In all languages, people can describe cognitively based feelings via observable bodily "symptoms" (that is, via some bodily events regarded as characteristic of these feelings).

9. In all languages, cognitively based feelings can be described with reference to bodily sensations.

10. In all languages, cognitively based feelings can be described via figurative "bodily images."

11. In all languages, there are alternative grammatical constructions for describing (and interpreting) cognitively based feelings.[15]

Wierzbicka is well aware of distinctions between cultures in terms of the comprehension and description of emotion, but she maintains that, within this diversity, there are undeniable commonalities and even universals:

> The problem is how to sort out the cultural-specific from the universal; how to comprehend the former through the latter; and, also, how to develop some understanding of the universal by sifting through a wide range of languages and cultures rather than by absolutizing modes of understanding derived exclusively from one's own language. For all this, I have claimed, we need a well-founded tertium comparationis, and such a tertium comparationis is provided by the mini-language of universal human concepts, derived from empirical cross-linguistic investigations.[16]

EMOTION AND SOCIAL CONSTRUCTIVISM

Against theories promoting the concept of universal emotion stands a different set of positions grounded in a variety of social-scientific methods, especially anthropology and sociology but also a range of methodologies of culture covering the studies of gender, race, literature, philosophy, and more. Influenced by such social-scientific analyses, we should ask ourselves if emotion is even a stable object of study *within* academic discourse, what to talk of in the diverse experiences of people across time and culture. "Are we really talking about the same object when we refer to 'emotion' as understood by Joseph LeDoux in the neurosciences of 1996 and 'emotion' as used by Klaus Scherer for experimental developmental psychology in 1979? . . . [I]s there anything in common between *les affect* as understood by Gilles Deleuze and Félix Guattari in 1980, the Indonesian *perasaan hati* in the mid 1980s, 'affect' as used in English by . . . Massumi in 2002, and the *emozioni* as described by Cesare Lombroso in 1876? In brief, is there a unity of meaning sufficient to permit us to deal with these very different terms originating in very different fields, times, and cultures as 'emotion'?"[17]

Among psychologists, Robert Zajonc stands out as someone who argued that emotions are postcognitive, using a definition of cognition that is restricted to a relatively high level in which the conceptual model

for the human brain is a computer and the forms of thinking are akin to solving mathematical equations.[18] In his thought, emotion is critical in all human behavior, and particularly in decision-making, and it functions at a precognitive, unconscious level:

> An affective reaction, such as liking, disliking, preference, evaluation, or the experience of pleasure or displeasure, is based on a prior cognitive process in which a variety of content discriminations are made and features are identified, examined for their value, and weighed for their contributions. Once this analytic task has been completed, a computation of the components can generate an overall affective judgment. Before I can like something I must have some knowledge about it, and in the very least, I must have identified some of its discriminant features. Objects must be cognized because they can be evaluated.[19]

Several anthropologists make convincing arguments from social-constructivist perspectives that demonstrate the socially embedded nature of emotion. Lila Abu-Lughod is important in this regard, especially in her work on the emotional lives of Bedouin women in Egypt.[20] More relevant for my purposes here is Catherine A. Lutz, who worked among the people of the Ifaluk Atoll in the South West Pacific. Her important book on the subject opens with one of the best summaries of the social-constructivist approach:

> At first blush, nothing might appear more natural and hence less cultural than emotions, nothing more private and hence less amenable to public scrutiny, nothing more inchoate and less compatible with the logos of social science. These views can be treated, however, as items in a cultural discourse whose traditional assumptions about human nature and whose dualisms—body and mind, public and private, essence and appearance, and irrationality and thought—constitute what we take to be the self-evident nature of emotion.[21]

Lutz's explanation of cultural differences in the experience and expression of emotion does not emphasize causality, even though emotions are ascribed their origins. In the case of the Ifaluk whom she studied, their lack of capitalism and their organization as a society based on individual human contact prevented them from developing alienating social characteristics and allowed them to enjoy holistic and healthy emotional lives.[22] Against the view that emotions are the same across cultures, she locates emotion *within* culture and reorients the question into one of how a particular cultural expression of emotion might be translatable into another context. For Lutz, importantly, "emotional experience is not precultural but pre*eminently* cultural."[23]

The struggle between social-constructivist theories of emotion and universalist ones remains unresolved; and it is not true that proponents of one or the other method necessarily occupy unrelated, antagonistic positions. Among the important attempts to bridge the gap between universalist and social-constructionist approaches to emotion, the anthropologist Karl G. Heider (building on earlier scholarship in the field) has argued that emotions and emotional behavior are a mix of "pancultural" and "culture-specific" behaviors, but since culture-specific patterns share their context with the pancultural, both must be studied concurrently.[24] Heider's theory of emotion behaviors is universalistic in the sense that it is based on a belief in basic emotions (à la Ekman). However, he allows for two stages of cultural intervention in an emotional event, such that any quest for an unmediated universal emotion becomes meaningless. For him, an antecedent emotional event is mediated by the cultural understanding of that event *before* it is experienced as an inner state by the individual, and is subsequently subjected to culturally normative rules of behavior before it is expressed outwardly.[25] What results is a "very general model that admits the complexity of real emotion behavior" and "recognizes both the simultaneous synchronic combination of several emotions and the diachronic succession of emotions."[26]

EMOTIONAL METAPHORS

Turning from anthropology back to linguistics, a somewhat different understanding of emotion, which moves between a constructivist and universalist model (one that centers on the importance of metaphor), is proposed by Zoltán Kövecses. According to Kövecses, the full range of meaning of an emotion (anger, for example) is not exhausted by its emotion word *(anger)*, since the emotion of anger can be expressed very effectively by a range of metaphors such as "turning red in the face," "having one's blood boil," "blowing up," and so on. Such expressions evoke visual metaphors—the ferocity of an animal, the violence of an explosion, and, very often, the various effects of heat. Kövecses's theory of emotional language relies on distinguishing between expressive and descriptive terms, with the latter carrying more relevance as descriptors of emotion, and themselves being divided into literal and figurative.[27]

Kövecses understands the division between universalist and social-constructionist views of emotion to be problematic and tries to find a compromise between the two approaches, arguing that individuals can "choose to conceptualize their emotions in many different ways *within*

the constraints imposed on them by universal physiology. These limits leave a lot of room for speakers of very different languages to conceptualize their intense emotions in sometimes very different ways."[28] Kövecses dismisses the notion of "pure" emotions or even pure emotional metaphors at the same time as he sees metaphors of "force" dominating emotional vocabulary and therefore serving as the primary emotional metaphor. As such, even though he does not push the hypothesis that emotions are universal, he does argue that although "[e]motion metaphors are not isolated and unrelated specific-level metaphors," they do form "a large and intricate system that is organized around the generic concept of force."[29] He considers his mediatory position regarding the nature of emotion as "body-based constructionism," reflecting a belief that some aspects of emotion are related to physiological functions and therefore are universal:

> Once the universal aspects of emotional language are parsed out, the very significant remaining differences in emotion language and concepts can be explained by reference to differences in cultural knowledge and pragmatic discourse functions that work according to divergent culturally defined rules or scenarios. This approach also allows us to see points of tension where cultural interests might contradict, suppress, or distort innate tendencies of expression. Thus, we need not be forever aligned in opposing camps, the innatists pitted against the social constructionists.[30]

Another important reconciliation of humanistic constructivism and universalist theories as drawn from the life sciences is found in the work of the historian William M. Reddy. In an important article published in 1997, Reddy critiqued the social constructivism of some recent anthropological writing and proposed a translation of universalism and social constructivism into a theory of speech acts. In his words, "I propose to find within the very plasticity of the individual grounds for making universal assertions that can motivate ethnographic and historical analysis that is politically meaningful. Grounding universal claims in emotional life rather than in identity, gender, culture, or discourse sidesteps the thorny questions that have recently formed insurmountable stumbling blocks to any universalism or humanism."[31] He compares social constructivism to the "performative," something that effects change in the world, and universalism with the "constative," something that describes the world. Emotional statements such as "I am happy" or "I am sad" simultaneously describe a state but also transform it, in the sense that performing emotion—through telling oneself and others that one is happy—often has an impact on one's emotional state.[32] Emotional statements therefore

simultaneously possess performative and constative properties, a phenomenon for which Reddy uses the term *emotive*.

The concept of the "emotive" is intended by Reddy in the first place to bridge the gap between universalism and social constructivism, something that he hoped to accomplish by pointing out how emotion, as "the real world-anchor of signs," not only describes a state but also influences it:

> An emotive utterance is not self-referential like a performative but claims by definition to refer to something close to its origin, to its own world-anchor. Why does this kind of reference not fail . . .? The answer is that it does fail. The emotive derives from the failure. If the emotive did not fail, it would be a "mere report," an accurate representation. A statement about how one feels is always a failure to one degree or another; like a performative it is neither true nor false. Emotives constitute a kind of pledge that alters, a kind of getting-through of something nonverbal into the verbal domain that could never be called an equivalence or a representation. The very failure of representation is recognized and brings an emotional response itself; this response is part of the emotive effect. This is true whether one's "intention" is to speak the "truth" about one's feelings or not. This problematic link between emotive and emotion, this dilemma, is our activity as a person.[33]

Reddy's concept of the "emotive" can be critiqued from a number of perspectives, not the least of which is that it is logocentric, deriving as it does from a theory of speech acts rather than from a study of feelings, psychology, or some other arena of human experience. There is no real reason to assume that the *thought* "I am happy" has the same effect on me and my environment as my articulating the sentence "I am happy" out loud. Nor does my forcing myself to smile or laugh have the same effect as my uttering the words.[34] One can well imagine a context in which the facial expression or action (hugging the person next to me, for example, or jumping up and down in public) would be a more effective, "constative" as well as "performative" emotive. He could also be criticized for not making a satisfactory methodological distinction between anthropological fieldwork and historical research, in the sense that the subject of the former is modified by the presence of the ethnographer whereas the historian doesn't change the behavior of (dead) historical actors. And, relevant to the issue of both method and language, his elaboration of the notion of the "emotive" can be criticized for being overly synchronic, ignoring both memory and aspiration on the part of the emotional actors.[35]

Reddy addresses some criticisms of his theory of the "emotive" and elaborates on it further in his book *The Navigation of Feeling*, where he

draws heavily from research in cognitive psychology, according to which it is impossible to separate emotions from cognition or from reason. Emotions can be neither clearly defined the way theories of "basic emotions" might attempt to do, nor even neatly separated from one another. He ends up embracing the idea of emotion as "cogmotion," or "overlearned cognitive habits." The concept of "cogmotion" suggests that emotions are not experienced and learned through conscious decisions, but they are still constrained, according to Reddy, in two important ways:

> (1) Most psychologists agree that emotions have a special relationship to goals. They have a "valence" or "hedonic tone" that renders them either inherently pleasant or inherently unpleasant; and they have an "intensity" that determines how easy or difficult it is for a person to override them. (2) New work on the nature of mental control shows that there are special constraints on the kind of learning, or unlearning, that involves emotions.[36]

Reddy's ideas concerning emotions, the emotive, and emotional regimes have important consequences for the study of emotion and affect in society. The implications for anthropology go to its very core: "The question of whether emotions are social constructs or universal, and what the relationship might be between these two poles, goes to the epistemological heart of the discipline. If one adopts the expansive conception of culture of Geertz, which allows for no extracultural space, then there is no longer any possibility of an independent position from which differences between culturally formed expressions of emotions can be registered. It also becomes impossible to conceive how emotions might change over time; or rather, such change is so radically contingent that it admits of no analysis."[37]

Another important implication of his work, of which the ramifications are central to my project, is the relationship between emotions and goals. The idea that emotions have a hedonic inherency as either pleasant or unpleasant suggests that human beings might actively welcome some emotions and avoid others, and also manipulate the intensity with which emotions are experienced. Furthermore, learning and behavior modification that involves emotion might follow specific patterns or rules. If these observations hold true, it implies that emotions as experienced by individuals possess goals and aspirations, in the sense that emotional states are evoked and avoided, and conditions can be manipulated with the goal of shaping emotions in the future.

EMOTION AND AFFECT

The theoretical approaches to emotion discussed all too briefly above provide important insights into the place of emotion, while simultaneously failing to be wholly satisfying in furnishing an understanding of its nature. Much of the study of emotion focuses on the distinction between emotion and its affects. Emotion is treated either as a biological function akin to sensation or, more frequently, as a social expression of something that might be called a "feeling." Affect, in contrast, is understood to be a pre- or subconscious phenomenon that is both ephemeral and independent of the conscious choices and dispositions of the individual. There is some value to this distinction: in contrast to a concept of emotion that is mediated and sustained—a process, in essence—affect is something ephemeral that rises instantaneously and dissipates rapidly, leaving residual effect.[38] Even though such a distinction between emotion and affect is fraught with problems, it remains useful as a heuristic device for highlighting different kinds of experience and their perception and impact.

Affect has emerged in the last two decades as a popular subject of study, frequently married to the study of emotion but at times also divorced from it. It is affect rather than emotion that is the primary subject of inquiry in public displays of emotion and in the not-easily-analyzed processes of political life, consumer culture, entertainment economies, and the myriad other social arenas that locate individual human beings in broader communities. The anthropologist Michelle Rosaldo explained affect as a culturally and corporeally informed kind of cognition. "Emotions are thoughts somehow 'felt' in flushes, pulses, 'movements' of our livers, minds, hearts, stomachs, skin. They are *embodied* thoughts, thoughts seeped with the apprehension that 'I am involved.'"[39]

The importance granted to affect and emotion in the study of culture is part of a broader attempt to look at social and historical processes that have traditionally been ignored in academia. One can make three coherent arguments in favor of affect as a social force—what might be called "affect-culture." In the first place, the concept might help us understand the relationship between human bodies, nature, and action, together constituting a matrix of relationships that forms the basis of social life. In the second, the concept of affect-culture explains certain aspects of human life—cooperative living, sacrifice, generosity, attachment, and affection—much more effectively than do other existing theories that focus on economics, politics, and power. And finally, it pro-

vides a critical apparatus for gaining knowledge from human interactions and social movements, thereby helping us understand processes of social interaction in the future.[40] In short, the concept of affect holds promise for explicating a broad range of forces and events in society that are not satisfactorily explained with existing systems of analysis. This is not to suggest that a theory of affect might provide a comprehensive explanation of society that renders all other theories superfluous, but that the concept of affect is potentially a productive way of understanding many of the phenomena of human attitudes and behaviors that are central to this book.

AFFECT THEORIES AND THEIR HISTORIES

There is no one theory of affect; rather, affect has emerged as a concept that lends itself to a variety of theoretical approaches, some of which might seem more productive than others. A somewhat generalizable range of thinking on affect—for which the term *affect theory* has been claimed by its proponents—grew to prominence in the last decade of the previous century and continues to hold considerable importance, both demonstrated and furthered by the publication of *The Affect Theory Reader* in 2010.[41] This trend in theorizing affect is traceable to the work of several thinkers, among whom Brian Massumi and Eve Sedgwick stand out as particularly influential, although very distinct from each other. Their early work on affect appeared at almost exactly the same time, and both made strong arguments seeking to displace the centrality that structuralism and (more so) poststructuralism enjoy in cultural theory.[42] Sedgwick and Massumi exemplify the two main paths taken by affect theorists in the early phase of this field's growth, one influenced strongly by Silvan Tomkins's writings on psychobiology and differential affects, and the other by Gilles Deleuze's ethnology of bodily capacities, which is itself based on a modern recovery of some aspects of the thinking of the early modern philosopher Baruch Spinoza (d. 1677).

Tomkins's concept of affect follows an almost Darwinian notion of innate capacities that are subject to environmental and societal modification. His ideas constitute a corrective to the behavioral and cognitive methods that dominated psychological research in the last century. Tomkins argued that affect was a "primary innate biological motivating mechanism" that functioned together with other mechanisms in the environment (or the "biosocial system").[43] He stressed the importance of the autonomy of affect even though this form of autonomy was

located within the dynamics of interaction between the individual and society. Tomkins believed that affect effected perception, thought, and memory, in addition to the impact it had on amplifying the nature of feelings (such as pleasure or pain) and thereby making them more durable, memorable, and, consequently, individually and socially meaningful.[44] A critical aspect of Tomkins's theory of affect is his belief that some aspects of affect are basic and universal. They might differ in how individuals understand and manifest them as a consequence of their local customs and beliefs, but the basic affects transcend culture.[45]

In contrast to Tomkins, Deleuze situates affect in superficially similar structures of innateness combined with external stimuli that flow in the other direction. In this case, affect can be seen as "an entire, vital, and modulating field of myriad becomings across human and nonhuman."[46] More important even than the influence of Deleuze himself is that of Spinoza, a philosopher who predates the Enlightenment but whose thought—drawn in particular from his *Ethics*—has been habilitated into the contemporary discussion of affect. Certain statements made by Spinoza have almost become leitmotifs of affect theory, in particular his declaration that "No one has yet determined what the body can do."[47] Two points made by him concerning the body have been particularly influential: first, that the body's capacity is not determined by the body alone but that it is amplified and assisted by its external context; and second, even though we might not fully understand the body's nature, we can comprehend how a specific body functions in a particular social context.[48] Spinoza distinguished between *affectus* and *affectio*, "the force of an affecting body and the impact it leaves on the one affected."[49] *Affectio* can be ephemeral, but still leaves a lasting impact or impression that, in turn, generates bodily capacities. In Spinoza's words, "the human body can suffer many changes and yet retain the impressions or traces."[50] Whatever else Spinoza's ideas concerning affect might imply, they make clear that it is a relational phenomenon that draws together a body, the sentient aspects of the human being inhabiting it, and the social context within which that person is embedded.

The ideas of Spinoza and Deleuze find their greatest influence in constructing affect theory through the work of Brian Massumi. His early essay "The Autonomy of Affect" (1992) invited cultural theorists to focus on the body through a turn to affect. This project was continued in his subsequent work and was at the heart of his book *Parables of the Virtual* (2002), which has become almost canonical among self-professed affect theorists. Following Deleuze, Massumi maintains that affect is

essentially bodily, not asocial but presocial, and "filled with motion, vibratory motion, resonation," a "nonconscious, never-to-be-conscious autonomic remainder."[51] He defines affect in terms of autonomic responses that exist outside of conscious or cognitive forms of perception, locating them in a space of "visceral perception" that temporally precedes the moment of conventional perception.[52] This precognitive visceral moment is not the same as a physical reaction (skin responses, pupil dilation, and the like); instead it serves as a device to think of affect in virtual terms, as a sphere of potential, emergent, and indeterminate tendencies or incipient acts.[53] Massumi posits that conscious perception might be seen as the narration of affect, but that there still remains a "never-to-be-conscious autonomic remainder. . . . outside expectation and adaptation, as disconnected from meaningful sequencing, from narration, as it is from vital function."[54] This he sees as an excess of affect, from which a domesticated narration of emotion is "subtracted," the affective event's anomaly being "smoothed over retrospectively to fit conscious requirements of continuity and linear causality."[55] Conscious perception is limitative and subtractive because it smooths over complexity and, in the moment of actualization of the affective event, delimits what is actually virtual and unlimited.

Massumi acknowledges that societal factors play a role in affect, but maintains that they do so through a system based around the notion of "quantums." His theory of quantums brings together multiple levels of functioning and occurs on mutually exclusive paths of action, tendency, and expression; they exist only as potentials, never to be fully actualized.[56] It is this very indeterminacy that makes the notion of quantums so attractive to Massumi: the belief that "[a]ffect is the whole world" implies to him that a system of quantums is the underlying structure that explains all affective happenings in the world.[57] Affect is something that is temporally virtual, in addition to being indeterminate, and it is this virtuality that lends affect its autonomy since it is not constrained by anything that embodies it. Taken together, quantumcy, virtuality, and indeterminacy put "affect at every level of matter such that the distinctions of living and non-living, the biological and the physical, the natural and the cultural begin to fade."[58]

For Massumi, affect is autonomous, in the sense that it is unrestricted by the sociocultural constructs in which it occurs. In a sense, an affective event then has two parts, the external sociocultural factors that help shape it and an unassimilable inner event. This latter unrestricted and unassimilable factor he terms the "virtual," and regards it as the

location of affect.[59] He does stress at the beginning of his influential book that he is not proposing a return to what he calls a "pre-social" body since he doesn't consider affect to be "pre-social." What he is proposing is that affect is "social in a manner 'prior to' the separating out of individuals," and that it is "open-endedly social."[60]

Massumi distinguishes between affect and emotion, and in this regard he departs from both the cognitive science of Damasio (whose influence on him is pervasive) and the writings of Spinoza. For Massumi, emotion is more or less the same as "feeling," the point at which intensity gets inserted into actions, narratives, and meanings.[61] His need to acknowledge the indeterminacy of autonomic, bodily responses compels Massumi to define affect as autonomous from emotion as well as from language and conscious perception.

AFFECT AND ITS DISCONTENTS

My discussion of major currents in affect theory over the preceding pages has focused on formative theories in a field inseparable from the subject of this book, but with whose methods I do not necessarily agree. Several other writers develop these theories in ways that are more productive and relevant. Jonathan Flatley, for example, starts from a position similar to that of Massumi but departs from him in the degree to which he sees affect as being connected to the nonvirtual world. Affects might resist representation and operate with their own temporality but they cannot be repressed and they come out in a variety of unpredictable ways, such as in dreams or physical symptoms.[62] For Flatley, affects remain linked to emotions, in the sense that emotions result from the interaction of affect with human qualities such as instinct, habit, beliefs, thought, and ideas.[63] Other writers on affect have emphasized how embodied aspects of affect are inseparable from social dynamics in ways that are useful and productive. I find that the most fruitful deployment of the concept of affect occurs not in writings that are about affect itself but in ethnographic, sociological, or other works that deploy affective theories in the service of a more topically grounded discussion.

Many of the main problems of affect theory have already been alluded to above in the discussion of how emotion has faired in academic writing, in particular on the issue of the impact of neuroscience and cognitive psychology on some of the most influential voices in affect theory. This holds especially true for advocates of fields such as "neuropolitics" who suggest that neurobiological universals can predictably manifest them-

selves in sociopolitical behaviors and their outcomes. A major problem with such theories is the way in which they rely on research in the life sciences. As I have already addressed briefly above, scientific research—unlike work in the humanities and humanistic social sciences—is presented almost exclusively in journal articles that are written as progress reports on findings in ongoing research, rather than as eureka moments of the revelation of knowledge that vanquishes what stood before it. This is in contrast to the humanistic model in which books are viewed more highly than articles, and one is professionally rewarded for writing definitive works that effectively close discussion on a specific topic or approach to it. More often than not, scientific books that are popular with nonspecialist audiences are books *on* science rather than books *in* science: they require a degree of translation from the technical, symbolic, and formula-filled language of scientific research and, unlike with the fast pace at which journal articles appear at the immediate conclusion of a phase of research, they are separated from new research findings by the long process involved in book production and marketing. Furthermore, few scientists have the knack or desire to reach out to broad audiences, a project that relies on the popularization of technical ideas ("neuroscience for dummies") and on making earth-shattering claims or, at the very least, on making grand promises concerning how the book in question will advance our understanding of a very important thing. Both of these are decidedly unscientific approaches, readily apparent in the works of neuro-converts in the humanities and social sciences who are overly reliant on theories put forward in popularizing books by a handful of scientists, among whom Damasio and LeDoux stand out as especially influential.[64]

The influence of Damasio (from his popular book *Looking for Spinoza*) is particularly obvious in promulgating ideas concerning the relationship between emotions, feelings, and affects. Emotions are treated as *responses* to external stimuli, and they are located in the body although they occur without conscious knowledge. Feelings, in contrast, are often understood to be postconscious, in the sense that they are the result of emotions that occur in conjunction with conscious action. Affects lie somewhere in the preconsciousness and are neither emotions nor feelings. By way of example, "happiness" is an emotion related to the feeling of "being happy," which is consciously manifested by my smiling; my awareness of "being happy" is a signal which indicates to my conscious self that something, some affect, is occurring in my inner, precognitive, preconscious body.

The fascination with Damasio is also largely responsible for the popularity of Spinoza among affect theorists who treat him as a counterpoint to Descartes in a general trend to valorize the body and the material world, thereby reversing the emphasis on rationality, consciousness, and the mind in post-Enlightenment thinking. Viewed through a particular lens and against Descartes's mind-body dualism, Spinoza is a welcome monist who reclaims the importance of the physical world and locates the conscious and rational within it.[65]

Ruth Leys's critique of the turn to emotion and affect is broad in its scope, looking at this new development in fields as diverse as history, art and architectural history and criticism, media studies, cultural studies, literary studies, political theory, human geography, and urban and environmental studies. Her aim is to consider the claims of theorists who are deeply influenced by their enthusiasm for the cognitive sciences and have not only embraced new fields such as neurogeography, neuroaesthetics, and neuropolitics, but also argued that their own, existing disciplines in the humanities and social sciences should be reconfigured in light of new theoretical trends in studying emotion and affect.[66] Leys succinctly summarizes an antirationalism that is inseparable from the turn to the body in much of affect theory:

> The claim is that we human beings are corporeal creatures imbued with subliminal affective intensities and resonances that so decisively influence or condition our political and other beliefs that we ignore those affective intensities and resonances at our peril—not only because doing so leads us to underestimate the political harm that the deliberate manipulation of our affective lives can do but also because we will otherwise miss the potential for ethical creativity and transformation that "technologies of the self" designed to work on our embodied being can help bring about.[67]

Such a viewpoint contends that affects are prior to and independent of intention, meaning, belief, and reason, since they are events that occur either before the moment of conscious awareness or else below a threshold of consciousness. This noncognitive or—more relevantly—precognitive affective moment is visceral or, in Massumi's terms, it possesses an "irreducibly bodily and autonomic" quality.[68]

The pervasiveness of the universalist paradigm of emotion promoted by Tomkins and Damasio has been accepted by many affect theorists in large part, Leys argues, precisely because they think it furnishes the empirical evidence needed to put forward a corporeal, nonintentionalist account of emotion. If affects are devoid of inherent meaning or any association with something that triggers them, there has to be a physi-

ological reflex-like phenomenon in human beings that is completely unmediated both by consciousness and by external stimuli.

Leys can be faulted for only choosing to critique those examples from the life sciences that fit her arguments, or for not suggesting an alternative to the theories of affect and emotion she criticizes. However, she never claims that she intends to put forward such a theory; rather, she is distinguishing "bad" natural science from "good."[69] Her focus on problematic research and argument is fully justified in this regard.

I see several distinct, if interrelated, shortcomings in the enterprises of theorizing affect outlined above. Quite apart from the turn to cognitive science and the mixed-up methodological currents it implies, affect theory seems to be ideologically driven by an attempt to reverse an imagined poststructuralist theoretical hegemony, and therefore it necessitates a conscious turn away from rational methods. The need to maintain an asignifying transcendence for affect either requires or results in it being completely detached from emotion, a point made unequivocally by Massumi: "In the absence of an asignifying philosophy of affect, it is all too easy for received psychological categories to slip back in, undoing the considerable deconstructive work that has been effectively carried out by poststructuralism. Affect is most often used loosely as a synonym for emotion. But . . . emotion and affect—if affect is intensity—follow different logics and pertain to different orders."[70] He goes on to refer to emotion as "a subject content, the sociolinguistic fixing of the quality of an experience which is from that point onward defined as personal. Emotional is qualified intensity, the conventional, consensual point of insertion of intensity into semantically and semiotically formed progressions, into narrativizable action-reaction circuits, into function and meaning. It is intensity owned and recognized. It is crucial to theorize the difference between affect and emotion."[71]

Massumi's understanding of affect as asocial, virtual, and existing primarily as potential rather than actualized underlies his writing on the subject. It also makes this understanding of affect less usable as a theoretical concept. Inseparable but completely distinct from perception and emotion, affect remains undefinable and unknowable, and therefore both unanalyzable and completely unpredictable. "The problem with reducing affect to an autonomous, inchoate force is that it becomes an ethereal abstraction, its historical materiality removed from the grasp of critical assessment."[72] As a result, even though the move to the body and away from an emphasis on language and linguistics that is represented by Massumi might itself be useful, his notions of the "virtual"

and of "quantum logic" actually prevent any system of analysis of the very phenomena for which affect seems an attractive theoretical concept, these being the relationship between feelings and emotions on the one hand and the manner in which they are performed, articulated, and perceived on the other.

The separation of affect from emotion is upheld by other affect theorists influenced by Massumi: "The power of affect lies in the fact that it is unformed and unstructured (abstract). It is affect's 'abstractivity' that makes it transmittable in ways that feelings and emotions are not, and it is because affect is transmittable that it is potentially such a powerful social force. This is why it is important not to confuse affect with feelings and emotions."[73] The same enthusiastic affect theorist asserts that "affect is not a personal feeling. Feelings are personal and biographical, emotions are social, and affects are *prepersonal.* . . . An affect is a non-conscious experience of intensity; it is a moment of unformed and unstructured potential. . . . Affect cannot be fully realised in language, and because affect is always prior to and/or outside consciousness . . . [it] is the body's way of preparing itself for action in a given circumstance by adding a quantitative dimension of intensity to the quality of an experience. The body has a grammar of its own that cannot be fully captured in language."[74]

One criticism of the dominant trends in affect theory concerns a somewhat florid and convoluted use of language. This might seem like a trivial and ad hominem accusation, but I believe that the majority of writers who are committed to placing affect at the center of all human activities fail to eschew obfuscation because, without it, there is not much to say. For example, when Massumi states that "Thought strikes like lightning, with sheering ontogenetic force. It is *felt,*" one has little sense of what he actually means, stumbling as one does over a meaningless metaphor.[75]

It remains unclear what the notion of affect promulgated by self-professed affect theorists actually contributes. This is to say that, if affect (as Massumi describes it) is "primary, non-conscious, asubjective or presubjective, asignifying, unqualified and intensive,"[76] is there anything meaningful that it can contribute as an analytical and discursive concept? And if one acknowledges that between the protomoment of affect and the expression and perception of emotion lie several socially constructed moments—as many affect theorists do—then what remains of this kind of affect?

The lack of obvious relevance of precognitive affective moments to systems of analysis is something that Massumi not only accepts but

embraces, asserting that affect is not related to any emotional event or experience, that it "is not about empathy or emotive identification, or any form of identification for that matter."[77] Even the editors of *The Affect Theory Reader* acknowledge a limit to the usefulness of affect theory, although they show a surprising lack of awareness of the implications of such an acknowledgment: "This is the point at which we would want to mark a limit for theory's usefulness, and offer these essays as incitements to *more than* discourse. We want them to touch, to move, to mobilize readers. Rather than offering mere words, we want them to show what affect can *do*."[78] As Plamper has noted with some sarcasm, the "incitement to more than discourse" and the touching, moving, and mobilizing are all done in "mere words," without even a creative use of different typefaces or formatting, let alone a resort to any medium other than written language. It seems, therefore, that the most energetically discussed notions of affect lack a generalizable theory (or theories) that would be useful to anyone working with data. Not only does the acceptance or assertion that there is a precognitive affective event do nothing to help one understand the nature of conscious, felt, and enacted emotion and its social ramifications, but it provides no rubric through which one can engage in comparative analysis (or even informed discussions). This concept of affect as something that neither signifies nor allows for analysis and understanding does more than confound any attempt to conduct analyses of a more positivist or materialist kind.[79] If affect transcends, precedes, or is independent of meaning, signification, and causal relationships, what use is it?

A PATH FORWARD: AFFECT CULTURE AND SOCIAL AFFECT

Although some aspects of what is self-described as affect theory might be characterized as a passing scholarly fad, the so-called affective turn has proved valuable in destabilizing the dichotomy between mind and body or rationality and emotion that prevails in much scholarly writing, as well as in providing insight into societal forces not completely comprehensible through other theoretical models. This pushes not for more closed conversations on affect theory or on the nature of affect, but for a clearer understanding of how affect can be located in the study of history and society.[80] It is also very much the case that the writings of affect theorists have inspired a number of other thinkers to engage the concept of affect with positive results, to the point that one could argue that the

works by scholars in other fields who engage the concept of affect are more valuable than those by affect theorists themselves. It is with these points in mind that I suggest some ways of thinking about emotion and affect that make it productive for the study of visual and material objects, virtue, childhood, and other aspects of human life as they are played out in sociopolitical arenas.

I begin by recognizing that affects are inseparable from the social dynamics that govern individual human existence. Teresa Brennan has suggested that such affects become thickened in moments of real threat to survival such as hunger, societal dangers, or extreme grief, at which time anxieties give rise to affects as a form of physiological shift, with passionate emotion accompanying judgment.[81] Brennan does not consider affects to be either autonomous or asocial—they exist articulated as feelings and thereby influence the body's ability to adapt and survive. At first glance this might sound like a universalist biological explanation of the nature of affect, and to some degree it is. However, Brennan maintains that such affective articulations merge in a cultural space where they are shaped both by the individual body's perception of itself and by the bodily intensities of others. Thus the transmissions of affect might be physiological in effect (feelings of anxiety, flight responses, and so on) but they are social in origin, demonstrating that human beings exist only insofar as they are inseparable from their environment and others who inhabit it.[82]

Like Brennan but earlier, Lawrence Grossberg argues that affects help locate human beings in their environment. He sees affect as fulfilling a much needed function in cultural studies by providing a term that helps in understanding why ideology is only effective some of the time and, that too in varying degrees.[83] He stresses the manner in which quotidian existence comprises an inevitable articulation of pleasure and ideology, a dynamic that is ongoing both within and beyond the level of affect. "[I]t is in their affective lives that people constantly struggle to care about something and to find the energy to survive, to find the passion necessary to imagine and enact their own projects and possibilities."[84] His ideas concerning the ways in which affective intensities and affective investment in ideological formations give them motivating powers are especially promising, because these affective properties help explain why and how ideologies can be both naturalized and internalized so intensely.[85]

The sociopolitical implications of affect are explored in very productive ways by Rosemary Hennessy in her study of the politics of organized labor in Mexico. She starts with the awareness that, in the context of

social life and political contexts, "[t]he subjects involved in these rela-
tions are sensate beings, and the cooperative interactions that reproduce
life function through the meaning-making practices and political proc-
esses they employ."[86] Hennessy uses the term *affect-culture* to connote
"the transmission of sensation and cognitive emotion through cultural
practices."[87] She emphasizes that affect-culture's materiality is shaped
by the network of social relations within which individuals are embed-
ded, including in the circulation of narratives that are the sites in which
various aspects of social and political meaning are produced and
(re)invented. In turn, such networks and narratives produce social sub-
jects, but they do so both within and against systems of structured rela-
tionships, which are necessary for human survival. Affect-culture can
operate in a variety of different ways; very importantly, it can operate
intuitively (or obliquely) as a sense of something being wrong. Hennessy
employs the word *sense* because it carries the implication of a connection
to knowledge or awareness, as implied by the notion of common sense
as obvious knowledge or an awareness (rather than a cognitive or learned
knowledge) of right and wrong. One can therefore conceptualize mean-
ing making as occurring through a kind of sense that is not distinct from
something one might call ideology.[88]

Reddy also argues for a contextually grounded understanding of affect
and emotion, albeit one that is somewhat different from what is espoused
by Hennessy. He sees emotions as part of a serialized network of transfers
that participate actively in the construction of meaning through a com-
plex process involving sensory modalities, sociolinguistic structures, and
individual habits.[89] Overlearned cognitive habits sustain deeply integrated
goals, which can be modified through processes that involve very strong
emotions (such as grief or shame). Every human being is faced at every
moment with a large number of sensory inputs, habits, memory events,
and so on, all of which require some form of translation. Only a limited
number of these translation tasks get carried out to achieve a particular
goal, while the others remain somewhere in unformed or fragmented
ways. Emotion, as defined by Reddy, is a "range of loosely connected
thought material, formulated in varying codes, that has goal-relevant
valence and intensity, that may constitute a schema (or a set of loosely
connected schemas, or fragments of schemas); this range of thought tends
to be activated together . . . but, when activated, exceeds attention's
capacity to translate it into action or talk in a short time horizon."[90]

Although Reddy doesn't discuss the connection between emotion
and affect, he does suggest a productive way of understanding the

unstable relationship between societal norms and individual behavior, with one influencing the other through a system that locates emotion at the center. He uses the concept of emotives and emotional regimes to explain how public emotional acts and emotional standards help shape the lives of individuals who exist within them. In simple terms, emotion (as well as affect) helps explain historical events that elude simple political and economic explanations.

The above discussion is intended to make several related points concerning the study of emotion in human life at an individual and societal level. First, emotion exists in its expression and description, be it in spoken or written language, or in a bodily enactment of it, or in a visual representation. Each of these discernible affects or emotive actions is distinct from others, in that an emotion such as desire described in a love poem is not identical to the desire one human being feels for another, or to its representation in a painting or film. Furthermore, our understanding and expression of that desire individually and socially are inseparable from the broad, undefinable, and ever-changing emotional ecosystem in which we are embedded. In addition, expressions of emotion rely on conventions and semiotic systems of shared understanding for them to possess meaning. This holds true for straightforward expressions of emotion ("I feel scared") in much the same way as it does for obviously performative expressions of emotion, such as those one might find in South Asian dance or in early modern Persian miniature painting.

EMOTION ON STAGE

Throughout this book, I treat emotion as a critical dimension of human experience that exists at a social level. Bracketing for the moment any discussion of whether or not there is a shared affective or biological property to human emotion, emotions are relevant to this project inasmuch as they exist within a social sphere. This is true, I suspect, for emotion in general when it is studied as something other than a theoretical or psychological phenomenon, and particularly so in the textual description of emotion. Emotions, as described in premodern texts, are prescriptive more than they are descriptive, in the sense that emotions are actively evoked, either through teleologically constructed sensory regimes or through reflective or contemplative practices. Within an Islamic context, in his *Risāla fī-ajza' al-mūsīqī* (Treatise Concerning the Informative Parts of Music), al-Kindi (d. 870) described how particular colors and color combinations could elicit specific emotions,[91] Ibn

al-Haytham (d. ca. 1040) wrote at length about visual factors that make up beauty, and al-Farabi (d. 950) conducted experiments on the impact of musical notes on human moods.[92]

Medieval writings also have prescriptive conceptions of emotion and how it should be enacted and experienced. Byzantine Christian texts encouraged very specific ways in which a worshiper was expected to react upon seeing an icon or relic. Similar emotional acts—normally involving crying, but also rolling on the ground, rubbing, caressing, and so on—are also mentioned as appropriate responses in medieval Islamic texts. For example, in support of his argument that it was a person's educational level, not his or her religious affiliation, that determined whether one worshiped an abstract deity or a materially embodied one, al-Biruni (d. 1048) claimed that if uneducated Muslims were presented with a picture of the Prophet, or of the Ka'ba, "[t]heir joy in looking at the thing would bring them to kiss the picture, to rub their cheeks against it, and to roll themselves in the dust before it."[93]

As demonstrated by the textual references above, emotion words are frequently particular to specific cultures and contexts, to the point that it is difficult to argue for a sustained universality in how individuals understand emotions. This could hold true of common emotional concepts such as happiness and sadness, but the lack of universality is particularly obvious in emotional terms that are strongly culturally grounded, in particular "honor" and "shame." Shame is an emotional concept that has an ambivalent meaning in American and European cultures. Some might argue that it is not deeply grounded in Western societies, as evidenced by Ruth Benedict, who, in her influential book *The Chrysanthemum and the Sword,* popularized the distinction between "guilt cultures" (epitomized by the United States) and "shame cultures" (epitomized by Japan).[94] It is not coincidental that Benedict's book came out right after the Second World War, but the idea that societies such as the Japanese operate with distinct conceptions of feelings and their role in society is one that continues to hold to this day.

Ruth Leys, whose critique of certain aspects of the "affective turn" is discussed above, has done considerable work on habilitating the notion of shame in American culture, where it has not been treated historically as an important emotion or concept. Leys's point of entry into the discussion of shame is survivor guilt, especially as it is associated with the Nazi Holocaust. She understands guilt to be of two models, mimetic and antimimetic. In the first, the victim comes to identify with the aggressor and accepts the situation by not distinguishing between

beliefs and behaviors. In the second, the victim identifies with fellow victims and might imitate the aggressor only as a survival mechanism, allowing the victim to preserve a sense of self and keep the atrocities external to herself, thus maintaining a distinction between victim and perpetrator that can be held in memory without losing one's sense of self and victimhood. Leys locates shame in the antimimetic psychological model since it does not result in guilt over identifying with the enemy but rather begets an acute awareness of being observed by others in one's abject state of victimhood. As she clearly states, she is invested in countering what she regards as a societal shift from guilt to shame since, in her view, shame deprives the individual of agency and ultimately of responsibility.[95]

Leys has been criticized for relying on a primarily psychoanalytic approach that trivializes other methods in the study of emotion, guilt, and shame, as well as for largely ignoring the substantial archive of examples in which shame is mentioned and discussed in racial and queer contexts.[96] Regardless of whether or not there already exists a culture of shame in American society or whether there is a shift from guilt to shame, what is obvious from the nature of academic debates surrounding the topic is that shame is not an emotion or concept that enjoys wide social currency in American society as an emotion word or a social force. This is in contrast to other contexts, notable among them Muslim-majority societies, where notions of shame function openly in crucial ways.

The culturally specific nature of emotion and its expression has been the subject of study across a range of societies. In specifically Islamic contexts, several important works on the performative aspects of women's emotional lives serve to make this point very clearly while simultaneously demonstrating how the *enactment* of emotion is at least as important as its biological or psychological occurrence within an individual. In her influential anthropological work *Veiled Sentiments: Honor and Poetry in a Bedouin Society*, Abu-Lughod studied the way song functioned as a means to express emotion among the female members of the Awlad 'Ali, a Bedouin tribal group in Egypt. The oral and improvisational genre of songs called *ghinnāwas* functions as the primary context within which women can express the full spectrum of emotion; this can include joy and happiness, but it typically gives voice to grief, anxiety, and sadness in love, marriage, and motherhood. Members of the Awlad 'Ali, both female and male, are governed by strict codes of honor and modesty (*ḥasham*) that forbid the public expression of feelings associated with weakness and sexuality. Not only sexual

feelings but the broad range of emotions—such as heartache, desire, jealousy, and so on—associated with it are regulated through their denial in everyday life and conversation.[97] In a world where everyday emotion can never be acknowledged even to oneself, it finds expression in *ghinnāwa*. Emotion, for these Bedouin women, takes place within the confines of a literary genre that, though improvisational in its particulars, possesses fairly strict rules.

Similar observations concerning the constructed and performative nature of emotions have been made in the context of Pashtun women by Benedicte Grima and Amineh Ahmed. Pashtuns are an ethnolinguistic group from Pakistan and Afghanistan who are identified both by their language Pashto (or Pukhto) and by a comprehensive code of behavior called Pukhtunwali, or sometimes simply as "doing" or "living Pashto." Rules of modesty and honor similar to those characterizing the Bedouin in Abu-Lughod's work dictate that personal emotions and feelings cannot be addressed informally by Pashtun women but must be performed. The primary context in which emotions are addressed is through the concept of *gham-khādī*, "sorrow-joy" that encapsulates the entire construct of Pashtun emotional and social life and that itself is captured in the Pashto saying "Laughter looks good at a wedding, and tears at death *(shādi pe khandā kha khkāri aw meri pe zharā)*."[98] *Gham-khādī* refers to a form of networked living in which individuals share in the happiness and grief of others—kin, neighbors, and members of a broader community. This is done through participating in one another's celebrations and life events as well as by engaging in a ritualistic system of asking about the joys and sorrows that have occurred since one's last interaction with the person, a method of simultaneously catching up on news and of inquiring about the other person's state. The sharing of *gham-khādī* occurs ritualistically, and even positive events are framed largely within the more ritually regulated emotional enactments of sadness and grief. Marriage, for example, serves as the occasion to mourn the departure of a young woman from the home and family of her birth.[99]

The work of Grima, Abu-Lughod, and Ahmed lays clear the folly of treating culturally specific emotion words and emotional concepts as universal. But even the exploration of culturally embedded emotional concepts that are at the center of their ethnographic projects runs the risk of treating emotive words as ubiquitously understood identically within their local environments, which might not be the case in reality. Speaking anecdotally, in the northern Pakistani context where I grew up (and not too dissimilar from the one described by Ahmed), there are at least eight

emotion words denoting honor and shame used within a radius of one hundred kilometers. *Sharm, sharmindagī, ḥiyā, 'izzat, ābrū, ghayrat, nang,* and *nāmūs* all connote some version of these emotions. One might argue that some of these emotion words deal with self-subsistent male honor, others with honor as it relates to women, and still others to notions of virtue or of shyness. But in the end, these words are employed by their native users in ways that hold meanings that are overlapping and inconsistent, such that they indicate a constellation of emotions within society rather than specific ideas understood similarly by all who use them.

Such emotion words and the concepts underlying them are prevalent across many Islamic cultures, and it stands to reason that they exist on continuums such that they possess similar, but not identical, significations in related cultures. The notion of *ghayrat,* for example, has been the subject of analysis in the context of Iranian society, where it is a powerful and complex emotional concept. All Iranian men and women are expected to possess it, and it plays an essential role in determining individual and collective patterns of behavior. "More specifically, *ghayrat* specifies one's appropriate reactions to the particular acts of 'the other' in the form of a set of emotions such as *anger, hatred, jealousy,* and so on. *Ghayrat* may be perceived as an emotional alarm system inside a person the function of which is to protect whatever threatens one's most important values such as one's public image, family, religion, and country."[100]

Ghayrat embraces a broad range of actions in its conception of honor, including women's affirmation of their *ghayrat* through wearing the hijab, men's and women's *ghayrat* through comporting themselves with dignity, hospitality, and gravitas, and men's *ghayrat* defending the homeland from attack. *Ghayrat* as a personal quality is inseparable from familial, societal, and national honor, and it is intricately linked to notions of sexual honor in one's own (male) self and as resident in the female members of a family. To be honorable is to be *bāghayrat* ("with *ghayrat*"), as in this statement from the *Kayhan* newspaper describing how Iranian troops repelled an enemy attack during the Iran-Iraq war: "The Iranian *bāghayrat* young men sent the enemy out of the country *(jawānāh-yi bāghayrat-i irānī dushman rā az kishwar birūn kardand).*" And someone who is lacking in honorable behavior or lax in asserting his or her honor is *bīghayrat* ("without *ghayrat*"), as in the statement "*Bīghayrat!* How could you leave your sister alone in this city? *(Bīghayrat! Chetōr tūnestī khawhareto tū īn shahr tanhā bezarī?).*"[101]

Much more could be said about the relationship between honor and shame and the ways in which it intersects with societal notions of gen-

der and sexuality. I will address some related questions in the book, especially how issues of honor connect to virtue in the representations of children in the visual materials from Iran and Pakistan. Models of female honor (virginity and motherhood in particular) also figure prominently in the examples I have chosen from those two societies (and these patterns are present in some of the Turkish materials as well).

PUBLIC EMOTION

In the chapters that follow, I use the terms *emotion* and *affect,* as well as secondary terminology derived from them, without an overdetermined meaning, and sometimes in ways that contradict the definitions of affect theorists discussed in this chapter. For me *emotion* is more of a meta-concept than *affect,* and I use it somewhat interchangeably with *feeling.* My use of *affect* is a bit more problematic in that it runs counter to much of the prevalent use of the term. Briefly described, I treat affect as the perceivable, measurable, or describable effect of emotional events and experiences. These could conceivably be precognitive and therefore of a kind with notions of affect derived from the cognitive sciences, but since my interest is not in the physiology of experience, I am comfortable not concerning myself with this category of affect. For my purposes, affects are what is felt and what is emoted at an individual and collective level. It is not the undefined protoevent of human experience but rather the *happening* of that event, an enacted and perceived thing that is one of the ways in which a person knows that an experience is occurring or has occurred, and through which one reacts to an experience, thereby shaping future human experiences.

Locating emotion in the social sphere is not new, as I have tried to demonstrate in my discussion of important theories concerning it and its relation to affect. Let me emphasize two points in that regard which are central to my understanding of how emotion underlies many of the subjects touched on in this book: first, that the performativity or enactment of emotion is inseparable from its experience; and second, that emotions, emotion words, and emotion events cannot be comprehended apart from the sociopolitical environment in which they occur.

Emotions, to be fully effective, must be performed, because describing them doesn't convey their affective power. A description of the pain or grief of heartbreak or of loss does not convey pain or grief; at best it communicates their affective qualities metaphorically. When that same description is transformed into something performative—my seeing

someone crying while reading the poem, or my being effected by it in a song that I hear—it conveys emotional power. Whether or not the emotion evoked in me is the same as that which was enacted (or intended to be conveyed) is somewhat beside the point; what is important is that the emotion was evoked through an emotion act, not through words functioning as descriptors. In very important ways, somatic activity *makes* emotion—crying makes sadness, laughter makes happiness, putting one's hand on the stove makes pain, and walking up to a lioness protecting her cubs makes fear.

There is a long history of actively trying to evoke emotional reactions such as wonder, delight, or pleasure, and textual sources often give us information not about the nature of wonderment but about phenomena—acts, objects, and language—that are intended to provoke wonderment. It is worth pointing out that in Islamic thought happiness is directly linked to virtue, and so cultivating happiness results in greater individual and collective virtue. And in a similar vein, there is a robust genre of literature describing the natural and manufactured wonders of the world with the express purpose of evoking wonderment. Wonder at natural phenomena and strange animals encourages contemplation of God's creative powers, and contemplation of marvels of human making (such as the pyramids) serves as a reminder of mortality, since even people of wealth, power, and skill perish in the end.[102] Such an enactment or evocation of emotion is not necessarily limited to cultivating positive emotions or ones (such as shame, sympathy, and the like) that are obviously connected with virtue; "ugly" or "outlaw" emotions are also worth evoking and performing.[103] In an Islamic context, the tension between good and bad feelings lies at the center of most conceptions of progress in Sufi training. Spiritual advancement occurs through an alternation between experiential states *(ḥāl)* of constriction and expansion *(qabḍ* and *basṭ),* in which unpleasant experiences are viewed as essential and therefore positive.[104] A different, more performative form of cultivating negative or ugly emotions in oneself and in others is celebrated in Sufi-inspired poetry in a multitude of languages and is also valorized in classical Sufi literature. This entails behaving in scandalous ways that make one abhorrent in the eyes of others.[105]

Several terms can be employed to describe the comprehensive social network that results in and from the experience and performance of emotion. Reddy used the term *emotional regime* to designate the assemblages of what he called "emotives" in relationship with the symbolic practices and rituals that joined with them to form sociohistorical

processes.[106] Another way of thinking about the relationship of emotion and society is through a concept of "ecological phenomenology," which considers emotions as "complex phenomena embedded in processes that can only be understood within the larger fields that they help constitute and which, in turn, allows us to identify them."[107] Such an approach might allow for the consideration of emotional phenomena without our already possessing a fixed assumption of their nature and composition.

A more open term is *emotional habitus,* which has been used by several scholars to give an obviously dynamic sense to the place of emotion in society. This happens in part as a nod in the direction of Bourdieu's very influential theories of social function, but also because of the way it evokes the notion of feeling or mood. The implication is that the *habitus* is a collective feeling or "mood" and that the "making and using" of mood have to be integral parts of the goal of any sociopolitical process, since "no matter how clever and correct the critique or achievable the project, collective action is impossible if people are not, so to speak, *in the mood.*"[108]

In my discussion of visual materials representing children, I am not attempting to explore the relationship of emotion to religion in a narrow sense. Nor am I interested in retrieving some sort of space from which ethical pronouncements concerning human behavior can be made. Rather, I am studying human behavior and its use of educational and ideological materials (in the broadest sense of the terms) in a holistic way that sees the expression of emotion and its evocation and enactment, as well as human behavior in general, as part of an integrated attitude toward the world in which religion, politics, individuals, and society are inextricably linked.[109]

I maintain that the regulatory forces of society do not simply *control* behavior, belief, and emotion, but that they *construct* them. This holds true whether they are conscious or unconscious, intentional or unintentional. In many respects, this concept follows Bourdieu's ideas, rethinking his idea of *habitus* as more than an unconscious conceptual space in which dispositions shape and are shaped by the individual. The challenge is to account both for the intentional and conscious manipulation of dispositions and for the existence of unpredictable behavior at an individual and collective level. Human emotional responses are never linear or predictable reactions to stimuli, but always circulate on a continuum, in the sense that they occur as a result of external and internal events and subsequently participate in the making of ensuing events. "Emotions involve many capacities of the body—facial expressions,

firings of neurons, thought processes, production of tears or sweat, expletives, changes in heart rate and breathing, gestures, postures, and movements—which can take place anywhere along a continuum from wholly conscious and deliberate to completely inadvertent, shifting in the course of their execution along this continuum."[110]

The importance of the social dimension of emotions and emotional acts goes beyond the study of emotion and affect to impact all aspects of social life, including politics, a sphere that is deeply imbricated in the visual regimes of the societies analyzed here. Affect is a key concept in coming to a broad understanding of the political, in that it simultaneously explains the processes that are inexplicable through other functional explanations and it exists as an object of power. In the latter sense, one might say that affect—both in the meaning used by affect theorists and in the more effective and performative meaning I am affording it here—limits power, inasmuch as political formations are reactive to and formed by it. In the end, it is within social spaces fenced in by emotional regimes that human beings find themselves and make sense of themselves in relationship to others and over the course of their lives.

Bringing Up Baby

The Construction of Childhood

The conception of childhood as a distinct life stage separate from adulthood is a modern idea that is culturally specific and contextually flexible. This view manifests itself in a presumption of innocence and anxieties over its loss, in severe discomfort over and the regulation of child sexuality, contested ages of consent for marriage, debates over child soldiers (and the changing age of conscription in times of special need), as well as in other things. *Childhood* is different from the *experiences, biology,* and *psychology* of children, in that it is an *adult*-defined state of being a child. Children, for their part, might not have a say in the definition and legislation of childhood, but they are adept at exerting agency within and manipulating the boundaries of childhood. Child agency arguably contradicts essential properties of the state of childhood, these being the presumption of helplessness and innocence. Both of these qualities inform the notion of cuteness, which is also a necessary characteristic of the idealized child.

Dominant modern conceptions of childhood depict it as a time of learning and play, and choose to ignore children's participation in the labor, political, or other social spheres. Several historians of the United States and Europe have demonstrated how attitudes toward children and childhood change over time as a response to political, economic, and social factors. During the Middle Ages, in some parts of Europe children were seen as miniature adults.[1] Prior to the middle of the eighteenth century, childhood as we commonly construct it today did not exist as a

concept and, from the time they exited infancy, children were frequently dressed in smaller versions of the adult garments typical of their social background. The above-mentioned view of them as little different from miniature adults indicated that any dispensations granted them with regard to responsibilities and physical work (or to being exploited) were directly related to the prevailing understanding of their physical limitations, not to their entitlement as children.[2] Through much of premodern European history, society was uncertain about the moral nature of children. Many Protestants—and especially the Puritans—believed that children were born sinful and needed to be guided to virtue; others, like the philosopher Rousseau, held that they were inherently good and innocent.[3] In some respects, one cannot help but see parallels between attitudes concerning childhood and those toward women in these historical contexts (and in the present as well, on occasion), in terms of the way each is seen as a human group with diminished capacity and belonging primarily in a domestic rather than public sphere.

It was often seen as unremarkable and expected for children to participate in the labor force, and such attitudes only diminished in modern Europe with rising affluence and a growing disparity between adult and child levels of productivity, such that a child's labor became increasingly unimportant relative to an investment in education that promised substantially greater income when the individual entered the labor force as an adult.

Equally importantly, many premodern and modern models of childhood view it—like adulthood—as a state that is only categorically age-graded. For much of history, human beings passed through life in broad age categories of infancy, childhood, adulthood, and the infirmity of old age. Childhood ended with puberty, and even when it was not formally tied to that biological moment, children as young as ten or twelve were considered legal adults.[4] The age-based gradation of stages of childhood is tied strongly to the division of children into age-defined educational groups. In fact, the growth of mass education on the modern model—of classrooms occupied by age cohorts—might well be the most important factor in the emergence of modern conceptions of childhood.

The spread of education is linked directly to societal as well as familial prosperity, and modern societies that have vast disparities in income continue to manifest diverse child lives even if they aspire to a modern normative notion of childhood. Urban middle and upper classes have no immediate need for the labor of their own children and can afford to keep them in a state of protected childhood in which the child's job is to

be a student. Poor children in the same society enter the labor force—both full- and part-time—much earlier in their lives and attend school for fewer years, if at all. Even in cases where lower-income children attend school, their labor is needed by the family on a part-time basis, such that their experience of childhood is not idyllic. In the case of girls, labor often tends to be unpaid in the household and starts earlier than for boys, who are more likely to take on paid employment outside the home. For girls, household work evolves naturally into women's work, and is a major explanation for why girls from low-income families tend to receive less education than their brothers and also to marry earlier.

When children work outside the home—be it part-time or full-time—they often are employed in simple and menial tasks, including domestic service, child-rearing, the lower professions in the food and hospitality industries, and doing simple tasks in small businesses. In many parts of the world, children are employed in jobs involving complex tasks, especially in the textile and weaving industries. That this practice has been eliminated in the formal domestic economies of the developed world has much to do with the availability of cheap goods imported from elsewhere (often relying on child labor) as well as with the diminished need for children's work, which, at an individual level, has a negligible incremental benefit to an economy. A decreased participation and visibility of children in the labor force furthers the societal belief that *children should not work* and that *children cannot work,* in the sense that, with diminished exposure to children doing complex tasks, one comes to believe that they are incapable of performing them.

The issues related to child labor are ones familiar to policy makers, politicians, and economists, but they are seldom openly discussed in developed societies because they challenge beliefs fundamental to our understandings of modern life. A focus on the propriety and impropriety of hiring children to engage in conventional wage labor (of the sort that concerns entities such as the International Labor Organization) draws attention away from the extensive amount of work done by children. "There are children, mostly girls, who act as caregivers, children who work as beggars, shoe-shiners, day labourers . . . and children whose labour does not fit the Western distinctions between work and play but interweaves aspects of training, help in household economies and other kinds of socialization. But it is particular forms of child labour that have caught the imagination of policy-makers in the West. These forms fit our collective historical memory of Dickensian child factory work."[5]

The modern concept of childhood as a time when children are both free and protected from the responsibilities and sober realities of adulthood is a construct of affluent countries in the global North that has subsequently been treated as a universal category and applied (in haphazard ways) to attitudes toward children at a global level. Idealized childhood exists in a web of relations to other concepts such as innocence, cuteness, and youth. Like innocence, it is something that can be lost and something that must be guarded from a noninnocent world. The phenomenon of cuteness as it relates to childhood will be discussed in some detail in chapter 5. At this stage, it is sufficient to mention that innocence and cuteness—in fact, the entire construct that is the notion of childhood—exist first and foremost for the sake of adults. Adults not only do not recognize children in their natural state (whatever that may be); they also actively seek to constrain them within adult structures of physical and psychological restraint. Adults dramatize the vulnerabilities of children by using a range of means at their disposal to infantilize children: they are dressed in particular ways, given distinctive hair styles, intentionally or unintentionally humiliated and embarrassed, and subjected to other means to maintain their distinction from the adult phase of life. Adults ignore the reality and legitimacy of most child fears and anxieties and, even more so, of child sexuality.[6]

A number of adult concerns underlie the construction of childhood, most obviously ones involving the difficulties with living their own lives as adults, and others related to issues of mortality, as each adult looks backward at the ever-receding time in his or her life when he or she was furthest away from infirmity and death. One cannot be a child again but, by constructing childhood in specific ways, one can regain contact with an idealized moment of carefree existence. Childhood, then, is the system by which adults force very young human beings to be "child-like" in accordance with adult expectations. "Children . . . must learn to present themselves *as* an image. They must learn a special sort of exhibitionism and reproduce in themselves the charming qualities adults long to see. They may recognise the pleasure that childhood provides for adults but they must not reveal that knowledge, observing adult behaviour only secretly. Open refusal to co-operate invites punishment and forced return to childishness in tears and humiliation."[7]

MAKING CHILDHOOD

Western notions of childhood as a distinct phase of human life that exists as a pure, other, and ideal world might well be neoromantic long-

ings based upon a disillusionment with the perceived absence of virtue and spirituality in modern society just as they are grounded in changes in educational and economic well-being. The rise across the global North of disillusionment with lives dictated by industrialization and urbanization generated a nostalgia for a romantic country life. In the case of the United States, such feelings lay at the heart of spiritualist and literary movements. They were also promoted in popular media through early Disney films such as *Steamboat Willy* in 1928 and *The Opry House* in 1929 and, half a century later, were epitomized in the globally popular television series *Little House on the Prairie*, a highly romanticized rendition of the *Little House* books by Laura Ingalls Wilder. Children and childhood are a pillar of such neoromantic ideas of an innocent and ideal life, bringing together as they do the sentimentality of an early time in history and an earlier time in life.[8]

Adult desires to connect longing for a simpler time in history with a simpler time in one's own lives engender an aggressive protectiveness toward the construct that is childhood. Twinned with the importance given to a long period of education in most of the contemporary world, juvenescence has become a prolonged period that has distended the concept of childhood to include a previously unknown time of "adolescence" and of youth that extends well into middle age.

The prosperity and social capital that allow some sections of society to live in prolonged periods of childhood and youth also mean that other sections of society—the poor in the global South and "at-risk" people in the North—have to exit childhood much earlier and enter adulthood.[9] Adolescence, for its part, has been held up for well over a century as a distinct period in life in the West, as a middle passage in which human beings are understood to be at the mercy of their hormones and subject to mood swings as they transition from childhood to adulthood and develop a sustainable set of values and sense of identity. Adolescence is a period of indiscretion, adventure, and experimentation that, as a consequence of the extension of the time of youth, has been extended more recently into the period of early adulthood. Adulthood is differentiated from childhood by being a stable state during which an individual is independent and maintains stable values, aspirations, and notions of the self. Detached from any connection to puberty or other biological changes, adolescence becomes unmoored as a phase of life that separates childhood, in the sense of biological juvenescence, from full adulthood and, with an increasingly delayed entry into the workforce, from parenthood as well. When seen together with the tendency

to continue working until a later age, adolescence and youthfulness become an ever-later phase in human life.

INNOCENCE AND THE MODERN

Imagined childhood innocence has far-reaching consequences for adult society across the world. For example, the evocation of innocence is a cornerstone of modern Japanese media and consumer culture, where a pervasive aesthetic of cuteness impacts dress, entertainment, and advertising even for traditionally sedate businesses such as banks. Elsewhere, as Russia emerged from its Soviet period in the 1990s, Moscow experienced a well-publicized crisis over the nature of public art when the Georgian sculptor Zurab Tseretli was paid handsomely for a series of massive installations of cartoon-like characters that drew on Russian fairy tales. Whereas the state was criticized for grossly large expenditures on questionable public art at a time when a cash-strapped society was just beginning its process of economic liberalization—and Tseretli was condemned for his overly cozy relationship with the Soviet and subsequently Russian state—his almost absurd work is telling about the place of innocence in modern adult life. One could argue that cartoonish art produced by a well-connected "court artist" speaks to an official desire to represent society in terms that cast the present and future as times of innocence. While the early Soviet Union was hard-pressed to make itself accepted as a sophisticated and advanced society in all spheres of public life (technological, scientific, artistic, infrastructural, social, and so on), the Russia looking ahead to the twenty-first century could look back to a romanticized and pure past, and articulate it as an innocence reborn, reflecting both a nostalgia for the ideals of the Soviet Union and an anxiety about the rough future of the society or the prospect of most of citizens ever sharing in the dividends of their country's economic transformation. In this sense and context, "the language of innocence effects a detour around questions of political accountability . . . as well as a deferral of expectations for a rapid rise in standards of governance and standards of living."[10] The neoromantic implications of such public and adult appeals to innocence are not unique to Russia or to the art world: they play a major role in the emphasis on late-life youthfulness ("70 is the new 50," Martha Stewart declared shortly after her seventy-first birthday),[11] in the acceptance of adult fascination with books and toys ostensibly intended for children, and in the uninterrogated willingness to construct childhood as a monolithic edifice of innocence.

In light of the centrality of the concept of childhood to the construction of adulthood itself, it is small wonder that modern childhood as an idealized state is jealously guarded, to the point that children are confined within a structure of emotional distance reflecting adult anxieties about all things that are serious or painful. One of the principal representational strategies of such emotional distancing is the use of animals as stand-ins for human beings. "The talking, thinking, acting animals could provide for children what they were already providing for their adult mentors—a buffered engagement with a message of cultural significance. The lively animals would soften the didactic tone and ease the tensions raised by dealing with issues not yet fully resolved or socially controversial."[12] Animals stand in for human characters not for the sake of children but for adults. "Anthropomorphism, animal characters as people, can add a degree of emotional distance for the reader/writer/speaker when the story message is very powerful, personal, and painful. We most need to read about, write about, and talk about those things that are personally painful, embarrassing, and dangerous to us. Having animals do the acting and mistake-making allows the face-saving emotional distance often needed to be able to join the conversation."[13]

Adult concerns with the protection of the helpless and innocent child from a feral society are therefore based not on any reality particular to juvenile human beings but on the realities of adulthood. "The lamented loss of innocence is not only the innocence of childhood, but the innocence of the adult gaze."[14] The unspoken truth in the infantilization of children and the deployment of complex strategies for maintaining the blanket of innocence on adult society is that everyone is aware, at some level, that children are not helpless and passive nonactors in mortal need of adult control. Adults are compelled to manipulate and modify children, and to categorize them in order to manage the anxieties of their own collective existence. This attitude has dramatically been labeled a form of narcissism by Daniel Harris in his incisive writing on the concept of cuteness:

> Far from being content with the helplessness of our young as we find them in their natural state, we take all kinds of artificial measures to dramatize this vulnerability even further by defacing them, embarrassing them, devitalizing them, depriving them of their selfhood, and converting them, with the help of all of the visual and sartorial tricks at our disposal, into disempowered objects, furry love balls quivering in soft fabrics as they lapse into convulsive withdrawal for their daily fix of TLC.
>
> Exaggerating the vast discrepancies of power between the sturdy adult and the enfeebled and susceptible child, the narcissism of cuteness is also

very evident in the way that the aesthetic ascribes human attributes to non-human things. Anthropomorphism is to a large extent the rhetorical strategy of children's books which often generate their narratives from a kind of animal transvestism in which dogs, cats, bears, and pigs have the clothing and demeanor of human beings.[15]

IDEALIZED CHILDHOOD AND ANTICHILDHOOD

The belief in childhood as a universal natural state is so broadly reflected in popular culture in the West as well as the Islamic world that it is almost not worth mentioning except for the way in which it blatantly contradicts the realities of human life. There are many examples in scholarly literature of uncritical statements on the shared idyll of children's lives, the following one on the reading lives of children being but one example: "No matter where they live, children seek friends, laugh and cry, and revel in stories. Universals of childhood connect young readers as they enjoy books that originated in cultures different from their own."[16] It would be equally true to say that all human beings "seek friends, laugh and cry, and revel in stories"—the connection with "universals of childhood" suggests that children experience these things differently from adults and that reading and the enjoyment of books are part of the "universals of childhood."

As it happens, child poverty continues to be widespread, access to education is far from universal, and reading materials remain scarce in many communities around the world. Acknowledgment of this obvious fact in the face of the brittle construct of idealized childhood creates the counterimage of the child in complete want. That kind of childhood is equally manufactured in the shape of an evacuation of all the positive characteristics of idealized childhood, and is defined by what it does *not* have. The deprived child is therefore cherished and longed for as another version of a person devoid of agency, equally helpless as the hermetically protected child, and whose lack and exposure all the more reaffirm the belief in the perfect ideal state of childhood. It becomes an antichildhood rather than a different inflection or experience of a period of human life.

The dichotomy between the ideal childhood and its opposite, the antichildhood, engenders the imagined child of the global South as one who is characterized by the above-mentioned lacks. This is the child that stares at us from the television screen, from news websites and magazines, and in mailings from charities requesting money for developmental projects. The child is normally young (seldom even in her preteens); almost never is the child overweight, or very well dressed (unless in the

school uniform provided by a charitable organization), or white. She looks straight into the camera with big eyes, but the photograph is not a portrait, because this child symbolizes the universal child defined by its absolute lacks and losses, its antichildhood. She stands in for every child in a global South reduced to a one-dimensional world of poverty and undevelopment. Even when the child is given a name—as in literature or on websites urging me to adopt or sponsor a child who will then write to me and keep me abreast of her happy advances in life—it is not the child in the picture that I get to sponsor (because definitionally that child is already saved). It is another child, facelessly and namelessly hiding behind the child in the picture. In my interaction with the representation of antichildhood, I am prodded to collude in the existence of both ideal childhood and quintessential antichildhood, wherein my participation is supposed to deliver the sort of large-scale projects of social uplifting that will move the child in question from the second category to the first, thereby reifying a romanticized and inflexible concept of childhood.[17] Ironically, in addition to dislocating the child of the global South from his societal context and his exercise of agency within his environment, the construction of childhood also erases the actual presence of the child (and his labor) in a global economic web that increasingly ties consumption in the global North to production in the South, where the constant drive to lower costs keeps the employment of children an attractive prospect.[18] Put in the starkest terms, the clothes and shoes worn by those living the idealized and romanticized childhood are often made by those trapped in antichildhood.

When a child defined by lack is actually named, he or she functions as an icon reaffirming the inviolable and fragile ideal of childhood. Just prior to the time of this book's writing, such a role was fulfilled by Aylan Kurdi, a three-year-old boy from Syria whose body, dressed in a red T-shirt, blue pants, and black shoes, washed up on an Aegean beach near the Turkish resort town of Bodrum on the morning of September 2, 2015. A photograph of the lifeless child lying face down in the sand as waves lapped over his head flashed across the world as a symbol of all that was wrong with the civil war in Syria and the rise of criminally militant religious movements, and of the problems of the global migration of political, religious, and economic refugees. The details of Aylan Kurdi's short life are conflicting and incomplete but they have clear elements of tragedy: his was a Kurdish family from the town of Kobane—notorious as the site of one of ISIS's most sustained attacks. The family had gone to Turkey as refugees, and then returned to Kobane only to

FIGURE 3. Commentary on Aylan Kurdi, by Mahnaz Yazdani (courtesy of the artist).

flee again to Turkey as they awaited the opportunity to move to Canada, where they had relatives ready to sponsor them. After stumbling through the potholes of Turkish and Canadian bureaucracy and despairing upon having their application rejected, his family headed for the Greek island of Kos aboard an overloaded inflatable raft that capsized five minutes into its thirty-minute journey, resulting in the deaths of at least twelve people. But it wasn't this story that was essential to the commemoration of what was celebrated as an untimely death or a lost childhood; it was the photograph—taken by a Turkish journalist named Nilüfer Demir—of the little boy's body lying on an empty beach that entered history as one of the iconic images of our times. The photographer took many other pictures of the incident that were published in newspapers and websites—images of a grim-faced Turkish policeman writing a report in his notebook, and then carrying the lifeless little body of Aylan Kurdi as it looked comically like a doll in the policeman's arms. But it was the faceless little body alone on the beach that captured the essence of the tragedy—the victim of an antichildhood lost a mere four kilometers from Greece, the European Union, and the promise of everything that an idealized childhood implies.

The reaction to the image of Aylan Kurdi was immediate and global. Many artists drew cartoons capturing aspects of the tragedy (such as the example in figure 3 drawn by an Iranian artist), and politicians from around the world spoke of the necessity for solutions to the war in Syria and to the migrant crisis along Europe's borders.[19] Newspapers speculated that this might be the event to mark a complete change in attitudes toward refugee resettlement. Aylan Kurdi's moment of fame has passed, of course, as has the hope that his death might be an instrument of positive change, and images of many more little boys and girls have gone viral as symbols of voyeuristic grief and have subsequently been forgotten. Even at the time, no one remembered the other children in Aylan's raft who drowned with him that night (not to mention the adults, including his mother), or the innumerable children who were living and dying under horrible conditions in Syria, or around the world, or drowning in the Aegean and Mediterranean (or in other seas) as overcrowded nonseaworthy craft surrendered their human cargo to the deep. The one thing that moment reaffirmed was the inviolability of our collective belief that childhood, by its very nature, is entitled to protection, safety, and comfort.

ANTICHILDREN, SOLDIERS, AND BRIDES

When conceived of beyond a purely one-dimensional state of need, the Southern antichildhood as imagined from a distance of geography as well as of privilege is characterized by two gender-determined constructions of lost childhood, that of the child bride and the child soldier. Though global in scope, these two constructs of antichildhood take on polemical dimensions when discussed in the context of the Islamic world. The issue of children at war is central to the arguments put forward in chapter 7; therefore I will underline briefly the ways in which such antichildhoods actually further the fragile construct of a universal idealized childhood.

Much of the literature emanating from the West and dealing with the participation of boys in the Iranian war effort against Iraq (1980–1988) takes a strongly judgmental view of children's involvement in war, and condemns Iran for not fitting within global norms of behavior in this regard. Several books and articles further the opinion that Iranian boys were coerced or brainwashed into participating in the war by Khomeini and the country's revolutionary religious elite.[20] Such a position not only refuses to acknowledge the agency of preteens, but often also fails

to place the Iranian experience within global practices and rules concerning children, the age of majority, and war.

When it was first ratified in 1989, the Convention on the Rights of the Child (CRC) was criticized because it set fifteen as the age above which children could participate in warfare. Several later meetings and protocols tried to raise the age at which individuals can take part in wars, and the CRC urged states to adopt an optional protocol to that effect. Finally, in 2000, the Rights of the Child committee declared in Article 38 of the Optional Protocol to the Convention on the Rights of the Child on the Involvement of Children in Armed Conflict that no one under the age of eighteen should be involved in armed conflict either directly or indirectly.[21] Yet, sadly and unsurprisingly, despite such internationally ratified attitudes, countries routinely violate these agreements.

It is beyond the scope of this book to address such questions in any detail, but it deserves to be highlighted that the age of conscription for males has frequently been linked to concepts of maturity. Such ideas are also critical in determining the age of majority for marriage (especially for females). And both of these categories have only very recently (and broadly unenforcably) been raised to sixteen or eighteen in many so-called developed societies. Similarly, many countries in the global North (and especially the Anglo-Saxon-majority ones) have argued against eighteen as a universal age of maturity for joining the military. In the case of the United States, the country passed the Child Soldiers Prevention Act (CSPA) in 2008, forbidding the government from providing military assistance to countries or groups that accepted volunteers under the age of fifteen or conscripted soldiers under the age of eighteen. The act provides no exclusions for noncombat service roles such as cooks, messengers, or sex slaves. Since the passage of the CSPA, the president of the United States has waived the CSPA in the name of national interest in almost every conflict in which the United States has a political or economic interest, including in the Central African Republic, Democratic Republic of Congo, Libya, Rwanda, Somalia, South Sudan, and Yemen. Exceptions tend to be countries in which the United States does not support the government, such as Syria, Sudan, and Myanmar.[22]

Children's participation in warfare is not a problem limited to the global South, but rather one that appears with regularity as a factor of military mobilization across the world. In particular, civil war situations—where a specific ethnic, national, or communal group feels under existential threat—cause children to move into adult functions earlier than they would otherwise, and to be formally and informally

contracted into militarized roles.[23] Yet there is a strong tendency in literature from the global North to treat questions of children in war and of child soldiers as a problem exclusive to the developing world. Prevailing contradictory notions of childhood as a state of innocence that gets corrupted by society and a state of wildness that is tamed through socialization see modern children in the global South as both victims of the circumstances of strife-ridden society and sometimes also culpable for the crimes they commit.

Paralleling the child soldier is the antichildhood of the child bride, a phenomenon common in many Muslim-majority countries. The Islamic age of female sexual and marital consent has been a major factor in anti-Muslim polemic in contemporary times. There is today no shortage of websites containing specious references to hadith and other authoritative texts permitting adult men to have sex with children (including infants), or else cherry-picked sources that, when combined together, are claimed to allow such practices. Such spurious claims are subsequently repeated as established facts about Islam. A common example of this is the misquotation of a hadith account concerning forms of permissible sexual contact between a menstruating woman and her husband, which is used by polemicists as evidence to claim that Islamic law sanctions nonpenetrative sex between an adult man and *any* underage girl or boy, including infants. Muhammad's marriage to ʿAisha is a central feature of this sort of polemical literature.[24]

In actual fact, discourse in much of the Islamic world, including in the societies studied in this book, is shaped only tangentially by polemical concerns, and primarily by Muslim notions of propriety and the need to reconcile them with the factual details of religious source texts. Across the Islamic world, religious historical memory of the times of the Prophet continues to shape modern policies concerning concepts of female and male physical and moral maturity and consent. In particular, the female age of marriage remains an important point of contention between religious conservatives and reformist members of society. In March 2015, Muhammad Khan Sherani, chairman of Pakistan's Council of Islamic Ideology (Islāmī Naẓariyātī Konsul, hereafter CII), was asked whether there were any laws in the country that were counter to the Shariʿa. He only mentioned two: the age of female consent for marriage, and the law that required a man to seek the permission of his wife before contracting a second marriage.[25] Pakistan, like many other countries, legislates the minimum age of marriage as eighteen for males and sixteen for females, and the Child Marriage Restraint Bill is supposed to

enforce the age of legal consent. Every few years, this law becomes the subject of political debate, and during this incident in 2015 a motion was floored to amend and reinforce the law in question. The head of the CII spoke to the media frequently about the un-Islamic nature of the age listed in marriage legislation, and declared on several occasions that there is no minimum age of marriage in Islam.[26] In its nonbinding declaration, the CII drew a distinction between *nikāḥ* (betrothal) and *rukhṣatī* (marital cohabitation), maintaining that the latter is allowed only when both husband and wife have reached puberty, which they did not define in terms of years.

The basis for such opposition to a defined age of marriageability in Pakistan—as it is in many Islamic countries, including Shiʿi-majority ones—is the age of ʿAisha at the time of her marriage to Muhammad, widely accepted as nine years old.[27] There are several hadith in the canonical collections that both directly and indirectly refer to ʿAisha's age at the time of her marriage. Al-Bukhari's *Ṣaḥīḥ* states that she was six when she was married to the Prophet, and nine when she moved in with him. Other versions of the hadith account found in the authoritative collections of al-Muslim, al-Nasaʾi, and Ibn Maja state that she was nine when the Prophet took her to his house and the marriage was consummated, and that she was eighteen when he died. Several other hadith accounts across the collections emphasize aspects of her young age: how she was outside playing with her friends when her mother called her inside, wiped her face, and brought her to the Prophet; how she played with her dolls; how her girlfriends used to come to her marital home every day to play with her; or how the Prophet would play with her himself.

Even when it is not clearly articulated as a justification, the age of ʿAisha at the time of her marriage forms the backdrop to current debates on the age of consent across the Islamic world. Immediately after the coup attempt in Turkey in July 2016 targeting the ruling Justice and Development Party (Adalet ve Kalkınma Partisi, or AKP), which has made the Islamicization of society a priority, the nation's Constitutional Court ruled to annul an existing law that considers all sexual acts involving individuals under the age of fifteen to be potential crimes. This ruling came in response to an application from a lower court which had ruled that individuals between the ages of twelve and fifteen years of age were capable of giving informed consent to sexual acts, an opinion that is surely informed by religious understandings of maturity.[28]

It is still the norm rather than the exception globally for females (and often males) to be considered ready for sex and marriage years before

they are given full adult rights, especially those of suffrage. Many countries with strong Roman Catholic traditions continue to allow underage females (that is, those below the legal age of comprehensive adulthood) to get married or to engage in sexual intercourse with adults, and the same holds true of several other countries in the global North. Until 2013, the age of sexual consent in Spain was thirteen and the age of consent for marriage was fourteen (the legal age of marriage has since been raised to sixteen, and the legal age of sexual consent has not been reset). Fourteen is a commonly accepted age of female marriageability in a number of non-Muslim-majority countries, especially in South America. Until 2013, the Vatican City's own age of consent was twelve, which provided fuel for a significant amount of Catholic bashing (it has since been raised to eighteen).[29]

In most Anglo-Saxon-majority countries, the age of consent and marriage has only risen to sixteen or eighteen in the last fifty years or so, and in several places it is still lower. The age of marriage is sixteen with parental consent in most US states, and in New Hampshire it remains legal for thirteen-year-old girls and fourteen-year-old boys to get married with parental and court approval.[30]

In European and American civic debates over consent and marriage, the relationship between age of consent and the perceived social vice of prostitution (as well as of sexual assault) has played a significant role. This issue highlights not only the soft nature of statutes concerning female adulthood, but also the relationship—however impressionistically arrived at—between female marriage, puberty, and the ability to give birth.

Recognizing that childhood is a culturally and historically constructed state, some modern scholars have tried to use a new conceptual frame for thinking about childhood and children, emphasizing the socially fabricated nature of childhood. Such an analytical paradigm acknowledges that children share social, physical, and psychological characteristics associated with biological immaturity, but maintains that childhood is only "an interpretative frame for contextualizing the early years of human life," not a natural or universal property of a human group.[31] The implications of such a view are significant, and underlie the attitude toward children and childhood adopted in this book: in addition to an explicit recognition that childhoods vary across culture and history, one must acknowledge that children themselves are active agents in shaping their own lives, in constructing their relations in society, and that they make conscious decisions to manipulate their environments and the attitudes of others toward them.

Good Muslims Do
Their Homework

CHILD RIGHTS

Western ideals concerning the nature of childhood are shifting, but they continue to function hegemonically and are exported to the global South, including to contexts that lack the resources to emulate them properly. This holds true in many parts of the Islamic world, which accepts notions of idealized childhood and the concomitant diminished legal status that children enjoy, at the same time that many such societies challenge formal universal documents outlining the nature and rights of children.

In the early years following the promulgation of the Universal Declaration of Human Rights in 1948, several Muslim religious experts and societies viewed the declaration as promoting a secular and Western set of values that was being imposed on the entire world, and that, in some respects, was at odds with Muslim values and precepts. For example, Saudi Arabia refused to ratify the declaration because it did not affirm that all human rights come from God.[1] Over time, however, many Islamic and other religious bodies and scholars came to embrace the broad notion of universal rights, and began to argue that such ideas were integral to the very nature of Islamic religious traditions and the message of scripture, and that secular society was only just catching up to concepts of human dignity and rights that the Qur'an had granted them a millennium and a half ago. In an Islamic context, such an atti-

tude is apparent in the emphasis starting in the 1980s on so-called Islamic rights, culminating in the Islamic Declarations on Human Rights and the Islamic Declarations on the Rights of the Child, issued by the Organization of the Islamic Conference (hereafter the OIC).[2] The earliest declaration on human rights by the OIC was made in 1981 in the Universal Islamic Declaration of Human Rights, with subsequent affirmations and amendments, such as the Cairo Declaration on Human Rights in Islam in 1990. Specific proclamations on child rights include the Declaration on the Rights and Care of the Child in Islam (1994) and the Rabat Declaration on Child's Issues (2005).[3]

In most modern Muslim-majority societies, a substantial portion of Shari'a-based discourse around human rights occurs within the context of inherited colonial legal structures, which left many countries with dual systems of law. In such arrangements, commercial and criminal law (among other areas) is covered by a more or less secular code derived from the colonial era, whereas a parallel system of "family" law—covering marriage and divorce, inheritance, custody issues, and related areas—is derived from Islamic precedents. The separation dates from colonial times when the latter category was considered comparatively unimportant and therefore left mostly to the discretion of the colonized peoples, with the end result that issues dealing with the family (and specifically with women and children) came to be viewed as sacrosanct matters of religious authority in these societies. As such, much of the modern Islamic discourse on the rights of the child tends to frame issues in terms that imitate the earliest period of Islamic society, such as the condemnation of female infanticide found in the Qur'an (60:12). Children are also recognized as having prenatal rights, to the point that a miscarried fetus receives funerary rites and burial. Fetuses are covered by Shari'a-based prohibitions on doing physical harm to a person, and pregnant women are not required to fast in Ramadan (in fact, they are encouraged not to). Child rights follow a similar model of being based on classical Shari'a discourse: being legally born into a marriage is viewed both as a right and as a major reason for the social necessity of heterosexual marriage and the criminalization of nonmarital sex. Children have the right to inheritance (something that has direct bearing on the legality of adoption in Muslim contexts) and the right to maintenance in the event of their parents' divorce.

Such ideas are not out of keeping with universal notions of the rights of a child. What makes Islamic declarations different is the idea of child responsibility that accompanies them. Child rights, in these constructions,

focus primarily on parental and familial responsibilities toward children, not on universal or societal responsibilities, and children are simultaneously seen as having rights over their parents and society and being responsible toward their parents and elders, whom they are obligated to respect and obey. In view of the importance that the Qur'an and the hadith, as records of prophetic tradition, place on children's obligations toward parents,[4] some religious authorities argue that obligations toward one's parents are second only to duties toward God, and therefore child rights take a backseat to parental rights, the violation of which represents a major sin on the part of the child.[5]

In many Muslim-majority societies, scholars who argue for literalist continuity with the classical religious structures of ethical and legal derivation are at odds with modernists who use a constellation of methods to arrive at what they consider to be soundly Muslim practices and beliefs that are in harmony with the times. The differences between these groups are often most apparent on issues of human rights, most notably those of women, to which child rights are inextricably linked. In some contexts, there is growing awareness of the importance of child rights, although normally this is still seen in terms of the child's emotional and physical welfare within a familial framework. Thus in 1981 the Universal Islamic Declaration of Human Rights ratified child rights in the following terms: "Every child has the right to be maintained and properly brought up by its parents, it being forbidden that children are made to work at an early age or that any burden is put on them which would arrest or harm their natural development."[6] Article 7 of the Cairo Declaration on Human Rights in Islam (CDHRI) from 1990 carries these rights further by stating: "As of the moment of birth, every child has rights due from the parents, society and the state to be accorded proper nursing, education and material, hygienic and moral care. Both the fetus and the mother must be protected and accorded special care." It goes on to reaffirm parental responsibilities as well as the belief that conformity to the Shari'a is the final yardstick according to which rights and well-being are to be judged: "Parents and those in such like capacity have the right to choose the type of education they desire for their children, provided they take into consideration the interest and future of the children in accordance with ethical values and the principles of the Shari'ah"; and "Both parents are entitled to certain rights from their children, and relatives are entitled to rights from their kin, in accordance with the tenets of the Shari'ah."[7]

The CDHRI is a significant document since, through it, a majority of Muslim-majority countries affirmed the primacy of "the tenets of the

Shariʿa" as a "yardstick" by which human rights are to be measured. As such, these countries clearly indicated their lack of conformity to the universal declarations on human rights to which almost all of them are signatories, and the CDHRI has been broadly criticized on those grounds. Specifically, the CDHRI is seen as directly contradicting the UN Convention on the Rights of the Child, which was ratified by Muslim-majority countries even while they expressed reservations about aspects of it, which they viewed as being in conflict with their national laws and religious ideals.[8] Such a societal desire in some Muslim quarters for exceptionalism in the construction of child rights is curious in light of the way the Declaration on the Rights and Care of the Child in Islam (DRCCI, 1994) calls on all member states to ratify the UN Convention on the Rights of the Child from 1989 and "to bring their constitutions, laws and practices into conformity with the provisions of the Convention." The DRCCI maintains elements of Muslim exceptionalism that directly contradict several universalist principles, and it simultaneously demonstrates the manner in which many Muslim-majority societies prioritize socioreligious values of duty, lineage, and religious harmony, and interpret human (including child) rights as subject to these values.[9] A similar emphasis is found in the Covenant on the Rights of the Child in Islam, adopted by the OIC at its conference of Foreign Ministers in Sanʿa, Yemen, in June 2005. This document repeatedly iterates that child rights exist within and under the rubric of the Shariʿa, and that the state's right to its own systems and its obligation to enforce the Shariʿa take precedence over rights in the sense of freedoms. This document (and others like it issued by the OIC in the current millennium) is very clear in its statements in support of child rights to education, food, and health, irrespective of gender or religion. It also explicitly condemns certain practices of child victimization such as child labor, prostitution, female genital mutilation, and child marriage, all of which suggest that the UN declarations on human rights, and global attitudes toward the above issues, have had an impact on the conception of Islamic human rights. Nevertheless, it remains the case that children are afforded a marked lack of autonomy; they are to be *taken care of*, a point that is most obvious in matters of education and morality.[10] Furthermore, this document does not have a clear definition of what constitutes the state of being a child. Article 1 states: "For the purpose of the present Covenant, a child means every human being who, according to the law applicable to him/her, has not attained maturity"; but it fails to provide a definition of what constitutes "maturity," and several

Muslim-majority countries are not signatories to international conventions that define the age of majority as eighteen.[11]

Some modern Muslim writers argue for concepts of childhood and the status of children that are heavily influenced by twentieth-century global developments in this regard, but they do so on the basis of Islamic precepts and represent significant attempts to reconcile classical religious principles with modern ideas. For example, the Pakistani legal scholar Imran Ahsan Nyazee has repeatedly tried to demonstrate that Islamic law upholds the same notions of human rights—including child rights—that are established in contemporary international documents.[12] The Lebanese modernist Subhi al-Salih believes that Islam affords the child the same level of dignity (karāma) as it does the adult.[13] And the Iranian human rights activist Shirin Ebadi, who authored a comprehensive document on child rights in Islam, presents such rights in a recognizably Islamic frame and emphasizes significant points (such as the right to a name) that foreground concerns over childhood that prioritize legal notions of dignity and personhood over abstract ideals.[14]

CHILDHOOD IN ISLAMIC HISTORY

It is not the case that twentieth- and twenty-first-century Islamic societal conceptions of childhood derive directly from notions of childhood in the classical and medieval Islamic world; attitudes toward citizenship and personhood in Muslim-majority societies have changed significantly since then, even before the Islamic world's sustained encounter with the West. Nevertheless, written sources from early periods of Islamic religious and intellectual history continue to be directly relevant to the construction of childhood in religious law and ethics, in that modern religious authorities remain heavily reliant on classical and medieval texts in the formulation of their positions. A loosely defined canon of such texts is also important in the establishment of broader societal attitudes on a range of subjects, and arguably is increasingly so with growing access to such materials—first through widespread literacy, affordable printing technologies, increasing numbers of translations, and, most recently, through the broad dissemination of information over the Internet.

A number of terms for children appear in the Qur'an, with few age-related or developmentally related distinctions between them. Children are referred to broadly as dhurriyya ("progeny" or "offspring") on several occasions.[15] This word is feminine in Arabic and probably the most gender-neutral one used in the Qur'an, since the majority of other

words—unless explicitly referring to females—either reflect male normativity in speech or specifically address males. Additional collective words for offspring include *banūn, abnā,* and *awlād,* all meaning "sons." These words also appear in the singular *(ibn* and *walad)* for "boy." The words that specifically refer to infants are *ṣabī* (pl. *ṣibyān)* and *ṭifl* (pl. *aṭfāl),* although the latter has a broader age range and can properly be translated as "child." Childhood is separated from adulthood by the life passage of "attainment" *(bulūgh),* which is described as the attainment of either puberty *(al-ḥulm,* Q. 24:58, 59) or maturity *(al-'ashudd,* Q. 22:5, 40:67, 6:152). Maturity appears to be linked to sexual maturity, and arguably only refers to males, in contradiction to the way it gets defined in later practice, since the term *ḥulm* is etymologically linked to the word for nocturnal emissions, and has been understood as such in Islamic religious law and medical texts. Children also figure prominently in Qur'anic notions of personhood, society, rights, and obligations, especially in terms of the duties parents bear toward them and vice versa.[16]

Premodern Islamic materials—legal and otherwise—certainly refer to various stages of preadulthood that recognize distinct phases of childhood through specific nouns covering newborns (and even stages of fetal development), as well as to categories of sexual, legal, and social maturity. There is, however, effectively no literature addressing children directly. Children are discussed in categories of relevance to adults, in the broad classifications of education, in legal contexts addressing family law, in medical writings, and in works of psychology and piety dealing with subjects such as bereavement over a deceased child. Even educational literature does not address children's education as distinct from the general categories of preparation, education, and nurturing *(tarbiyya)* that bring an individual to upstanding adulthood, and these are almost exclusively addressed to males. In this regard, much of classical Islamic literature is heavily reliant on Greek notions of ethics and education. For example, the *Ta'dīb al-aḥdāth* of Ishaq ibn Hunayn (d. 910 or 911 CE) and attributed to Plato is directed toward older students.[17] One particularly influential Greek text has been the *Oikonomikos* of the Neo-Pythagorean Bryson (probably flourished in the first or second century CE). Like other *Oikonomikos* treatises, it includes sections on raising children and infants. Bryson's work was translated into Arabic around the tenth century as *Tadbīr al-rajul li-manzilihi* and had significant impact on Muslim intellectual circles. The section on raising children was worked into the *Tahdhīb al-akhlāq* of Ibn Miskawayh (d. 1030), which subsequently served as the basis for the relevant

section of the *Book of Training the Soul (Kitāb riyāḍāt al-nafs)* in Ghazali's (d. 1111) famous *Iḥyā' 'ulūm al-dīn.*[18]

Early Islamic medical literature, which was also heavily reliant on Greek antecedents, contained sections on pediatric medicine. Such works include the *Kamāl al-ṣinā'a al-ṭibbiyya* of al-Majusi (d. last two decades of the tenth century), the *al-Qānūn fī-al-ṭibb* of Ibn Sina (d. 1037), and *al-Mukhtārāt fī-al-ṭibb* of Ibn Huban (d. 1213). The earliest-known medical treatise devoting itself entirely to the topic of children is the *Kitāb siyāsat al-ṣibyān wa-tadbīrihim* (lit. The Book of Overseeing of Boys and Their Management) by Ibn al-Jazzar al-Qayrawani (d. 980). Acknowledging his debt to the Hellenistic medical tradition, and especially to Galen, Ibn al-Jazzar devoted the first six chapters of his pioneering work to the hygienic care of newborn infants. The next fifteen chapters deal with diseases afflicting infants and their treatment, and are organized by body part. The last chapter addresses moral education and character, an obvious gesture that reflects a belief both in the connection between physical and moral health and in the view that moral goodness is the pinnacle of well-being.[19] This work provides a very detailed and thoughtful treatment of childhood pathologies and their differences from adult ones, alongside a similarly rich treatment of infant care. But for the purposes of my project, it is the recognition of infants as human beings of a special category in terms of treatment and understanding that is most relevant, because Ibn al-Jazzar's discussion marks the beginnings of the construction of childhood as a special human state as distinct from a legal or metaphysical one. "Characteristic of the spirit of the book is the image of the child . . . as a branch cut from a tree. While in his mother's womb the child is protected just as a branch is attached to a tree. However, when cut and taken to be transplanted elsewhere, the branch deserves special protection and so too does the new-born infant."[20]

Despite its recognition of the category of infancy, Ibn al-Jazzar's book does not construct *childhood* (as distinct from newborn infancy) as a discrete stage of life. The same holds true for works in other genres, including the broad category of legalistic writing. Hadith collections arranged by topic frequently have chapters dealing with children's issues, such as a chapter on nursing *(al-riḍa'),* children's education *(ta'dīb al-walad),* the fate of children who die, the rites specific to children *(al-'aqīqa),* the punishment of children by teachers, and such topics that legally recognize childhood without actually defining it. Even within this construct, very few works are devoted to the topic of the child. Among the known examples in the classical period of Islamic

history is the *Kitāb ādāb al-muʿallimīn* (Book on the Behavior of Teachers) by Ibn Sahnun of Qayrawan. Ibn Sahnun composed his work in the ninth century, and it was substantially revised in the tenth by ʿAli ibn Muhammad al-Qabisi as *al-Risāla al-mufaṣṣila* (Treatise on the Conditions of Students and Laws Governing Teachers and Students). Both works are primarily concerned with the technical and organizational aspects of education, and they provide limited insights into the nature of childhood, treating it primarily as one of the age-defined characteristics of the typical student.[21]

A noteworthy genre of premodern Muslim writing that sheds light on understandings of childhood and children comprises treatises consoling parents on the death of a child. This is distinct from the substantial juridical literature discussing infant and child deaths, which is focused mostly on whether children are held accountable in the afterlife and whether they can be sent to hell. An overwhelming consensus in religious writing regarding the moral innocence of children (and a consequent heavenly station in the afterlife) plays a central role in literature designed to console parents on the death of a child, a common occurrence in premodern times, when natal, infant, and child mortality rates were much higher than they are today. Yet the concept of childhood innocence was neither simple nor universal, in that premodern theologians differed over whether or not the children of disbelievers possess the sort of innocence that would grant them a place in heaven. The great Sunni theologian Ibn Taymiyya (d. 1328) maintained that children are born in a state of natural innocence *(fiṭra)* and are unaccountable for their parents' actions. Ghazali, reflecting some ambivalence in considering the children of unbelievers to be wholly innocent, places them in the same category as the insane: they are not punished because they cannot be held responsible, but they are also not rewarded for their actions.[22]

Recognition in such works of childhood—and especially infanthood—as a biological state apart from adulthood is not particularly noteworthy in the context of this study. After all, a newborn infant's need for care is self-apparent, as is the substantial physical transformation it undergoes on the journey to adulthood. A demonstrated awareness of psychological and emotional differences between the child and the adult would be more important because such recognition would validate a marked interiority to the child as a particular category of person. Few such works are known; a notable example is the *Tuḥfat al-mawdūd fī aḥkām al-mawlūd* of the Damascene scholar Ibn Qayyyim al-Jawziyya (d. 1350). The seventeenth chapter of this work provides an overview of

the stages of psychological development that displays the author's under-standing of children as being different from adults, subject to stages of development, and complex in distinct ways. The author is especially con-cerned with the stage at which a child develops the ability to discern good from evil and with the onset of puberty. Both of these developmen-tal milestones are of obvious religious concern, and Ibn Qayyim al-Jawz-iyya provides a range of opinions concerning the physical age at which they occur. The age at which a child develops the ability to discern right from wrong (and therefore to be morally responsible) is commonly understood to be seven years, but Ibn Qayyim al-Jawziyya offers other options, ranging from three to ten. Similarly, puberty and the onset of the status of being a young man is placed at fifteen, although he recog-nizes a diversity of opinion in this regard as well. The lack of precision in terms of physical age is an important indicator of the author's acknowl-edgment that differences exist in processes of intellectual and physical development.[23] He also highlights the point at which a baby first smiles (listed as forty days), which reflects the onset of self-awareness and intel-lectual development, and the beginning of dreaming (which plays an important role in Muslim understandings of religious knowledge and the imagination), at the age of two months.[24]

Ibn Qayyim al-Jawziyya believes that the first years of a person's life have a lasting impact on his or her moral development, and that essen-tial positive traits (listed as generosity, honesty, diligence, and control-ling one's desires) must be inculcated early on. In chapter 16 he urges parents to exercise control over whom the child associates with, to pre-vent them from indulging in vices such as lying, stealing, drinking alco-hol, and (in the case of boys) wearing silk. Notably, Ibn Qayyim explic-itly recognizes the distinctiveness of each child and encourages that individual inclinations be taken into account in educating children and directing them toward specific careers.[25]

The important question of the education of children is dealt with in some detail by the highly influential Muslim scholar Abu Hamid al-Ghazali (d. 1111), a philosopher, theologian, and Sufi who attempted to synthesize disparate intellectual currents in Islamic thought into a new Sunni orthodox piety. Since shortly after his death, his impact has extended beyond Sufi and theological intellectual circles to wider society, making him one of the most popular religious thinkers across the entire Muslim world. In particular, Ghazali's *Ihya' 'ulūm al-din* (The Revitali-zation of the Religious Sciences) has been the most broadly influential ethical and spiritual work in the history of Islamic scholarship; widely

translated and circulated, it continues to be used across the Islamic world to this day. Arranged in four parts comprising a total of forty "books," this work attempts to cover all aspects of human religious life with an eye toward spiritual and moral perfection. As such, issues related to education permeate the book, as do questions of psychology. Certain sections of the work deal specifically with matters of education. In particular, the *Kitāb al-'ilm* deals with formal aspects of the educational process; and the *Kitāb riyāḍat al-nafs wa-tahdhīb al-akhlāq wa-mu'ālajat amrāḍ al-qalb* focuses on spiritual and moral refinement and specifically includes a chapter on children, titled "On the Manner of Training Children at the Beginning of Their Development and the Manner of Making Them Cultured and Beautifying Their Character" *(Bayān al-ṭarīq fī-riyāḍat al-ṣibyān fī-awwal nushu'ihim wa-wajh ta'dībihim wa-taḥsīn akhlāqihim)*. The specifics of his views on childhood education are somewhat tangential to the purpose of my book, but his statements regarding the relationship of childhood to adulthood are not.

Ghazali argues that children are completely pure and receptive to inputs, and that it is the responsibility of their parents to make sure they are taught good habits and provided with appropriate moral education.[26] He views children as unformed in certain ways, such that they have neither the emotional control nor the ability to reason of morally formed adults. This is demonstrated by how they are quick to anger and are lacking in patience. The latter quality he relates to the broader question of when a human being is morally accountable *(mukallif)*: Ghazali states that children cannot attain the quality of patience because patience requires one to have experienced adversity, and that they cannot yet engage in good and evil acts in such a way that they would be held accountable by God; instead their moral actions are of a kind for which only their parents and guardians should hold them accountable.[27] In short, Ghazali seems to view children in terms of their receptivity to learning good or bad things and their susceptibility to falling on the wrong path or falling victim to temptation if they are not raised properly. One important difference between children and adults, in his view, is that children can only grasp sensory things *(maḥsūsāt)*, not intelligible ones *(ma'qūlāt)*, whereas adults *(bāligh, more accurately, those who are no longer children)* can grasp both.[28]

Although Ghazali's ideas regarding the education and rearing of children are part of the general trajectory of Hellenistically derived classical Islamic thought on the subject, his writings reflect some significant departures, especially as regards the relative value he places on moral

advancement in comparison to all other activities. For example, he does not make a direct connection between physical activity and the building of moral character and only supports it because it wards off laziness. His approval of certain kinds of play is similar in tone, in that a lack of play results in a loss of mental acuity: "Prevention of the child from playing games and constant insistence on learning deaden his heart, blunt his sharpness of wit, and burden his life; he looks for a ruse to escape them (his studies) altogether."[29] Ghazali values play for a variety of reasons, all of which lead the individual to be better able to succeed in the ultimately religious purposes of life. From the very start, he believes that games help distract an infant and help with weaning. The imaginative aspects of play turn children away from their immediate surroundings and motivate them to think in the abstract, thus improving their ability to study, although unsupervised play distracts children and makes them worse students.[30]

Ghazali's views on the purpose of play are illustrative of his (and other classical Muslim thinkers') attitudes toward child psychology as a whole. Ghazali sees it as an essential component of moral development: "The human is created in the beginning of its childhood deficient like the wild beasts, with nothing created in it except for the desire for nutrition, which it needs. There then appears in it the desire for play and adornment, and then the desire for sex, in this order."[31] Children's intellectual and moral capacities are explicitly likened to those of adults who fail to live up to standards of moral behavior. Thus adult human beings who believe that they are independent agents and not reliant on God are compared to children watching a puppet theater and failing to understand that the puppets are actually acting through the will of a puppeteer, or to those preoccupied with worldly pleasures and failing to recognize the delights of a heavenly afterlife.[32]

Such attitudes fit within broader premodern Islamic ideas regarding children as unformed and vulnerable human beings who require protection and nurturing alongside discipline and training. The broader message of hadith and similar traditions used by al-Ghazali and other scholars goes to further this attitude. Having children is viewed as an individual and collective religious benefit, a point made explicitly by Ghazali in the section on marriage in his *Iḥya' 'ulūm al-dīn (Kitāb ādāb al-nikāḥ)*: "There are five benefits in it [marriage]: the child *(al-walad)*, defeating your desires *(kasr al-shahwah)*, managing a household *(tadbīr al-manzil)*, multiplying your tribe *(kathrat al-'ashīra)*, and struggling against the self through being firm in these *(mujāhidat al-nafs bi-al-qiyām bi-hinna)*."

The reasons to have children are (a) to please God because having children perpetuates the species; (b) to please the Prophet because it increases the number of Muslims; (c) because virtuous children pray for their parents, particularly after their deaths; and (d) because children who predecease their parents can intercede on their behalf on the Day of Judgment.[33] The value of having children is both private and public, but does not have anything to do with the intrinsic value of childhood itself, or with something that furthers the adult world (or even the child's parents) in any experiential or intellectual sense. Even advocates of the controversial Sufi practice of *shāhid bāzī* prevalent in the Persianate world, in which male Sufi practitioners contemplate the beauty of a male child in their midst, take a narrowly instrumental understanding of the presence of the boy. The person being contemplated is often called a "youth" in English translation; however, the Arabo-Persian word *amrad* refers to a male who has yet to start growing a beard and should rightly be called a "boy" in modern usage. It is the boy's physical beauty that is contemplated in these contexts, not his inner qualities or the abstract attributes of youth itself.[34]

One notable instance of the recognition of childhood versus adulthood in classical Islam is found in a saying attributed to the Caliph 'Umar: "Speak to your children in accordance with their mental development *('alā qadr 'uqūlihim)*, because surely they were born at a time different from yours."[35] Of course, this does not refer to childhood itself, but recognizes generational change as an aspect of history. There is substantial continuity between classical Islamic legal notions of childhood and religious sociolegal ideals that carry into modern times in a number of Muslim-majority societies. For example, Ashraf 'Ali Thanwi (d. 1943), a prolific and highly influential Indian Muslim scholar of the Deobandi school, addresses children directly in his popular handbook *Ādāb-i zingagī* (Etiquette of Life). However, he does so in the section of the book titled *Parents' Rights (ḥuqūq-i wālidayn),* which is almost entirely devoted to the extensive obligations and respect owed by offspring to their parents. Barely ten lines in the section "Rights in Islam" *(ḥuqūq al-islām)* are on the rights of children or offspring *(awlād)*. The first of these is to have their father marry a virtuous woman so that the children are good, and others include the right to a loving upbringing in childhood (especially for girls), to a pious and upstanding nursemaid, to being taught about religion, to having children's marriages taken care of, to arranging a second marriage for a daughter if she is widowed, and to sheltering her in the marital home until that happens while paying for her expenses.[36]

THE MODERN MUSLIM CHILD

Although there is substantial cultural variation in their practice, the journey of Muslims through childhood into adulthood is marked by a number of moments of passage: a newborn is brought into the faith as soon after birth as possible by making the call to prayer into her or his ear. The transition from the anonymous and highly vulnerable state of being a newborn to that of an infant occurs through the ʿaqīqa ceremony, accompanied by hair cutting, formal naming, and an animal sacrifice. For males (and females in some societies), circumcision at an unspecified age marks a transition from early childhood into a vaguely articulated notion of adolescence (although the majority of Muslim societies perform male circumcision at a very early age and strongly disapprove of female circumcision). Loosely connected to the biological transition of puberty—and the closest stage to what could be termed adolescence—is the notion of "maturity" or "attainment" (bulūgh) as the stage at which children develop moral reason and can be expected to participate in religious ritual life, marked by engaging in rituals such as fasting and praying, and by reading (and finishing) the Qur'an. As has already been alluded to, in a formal sense the end of childhood is marked not by a specific legal age of adulthood, but by the fact and act of sexual intercourse in marriage (nikāḥ), especially in the case of girls. Not only do these rites of passage vary tremendously in how they are observed, but several of them also occur at different stages for males and females. As a general rule, the female path to adulthood is quicker, both in a biological and reproductive sense and in terms of the age at which girls can be expected to possess moral reason and therefore be bound by religious obligations.

Each in their own way, modern Muslim societies have developed understandings of childhood that combine specifically Islamic conceptions of individuality and personhood with more widely accepted ideas. In Egypt at the turn of the twentieth century, children were seen as dependent and helpless individuals who went through distinct developmental stages. After an early period of ignorance, around the age of seven they attained the age of discernment (tamyīz), which enabled them to distinguish right from wrong and to fulfill their religious obligations. They were formally gendered—with the social consequences that implies—with the onset of puberty (bulūgh), which was directly associated with the first menstruation in girls and the first nocturnal emission in boys. In the case of girls, this major rite of passage was followed

shortly afterward by marriage and motherhood, which marked entry into recognized adulthood. In the case of boys, they transitioned into men on the basis of acknowledged mental capacity, with sexual factors not playing a formal public role in determining this change.[37]

Despite the emphasis on biologically grounded stages in the journey to adulthood, for all practical purposes every modern Muslim society (including the three at the center of this book) uses age-graded ideas regarding the nature of childhood that are closely tied to cohort-based education. One can argue that classical Islamic conceptions of maturity are based on education as well, in the sense that biological maturity is seen as an external sign of an inner psychological and moral transformation that allows an individual to reason and be responsible in adult terms.

CHILDREN AND EDUCATION

Whether it is experience or biology that determines the thinking and behavior of children, there are undeniable, important observable differences between adults and children. Of course, there are observable behavioral and learning differences among adults themselves, just as there are between children. What remains unclear is whether or not the differences between children and adults are categorically distinct and more absolute than those between adults, and if such differences hold true across cultures. If the answer to either of these question is in the negative, that would further arguments in favor of reevaluating childhood as a stable state of human life.

One arena in which the distinctiveness of childhood is starkly demarcated is in education and the related production of children's literature. Much of the research on education—especially as it relates to moral and ethical development—bases itself on cognitive models of child psychology. A particularly significant body of work is that of Lawrence Kohlberg, who conducted research premised on the assumption that there are definite stages of moral development, which are themselves based on cognitive differences that are age-related, although not in an absolute sense. According to Kohlberg's influential (if not universally accepted) theory of moral development, passage from one stage to the next derives from the interaction of the individual with his or her environment, continuing into adulthood. The overall model is one in which new information that is incongruous with the individual's existing views results in a disequilibrium, which is fixed by modifying her or his

existing perspective to fit the new situation. Children develop from a "Premoral Stage" to stage 1 ("the Preconventional Level"), in which the child responds to notions of good and bad and right and wrong, but interprets such labels in hedonistic or physical terms (that is, in terms of reward and punishment).[38] This theory assumes that children actively participate in their own moral development. Other studies have demonstrated how children's literature can help them structure their learning environments and use the characters in a story to engage in moral reasoning. In keeping with Kohlberg's stages of moral development, books based on such models can teach children about social obligations and to consider the welfare of others. Yet more studies indicate that children as young as nine or ten who have not been taught history systematically display an interest in the past and in human motivations and causal relationships. They are also able to construct coherent historical narratives, but they lack frameworks in which to ground their historical thinking, and they combine imaginative with historical thinking using fantastical systems of relationships.[39]

Before the emergence of written works specifically intended for children, they were educated using texts intended for adults. Literature specifically written for children predates the spread of mass education in Europe, but there is no doubt that the flourishing and development of children's literature coincide with a new, modern emphasis on universal early education. Such publications were also partially the consequence of the almost simultaneous development in printing technologies that brought down the price of books and other reading materials. The regularizing of schooling created a need for schoolbooks and subsequently for other reading material aimed at newly literate young readers.[40] Equally importantly, the idea that children's books should be graded according to age group is a direct consequence of the rise of age-based cohorts in school classes. The earliest books in English that are regarded as fulfilling the criteria to be called proper children's literature were published in England in the 1740s, the most notable being *The Pretty Little Pocket Book Intended for the Instruction and Amusement of Little Master Tommy and Pretty Miss Polly* by John Newbery. It was intended to entertain and simultaneously instruct children, and it marked the emergence of a new recognition of the nature of childhood, which required unique and pleasurable ways to educate children.[41] Such publications were also partially the consequence of the almost simultaneous development in printing technologies that brought down the price of books and other reading materials. The spread of early education and

the regularization of schooling created a market for schoolbooks as well as for other materials directed at a new, young reading public. In its origins, therefore, children's literature was essentially didactic and related to pedagogical goals, as a powerful means of educating children.[42] However, the recognition that instructional materials must be entertaining became a significant marker of literature specifically intended for children, even more so than simplification.

Arabic literature specifically targeted at children emerged roughly a century later than it did in Western languages.[43] The development of children's literature in Arabic and in other languages in the Islamic world follows a trajectory similar to that of European children's literature, although with an element of delay, since modern public education arose later in these societies, under the direct influence of the West through colonial influence, missionary activity, and other means. In the Arab world, the earliest books intended for children appeared at the end of the nineteenth century in Egypt, after which others were published in Lebanon, Syria, and Iraq.[44] Much of the early literature intended for children had a moralizing and instructive tone, with religion occupying a primary place; books were often explicitly religious, or else they comprised moralizing historical fiction, children's stories, and fables. Authors sometimes were (and continue to be) explicit in their belief that books for children *should* be moral and religious. When asked why most of his writings dealt with the prophet Muhammad, the respected Egyptian children's author Abdel-Tawab Youssef replied: "I want him to be a guide . . . an ideal . . . for all Arab children. . . . We want to follow his pace . . . and take the way he took."[45] This attitude is affirmed by other children's writers and scholars of children's literature in the Arab world such as Aziza Manaa, who claims that three-quarters of all children's books translated into Arabic have harmful or offensive themes.[46]

EDUCATION AND CHILDREN'S LITERATURE IN THE ISLAMIC WORLD

The moral goals of children's education in the Islamic world are very clear before the advent of universal education, in homeschooling materials, and in the public educational systems of some countries in which so-called Muslim virtues form the desired basis of society. The words in Arabic commonly associated with education are *ta'līm*, *tarbiyya*, and *ta'dīb*. The last refers most properly to socialization in what is considered societal moral, ethical, and appropriate behavior. *Tarbiyya* often is used

for the broader exercise of childrearing, but with the implicit sense that—in addition to providing for the child's physical and emotional needs—it involves guiding her in the process of developing her full potential. *Ta'līm* is the word used for education in the narrow sense of schooling, with teaching and training imparted by a teacher to a student or group of students. It covers the idea of secular education as well, but individuals committed to the organization of society on religious grounds often use the term to refer to an educational system that increases religious understanding and commitment in every arena of individual and collective life. And since teachers are viewed as religious and moral role models, their individual beliefs become directly relevant to the educational enterprise. Education, in this sense, is ultimately religious and moral, and its reach necessarily extends beyond the classroom.[47]

In actual fact, Muslim-majority societies have embraced the ideal of state-sponsored and -supported universal education, even in contexts where the educational enterprise has explicit religious elements and goals. Modern Islamic educational materials are occasionally defensive and corrective with regard to Western education, most often as an explicit reaction to perceived problems caused by a colonial educational past. But even in these cases, modern education is based on a Western model, and certain pedagogical methods, such as picture-based learning (and comics and the like) are completely borrowed.[48]

The first modern developments in children's literature in the Arab world occurred in Egypt when, at the beginning of the nineteenth century, the reformer Rifa'a al-Tahtawi brought reformist ideas back from France. Tahtawi established the Bulaq press in 1824, but literature for children didn't appear until several decades later, and a children's press wasn't founded until 1870. This was initially a small venture producing a limited number of books for children from the privileged classes, but after the 1920s it was substantially expanded and began to translate foreign materials, occasionally with significant changes to make them appropriate to the local context. For example, when Mickey Mouse arrived in 1936, the translators didn't use speech balloons, and wrote the text in the popular poetic form of *zajal* in colloquial Egyptian rather than in standard literary Arabic. Tintin, whose books were first published in Egypt in 1948, was renamed Humhum and had a markedly darker skintone.[49]

As Muslim-majority countries gained independence starting toward the end of the nineteenth century and continuing into the first half of the twentieth, many governments attempted to indigenize their systems of

education and to reconcile existing systems, which had split the scientific and presumably "secular" subjects from the religious ones, with the former taught in the more prestigious, Western-style schools and the latter in the less patronized and esteemed institutions of the *madrasa* and *kuttāb*. This process continued in fits and starts through the twentieth century, gaining momentum in the 1970s when a series of events marked the rise of a politicized form of Muslim identity in several countries. The first World Conference on Muslim Education was held in Mecca in 1977 and was followed by meetings in Islamabad (1980), Dhaka (1981), and Jakarta (1982), with the explicit purpose of reconciling tensions between secular and religious ideals in schooling. The conferences brought forward some recommendations for the Islamicization of education, the most prominent among them being the establishment of a number of Islamic universities and conscious attempts to Islamicize existing disciplines such as economics, sociology, and others, with direct implications for primary and secondary education.[50]

The implementation of strategies for the Islamicization of secondary education has differed greatly from country to country, such that there is little that can be seen as an overriding pattern even among Sunni-majority societies. Saudi Arabia, whose influence on formal and informal religious education in many Muslim communities cannot be overestimated, often expresses the concern that countries like Egypt have not gone far enough in integrating Islamic values and thought into school curriculums.[51]

Religious schooling, and especially the degree and manner in which visual images are employed within it, varies greatly in the Islamic world. I will address some peculiarities of the three cases of Turkey, Iran, and Pakistan that lie at the center of this book in the chapters that focus on those societies. Beyond those examples, the majority of scholarship on education in the Islamic world concerns Egypt, although there is significant relevant work concerning other contexts. For example, pre–civil war Syria provides an interesting case study in the transnational nature of Shiʻi religious schooling. The majority of Shiʻi religious books for children in Syria were imported from Lebanon, although some came from Iran and Iraq as well. Studying a selection of Shiʻi children's books sold around the shrine of Sayyida Zaynab, Edith Szanto has identified a number of ways such materials attempt to educate children, noticing, in particular, differences between the educational approaches of texts from different countries. Books published in Iran—or by Arab publishers with close ties to Iran—place a strong emphasis on authority and

guidance. Iraqi books, in contrast, emphasize the mediatory power of authority figures such as teachers and grandparents, and also stress the imminent return of the Mahdi and therefore the coming of an idealized, utopian future.[52]

Szanto also notes how the relationship between the subject matter, text, and visual images in such books carries lessons that go beyond the formal content of the text. For example, a book titled *Munāsibāt khālida* (Eternal Proprieties) teaches about important religious events using visual symbols, representing them iconically on the book's cover: an image of the Prophet holding up 'Ali's arm represents the festival of Al-Ghadir (which marks the Prophet's appointment of 'Ali as his successor), the Ka'ba represents pilgrimage, a girl looking at the silhouette of a camel represents the Hijra, and a boy contemplating a scene from the Battle of Karbala symbolizes the day of 'Ashura. Within the book, images are juxtaposed with text on each page; in particular, pictures of children are foregrounded and shown visibly responding to significant historic events with their facial expression, or they are placed below, probably to indicate a reverential and subservient attitude. Notably, the publishers of the work actively attempt to convey their message to the intended audience, and the text on each page explains the importance of the event being represented and describes the appropriate emotional and physical responses.[53]

Egypt represents a prime example of the historical transitions between educational systems in the Islamic world. The most populous and culturally significant country in the Arab world, it entered the twentieth century with a strong bifurcation between elite education, comprising secondary schools and colleges established and run by foreign (often Christian missionary) organizations, and a very inadequate and uncoordinated network of substandard private and religious schools serving the majority of the population. There were several attempts to reform education under successive nationalist governments, but it was not until after the formation of pan-Islamic organizations and the convening of World Conferences on Muslim Education that, in 1991, Egypt launched a national project on education. The initiative emphasized the importance of promoting scientific and technical education in order to remain globally competitive, but also doing so in a way that paid attention to the Islamic values of the majority of the country's population.[54]

Even though Egypt, like some other Muslim-majority countries, has placed the greatest emphasis on higher education in technical fields with a specifically defensive and competitive strategy, it has also made sub-

stantial attempts to modernize its system of secondary education. Modern developments in educational and psychological theory have even impacted the religious education imparted in secondary schools, and have resulted in a marked increase in the production and use of print materials aimed at ingraining Islamic values and religious knowledge in children. Public school textbooks rely on interactive exercises and short plays *(tamthīlāt)* to engage children and encourage them to internalize religious lessons. By the end of their fifth year in school, Egyptian children are expected to have covered approximately five hundred pages worth of Islamic materials in their textbooks. Much of the material has to be memorized, both for reasons endemic to a system of education based on annual examinations and because of the tradition of memorizing and reciting religious materials.[55] Modern textbooks attempt to link children's own experiences with the historical events and religious figures they address—for example, at the end of the twentieth century, the first-grade textbook produced by the Ministry of Education opened with a story from the prophet Muhammad's childhood, emphasizing his family relationships and speaking about him and his environment in ways that were intended to make him more relatable to children.[56] Religious textbooks produced by the Egyptian government include quotations from the Qur'an and hadith accompanied by explanatory materials; edifying essays, songs, and poems for memorization and recitation; and group activities such as vocabulary exercises, short plays, picture exercises, and discussion questions. The textbooks are graded by age cohort, with the earlier, simpler versions of stories and ethical essays being accompanied by more pictures than later ones, and with the latter placing greater emphasis on the messages and meanings underlying religious texts and rituals. The textbooks are designed to be a "source of the child's most elementary moral knowledge," and teachers are urged to impart the values of "diligence in their work, compassion for others, and good manners in public places."[57]

An important aspect of standard public secondary education in religious matters is the manner in which the state—through teachers, classrooms, and textbook authors—positions itself as the agent of imparting religious knowledge and morals to children, implicitly usurping this sphere of authority from families. Yet, during the same period when a consciously Islamicized concept of public education flourished in Egypt (as well as in several other countries, including Turkey, Pakistan, and Iran), private sector companies also began producing materials for homeschooling in Islam. Like the public school textbooks, such materials

were designed with the intention of fashioning a modern, cultured, and virtuous citizen through the consumption of print and other modern media. In the case of Egypt, Safir Publishing Company has been prominent in providing such materials for children along with guides for parents on how to instruct children in the manner of prayer. In addition to age-graded books on religious teachings and history, it has turned out coloring and puzzle books, posters, flashcards, audiovisual materials, and jigsaw puzzles and board games with names like *Battles of the Prophet.*[58]

These examples of religious pedagogical materials incorporate modern developments in educational and psychological theory, resulting in new ways of trying to inculcate Islamic knowledge in children that are more effective than old fashioned textbooks, the content and structure of which are dictated by well-worn, traditional Islamic scholarly practices. Religious homeschooling products intentionally target the middle class. Safir—as the most prominent Egyptian example—was established as a publicity firm in 1982 but expanded into the production of Islamic educational materials with a division called Children's Culture United *(Wahda thaqāfat al-ṭifl)* in 1986. Safir's materials are aggressively marketed and used in private schools and homeschooling, and are promoted abroad at book fairs. Unlike the more commonly available, older-style children's religious books, Safir's materials are on high-quality paper stock with good colors, and are complemented by consumer products directed at children. The company relies on the expertise of specialists in child psychology and child education to design and produce their materials.[59] This new phenomenon of publishing "attractive" religious materials for children creates a parallel system of education, with private sector actors—educational professionals, writers, and business people—competing with traditional religious scholars in conveying knowledge of and about Islam. This should be seen as another piece of evidence demonstrating that Islamic societies have always had multiple religious voices in them; but it is also a manifestation of the modern contest over religious authority in which new religious movements—from the predominantly Arab Muslim Brotherhood to the predominantly Turkish Gülenist movement—challenge the authority of the traditional *'ulama.*

GENDERING CHILDHOOD

Despite the fact that nineteenth- and early-twentieth-century educational reforms in the Islamic world frequently included policies and

actions in support of girls' education, most of the focus on childhood and children displays a strong male normativist bias. This holds true in the case of education—especially after the primary level—but also very broadly in the way childhood itself is conceived and described. There are marked differences between the various conceptualizations of the child as student, future adult, citizen, offspring, religious actor, and so on, and the gendering of children occurs differently in these varied roles. For example, the infantilization of children is very clearly articulated by gender, but it would be misleading to make a simplistic distinction between the treatment of girls and boys. One might be tempted to see in a stereotypical notion of the ideal family that greater emphasis is placed on the cuteness of girls, and to draw a connection between the early social sexualization of females and a concomitant desire to infantilize them so as to prolong their period of asexual innocence. Similarly, the early gendering of what toys are appropriate for boys and girls—and fears over boys dressing in ways that are perceived as nonmasculine— might serve to bring boys out of the realm of the cute or the innocent earlier than girls in order to prepare them for their roles as responsible parties in patriarchal society. But for any such social construction there are others that challenge these imaginings. Many cultures and social contexts promote the coddling of boys for many more years than they do for girls, since infantilized "mama's boys" are of more value to parents than sons who might set themselves apart from their birth families.[60] A contradictory but prevalent model of childhood sends sons out into the world earlier; mindful of the danger of girls beings subjected to exploitation (particularly of a sexual nature), families in some parts of the Islamic world try to keep their daughters at home until they are married, but send their sons out into the workforce, subjecting them to the risk of a variety of forms of exploitation.

The differences between the treatment of boys and girls are particularly apparent in the period of modern Islamic reform movements (particularly the nineteenth and early twentieth centuries). Most reformers were unequivocal in their support of female education, since an educated girl fit within their broader conception of modern childhood, which required reforms in matters of dress, manners, and thought. In the case of Egypt, as elsewhere, the modernization of girls was integrally linked to that of the adult female population. The reformer Qasim Amin published a book titled *The New Woman* in 1900, in which he announced the arrival of the new modern Egyptian woman, who was necessarily educated, since it was through her and her promotion of a

materially and morally progressive household that the nation would advance.[61]

In Egypt, the debate over girls' education in the nineteenth and early twentieth centuries was not about whether or not girls should be educated but rather about the nature of their education and the number of years of schooling that was necessary and appropriate for them. Educational opportunities were closely tied to economic and social options and expectations, and were inflected by class as much as they were by gender. Curricula were based on social class, with upper- and middle-class girls having access to education in arts and languages, viewed as appropriate signs of being cultured women of their social strata. The aim was still to educate girls to be appropriate companions and homemakers for the new, sophisticated Egyptian men, but ones who created different environments and raised different children from their poor counterparts. Such attitudes are explicit in the writings of the reformers of the period: Rifa'a al-Tahtawi, the person most to credit for the beginnings of modern education for women in Egypt, declared that girls who learned nothing but sewing would only be interested in nonsense like clothes and food. Instead, they had to be taught to be beautiful on the inside as well. And Salamah Musa, writing almost a century after Tahtawi, declared that teaching girls only about cooking, cleaning, and reproduction would do nothing to develop their personalities.[62]

One important fact to bear in mind is that often there were substantial gaps between the stated ideals of universal education and its realities. In the case of Egypt, seventy thousand students attended seven hundred elementary schools in 1920. Elementary education was made compulsory in 1923, and by 1948 there were five thousand schools with one millions students enrolled in them. However, the primary educational resources—in terms of schools, books, and teachers—were drastically insufficient for the population, and few children other than upper-class boys attended school for more than two or three years, or for more than half of each school day. By 1955, barely 9 percent of the child population of Egypt was in schools.[63] The reality behind the ideals of governmental policies was that the poor had very little access to education, and when they did, the necessity of putting children to work meant that they could not avail themselves of it fully. And in the case of the middle and upper classes, the prioritization of male over female education meant that girls went to school for fewer years and were less encouraged to take most subjects seriously. The different value placed on male and female education is readily apparent in the illustrations in

a collection of poems by the influential author of children's books Muhammad al-Harawi. Titled *Samīr al-aṭfāl,* this work includes many photographs of children beside modern technological items such as cameras, telescopes, typewriters, and cars. The children in the pictures are overwhelmingly male; the female students that do appear are engaged in activities that strongly signify appropriate activities for girls. They appear standing behind the boys with books in their hands (signifying studiousness and good behavior), or putting money into piggy banks, signifying their frugality and studying of home economics, all of which are important for adult women running households and being mothers. Heidi Morrison draws attention to one illustration depicting a girl in Western clothes sitting at her desk, reviewing an agenda and looking at her watch. She is accompanied by her brother, who is also holding a watch. The illustration appears to suggest that no middle- or upper-class child should go without a watch, since keeping time is a sign of efficiency and diligence to the same degree that Western clothes and recent technological innovations are. That the girl has a watch just like her brother does suggest that keeping time, like studying, is important for modern girls.[64] But what is unclear is whether or not the girl is expected to do the same things with her time as her brother, since societal expectations for boys and girls were explicitly different at this time.

THE GENDER TRAP

The nonlinear way in which childhood is gendered in the modern period is even broader in its implications. In the first place, modern girls are afforded freedoms and opportunities that are different from boys; and in the second, age and social position work alongside gender to shape the lives of girls and women.

Modern social and educational reforms changed certain expectations regarding girls and women—especially for the middle and upper classes—but they also brought new kinds of constraints. Even though there was a great deal of emphasis on female schooling, the purpose of this new education was to train a better homemaker and mother for future generations of modern Muslim citizens, and girls were actively discouraged from venturing beyond the confines of modern domestic femininity.[65] At some level then, the making of the modern girl and woman is part of a larger nationalistic patriarchal project in which female citizens are fashioned within a broader masculine-centric notion of modernity. Masculinity is also constrained in this notion of modern

personhood in many respects, in the sense that boys are expected to behave in ways that will eventually lead them to become ideal men. But modern manhood is identified with a broad set of personal and societal freedoms, whereas in nationalist and reformist imaginings modern womanhood is framed entirely within the construct of traditional female roles. As such, female children are inseparable from female adults, who exist in order to be mothers and homemakers for modern boys and men. The girl is a future mother and wife in a way a boy is seldom considered a future father and husband, but rather a citizen. Girlhood thus remains inseparable from womanhood and the two elide into each other in the category of the young woman who is yet to marry and have children, the implications of which I explore in more detail in my discussions of Pakistan and Iran.[66]

CHAPTER 5

Cuteness and Childhood
in Turkey

Turkey constitutes an excellent case study of the place of children in national emotive regimes. Almost universal literacy, a large middle class participating in religious and other consumer cultures, and a long-standing national project of ideological formation through education, partnered with a decades-long commitment to important aspects of gender equality, come together to create a space in which children figure prominently in constructions of the present and aspirations for the future.

Turkey is a secular (more accurately speaking, a "laicist") republic, which, for the first two-thirds of its history, displayed little tolerance for expressions of religion in public life. This was especially true in matters of education, with the state keeping religion out of government-run schools. Significant changes to the nature of public religious life in Turkey occurred in the 1980s and 1990s during a time of major socioeconomic transformations, including the rise of a provincial, economic elite, substantial migration to the cities, and the growth of political clout among more religious segments of society that previously had been excluded from the sociopolitical mainstream. Public religious displays and religious education became broadly accepted during this period, which also witnessed the blossoming of religious publishing and education.

EDUCATION IN TURKEY

The period of the Tanzimat reforms in the Ottoman Empire (1780–1876) involved a broad-based adoption of Western political and educational institutions and simultaneous attempts to preserve what were seen as Ottoman Islamic values and traditions. The influence of Western institutions and mores increased during the Ottoman constitutional period (1876–1923); subsequently, large-scale changes in educational and social affairs were formalized after the establishment of the Turkish Republic and during its early republican period, which lasted until 1948.

A modern army school of engineering had already been started at the end of the eighteenth century with help from the French government (even instruction was in French at this institution). Similar reforms in education and administration continued over the course of the nineteenth century with the establishment of a school of medicine, another for surgery, a modern military academy, and a school of music. All these institutions functioned on European models, and during this time the most advanced students in a variety of disciplines were sent to Europe for further studies. Even though most reforms in education dealt with higher institutions, compulsory universal elementary education was introduced in 1824, extremely early compared to other Muslim-majority societies. At this time, however, there were no secondary or intermediate educational institutions to bridge the gap between primary school and higher education, and two were established only in 1839.[1] Important principles of universal education were formally promulgated in December 1876, declaring that every citizen had a right to an education, that all schools must be under government supervision, and that they must be universal in their subjects and pedagogy and therefore appropriate for everyone regardless of religious or communal affiliation. In recognition of the existence of serious shortcomings in teaching methods and the way course content progressed from one year to the next, syllabi were adopted from American and European institutions.

Although the priority was very clearly on the education of boys, especially at higher levels, Ottoman-era reforms are noteworthy for their formal emphasis on modern female education. The first public school for girls opened its doors in 1858, and the edict from 1869 making primary school education compulsory for children between the ages of six and ten explicitly included girls.[2] Just prior to the end of the empire, more legislation promulgated in 1913 reformed elementary education, making it compulsory and free for six years, and formalizing a system of teacher

training for men as well as women. The emphasis on primary and secondary education only increased after the establishment of the republic, since the new government was keenly aware of the value education held for the nationalist project. It convened a series of educational conferences and councils, which formally laid out the mission of primary, secondary, and higher education, explicitly linking them to broader civic activities and to youth programs in athletics and to the boy scouts. Modernity for Turks was conceived of in secular terms fashioned on European models. This applied to everyone, including children, and its promotion was a stated purpose of the educational system, as articulated in the government's educational program of 1923, according to which the founders of the republic "intended to adopt western civilization as a whole, including western secular culture, to raise the nation to the contemporary western level, and to avoid superstition, mystical feelings, scholastic ideas, and out-of-date principles of life, adopting positivism."[3]

As part of the reform acts adopted on March 3, 1924, which formally established a secular Turkish republic, all educational and teaching institutions were brought under the Ministry of Education. This included religious schools *(medreses),* which previously had been run by the now abolished Ministry of Religious Affairs and Endowments *(Şeriye ve Evkâf Vekâleti).* Over subsequent decades, several government declarations reiterated a national commitment to molding the ideal modern citizen and education's centrality to such a project. The first minister of education of the republic declared that education had three main aims: (i) that Turkish youth would be educated to be nationalistic, populist, and secular; (ii) that illiteracy would be eliminated through universal elementary education; and (iii) that "the Turkish nation [would] be raised to the level of contemporary civilization."[4] Similar values were articulated at a council of education held decades later, in 1962:

> The aim of Turkish national education is to educate all members of the Turkish nation so that they will be joined together in sorrow, happiness, and destiny, as an indivisible entity with a national consciousness; to enhance national, moral, and human values; to develop the nation as a harmonious society enjoying free expression of opinion within a democratic system that is open to free enterprise and fosters social responsibility; and thus, through the development of skills (technology), knowledge, arts, and economy, to make her into a distinguished participant of contemporary civilization.[5]

Despite a national system of state-controlled secular secondary education and the domestication of Islamic higher-level seminaries into faculties of divinity *(İlahiyat Fakültesi),* an informal private network of religious

schools, called *imam-hatip* schools, remained important in broader Turk-ish society. These religious educational institutions came to be viewed as incubators of antinational ideas from the 1960s onward. Consequently, after the "soft" military coup of 1997, a new policy was implemented in an attempt to limit the influence of the *imam-hatip* schools: religious mid-dle school (that is, years six through eight) was eliminated, breaking the connection between elementary religious education and high schools.[6]

These changes came after almost two decades of official softening on matters of religious education, which had been part of crucial transfor-mations in the structure of the Turkish state. Following several periods of unrest that pitted various political factions of Turkish society (virtually all of which were secular) against one another, in 1980 the government of Turkey decided that Islam could serve as a unifying force and reversed many elements of state policy that kept religion out of the state curricu-lum. The government mandated lessons in religion for students from the fourth year onward. The new curriculum combined traditional Islamic religious subjects with civic and ethical lessons, a phenomenon reflected in the titles of the official textbooks, such as *Religious Culture and Knowledge of Morality (Din Kültürü ve Ahlâk Bilgisi)*.[7] A significant aspect of this new situation was the formal habilitation of the *imam-hatip* schools, religious secondary schools that previously had served to provide religious education to a limited section of society and whose curriculum was not recognized by the Turkish state. After 1980, diplomas from these institutions were fully recognized and their graduates allowed to compete for university admissions alongside students educated in the formal Turkish-state curriculum. *İmam-hatip* schools flourished, growing by 59 percent between 1983 and 1997 (when Turkey underwent a "soft" mili-tary coup). These schools were the major consumers of religious books in the country, and their increase resulted in a dramatic growth in religious publishing and the proliferation of Islamic publishing houses during this period. The financial growth of a religious publishing industry had the additional consequence of generating a new economy of translations, commissioned authorships, and the concomitant emergence of a new, autonomous class of Muslim intellectuals who were free to think and write outside the state-sanctioned versions of religion.[8]

TURKEY, RELIGION, AND THE PRESENT

The overtly religious political party named Adalet ve Kalkınma Partisi (Justice and Development Party, hereafter AKP) secured a decisive victory

in the Turkish national elections in 2002; since then, it has held a strong majority in each election, allowing it to pursue a broad social, educational, and religious agenda. One of the greatest consequences of the hegemonic authority of the AKP is that a variety of religious voices explicitly and implicitly endorsed by the ruling party has gained confidence in Turkish civic life. There was a visible growth in a professional religious bourgeoisie from Anatolian industrial towns during the last two decades of the twentieth century, resulting in a dramatically larger, socially and politically assertive, urban religious middle class that not only participates in political life but also creates a rising demand for what can only be called Islamic consumer and popular culture: religious couture and cosmetics, decorative aesthetics, and children's toys have flourished during this period, as has religious music, cinema, television, and literature.

A significant portion of the social engagement of the newly affluent and organized religious classes in Turkey is the outgrowth of private religious schools. Children from poor but religiously conservative families are provided free education in prestigious schools and, after completing their studies, are mentored in jobs in private companies owned by religious interest groups or in the government bureaucracies, which are increasingly staffed by socially and politically engaged religious individuals. The end result is that present-day Turkey has a large class of citizens with disposable incomes who assert their choices to live lives in keeping with their evolving and newly articulated religious values. They live in housing complexes and gated communities that reflect religious notions of privacy, take holidays in resorts that support a conservative lifestyle (offering gender-segregated swimming pools, for instance, and not serving alcohol), and attend religious social gatherings in luxury hotels owned by members of religious groups.[9]

Outside of the nationalist Sunni religious mainstream represented electorally by the AKP, the most influential religious groups in terms of their impact on modern Turkish education and consumer culture have been affiliated with the Nur movement, whose followers control a substantial number of publishing houses, television channels, and newspapers. Historically related to the Nur movement but distinct in the contemporary period are the followers of Fethüllah Gülen, who have also invested heavily in publishing, electronic media, and education. Gülen's followers enjoyed a privileged relationship with the AKP government but a rift between the two emerged in 2012, and in 2013 their extensive network of private college preparatory schools was disaccredited. The relationship deteriorated dramatically following the failed coup of July

2016, which was blamed on Gülen and his followers. Aside from broad purges of alleged Gülen supporters in the military, judiciary, police, and civil service, the assets of many publishing and media companies associated with the Gülen movement were seized, and their remaining schools were closed.

RELIGIOUS PUBLISHING

In recent decades, a broad range of publishers has been producing religious materials for children in Turkey. The majority of them, and certainly the most popular and dynamic among them, have been publishers associated with either the Nur movement or the Gülen group. Among these publishers, Timaş and Nesil stand out as exceptionally influential in the production of children's books and in religious cultural activities in Turkey in general. Both publishing houses combine a strong religious communitarian spirit, a social and educational mission, and an efficient corporate culture. They also embrace the latest technologies of information dispersal and entertainment in an attempt to reach a broader readership, including promoting themselves through social media, producing sophisticated web pages, using video advertising, and creating smart phone applications.[10]

Nesil is affiliated with the Nur Movement, while Timaş used to enjoy ties with the controversial Gülen group, which it publicly disavowed following the failed coup attempt in the summer of 2016. The Nur movement is an Islamic community for which printed texts and their circulation have played a very important role ever since the death of the founder, Said Nursi, in 1960. It is, therefore, no surprise that presses associated with the group have moved into much broader publishing roles. In the case of Nesil, it transformed itself from being a purely religious press into a publisher with broad catalogs that include translations of foreign literature, self-help and psychology books that would easily find a home in mainstream bookstores, and books on Turkish politics, history, and literature, among other subjects.

The same holds true of Timaş, but despite the strong similarities between the two publishers, they have distinct profiles, as do other religious publishing houses in Turkey. Although they both organize religious intellectual and literary events featuring prominent intellectuals associated with the movements with which they are affiliated, their financial relationship with specific religious communities is publicly unclear. Both have long recognized that they cannot simply rely on their

own religious communities as their market and therefore need to appeal to a broader readership.[11] Timaş has appeared keen to be perceived as inclusive in its attitudes and policies, and to be open to diverse intellectual positions, even nonreligious ones.[12] In contrast, Nesil is consciously closely associated with the Nur movement and attempts to reflect this in its publishing and editorial polices. Its core staff was part of the first generation of followers of Said Nursi and focused on the dissemination of the *Risale-i Nur,* Nursi's collected sayings and works, around which the Nur movement is organized as a religious community. Over time, a number of prominent figures associated with Nesil grew dissatisfied with what they viewed as an insular and narrow outlook and, in the first decade of this century, consciously changed the profile of the publishing house.[13] Such transformations were much more radical in the case of Timaş, which moved from holding a very narrow view of publishing as purely made up of the printing and dissemination of print materials, to a broad multimedia approach focused on the dissemination of ideas.[14]

The substantial disruption of the *imam-hatip* school system in 1997 had several consequences for Islamic publishing as it pertains to books for children: on the one hand, the closing of such schools represented a large market loss to religious publishers, who then had to look for more innovative ways to sell their materials. On the other, families who might previously have sent their children to religious schools now had an incentive to find appropriate materials in order to provide their children with a religious education at home, thereby creating a market for new kinds of materials oriented toward children. Some Turkish religious presses were quick to position themselves in this new social environment. Timaş, as a particularly successful example, created an explicit policy of having "a book for everyone" *(herkes için bir kitap),* including those readers who might not want religious works. When stocking branches of their shops in locations frequented by students or their stalls at bookfairs, they would frequently forgo religious titles and replace them with offerings on self-improvement and other subjects of broader interest.[15]

The policy of having a book for everyone also meant a conscious decision to offer children of all ages a broad range of books that goes beyond obviously pedagogical religious works to include titles that are attractive and entertaining. Timaş's interest in the children's book market is demonstrated by their separate imprint "Timaş Çocuk" (Timaş Child). Nesil, which has followed Timaş in expanding into a broader market, also has an imprint for its children's books. Both publishers operate as part of larger corporations with varied interests. Nesil, for

example, is part of the Nesil group of companies (Nesil Şirketler Grubu). The corporation's slogan declares: "If there was no Nesil, something would always be missing" *(Nesil olmasaydı bir şeyler hep eksik kalacaktı);* and it comprises other publishing and media interests such as a cultural magazine called *Moral Dünyası* (Moral World), a news service called *Moral Haber* (Moral News), another publishing interest called *Moral Kitap* (Moral Books), a radio station (Moral FM), a musical production company (Moral Prodüksiyon), and Moral cultural centers in different parts of Istanbul.[16] Its offices are in a large building along with those of other Nur-affiliated religious media corporations such as the Zaman and Milli newspapers and İhlas Publishing. This building, despite being modern in every way, reflects conservative religious values in its organization, such as in the design of toilets and the segregation of men and women.[17] The Nesil group is also very active in cultural, religious, and educational activities carried out in conjunction with other organizations affiliated with the Nur community, including with İstanbul İlim ve Kültür Vakfı (Istanbul Science and Culture Foundation), the flagship academic institution associated with the Nur movement.[18]

Turkish religious literature for children grew out of the trend toward Islamically themed novels in the last quarter of the twentieth century. Before this period, religious writing and printing were largely limited to the publication of formal religious texts, pious books on the hows and whys of religion *(ilmihal),* and religious periodicals representing a range of viewpoints. The first Islamic novel, *Minyeli Abdullah* by Hekimoğlu İsmail, appeared in 1967 and was followed three years later by *Huzur Sokağı* by Şule Yüksel Şenler. These two literary works proved to be immensely popular—they were reprinted hundreds of times, were made into films, and encouraged the growth of new genres of religious literature as well as cinema.[19] The authors of these first novels were explicit in their desire to educate society at large. As stated by Hekimoğlu İsmail:

> There were three important strains of thought during the 1960s: nationalists *(türkçüler),* religious people *(dindarlar),* and those who were against religion *(dine karşı olanlar).* The ideas of each were being propagated through books during those years. . . . The books of religious people, however, consisted only of *ilmihals* [essential Islamic teaching books]. They were repeatedly publishing *ilmihals.* Yet *ilmihal* is a book that is read by people who have already adopted Islam. Actually, the most important thing was a concern with "how might we lead people to believe in Islam?" I mean the way *(usul)* was wrong . . . we had to talk to the man in the street.[20]

An early series of books designed to provide religious education to young children was authored by M. Yaşar Kandemir, a respected religious scholar and the editor of the Turkish encyclopedia of Islam published by Türk Diyanet Vakfı. These books were targeted at children between the ages of six and nine, and were approved by the Turkish Ministry of Education in 1983 for use in schools. They were also recommended by the Religious Affairs Supreme Council. Despite this high level of endorsement, however, Kandemir's books were not well received in all religious quarters, and they were not sold in more conservative bookstores, ostensibly because they contained images of plants and animals.[21]

As I have stated already, there are many publishers of religious books for children in Turkey, but publishers affiliated with the Nur and Gülen movements have taken a clear lead at the higher end of the market. Books and other products for children constitute a major section of the publishing activity for both these presses. Nesil and Timaş, along with several other publishers, have learned valuable lessons concerning the effectiveness of education as an ideological tool from its use in the state's attempts at nation-building. After many years of operating underground or informally, several religious educational circles are now represented by such religious presses, and they operate openly as part of global educational networks. This holds true for modern Nur movements; it was even more the case until 2016 for the followers of Fethullah Gülen, for whom the importance of education is directly linked to a vision of a brighter future led and populated by morally and intellectually righteous citizens, referred to as the "Golden Generation" *(altın nesil)*. Until its headlong confrontation with the AKP government, the Gülen movement implemented its goals through a global network of schools and universities on five continents, which were accompanied by youth residential community and learning centers called "light houses" *(ışık evleri)*.[22] Members of the Nur movement are not as formal and organized in their global educational mission, but affiliated presses like Nesil have been much more active in broad-based children's publishing than affiliates of the Gülen movement.[23] The materials of both Timaş and Nesil are produced with the active participation of experts in child psychology and educational theory, and they match nonreligious publishers in production quality and illustration. Their children's imprints, Timaş Çocuk and Nesil Çocuk, are targeted at children twelve and under and offer books for narrower age groups within their target range as well as for parents and teachers. Their selections include coloring and

play books, science books and fairy tales, but the backbone of the catalog is religious publications about the lives of religious heroes, lessons from the Qur'an, and morality tales that promote a socially conservative view of idyllic life.

Although the leading Islamic publishers of children's books in Turkey try to appeal to a wide audience, they are very deliberate in promoting a specific notion of religion and making sure not to promulgate anything that does not conform to their own values. The longtime editor of Timaş (until the purges of 2016) was clear that she and the other people behind the press are Sunnis who base their values on the Qur'an, and that they will not publish anything from viewpoints (even progressive Muslim ones) that contradict these values. They have traditionally also drawn the line on publishing books, such as mysteries or detective stories, that promote violence.[24] Nesil takes an even narrower view of its publishing mandate and does not publish religious materials that can be interpreted as being critical of Said Nursi or the Nur movement. Both children's imprints are extremely popular to the point that they compete on equal terms with secular publications for the children's market, and might very well be more important in imparting religious education in Turkey than the network of children's Qur'an schools.[25]

It has been posited that a revolution in mass education and printing, combined with the emergence of a new category of religious intellectual, is responsible for the dramatic transformation of religious identities in Turkey.[26] This allows for a move away from more traditional networks of Islamic authority, such as those of the established *ulama* or of Sufi networks, in the direction of a discursive and relatively nonhierarchical religious space that lies outside the authoritarian control both of the state and of traditional religious hierarchies. Most significantly, the move toward print culture and new media offers emerging individuals and groups the ability to challenge prevailing ideas about religion and its place in society and the chance to establish new patterns of religiosity.[27]

CUTENESS AND CHILDREN

As mentioned in previous chapters, one of the most distinctive features of books intended for children is their extensive use of visual imagery. This holds true for religious books in Turkey, some of which display very high standards of graphic art. Cuteness functions as an essential component of children's books, to the point that it must be taken seriously as an affective and aesthetic quality of human experience.

Cuteness has been the subject of sporadic study in a number of theoretical disciplines since the early 1990s. Within a larger framework of cultural studies, the "cute" has been explored as an aesthetic and affective concept in relation to adulthood and childhood, consumer culture, monstrosity, and innocence, among other things. Much of the work is centered on Japan, where cuteness *(kawaii)* is a substantial element of adult lifestyles and of consumer culture. Adult women aspire to be cute in a well-defined sense, and a broad cross-section of society (men as well as women, and also children) participates in subcultures centered on cute commodities and symbols. Commodity cuteness—such as the corporately planned development of Pokémon—is a pervasive societal phenomenon, such that even middle-aged adult men have Pokémon (or other) character-themed phone covers and electronic "pets."

While Japanese-style cute culture might not play a central role in defining the parameters of cuteness at a global level, the Japanese example is important because of the way it illustrates multiple vectors along which cuteness is constructed and understood. The intersection of cuteness with emotion and aspiration, social and religious attitudes, and consumerism in the Islamic world operates on similar patterns.

Cuteness is not purely an aesthetic category but one that combines the aesthetic, emotive, and aspirational in a variety of unstable ways. As a result, the implications of cuteness and its imposition on children as a complex set of qualities are hard to define succinctly. The nonvisual aspects of cuteness include concepts of innocence, sweetness, happiness, and vulnerability, all of which are culturally inflected as signifiers, such that it is challenging to come up with a universal notion of the cute. Visual cuteness is easier to define as some combination of smallness and roundedness, supplemented by secondary cues such as large eyes and tiny (or entirely absent) noses and mouths. The consumer world of cute is so pervasive in most modern societies—in television and film, calendars and greeting cards, stuffed animals and toys, children's clothes and accessories, and much more—that one forgets the constructed nature of our notions of cuteness. In point of fact, even though one might argue for some instinctive wiring of the human brain that causes us to respond positively to human babies and the young of furry mammals, the elaborate construct represented by cuteness in modern society is heavily manipulated and manufactured as a system of signifiers.

That cuteness is socially constructed is obvious from the fact that many languages do not have words for cuteness that satisfactorily translate the concept. In standard Arabic, for example, a variety of

words, each carrying a different meaning, get used to convey the English-language meaning of cute: *laṭīf, ẓarīf, qamūr,* and *ḥalu/ḥalwī* are commonly used with different nuances. The word *ẓarīf* conveys a sense of elegant or beautiful "cuteness"; *laṭīf* implies niceness ("that old lady is so *laṭīfa!,*" meaning "sweet"); *ḥalu/ḥalwī* possesses the notion of "cute" as physically attractive ("that guy is *ḥalū!*"), and *qamūr* is cute both in the sense of sexy and in a babylike way. In Persian, words such as *jizab* and *bāmazeh* carry similarly nuanced meanings, and cuteness of the sort that evokes affection is often expressed through references to mice (as in calling your loved one *mūshī,* or saying "a mouse should eat you!" to a cute child with the same meaning as is conveyed by the English expression "I could just eat you up!"). In Urdu, *piyārā/piyārī* ("lovely") and *munnā/munnī* ("tiny") are often used to mean "cute;" the Arabic loan word *ma'ṣūm,* which is also used in Persian and Turkish, connotes innocence. In Turkish, in addition to the Arabic loan word *zarif,* cuteness can be conveyed as "nice" or "agreeable" by *hoş,* as puppy- and kitten-like cuteness by *sevimli* (also meaning "nice" and "likeable") or *şirin* (meaning "sweet"), and in the arched sense of cute ("stop acting cute") by *açıkgöz,* literally meaning "open-eyed" or "wide-eyed." This last meaning is reminiscent of the Latin etymology of the English word "cute" from "acute," and reminds one of the ambivalent nature of cuteness as something that is not entirely good.[28]

Aesthetically and morphologically, cuteness relies on a surplus of qualities that characterize the very young and the very old. The cute is small and rounded, often with an oversized head, big eyes, a tiny nose, and a tiny mouth, the latter two being almost absent in some representations. In motion, the cute waddles and toddles, displaying neither strength, speed, nor agility. It lacks dexterity as well as polished elocution. In short, the cute is marked by its absences relative to the normative human adult. Its appearance and abilities indicate lacks and vulnerabilities, and its mental and emotional state is characterized by ignorance of the bad things in life that plague the human adult.

Put together, the qualities of the cute epitomize the absence of malice, threat, selfishness, and even a sense of self. Its vulnerability, neediness, and powerlessness urge the human actor to respond to it in caring and nurturing ways—the very embodiment of the parental response to a helpless infant.[29] At the same time, its innocence, virtue, and happiness emphasize a set of qualities and idealized states to which adult humans aspire. Put differently, the cute manipulates human beings into being virtuous and imagining a better world, and the fact that we are willing

participants in this manipulation suggests that cuteness is a manifestation of our collective aspirational needs.

All cuteness is constructed, but the cuteness of commodities is manufactured, frequently carrying the signifiers of cuteness to excess. Hello Kitty might well represent the epitome of manufactured cute—a white cat with three dots instead of eyes and a mouth, an oversized head, a pot belly, and deformed hands and feet lacking both fingers and toes.[30] The characteristics (or deformities) that mark a departure from actual cats are the very things that make it the epitome of cute. Actual cats have sharp claws, and they bite, smell, and shed; they can be annoyingly loud, appear to relish being cruel to small animals that they capture, and leave little half-eaten rodents, reptiles, and insects in the middle of our beds. Hello Kitty not only does none of these things, but it is the combination of feelings of sympathy, pity, and superiority that it elicits that is the interactive response to the aesthetic of cute.[31]

The monstrous and the sexualized comprise two facets of the cute (as it is constructed in contemporary theoretical literature and in many aspects of consumer culture) that depart from stable notions of innocence and sweetness. The latter is implicit in the use of the word *cute* to describe someone who is sexually or physically attractive, but "sexy cute" is a broad and varied aesthetic, from partially clad women with rabbit ears and tails (the Playboy Bunny), through the idea of the boy toy, to the myriad examples of infantile cutesy female characters in popular media. What differentiates *cute* as sexually desirable from *beautiful* is that the cute is nonthreatening and controllable, characterized yet again by a relative lack.

CUTENESS AND JAPANESE CULTURE

More than in any other social context, the Japanese notion of cuteness has been a focused topic of study for almost two decades and therefore is invaluable for exploring the contours of cuteness and its social and affective functions. As defined by Anne Allison: "*kawaii* [cuteness] is associated with the qualities of *amae*—sweetness connected to dependence— and *yasashii*—gentleness. While *kawaii* is linked to girls and girlishness, it is not exclusively 'feminine.' Someone's personality can be called *kawaii*, for example, and so can a boy's face, though this could also mean it was girlish. Toys for kids are seen as *kawaii*. . . . Cuteness, for these girls, is something one both buys to consume and also cultivates in and as part of the self."[32] *Kawaii* has also been described as a style that is "infantile and delicate at the same time as being pretty."[33]

For girls and young women, *kawaii* connotes qualities of gentleness, sweetness, and dependence; it is consciously evocative of childhood and childlike experiences, including freedom from the stresses of the adult world. This concept of cuteness shares several nuances with the English-language meaning of "cute" as well as with certain words connoting cuteness in Islamic languages, although the connection with vulnerability and dependency is greater in Japanese because of the etymological connection between the word for cute *(kawaii)* and that for pathetic or pitiable *(kawaisō)*.[34] This connection is culturally reinforced by the Japanese cultural virtue of *amae* (dependency), exemplified in the relationship of a child and mother. Such a model of dependency—of which *kawaii* culture is but one manifestation—functions as a societally valued template for a range of interpersonal relationships in Japan.[35]

Cute culture is associated with the changing roles for women and girls in Japanese consumer culture. It can be traced back to the 1970s and the emergence of the young, unmarried woman *(shōjo)* as a social actor, symbol, fetish object, and finally consumer. "The *shōjo* and her 'girl culture' marked the rise of *kawaii* as a galvanizing touchstone of female, youth-oriented, affective, aestheticized, commodified Japan."[36] Girl culture and the cultivation of cute result in the generation and consumption of highly feminine commodities—referred to as *fanshii guzzu* ("fancy goods") and targeted primarily at women and girls. Some scholars have argued that consciously pleasurable consumption serves as a counterpoint to the hard work and performance pressures of school, work, and home life. Since, in Japan, work and preprofessional schooling are traditionally the domains of men and boys, and unmarried girls are not yet engaged in the womanly tasks of housekeeping and motherhood, such an argument sees girls as epitomizing the positive qualities of cuteness.[37] Through them, cuteness is a quality not only of humans and imaginary characters but of consumption itself. To consume cuteness and enact this consumption publicly (or even to oneself) is to signify one's longing for comfort and being taken care of. Importantly, by surrounding oneself with cute objects, individuals *become* cute. "Cute fashion in Japan was more than merely cuddling cute things; it was all about 'becoming' the cute object itself by acting infantile."[38] By becoming cute *(kawaii)* a person courts other people's need to nurture and care for something. Dependency, softness, and the need for nurturing are nostalgically associated with imagined childhood, but they are desired by all members of society, including women, boys, and adult men. This cuteness ceases to be the domain solely of girls and comes to

characterize all cross-sections of Japanese society.[39] The casting of one-self as cute in appearance, voice, and manner—including adopting a childish, rounded style of writing called *burikko*—is used by adult women as part of a strategy for success in professional work environments.[40] At its surface—and in most discussions of the phenomenon of cute fashion and behavior—*kawaii* culture is associated with innocence and asexuality. Innocence and childhood are, of course, not categorically separate from eroticism and sexuality. As observed by Yano, "Given the fetishization of schoolgirls in Japan (including their uniforms), practices of *rorikon* ('Lolita complex'; a fixation upon young girls as sexual objects), and the commercialization of these two in the form of *enjo kōsai* ('compensated dating,' that is, teenage girls socializing with men for pay), the sexy is not such a far reach from *kawaii* in contemporary Japan."[41]

The pervasive quality of cute aesthetics and the virtues related to cuteness are apparent in the nature of popular dolls as well: Licca-Chan (Rika-chan), the Japanese cultural equivalent of Barbie, is designed to be cute and gentle-looking, not glamorous. In describing their feelings about cute characters, Japanese people do not simply talk about the physical signifiers of cuteness (such as large eyes, an oversized head on a small, rounded body, a tiny or absent nose, and so on), but also about the relationships they develop with these characters. Thus a man in his thirties can speak about his deep bond with the character Doraemon, an attachment that is more significant and pervasive than simply *liking* the cat for being cute. Doraemon is the companion of a character called Nobita, a sweet boy who blunders into trouble regularly, only to be saved by Doraemon, who provides strange, futuristic gadgets from a magic pouch. Doraemon can therefore be seen as a guide or conduit to an imaginary idyllic realm, as Allison describes in the case of the adult Doraemon fan:

> What is cute here is not only the figure [Doraemon] cuts (blue color, pouch-lined tummy, oversized head, cuddly paws), but also the relationship Doraemon establishes with an imaginary world. Devices such as the *"doko-demo doa"* (door that opens into anywhere) are a reminder, for this adult fan, of something beyond the reality of his office, cramped housing and daily commutes. This is what [he] carries with him from his childhood fascination with Doraemon: a mechanism for interacting with the world of the imagination. And for him, this is soothing in an age marked by heightened alienation, atomism, and flux.[42]

One can read this desire as a form of nostalgia or escapism that contrasts the limited horizons of one's present adult life with the freedoms

of an idealized childhood. However, it might be more accurate to think of this view of childhood as aspirational rather than nostalgic, since the childhood in question is an imagined one, and the adult does not wish to return to the state of being a child so much as to embrace—in some shape or form—childlike qualities as an adult.

A similar aspirational and imaginal quality can be seen in the popularity of virtual pets in Japan, which exist on the screens of electronic devices such as the immensely popular (and cute) Tamagotchi, in which one can not only possess a cute pet but interact with it in substantive ways: the person hatches an egg on the screen and then cares for her virtual pet, which thrives depending on how much it is nurtured by its owner.

The pervasiveness of cuteness in Japanese culture is actively perceived as a positive thing by many people. As Allison reports from her fieldwork, parents approve of the phenomenon: "*Pokémon* has stimulated their kids' reading, motivated them to study and learn a minutiae of facts, helped create a cooperative play atmosphere between . . . children, encouraged creativity and strategy building, and fed interest in something they approach as active rather than passive consumers."[43]

THE CUTENESS OF COMMODITIES

The aspirational and performative functions of cuteness are strongly reinforced by consumer culture. In the case of Japan, commodity cuteness—as a pervasively identifiable form of cuteness—dates from the 1970s, when the economic boom of the late 1960s allowed for a massive growth in consumer culture, and children's fashion and toys focused on the cute and beautiful. It was at this time that Sanrio began marketing Hello Kitty products, which served as a catalyst for the development of cute and miniature consumer products as well as an entire advertising culture built around cuteness. Sanrio itself epitomizes this socioeconomic transformation: a dry goods company established in 1960 under the name of Yamanashi Silk Center Co., Ltd., it was completely restructured in 1973 to become the Japanese equivalent of the American company Hallmark. In order to capitalize on the emerging market for consumer goods such as stationery and other small, frilly, and colorful objects marketed to girls, the company's founder invented the new name Sanrio as one that was consciously non-Japanese and vaguely international: it carried a strong resonance of California, home of Walt Disney, whom the founder of the company idolized—"San" was for many a city in that state and "rio" the Spanish word for "river."[44]

By the 1990s, personal items branded with cute characters had become pervasive even among adult men, among whom the blue robotic cat Doraemon (of anime and manga fame and discussed above) was most popular.[45] Since then, cute character merchandizing has become an omnipresent part of commodity culture, appearing on everything from T-shirts and school supplies to housewares and clothing. Cute characters also appear on posters advertising public and private events, in the logos of banks, and on governmental announcements.[46]

Japanese commodity cuteness has a relevance that extends beyond the country's shores. The broad international appeal of Japanese anime, manga, and related character marketing is acknowledged to be economically and culturally important for securing Japan's place in the world.[47] Japanese cultural critics, together with the manufacturers of consumer entertainment and commodities such as *Pokémon*, attribute this to the aura of "cuteness," which has an appeal that transcends age and gender. As explained by Kubo Masakazu, a *Pokémon* producer, the entire *Pokémon* operation (resting on the three pillars of the card game, the electronic game, and the TV series and movies) consciously projects a "harmony" of its components that is attributed primarily to what is characterized as "cuteness."[48] The related entertainment businesses of anime, manga, and video games have a market importance that rivals the automobile industry, suggesting that Japan's global influence is as much cultural as it is industrial and technological. *Pokémon* (which generated over $8 billion in revenue in 2001) simultaneously defines cuteness and suggests that cuteness is perceived similarly by people around the world.[49]

Cuteness, specifically its gentle aspect *(yasashii)*, was intentionally made part of *Pokémon*'s appeal when its parent company decided to target a broader audience than the eight- to fourteen-year-old boys for whom *Pokémon* was originally intended. Interested in drawing younger boys, girls, and the mothers of these children into an ever-expanding franchise, the company consciously came up with a character that was unequivocally cute: Pikachu, with its characteristic shape, catch phrase *("pika pika chuuuuuu")*, and bright yellow body being emblematic of this cuteness.[50]

GLOBALIZED CUTENESS AND ADULT ASPIRATIONS

Japanese cultural understandings of cuteness and its relationship to consumer culture are not replicated in the Islamic world (although there certainly are local examples of youth culture imitating *kawaii* as a

fashion choice).[51] What the Japanese example demonstrates is the way in which notions of cuteness are contextually located in time and flourish with consumerism. It also serves as a clear illustration of the manner in which cuteness is not about children as much as it is about adults and their desires. And very importantly, it clarifies important ways in which cuteness is affective and aspirational, in the sense that the cute person, object, or behavior transcends its visual and physical characteristics and becomes an indicator of cultural values.

In the Japanese case, the emergence of modern cute is inseparable from the development of "fancy goods," which, it has been argued, is related to the simultaneous emergence of another category of consumer commodities, the "character goods" *(kyarakutā guzzu)* that are main aspects of anime, manga, electronic pets, and so on. "Variable in what this actually refers to, cuteness involves emotional attachments to imaginary creations/creatures with resonances to childhood and also Japanese traditional culture. The way in which cuteness gets packaged, however, is in a hyper-consumerist form that is also technologically advanced (digital screens) and nomadically portable (Game-Boys)."[52] It is the development of such "character goods" and their proliferation that give *kawaii*-based empathy the central role it enjoys in Japanese contemporary culture.[53] Put differently, it is a culture of popular goods and their consumption that generates the values that both shape and respond to culturally specific concepts of idealized cuteness.

A major point, and one alluded to throughout this book, is that cuteness is primarily about adults and not children. The condition of childhood is imposed upon children, in the sense that "childhood" is an adult-defined set of characteristics delineating what it is to be a child, not something intrinsic to children or what children themselves see the child-state to be. In this sense, cuteness is something that adults impose on children and in which children participate to varying degrees. "Cuteness, in short, is not something we find in our children but something we do to them."[54] Just as cute representations of cartoon cats sublimate the actual violence and unpleasantness of real cats, the emphasis on the cute aspects of a child draws attention away from unpleasant aspects of being a child and also those of being around one. Cute children don't throw tantrums, get earaches, need diapers changed, or set the dog on fire; they are not selfish nor do they have sexual identities. At the same time, cute children exist in a hermetically sealed world where they are untouched by horrible things as well as the tedious and mundane ones that characterize the real world of adults.

For the purposes of this book, my focus on discussing the cute is squarely on children and childhood, but it bears mentioning that the elderly get constructed as cute to almost the same degree as the young. Certainly, the cute elderly are not as culturally pervasive as the cute young, especially in consumer goods and their marketing, although the latter might have more to do with the nature of consumers with purchasing power than with anything else. But when stories, cartoons, and other idealistic media represent the cute elderly, they ignore the many harsh realities of old age and instead depict an almost childish state of softness and neediness, devoid of pain and disability. Cute, as a construction, stabilizes the state of the child and the old person, presenting both as discrete and sexless times, with no reference to the realities of human biology, social relations, and actual actions and their consequences.[55]

The juxtaposition of childhood with old age is demonstrated in figure 4, taken from the lesson on Islamic ritual requirements concerning charitable giving in a Turkish homeschooling textbook. Both the old man and the little girl are cute, as signified by their round faces and tiny eyes, noses, and mouths. In this example, the girl shown helping the old man illustrates the virtue of generosity, explicitly discussed in the accompanying lesson and in a text box facing the image, which contains a saying of the Prophet: "The giving hand is superior to the taking hand *(Veren el, alan elden üstündür)*." Such object lessons appear to afford agency to children (in their ability to help the elderly), and might be understood as blurring the boundary between childhood and adulthood. In fact, they do the opposite: the juxtaposition of the elderly as feeble and in need of assistance—illustrated by the stooped back and cane— with the very limited way in which a little girl can participate in the formal religious obligations of giving charity *(zekât* and *sadaka)* that are the subject of this lesson serves to bracket out the period of adulthood as a normative human status distinct from those of childhood and old age. Unlike the elderly, adults can cross roads without help, and unlike children, they can also fulfill their ritual obligations properly.

In removing entire categories of human beings from the real contexts of human existence, the construction of the cute sublimates the realities of violence, unpleasantness, and pain—indeed, entire processes that are integral to the course of human life. In so doing, the construction of the cute is actually an exercise in deformation or mutilation, wherein actual states, animals, objects, and phenomena are stripped of certain qualities in order to make them conform to the needs and expectations of others. The grotesque and mutilated nature of the cute was pointed out by

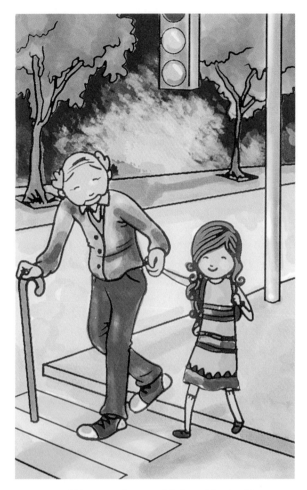

FIGURE 4. Old man and young girl, from Alpaslan Durmuş, Dudu Ekinci and Hatice Işılak (2008), *Ev Okulu, ilmihâl-2* (Istanbul: EDAM—Eğitim Danışmanlığı ve Araştırmaları Merkezi), 39.

Daniel Harris, particularly with regard to the way in which the cute-related attitude—at first glance solicitous, maternal, and nurturing—is actually a transformative gaze that mutilates the object of its affection in order to satisfy its own needs:

> Because it aestheticizes unhappiness, helplessness, and deformity, it almost always involves an act of sadism on the part of its creator who makes an unconscious attempt to maim, hobble, and embarrass the thing he seeks to

idolize. The process of conveying cuteness to the viewer disempowers its objects, forcing them into ridiculous situations and making them appear more ignorant and vulnerable than they really are. . . . Adorable things are often most adorable in the middle of a pratfall or a blunder: Winnie the Pooh with his snout stuck in the hive; the 101 dalmatians of Disney's classic collapsing in double splits and sprawling across the ice.[56]

The cute—to put it in the bluntest terms—is a category of mutant and deformed humans whose inferiorities, inabilities, weaknesses, and neediness allow one to patronize, subjugate, and possess them. And even though the creation of the cute is an adult exercise in deformation, children embrace the concept of cuteness in objects and in themselves, in part because of the seductive fantasy that cuteness represents, and partly because they learn early and repeatedly that conforming to notions of the cute carries substantial rewards. In fact, one might argue that children's participation in the culture of cuteness might be an instrument of their own empowerment, an escape from the constrictions of cuteness by imposing the category on another and thereby overturning their own status without actually subverting the paradigm.

CHILDREN'S BOOKS, RELIGION, AND CUTENESS

With the exception of textbooks, books intended for children belong squarely in the broad category of consumer goods and are marketed as such. In Turkey, as in many other countries, books for young readers are part of an array of attractive goods such as stickers, colorful pencils, and other stationery items. Related religious items include rulers (scales) with three-dimensional images of a child in prayer postures, digital watches with the call to prayer, and, more recently, talking prayer rugs such as the one advertised in figure 5. As has already been mentioned in the context of Japanese consumer culture, cute goods are aspirational and affective in a number of ways, in that cuteness reflects and shapes cultural values.

Visual cuteness is an important element of children's storybooks, where it functions as one of the primary signifiers indicating that a book is intended for children. This holds true for religious books as well, be they narrative in nature (for example, prophetic stories), moral fables, or instructional works. Such deployments of visual cuteness characterize almost all images from Turkish children's books in this chapter. Children, landscapes, and animals all appear happy and bouncy, with rounded elements to bodies and faces, tiny noses, and closed eyes—

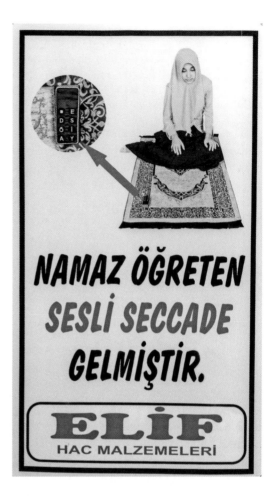

FIGURE 5. Advertisement for a talking prayer mat, Istanbul, Turkey (photograph by the author, December 2015).

resonating with visual signifiers of cuteness. Frequently there is nothing about such images that is identifiably religious, even though the theme of the books is explicitly about spirituality and piety. The book cover in figure 6 illustrates these characteristics: although the boy in the image is not physically round and chubby, he has a round face and round eyes. His own cuteness is reinforced by his smiling horse, with its blissfully closed eyes, curls, and absent feet. There is nothing specifically about the image on the cover of this popular book (in its sixth printing) that identifies it as religious. However, the title makes the subject matter clear as an account of prophetic miracles.

In addition to indicating that a book is intended for children, cute visual signifiers are frequently deployed in Turkish religious books to

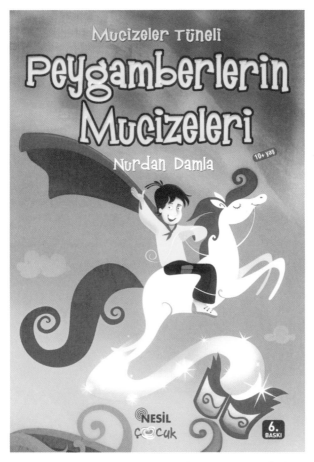

FIGURE 6. Cover page of Nurdan Damla (2007), *Peygamberlerin Mucizeleri* (Istanbul: Nesil Çocuk).

soften otherwise serious topics in a number of ways. Figure 7 shows a two-page quiz in the second volume of the same religious homeschooling book from which figure 4 is taken. The quiz asks students to fill in the blanks using one of seven words highlighted in boxes on the right-hand side. The questions focus on knowledge of Islamic ritual prayer: "The person making the call to prayer is called _____"; "The tall part of a mosque used for making the call to prayer is called _____"; and so on. This straightforward quiz is presented using a curious and complex visual rendering, in which the printed page depicts an old-looking open book reminiscent of a book of fairytales. Cute little children sit and

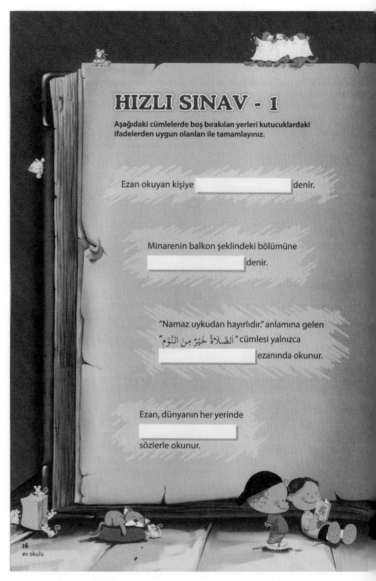

HIZLI SINAV - 1

Aşağıdaki cümlelerde boş bırakılan yerleri kutucuklardaki
ifadelerden uygun olanları ile tamamlayınız.

Ezan okuyan kişiye _____ denir.

Minarenin balkon şeklindeki bölümüne
_____ denir.

"Namaz uykudan hayırlıdır." anlamına gelen
"اَلصَّلَاةُ خَيْرٌ مِنَ النَّوْمِ" cümlesi yalnızca
_____ ezanında okunur.

Ezan, dünyanın her yerinde

sözlerle okunur.

16
ev okulu

FIGURE 7. "Quick Quiz," from Alpaslan Durmuş, Dudu Ekinci, and
Hatice Işılak (2008), *Ev Okulu, ilmihâl-2* (Istanbul: EDAM—Eğitim
Danışmanlığı ve Araştırmaları Merkezi), 16–17.

dua

aynı

sabah

kamet

şerefe

minare

müezzin

Camilerin, ezanı mümkün olduğunca uzağa duyurabilmek için yapılan yüksek bölümlerine _____ adı verilir.

Ezan okunurken müezzinin söylediklerini biz de içimizden tekrarlarız. Ezan bittikten sonra da _____ ederiz.

"Namaz başlıyor." anlamına gelen "قَدْ قَا مَتِ الصَّلَاةُ" cümlesi ezanda yoktur, sadece _____ okunurken söylenir.

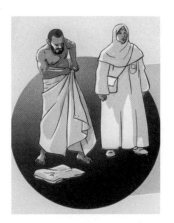

FIGURE 8. The Hajj, from Alpaslan Durmuş,
Dudu Ekinci, and Hatice Işılak (2008), *Ev
Okulu, ilmihâl-2* (Istanbul: EDAM—Eğitim
Danışmanlığı ve Araştırmaları Merkezi), 18.

stand in the foreground with a drowsy puppy and sleeping cat. The margins of the open book are covered with cute animal characters: little animals peek out from the pages, at the top right a mouse tempts a drooling dog with a bone attached to a fishing rod; below them, a bee is pouring water out of a watering can onto nothing in particular; and to the top left, a group of unidentifiable small mammals is huddled behind a white sheet while one of them holds a paint brush.

The layout of these two pages is curious, because this format of a book within a book, or of seemingly unnecessary cute characters, is not followed on other pages, including on those with subsequent quizzes. Leaving aside the possibility that it simply reflects bad production decisions, I believe the pages in figure 7 represent an excellent example of the use of cuteness and cute images as affective multipliers with the intent of eliciting an emotion. Quizzes in general—and first quizzes in particular—cause anxiety, and the abundance of cute markers framed in a storybook-like setting is designed to signify that the pages in question (and the quiz) should not be anxiety-inducing. The animals might even serve, to some degree, as stand-ins for adult human beings—parents and teachers—in an attempt to rid the quiz of an anxiety that adults themselves have felt on the numerous occasions when they have taken exams.

This example of the use of visual cuteness is in contrast to the page teaching about the Hajj pilgrimage, which only has representations of relatively normal looking adults (figure 8). The visual choices are significant: Hajj is an activity associated with adults, not children. In fact,

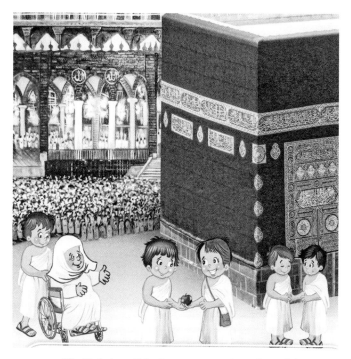

FIGURE 9. The Hajj, from Tuba Bozcan (2013), *Sevimli Tırtıl ile: Dinimin Değerlerini Öğreniyorum,* (Istanbul: Damla Yayınevi), 90.

it is a ritual that is frequently fulfilled late in life because it wipes one's slate of sins clean, which therefore places Hajj at the opposite end from childhood in the stages of life. In this context, children would be learning about the Hajj as a ritual in which adults engage and which they will only fulfill themselves when they are adults. As such, there is no need to make its representation appealing to children.

One Turkish children's book that actually shows cute children on the Hajj does so for complex purposes (figure 9). In a volume on learning the important aspects of Islam in a series titled "With the Cute Caterpillar," the text box at the bottom of the page provides information on the importance of the Ka'ba. The crowd of robed (and generally dark-skinned) worshipers in the background contrasts sharply with the cute boys and equally cute old lady in a wheelchair in the foreground. The boys are not participating in Hajj rituals at all, even though they are dressed in pilgrim's attire. Instead, they are engaging in virtuous and

meritorious deeds—helping an old lady, offering another Muslim a piece of fruit, and showing fellowship with other pilgrims. In short, the Hajj is being represented not in the context of instructing children on the important rituals associated with the pilgrimage but as a backdrop to teach about the fellowship of all Muslims and to provide examples of virtuous behavior in which good children ought to engage.

PERFORMING ANXIETY

Visual cuteness is frequently deployed to make anxiety-provoking, scary, or morally and ethically ambiguous situations more palatable to children. Very importantly, the decision to use cuteness in such situations is made by adults, not children, and therefore reflects adult concerns about suitability, which are only partly grounded in collective adult experiences concerning what children can and cannot handle emotionally and mentally. Adult concerns are equally based on adult conceptions of idealized childhood as a hermetically protected state, and on their own unresolved anxieties about the situations being represented.

Figure 10 reproduces pages from an illustrated book on the life of Adam, part of a series illustrated by Cem Kızıltuğ. Kızıltuğ is a highly regarded and internationally acclaimed cartoonist and illustrator who worked for the major Turkish newspaper *Zaman,* and has had his work featured in Turkish Airlines's advertising campaigns. He has made a name for himself in the production of children's books, and his distinct style has influenced several other artists. His illustrations for a series of books on the lives of the prophets published by Timaş and then republished in a new edition by the children's division of the press, Timaş Çocuk, set new standards in representational art that satisfied contemporary Turkish Muslim sensibilities regarding appropriate ways of representing religious heroes.

The double page in figure 10 depicts a scene from Adam and Eve's expulsion from heaven, a grave incident with the potential to be frightening, and one that is directly associated with negative aspects of the human predicament. The artist utilizes several strategies to soften the hardness of the myth: the bright color palette and simple geometric lines are complemented by the nonthreatening way in which the sun and planets are portrayed in a sky full of birds and twinkling stars. Even Satan—at the bottom righthand—is not especially frightening, despite being in the colors of hell fire.

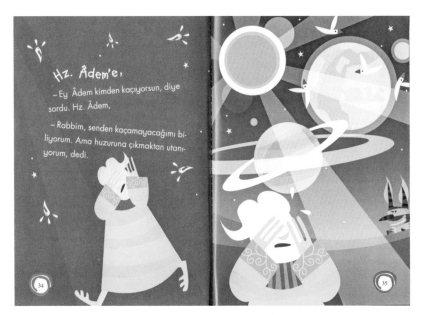

Hz. Âdem'e,

– Ey Âdem kimden kaçıyorsun, diye sordu. Hz. Âdem,

– Rabbim, senden kaçamayacağımı biliyorum. Ama huzuruna çıkmaktan utanıyorum, dedi.

FIGURE 10. Adam's expulsion from heaven, from Belkis İbrahimhakkıoğlu and Cem Kızıltuğ (2013), *Hazreti Adem*, Peygamber Öyküleri (Istanbul: Timaş Çocuk), 34–35.

A similarly conscious use of representational strategies is apparent in Kızıltuğ's depiction of the crucifixion in a book on the life of Jesus (figure 11). The difference between good and evil characters in the scene is visually signified by the roundedness of the good or innocent people inside the window, the spikey angularity of the figure in the foreground, and the two men with the cross. The cross itself constitutes the strongest affective element of the image: it is visibly animate and anthropomorphic due to its shape and the inclusion of hands, eyes, and a mouth, but its moral standing as good or evil remains unclear. On the one hand, the big, sharp teeth and sharp angles indicate that the cross is bad. But on the other, the nails piercing it might also suggest that it is a victim rather than a willing participant in the crucifixion. What is certain, however, is that the absence of a human figure being crucified, or even a direct allusion to the gruesome physicality of the incident, results from adult understandings of propriety in depicting violence and their own difficulty in coming to terms with the existential and theological problems of evil—in simple terms, the problem of understanding why God allows or wills bad things to happen to good people.[57]

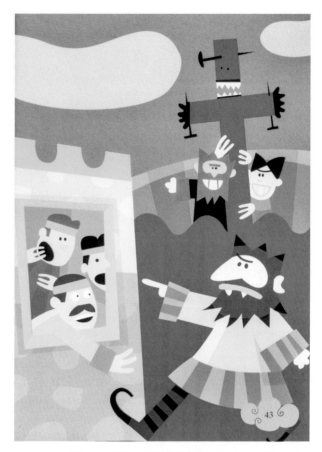

FIGURE 11. The crucifixion, from Belkis İbrahimhakkıoğlu and Cem Kızıltuğ (2013), *Hazreti İsa,* Peygamber Öyküleri (Istanbul: Timaş Çocuk), 43.

WASHING THE BLOOD FROM SACRIFICE

The morally ambiguous religious event par excellence in a Muslim context is the Abrahamic sacrifice. Even though the Qur'an does not specify which of his sons Ibrahim (Abraham) intended to kill, Muslim scholarly and community consensus quickly settled on Isma'il (Ishmael). The broad outlines of the myth, as believed by the majority of Muslims, are that either God asks Ibrahim to sacrifice the thing most dear to him as a test of his loyalty, or else Ibrahim promises to do so as part of a vow. His most cherished thing is his son Isma'il, and he is set on fulfilling this painful sacrifice. The temptation not to go through with the killing of

his child is represented by Satan, who appears three times to Ibrahim, and each time the prophet turns away from temptation, turning Satan to stone. Isma'il is a willing sacrificial victim and lays down to have his throat cut, but the father cannot bear to watch himself kill his son and blindfolds himself. In most understandings, he then carries out the act of the sacrifice, but unknown to him, God has substituted a ram for Isma'il, and Ibrahim opens his eyes to see his unharmed son standing by his side and a dead sheep in front of him.

Commemoration of the Abrahamic sacrifice is central to Muslim ritual life. The three petrified Satanic pillars in Mecca are stoned ritualistically by pilgrims during the Hajj and lesser pilgrimages ('Umra), and the actual sacrifice is commemorated all across the Islamic world. Called *Kurban* in Turkish, it marks the end of the Hajj, but the sacrifice itself occurs everywhere with direct family involvement, including that of children. Outside of dense urban centers, families purchase sheep, goats, cows, and even camels and bring them home, where they are fed and nurtured for several days before the festival. Not surprisingly, children tend to treat the sacrificial animal like a pet during this period, with predictable traumatic feelings when it is eventually killed. Even in most urban areas, there is no escaping the slaughter: animal markets appear in places where they do not ordinarily exist, and people who normally buy meat from markets purchase live animals and arrange to have them killed ritualistically, or else they take them home and sacrifice them in the streets or on the roofs of apartment buildings, with flowing blood visible to any and all passersby.

Blood sacrifices—substitutionary or otherwise—are morally ambiguous phenomena, a point made clearly in some modern scholarship on them and dealt with in this book, in terms of its sociopolitical implications, in chapter 7. In particular, the Abrahamic sacrifice can be critiqued for elevating the sacrifice of one's children (specifically, one's sons) as the most selfless moral act an individual can do, and for how this message contributes very directly to the glorification of warfare and the perpetuation of male privilege. Apart from these societal implications, the Muslim animal sacrifice is emotionally and morally problematic not just for children but also for parents, who need to explain why a cute fluffy pet has its throat cut in public and is converted into meat, offal, and hide. This adult anxiety is reflected in the visual treatment of the subject matter, where cuteness is aggressively deployed to the exclusion of any representations of the blood sacrifice itself.

Examples of visual strategies to soften the violence of animal sacrifice abound in Turkish religious children's books. Figure 12 reproduces one of

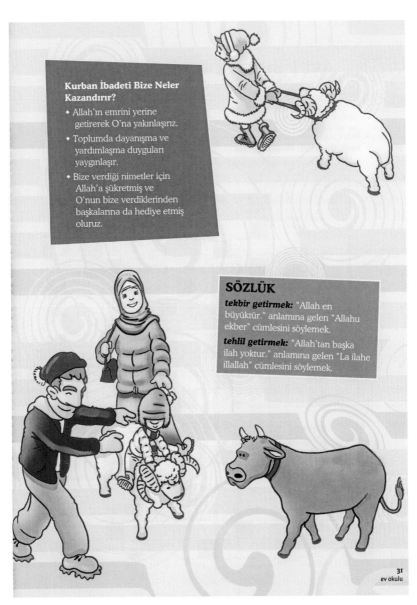

FIGURE 12. The festival of the Sacrifice (Kurban Bayramı), from Alpaslan Durmuş, Dudu Ekinci, and Hatice Işılak (2008), *Ev Okulu, ilmihâl-2* (Istanbul: EDAM—Eğitim Danışmanlığı ve Araştırmaları Merkezi), 31.

two facing pages of the lesson on the sacrifice from the same homeschooling textbook from which examples appear earlier in this chapter. The text unambiguously explains that the main holiday of the Islamic calendar, Kurban Bayramı, is so named because of the animal sacrifice central to it. It goes on to describe the kinds of animals that can be slaughtered, and explains the important lessons this festival provides. But the illustrations accompanying the text are markedly devoid of any allusion to the blood sacrifice itself. A cute lamb stands by itself on the facing page and a little girl dressed for winter in a pink hat, earmuffs, and boots leads a ram to nowhere in particular. At the bottom right, a brown cow stares intently as a little boy, with his hat falling down over his eyes, takes a ride on a ram while his parents look on in a scene that seems to have substituted the animal for a sled. All the vignettes would fit perfectly into an illustrated story about a family visit to a farm, and provide no indication of the bloody seriousness of the event they purport to illustrate.

The lack of direct visual reference to the Abrahamic sacrifice in this example is not an isolated case. Figures 13 and 14 show two consecutive pages from a book titled *Tale of the Sacrifice*. The first plate describes how Satan (shown here as a man dressed in blue) tried to tempt both Isma'il and his mother Hajar into refusing to cooperate in the sacrifice, and tells how they both reaffirmed their readiness to participate. Aside from simply looking like a mean person with an angular shape, dark circles around his eyes, and a toothy mouth, there is nothing that marks Satan as especially demonic.

The subsequent page (figure 14) relates the exchange between Ibrahim and his son immediately prior to the sacrificial act, and tells how an angel substituted a ram for the boy. Again, the sacrifice is not represented; one only sees a round and happy ram staring off the page in a colorful landscape.

The strategy of using visual affect to moderate emotional responses to the blood sacrifice is demonstrated best in Kızıltuğ's illustrations in the volume on Ibrahim in an earlier edition of the series on the lives of the prophets from which examples from the volumes on Adam and Jesus appear in figures 10 and 11. The cover of the book (figure 15) shows nothing of Ibrahim except his hand holding a knife. As with the crucifix in figure 11, the illustrator has animated an object, in this case the knife; when it appears on the cover and throughout the book, it smiles beside a bouncy and fluffy sheep. The actual sacrifice is never alluded to directly, and there is no departure from the overwhelmingly positive visual tone.

FIGURE 13. The temptation of Abraham, from Mehmet Nalbant and Betül Aytaç (2006), *Kurban Öyküsü, Hz. İbrahim,* 2nd ed. (Istanbul: Semerkend, Mavi Ucurtma Series), 22.

İbrahim:

"Oğlum,

Biricik yavrum,

Seni rüyamda

Kurban ediyordum."

İsmail:

"Babacığım,

Ben hazırım.

Feda olsun rabbime canım."

İbrahim biledi bıçağını,

Denedi kesmeyi kurbanını,

Bıçak kesmedi.

Taşı kesti,

İsmail'i kesmedi.

Melek bir kurban getirdi,

İsmail'in yerine kurban kesildi.

FIGURE 14. The sacrifice, from Mehmet Nalbant and Betül Aytaç (2006), *Kurban Öyküsü, Hz. İbrahim,* 2nd ed. (Istanbul: Semerkend, Mavi Ucurtma Series), 23.

FIGURE 15. The Abrahamic sacrifice, cover page from Belkis İbrahimhakkıoğlu (author) and Cem Kızıltuğ (illustrator), *Hazreti İbrahim, Peygamber Öyküleri* (Istanbul: Timaş Yayınevi).

CONCLUSION

All these examples of children's books belong squarely within the realm of consumer culture. Regardless of whether or not children make choices to acquire or to read specific books, the decisions to write, publish, distribute, and—to a major degree—purchase them are made by adults whose motivations in these regards are complex and frequently unarticulated. Aspirations regarding the nurturing of future, model generations run deep in Turkish society both as part of the secular national

project and in a variety of religious agendas. The religious and moral educational books examined in this chapter fit within precisely this framework, as materials that simultaneously seek to frame the experience of children and to construct childhood in ways through which children and their cuteness become instrumental in determining the allowable nature of affective response in a range of circumstances. Cuteness becomes a visual affect of virtue in such a complete way that for children to be cute directly marks them as virtuous. This matter is amply demonstrated in the religious poster arts of Pakistan, which are analyzed in the next chapter.

The Poster Children of Pakistan

Pakistan differs markedly from Turkey and Iran in the important respect that it has not prioritized basic literacy and universal education. Barely 2 percent of the federal budget goes toward education, and much of that is for higher education, especially in the sciences, which are perceived as essential to national security and prosperity in ways that primary and secondary schooling are not. Federal spending is supplemented by the provincial budgets, but it is still much lower than the share of the budget allocated to education in either Turkey or Iran. And when one takes into account that both Iran and Turkey are substantially wealthier countries than Pakistan with less than half the population, the actual disparity between educational spending is stark. A direct result of the low priority placed on primary and secondary education is that Pakistan's literacy rate is extremely low (the lowest in its cohort of countries when viewed on a developmental scale). There are many consequences of this phenomenon, but, for my purposes here, the most important is that a largely illiterate or semiliterate population necessarily has a different relationship to the value of images and text as signifiers than do more literate polities.

THE MEANING OF LITERACY

According to the population census of 1981, Pakistan indicated a literacy rate of 26.2 percent, with literacy being defined as the ability to

"read a newspaper and write a simple letter in any language."[1] By the time of the population census of 1998, literacy rates had risen to 43.9 percent, and there is evidence to suggest that the rate of growth has increased since then, albeit at a very slow rate. But there remain marked disparities between provinces, between urban and rural areas, and between genders. Overall, males were more than twice as likely to be literate than females in 1981, a ratio that improved only slightly at the end of the last century, with male literacy rates of 54.8 percent versus female rates of 32 percent. The urban literacy rate was almost twice that of the rural rate (63.08 versus 33.6 in 1998), although this represents a significant improvement over the statistics from 1981, when the ratio was 47.1 to 17.3. The biggest disparities remain between urban and rural areas, especially the remoter parts of Baluchistan and the Federally Administered Tribal Areas (FATA) bordering Afghanistan, where the literacy ratio across gender is also the worst. In such underdeveloped areas, the literacy rate was around 17 percent at the end of the last century, against an urban literacy rate of 63 percent, and the female rates were one-sixth the male rates.[2]

TWO-TIERED EDUCATION

I have discussed the social implications of the uneven nature of literacy in Pakistan and its relationship to religiosity elsewhere.[3] Literacy rates are the most tangible signifiers of the concept of educatedness in Pakistani society, where being educated is an important indicator of status. Access to this status comes from formal education, just as it does in other societies, but education in Pakistan is fraught with particular difficulties as a direct consequence of the country's multiethnic makeup and a colonial legacy that has privileged English and Urdu in important ways.

At its independence from the British in 1947, Pakistan inherited a stratified system of education that has grown even more complicated over the years. The highest tier is occupied by private schools originally designed to educate British and Anglo-Indian children or else to teach (and civilize) the children of the feudal aristocracy of the Punjab and its frontier. They are joined by new, small, elite English-medium schools that promise a quality of education rivaling that provided by the very top tier of the established private schools. Next come a range of private English-medium schools run by Catholic missionaries or else by large state corporations or else the federal government as part of a program of elite schools.[4]

Somewhat below the secular private schools and missionary schools are schools for boys run by the Pakistani military. Some were taken over in the 1970s from Christian missions as part of a wider project of nationalizing education, while others were established for the specific purpose of serving as feeder schools for the military or as institutions offering a decent education (primarily, but not exclusively, to the children of army officers) in places with no other acceptable schools. In addition to the military schools, institutions such as the national railways, the national power company, the national steel corporation, and the national tobacco company (most of which are legacies of the British) run schools for the children of their executives and anyone who has the money to attend.

Below these elite schools are government-funded public schools for both boys and girls that teach in English, and below them are Urdu-medium government schools. There is very little schooling in the native languages of the majority of the population even though the overwhelming majority of Pakistanis do not speak either Urdu or English as their first language.

Urdu was the language associated with Muslim nationalistic aspirations in British India and carried ideological value for the leadership of the Muslim League, whose members dominated Pakistan's leadership for the first years after its independence. It was imposed as the national language of the new state, despite the fact that Urdu was spoken by less than ten percent of the residents of what is now Pakistan. Even though English has remained the language of true power and prestige in the country, Urdu has emerged as the language of the middle class. It is spoken by everyone with a primary school education or with exposure to national media, which is almost entirely in Urdu. It also carries strong nationalistic and nativistic connotations among the middle class, who view it as a "Muslim" language in ways they do not regard the ethnic regional languages, and certainly not English.

The imposition of Urdu as a national language was met with considerable resistance, and the Pakistani government's failure to implement an effective program in universal education is, to some extent, a direct result of its attempts to accommodate resentments in a federated state with provinces explicitly named after ethnolinguistic groups. On the one hand, Urdu is the official language of the country and is necessary for accessing services—including employment, education, medical care, and legal recourse—from federal and provincial governments as well as from parastatal agencies. On the other, the federal government affords

considerable autonomy in decision-making to the provinces. In particular, public primary and secondary education is channeled through provincial governments. Beyond providing guidelines on basic curricular requirements, the federal government allows the provinces to shape their textbooks to their own liking, a practice that runs counter to the goals of using universal secondary education as a tool of nation-building as one sees in Turkey and Iran. Teacher training and certification for the public schools are also left to the discretion of the provinces (and are not enforced with private schools).

On top of the many problems resulting directly from the lack of an effective centralized prioritization of education, the relationship between Urdu and English is poorly defined. English remains the language of prestige and of most higher education, relegating the national language to an arena where it is neither owned by the majority of the population nor taught evenly. Tariq Rahman provides a succinct appraisal of the complex relationship between Urdu and English in Pakistan:

> Urdu, then, is very much at the centre of three highly explosive issues in Pakistani politics: ethnicity, militant Islam, and class conflict. The state teaches Urdu to counter ethnicity but this has two contradictory effects: first, it strengthens ethnic resistance because it keeps the grievance of suppressing ethnic languages alive; second, it strengthens the religious right because Urdu is associated with, and is used by, the religious right in Pakistan. But the religious right does not represent religion alone. It also represents the class-wise distribution of power (and resources which are a consequence of it). . . . The upper echelons of liberals and leftists, who should have favoured Urdu and the indigenous languages of the people, have generally favoured English. . . . Much of the indignation against the Westernized lifestyles of the elite, though couched in the idiom of religion, is really an expression of the anger of the dispossessed. As Urdu (vis à vis English) is one of the symbols of the dispossessed in most of the urban centres of the country, it is intimately connected with class politics as well as ethnic politics in Pakistan.[5]

It is this combination of factors, including an aspiration to national unity and a recognition that Urdu represents the best prospect for economic advancement for individuals belonging to marginal or economically disadvantaged groups, that ensures the pervasive use of Urdu and the demand for schooling in it. Yet, despite the fact that the overwhelming majority of students attend Urdu-medium schools, be they public, private, or religious, the lion's share of government spending on schools goes to the English-medium public schools, which, sadly, still rank at the bottom of the schools that use English as a medium of instruction.

The disparity in educational systems and standards is so great as to make the distinctions caste-like, a form of educational apartheid that stays with most people for the rest of their lives.[6]

For all intents and purposes, the government of Pakistan has both ceded its responsibility to provide universal public education and shown very limited interest in using the public educational system as a truly potent tool of nation-building. This is not to say that national ideologies are not promoted through the primary and secondary curricula, but that they are reflective of the reticence that state spokespeople feel in defining a national identity. Indeed, in the absence of a unifying narrative of ethnic nationalism such as one finds in Turkey or Iran, Pakistani nationalism does not promote any ethnolinguistic identity but rather one defined by a religious vision. This phenomenon is shared by Iran as well, but in the latter case religious revisionism is used primarily to delegitimize the version of nationalism promoted by the previous monarchical regime and to position the country as a pan-Islamic force. In contrast, Pakistan's religious narrative is designed to legitimate a modern state against its own potential subnationalisms. One example illustrating this situation is the way the origins of Pakistan are explicitly linked in social studies textbooks to the eighth-century Arab general Muhammad ibn Qasim (d. 715)—he is celebrated as the first Muslim ruler in South Asia and even as the "founder of Pakistan."[7]

The Pakistani state has invested heavily in the maintenance of a separate system of education for the financial and power elite, expending disproportionate funds on the upper end of its multitiered system. On the one hand, this situation indicates that the Pakistani government does not have much faith in its own system of public education.[8] On the other, it represents an explicit acknowledgment of the crucial role fluency in English plays in stratifying Pakistani society, and the acceptance of a multitiered class structure with an almost insurmountable chasm between English speakers and those whose educational aspirations do not, or cannot, extend beyond what is taught in Urdu-medium schools. No recent figures are available comparing expenditures on Urdu versus English schools; however, in 1999 it cost Rs. 2.66 million (roughly US $26,000) to open three Urdu-medium primary schools in Islamabad—perhaps the most expensive market in the country. In contrast, it cost Rs. 10 million (US $100,000) for one military school in Larkana, Sindh, where land prices should be much cheaper.[9] And this school does not rank anywhere near the top among the government-subsidized English schools.

Fifty years ago, before elite private schools had multiplied in number in urban areas, access to English-medium schools was already an important method of maintaining class distinction in Pakistan:

> In fact, there is a lot of evidence that the products of such schools came from richer and more powerful families than their vernacular-educated counterparts and did consider themselves superior to them even without reference to their privileged schooling. Schooling, however, gave them an obvious marker of elitist identity: the spontaneous and natural use of Pakistani English in an accent nearer to the British pronunciation than that of other Pakistanis. Moreover, what increased their self-esteem was the fact that they did, indeed, fare better in the Inter Services Selection Board (ISSB); the armed forces academies; the superior civil services examinations, and other elitist jobs in the sixties. Moreover, they felt that no drawing room, however posh; no club, however exclusive; no organization, however elitist—both in Pakistan and abroad—was closed to them. English was much more than a language; it was a badge of status; a marker of elitist upbringing. It gave confidence and even without wishing to sound snobbish, the fluent speakers of English from the English-medium schools (especially from the elitist missionary schools who spoke even better English than their counterparts from the cadet colleges) appeared snobbish to others.[10]

The division between English and Urdu education is caste-like at its extremes, but there is a degree of class overlap between the bottom tier of state English-medium schools and the top tier of Urdu ones, with the latter found only in urban areas. In these circumstances, the choice to attend an English school—however poor it might be—is one based on an aspiration for socioeconomic advancement.

RELIGIOUS EDUCATION IN PAKISTAN

In the absence of a robust system of universal public education, Pakistani parents turn to the patchwork of private schools of varied quality and provenance. These include private Islamic religious schools, or madrasas, which are held accountable by their critics not only for failing to teach the national curriculum but also for indoctrinating children into a closed-minded, violent, and xenophobic view of the world. There is also a broad belief that, because of the lack of universal public education, the madrasas constitute the only available option for poor children. Belief in the pervasive presence of madrasa education in Pakistan and in its potential malevolence is widespread and shapes the educational policies of Pakistan in ways that are not necessarily conducive to the interests of children.[11] Ahmed Rashid, the best-selling expert on politicized

Islam and violence in Pakistan and Afghanistan, cites an unspecified intelligence report to say that, in 1988, over half a million students were enrolled in a total of eight thousand registered and twenty-five thousand unregistered madrasas.[12] Similar views on madrasas and education in Pakistan are reflected in media reports that rely on largely unsubstantiated claims made by policy makers, civil servants, and the police, which vary widely in their estimates of madrasa attendees, from between 10 percent of all Pakistani students to a ridiculous 33 percent.[13] In turn, much of the scholarship on education in Pakistan relies on reports in the English-language press for statistics on madrasas.

Four unavoidable conclusions are to be drawn from such reports: (i) the popularity of madrasas is a direct result of the failure of the government of Pakistan in providing comprehensive public education throughout the country; (ii) madrasas teach a politicized, intolerant, and virulent form of Islam in a way that other educational institutions do not; (iii) the number of madrasas is growing as is their enrollment; and (iv) their growth is directly linked to the growth of virulent Islamic ideologies in Pakistani society. In fact, more rigorous empirical research on education in Pakistan suggests that the role of madrasas is orders of magnitude less than what many supposed experts hold to be the case.[14]

The supposed correlation between poverty, religious militancy, and madrasa education in Pakistan is unproven. In fact, research suggests that the choice to send one's children to a madrasa is not primarily ideological. Almost half the families who send their children to madrasas also send them to public schools, and more than a quarter enroll their children in secular private schools along with madrasas, or else all three categories of schools simultaneously. It is probably true that a higher fraction of children go to madrasas in situations—such as remote rural areas—where other schooling options are unavailable, and that the percentage is higher among the poor than the rich, but the numbers doing so are very small, standing at less than 4 percent. In areas where public and private schools are available, family income has no significant impact on whether or not one belongs to that 1 percent of the population that sends children to madrasas. In fact, it appears that enrolling a child in a madrasa is one of the least important factors that families consider in decisions surrounding the education of their children.[15] "[T]he schooling decision for an average Pakistani household in a rural region consists of an enrollment decision (Should I send my child to school?) followed by a private/public decision, with a *madrasa* as a possibility. When there are no nearby schools, households exit from the

education system altogether, although there is evidence of an increase in the market share of *madrasas* among the poor in these settlements. When both private and public schools are available, richer households exit to the private system, but there is no difference in *madrasa* shares with household."[16]

RELIGION AND VERNACULAR CHOICES

Paralleling the broad range of educational situations in Pakistan, a distinctive feature of the society with relevance to this book is the ways in which a relatively weak governmental project of ideological formation allows for the robust existence of a variety of religious practices and views. The most formal divisions among Muslims in the country follow sectarian lines, with the majority professing adherence to various forms of Sunnism and approximately 20 percent to Shi'ism. The majority of Sunnis have no conscious sectarian identity beyond being Sunni, although they nominally follow the Hanafi legal school and the confessional tradition of the *'ulama* of the Barelwi tradition. This distinguishes them from other Sunnis, in particular the Deobandis—who have become politically visible and influential since the 1970s—as well as from the Tablighi Jama'at and the Ahl-i Hadis.[17] Even though Pakistan does not have a vigorous educational system to impart ideology to schoolchildren, religious attitudes in the country are shaped by a variety of modern belief systems. The Sunni movements that dominate the country— the Barelwis, Deobandis, Ahl-i Hadis, Tablighi Jama'at, and even the newer Salafi movements—emerged out of the reformist atmosphere of the nineteenth century and early twentieth. Among the majority of these groups, the *'ulama* saw themselves as defenders of religion against forces of secularization and Westernization as well as against religious corruptions.

Although there is vibrant and contentious debate among religious groups on the ways in which doctrine and theology should structure social life, the fact is that the high-ranking *'ulama* have limited direct influence on the attitudes and behavior of the population at large. This is a direct consequence of factors discussed above: the absence of a comprehensive educational infrastructure, and the related lack of commitment to the promulgation of Urdu, which maintains a separation between the high-ranking *'ulama* (who use Urdu almost exclusively) and the bulk of the population, which is still more comfortable in subnational languages. It is the more charismatic (and often more

politically strident) lower ranks of the *'ulama* who enjoy greater influence in shaping religious and social opinions.

In public culture, modern differences among the majority Sunnis and their attitudes toward minorities represent the major factors of Muslim practice and identity in Pakistan. Regardless of official denominational affiliation, the major division among the Sunnis is between those who believe in intercessory models of religious life and salvific expectation on the one hand, and those who deny any intercessory power on the other. As is the case in many parts of the Islamic world, including both Turkey and Iran, vernacular religious beliefs and practices allow for the participation of a multitude of living, dead, and even mythical saintly figures who function at the center of devotional life. Sufi saints fulfill this role for most Pakistanis. Some Sufi figures, such as 'Ali Hujwiri (called Data Ganj Bakhsh, d. 1077 CE) or La'l Shahbaz Qalandar (d. 1274), enjoy such popularity that they can be considered national saints; others are of local importance and tend to be unknown outside a limited geographic area.

The essential quality of such saints is their possession of a charismatic religious power, called *barkat* in Pakistan and Iran *(bereket* in Turkish, from the Arabic *baraka)*. *Barkat* is a divinely bestowed nonmaterial commodity possessed by saints, which they can pass on to others in two forms. The first is contagious *barkat,* which is passed from the saint to a disciple, either deliberately on the part of the saint or else through a ruse on the part of the receiver who "steals" some of the saint's charisma. Contagious *barkat* can subsequently be passed on to others as either contagious or noncontagious *barkat.* Noncontagious *barkat* is the kind that is sought by the majority of religious devotees as a blessing, a promise of good fortune, or a protection against misfortune. Once received, this kind of power is limited to the recipient and cannot be passed on to others. *Barkat* is most often acquired through visiting shrines, where petitioners pray, make vows, and offer money. Devotion to saints and shrine visitation are a major part of the religious life of many people in Pakistan as well as in Iran and Turkey. Unlike mosque-based rituals, devotional acts involving shrines occur largely on the devotee's own terms: there is no real schedule of visitation (apart from specific festivals), and one can go at one's own need and convenience. Petitioners are also at liberty to visit any shrine they want and show devotion to a multitude of departed saints, since there is no formal competition between shrines demanding exclusive devotion.

Barkat plays a complex and informal role in the quest for a successful and virtuous life: believers in *barkat* engage in acts of gift giving—of

money, flowers, shrouds, vows of service, and so on—in exchange for which they acquire *barkat* in a process of exchange that is not linearly commodified. Their rituals of gift giving are simply viewed as pious acts that participants in the system hope will be viewed by the saintly possessor of *barkat* as a mark of their virtue and devotion, thereby increasing the chances of petitions being granted.[18]

As mentioned above, devotion to saints and shrines is a common religious practice in many parts of the Islamic world, and is part of a broad, informal system of religious practice that is not limited to any clearly defined sectarian group. In the case of Pakistan (and in South Asia in general), the reputation of charismatic shrines and individuals crosses sectarian and even religious divisions, such that many Islamic shrines in Pakistan are visited by Hindus, Christians, and Sikhs. The only formal Sunni school in Pakistan that sanctions shrine visitation and devotion to saints is the Barelwi one.[19] However, the majority of Pakistanis do not follow the specific rulings of religious scholars very closely, such that shrine visitation, devotion to saints, and the spiritual economy of *barkat* are all essential components of the tapestry of vernacular religion in the country. This adherence to an intercessory model of religion frequently comes into conflict with nonintercessory doctrinal models, but its expression among Pakistani Muslims is a direct result not of scholarly teaching but of a constellation of beliefs.[20]

POSTER ARTS

It is difficult to make a definitive case for this, but Pakistan's lack of comprehensive literacy and education, low average purchasing power, and weak central state must have important consequences on matters of social and cultural infrastructure. Arguably, these conditions allow for a dispersed and rich visual culture, which is obvious in several aspects of the Pakistani visual regime, most strikingly in trucks and other decorated vehicles.[21] One notable element of the religious visual culture of Pakistan is the proliferation of posters that are sold near shrines or at certain religious bookstores. Covering a range of subjects, they reflect two main printing technologies, the first being cheaply produced chromolithographs and the second glossy posters on higher-quality paper and often in larger sizes, reprinted on the back of old poster stock imported from Europe.[22] Religious posters are sold together with nonreligious ones depicting pleasing subjects such as landscapes, flowers, birds, and cute babies. Ones with majoritarian and broadly acceptable

religious content frequently are sold in regular book and stationery shops. Other posters, such as ones with a regional Sufi appeal, ones with explicitly Shiʻi content (especially when they have images of religious personages), and ones that would be considered too kitschy by urban, middle-class consumers, are sold at stalls near shrines or in the rapidly vanishing book and paper markets (called "Urdu bazaars").

Shrine shops sell posters depicting a variety of subjects in addition to religious ones. The subject matter of Sufi posters can reflect the importance of the local shrine or depict others in the immediate region, or they can be posters featuring important Sufi figures of national importance such as ʻAbd al-Qadir Jilani (d. 1166), Data Ganj Bakhsh ʻAli Hujwiri, or Laʻl Shahbaz Qalandar. Some shrines, such as that of Mian Mir (d. 1635) in Lahore, combine a Sufi and Shiʻi appeal and shops in their vicinity sell Sufi posters alongside Shiʻi ones, which often depict ʻAli and other religious figures, although such activities have diminished in recent years as a consequence of the intensely politicized religious climate of the country.

Research on Pakistani truck decoration and on Indian religious chromolithographs makes clear that such popular visual forms can be understood most productively within their sociocultural framework rather than in the context of historical trajectories of artistic production. Consumers of such visual items, and of popular religious arts in general, show little interest in the authorship, aesthetic merit, or details of production. Instead, they are concerned primarily with the function of images as "the sources of future interventions, rather than as embodiments of past intentionalities."[23]

Popular religious posters can be encountered in many places in Pakistan, but it is difficult to assess how they function within domestic space, beyond their role as religious souvenirs and the wider affective functions discussed in the following pages. For example, there is no recognizable tradition of placing pictures of pious children in children's rooms for didactic or exemplary purposes, nor are there devotional practices associated with such images. But adult attempts to inculcate good behavior in children rely on visual representations of children in school textbooks and on educational posters illustrating proper hygiene, civic sense, and a number of other topics. It therefore stands to reason that religious posters featuring children could serve related functions.[24]

In some ways, Pakistani religious posters are related to Indian chromolithographs, although stylistically they combine elements from Indian and Iranian representational traditions.[25] Such posters are

referred to as "religious images" *(maẓhabī taṣwīr)*, "religious posters" *(postar-i dīnī)*, and "images [or souvenirs] of pilgrimages" *(ziyārat kī taṣwīr)*, and are treated most often as religious souvenirs. They are often framed by the recipient and displayed in small shops, restaurants, or devotees' homes. At smaller shrines, they can fulfill a votive function, having been donated by devotees of the shrine and subsequently displayed. As in the case of Indian calendar arts, some artists and publishers in Pakistan specialize in the painting of Sufi religious posters, among them Hafiz Qamar ud-Din and Sons, Malik Shafiq Art, Sarwar Khan, and Mama Calendarwala.[26] However, the nature of the subject, the demands of consumers, and the lack of cultural awareness concerning intellectual and artistic property rights mean that paintings are frequently modified or imitated, or that elements of one are reworked with parts of others in a collage. The positive result of such a dynamic culture of production is that posters are artistically, aesthetically, and affectively innovative, and they reflect changes in sociocultural dispositions quickly, if not always in ways that are easy to analyze.

The relevance of poster arts to changes in modern societies has been analyzed extensively by Christopher Pinney in the case of India, where chromolithographs—"photos of the gods"—have exhibited dynamic iconographic transformations from the late nineteenth century through the many phases of change undergone by Indian society over the course of the twentieth century, and they have helped frame society at the same time as they have reflected it.[27] The majority feature Hindu deities, although political figures (sometimes in conjunction with gods) are also important subjects of such posters. Images of children have appeared primarily in the context of the depiction of Krishna as a baby. Toward the end of the twentieth century, one witnesses a marked increase in the popularity of this kind of image, and child manifestations of other deities, such as Parvati, Rama, and Hanuman, are now readily available.[28] Shiva—a deity whose countenance and iconographic markers should not lend themselves easily to being depicted as a child—is also a popular subject. As a child, the ascetic god is cute, chubby, and sweet, mimicking established conventions of depicting Krishna.[29] The growing popularity of cute children as manifestations of the Hindu gods has not yet been the subject of any sustained analysis, but it does suggest a late-twentieth-century neoromantic or nostalgic turn to the cute in a manner that resonates with the growth of cute consumer culture in societies such as Japan. Over the same time period as when one sees the popularization of Hindu child gods, one also witnesses an increased reliance on images of

children—holding guns or dressed as soldiers, farmers, or politicians—in Indian poster arts.[30] I will take up the importance of the visual representation of nationalistic children in the construction of modern sociopolitical discourse in the context of Iranian society in the next chapter. More generally, the cuteness and innocence of children are visually deployed in what could be called "wish images" in order to reflect and instill notions of goodness and virtue in adults as well as children, a phenomenon amply demonstrated by the religious poster arts of Pakistan.

THE CUTE, THE GOOD, AND THE VIRTUOUS

The poster in figure 16 epitomizes the juxtaposition of cuteness and piety, with a little boy reading a book placed beside images of the Prophet's Mosque in Medina and the Ka'ba in Mecca. These two buildings function iconically in Pakistan and elsewhere as representations of the prophet Muhammad and of God, a phenomenon underscored in this illustration by the Muslim creedal statement *(shahāda)* that appears above the two buildings and textually refers to Allah and the Prophet.[31] It is these visual markers (reinforced by the green cap) that make it clear that the baby boy is engaged in the religious act of reading the Qur'an. The incongruity of a boy of too young an age to read and wearing nothing but a diaper engaged in this act—which is simultaneously ritualistic and prayerful—would not be of concern for the poster's intended audience. After all, the point behind the image is the opposite: the affective response would be to realize that *even babies* act piously, underlining the degree to which piety is obligatory for adults and automatically chastising them for not being sufficiently pious relative to a little child, who has no formal religious or moral obligations and therefore is behaving this way entirely out of his own volition or his nature *(fitra/fitrat)*.

Cuteness is most meaningful as a concept that helps us understand the ways in which ideas of goodness and evil, virtue and vice, and beauty and ugliness are shaped around the imagined child. Cuteness functions as an ambivalent signifier, particularly in its relationship to notions of innocence and virtue, which are distinct (though not entirely separate) from concepts of helplessness and dependence. It is these questions of innocence and virtue that lie at the heart of how the imagined child functions as an affective phenomenon in contemporary Islamic societies. Innocence certainly plays a central role in the construction of the cute, in that the assumption of cuteness is very much about recovering or returning to a state of natural and unconscious

FIGURE 16. Pakistani poster of a baby boy reading the Qur'an (Museum Fünf Kontinente, Munich, No. 89-312 093).

innocence from which we have been alienated by the simple fact of becoming adults. The child state is seen as pure and genuine, in contrast to a superficial and shallow adulthood in which we are forced to conceal our emotions and desires, and to live lives of forced conformity to external requirements.[32]

The idealized state of the cute child is thus the opposite of the ugly and harsh realities of being an adult, drawing adulthood close to antichildhood in a structure that contrasts childhood to its antipodes. In Islamic constructions, however, the child is not a blank slate upon which innocence is inscribed, nor is the adult a victim of circumstance. Instead, both child and adult are actors, and the distinct characteristics marking the states of child versus adult take on a moral hue; cuteness becomes an aspect of beauty, and beauty is related to goodness and virtue.

Many of the visual materials examined here destabilize the relationship between cuteness, innocence, and helplessness. In the first place, helplessness is not a necessary (or even an important) factor in cuteness or childhood. In the second, innocence can mean different things. That children are cute but not necessarily helpless is somewhat obvious and I will not discuss it further, except to draw attention to the fact that

childhood helplessness is a cornerstone of adult desires to control children and provide them with an idyllic, completely safe environment that lies in contradiction to the world in which the majority of the planet's children actually live.

Innocence takes two discrete (if interrelated) forms—innocence as helplessness and innocence as virtue or sinlessness. There is a distinction between innocence as an ignorance of nonidyllic things, or bad things, and innocence as an absence of sin or guilt. Although the separation between the two does not hold perfectly, the materials studied here associate childhood innocence with the latter state—the absence of sin and guilt. As such, innocence, childhood, and cuteness are associated with virtue and goodness, making childhood a *moral* state as well as a *biological* one. The innocent are morally good, and children are innocent.

Virtue is also of two kinds—the virtue of those who are sinless *because they have not sinned yet,* and the virtue of those who *have done good.* Infantile virtue is the former, the virtue of self-sacrifice the latter. Cuteness functions as one of several signifiers of innocence, and innocence as a quality essential to virtue. In addition to the infantile innocence of purity, self-sacrifice has been elevated in many modern Islamic societies to the level of ultimate virtue, as we shall explore in the next chapter through a focus on Iran.

Virtue has a long history of being twinned with concepts of attractiveness or beauty (within which one can subsume cuteness) in Islamic culture. The Qur'an uses the common Arabic words for beauty, *ḥusn* and *jamāl,* primarily to mean moral goodness or else as references to divine beauty. The word *ḥusn* is closely related etymologically to the word for "good" *(ḥasan),* and is employed in the Qur'an and in classical Islamic ethical literature to mean beauty of character or moral beauty. *Jamāl* is a formal divine quality and not used for physical beauty in the Qur'an. Over time, Muslim scholars—and especially Sufi thinkers—came to categorize the epithets of God found in the Qur'an into two groups, the "Attributes of Beauty" *(al-ṣifāt al-jamāliyya)* and the "Attributes of Majesty" *(al-ṣifāt al-jalāliyya).* Thus beauty, as *jamāl,* serves as a typological complement of majesty rather than referring to a visual or plastic form of attractiveness or pleasingness. Together, beauty and majesty encompass God's nurturing and authoritative aspects, and are often understood as feminine and masculine.[33] Even the Arabic and Qur'anic word commonly used to describe physical beauty and especially adornment *(zīna)* is often used in exhortative and didactic contexts. Like physical beauty and outward adornments, virtue and morality are also under-

stood to adorn human beings, such that Qur'anic notions of physical and visual beauty are inseparable from those of virtue.[34] Hadith traditions wed beauty to virtue by asserting that the beautiful believer is the most beloved by God and the ugly disbeliever the most hated by Him. A widespread belief in the physical beauty of prophets and saints underscores this tenet.[35]

The link between beauty and virtue is made forcefully by Ghazali. Although he discusses questions of beauty and virtue in a number of his works, his *Alchemy of Happiness (Kīmiyā-yi sa'ādat)*, a Persian text distilling essential aspects of his thought, is especially relevant to the subject. Like much of Sufi writing, in this work Ghazali argues that beauty matters primarily in terms of its relationship to perfection, which is an inner or esoteric quality, and for which outward physical appearances are often deceptive markers. He is forceful in making his point that externalities cannot be the defining characteristics of attractiveness: "If you look into the beauty of [man's] appearance, it is a skin drawn over a pile of dung. If he doesn't wash himself for two days he becomes disgraceful, such that he begins to stink and filth arises on him."[36] Elsewhere, he attempts to make much the same argument by pointing out that if real beauty were not of an inner kind, it would be absurd to love the Prophet and his companions for their beauty because they died, were buried, and turned to dust centuries ago. In the context of addressing prophetic beauty, Ghazali juxtaposes the love for a beautiful painted image against loving the prophets for their inner qualities.[37] He also posits that even children focus on inner rather than outer qualities when they are asked to describe a person.[38]

Although Ghazali believes that inner realities are superior to outward forms, he does assert a value to the visual that relies on a number of heuristic and aesthetic factors. He acknowledges that the visual possesses a visceral appeal in comparison to nonvisual imagination and thought.[39] And he asserts that there is a value to the contemplation of beautiful individuals and objects, because the amount of pleasure one feels by gazing on beauty is proportional to the amount of love aroused within oneself. Following existing Islamic models derived from Greek aesthetic and intellectual thought, Ghazali maintains that the essential connection between beauty and virtue implies that the capacity to appreciate beauty is an indication of the individual's inner virtue.[40] It is this marrying of beauty with virtue that accounts for the widespread belief that prophets and venerated religious figures such as the Shi'i imams were physically beautiful.

AFFECTING VIRTUE

I am not suggesting that modern attitudes toward representation or the didactic and affective place of images are derived directly from the writings of Ghazali or from medieval Islamic thought in general, although Ghazali's writings concerning piety and spirituality certainly continue to be read and emulated across the Islamic world today. Instead, I refer to the legacies of Islamic thought to underscore the continuing interrelatedness of beauty, virtue, and love in modern society. The reaction to beauty is an affective response, in the sense that it is the performed emotion of love that both instills and demonstrates the existence of virtue. To react emotionally under the right circumstances demonstrates to oneself and others that one is moral and good. When we take the broad view of beauty as including idealized notions of childhood, the visual depiction of children as cute or beautiful both signifies and conditions an affective response in which the viewer understands the child as virtuous. In so doing, this signification and response demonstrate an affective investment on the part of the viewer in a specific aesthetic social imagination through which she reaffirms her own status as a virtuous being, while simultaneously participating in the shaping of what constitute the parameters of behavior and morality in her own society.

This affective relationship is readily demonstrated in the poster arts of Pakistan, where children are frequently depicted in acts of religious virtue and in religious contexts where their presence is not necessary to the image except to amplify and focus affective emotional responses. In particular, representations of small children praying or reading the Qur'an are very common.

The image in figure 17 of two boys reading the Qur'an is very similar in signification to that of the baby boy earlier in the chapter (figure 16), except that the boys are a little older and appropriately dressed for a religious situation. Furthermore, the various components of the image are somewhat more integrated than they are in the poster of the baby boy. The Ka'ba and the Prophet's Mosque appear in the center of the poster, iconically reinforced by two roses bearing the names Allah and Muhammad, and the names themselves are written intertwined right below the two buildings. As in the previous poster, the *shahāda* (Muslim creedal statement) is written across the top, and this image also has a number of shrines of local significance in the middle ground behind the boys. There is a surfeit of religious signifiers here, and the religious

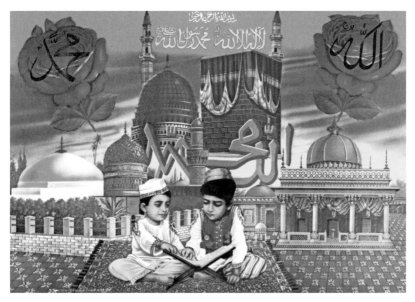

FIGURE 17. Poster of two boys reading the Qur'an (Museum Fünf Kontinente, Munich, No. 89–312 077).

acts of the children are recognizable to anyone even remotely familiar with the cultural context.

The image in figure 18 closely resembles the previous one except for the very significant difference that it depicts a girl and boy rather than two boys. Many elements of the two images are similar: the calligraphy in the background with the intertwined names Allah and Muhammad is the same; and although the Ka'ba and the Prophet's Mosque have been moved closer in the second image, they are so similar to the previous example that they were probably painted by the same artist. The big difference, aside from the presence of the girl, is the foregrounding of childhood piety, in the sense that the children dominate the frame, and references to God and the Prophet are reduced to signifiers, almost like a poster hanging on the wall of the room such as the one behind them showing an alpine scene. The details of the children's dress are much clearer that in the previous image, and one can read that the Qur'an is opened to the first chapter (which is very poorly written, for reasons that are unclear, given the care taken in painting the rest of the poster). The relationship between the two children is significant: both are dressed in what is clearly intended to be a religious manner, and the girl has already

FIGURE 18. Poster of a girl and boy reading the Qur'an (collection of the author).

adopted societally advocated standards of physical modesty. Despite the fact that, physically, they appear to be the same age, the girl is made to look like the older sibling: she has her arm around the boy in a protective way, and it is she who is pointing to the text as they read the Qur'an. Without any direct reference—or perhaps even the conscious intent of the artist—a central aspect of the gendered nature of childhood is communicated by the relationship between the boy and the girl: that the burdens and privileges of maturity fall on girls at younger ages than they do on boys. Even though the two children arguably are the same age, the girl is already more religiously trained and responsible than her brother.

Images of a girl and boy praying or reading the Qur'an together comprise a popular subject for religious posters in Pakistan, reflecting enthusiasm for a comprehensively virtuous childhood and the concomitant aspirational hope for a virtuous adult society. Many posters are made up of montages of several different scenes with photographs (rather than paintings) of children superimposed on them. The example in figure 19 celebrates Bodla Sikandar through his association with his famous master, Shahbaz Qalandar. Shahbaz Qalandar is one of the most renowned and beloved Sufi saints of Pakistan, and his shrine at Sehwan Sharif is a major pilgrimage site with a large festival on the anniversary of his death. Bodla Sikandar, referred to popularly and on this poster as Bodla Sarkar (Master Bodla), is revered as a lifetime devotee of Shahbaz Qalandar, who predicted the latter's arrival in Sehwan; a

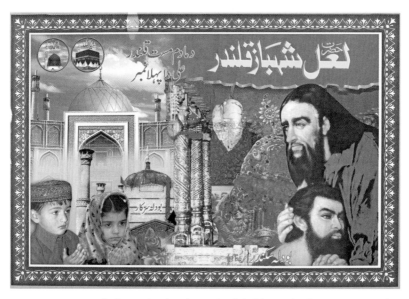

FIGURE 19. Poster of a boy and girl at the tomb of Shahbaz Qalandar (Museum Fünf Kontinente, Munich, No. 09–329 794).

popular song celebrating the imminent arrival of the saint is credited to Bodla Sikandar, who is said to have chanted it constantly.

This poster reinforces the relationship between master and disciple in a number of ways: on the right, Shahbaz Qalandar is holding Bodla against his chest, and the background on the left has a representation of the saint's shrine with a much smaller depiction of the disciple's shrine in front of it. The writing also signifies the nature of the relationship, with the master's title "Hazrat La'l Shahbaz Qalandar" written boldly in gold at the top, accompanied (in smaller size) by a popular couplet in his praise: "Drunk with every breath, 'Ali is the most eminent *(dama dam mast qalandar, 'Ali dā pehlā nambar).*" Bodla's name appears twice toward the bottom, almost as a caption on his tomb and on the disciple held against the master's breast. The poster would be complete without the two children, whose superimposed photographs are smoothly incorporated into the scene of the two Sufis on the right. Unlike the painted boy and girl in figure 18, these children are dressed in normal clothes rather than in idealized religious outfits—the boy is wearing a skullcap and the girl a scarf pinned at the chin, both everyday items donned to engage in ritual prayer. The image is ambiguous as to whether the children are petitioning the saint or simply praying in his

FIGURE 20. Poster of a boy at the tomb of Shahbaz Qalandar (Museum Fünf
Kontinente, Munich, No. 09–329 794).

presence, but whether or not the children are petitioning the saint is
irrelevant: ultimately, a child in prayer is a multiplier of pious affect,
since the poster itself represents piety and devotion independent of the
children. They add no meaning to a representation of a saint and his
devoted disciple; what they contribute is an enhancement of the feelings
and meanings evoked by the poster, which is a consequence simply of
small children engaged in virtuous and pious behavior.

Figure 20 is a different version of a very similar image. This one
focuses on Shahbaz Qalandar to the exclusion of his disciple Bodla
Sikandar (beyond the latter's presence in his master's embrace as seen in
figure 19). There is also no girl in the picture. However, the boy is very
cute, and much younger than the age at which one might reasonably
expect children to start engaging in religious rituals. He has been pho-
tographed in an idealized version of piety: an adult-sized prayer cap
that comes down too low on his head, a fancy jacket worn by little boys
on special occasions, and a string of prayer beads *(tasbīḥ)* wrapped
around his hands as he extends them in supplication. The affective value
of this boy is the same as that of the slightly older boy and girl in figure
19; this image simply makes it clearer that such representations are less
about encouraging children to engage in religious acts or to live lives of
virtue than they are to evoke such feelings and thoughts in adults and

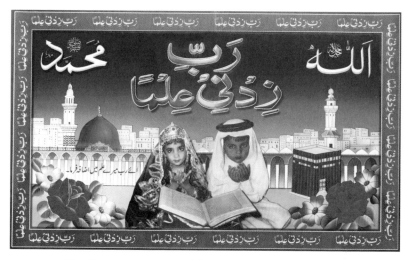

FIGURE 21. "Lord! Increase me in knowledge!" (Museum Fünf Kontinente, Munich).

thereby help create an emotive regime in which adult society functions in more virtuous ways.

Figure 21 exemplifies the manner in which children function as multipliers of affect in adult aspirations and emotions. It comprises a photograph of a girl and boy posing in what are supposed to be Arab costumes; they are seated behind an open Qur'an, and their hands are held in a supplicatory, prayerful position. The children are surrounded by a painting of the Ka'ba and its compound, with the Prophet's Mosque and a skyline evoking Mecca and Medina in the background. Written text figures prominently in this poster, with the names Allah and Muhammad appearing in white directly above the iconic buildings symbolizing God and His prophet. The large polychromatic writing at the top center of the poster and the writing in the border all around it repeat the Arabic phrase "*Rabbi zidnī 'ilman!* (My Lord! Increase me in knowledge!)." The poster is entirely in Arabic with the exception of an Urdu translation of the Arabic prayer written discretely to the left *(ay rabb mērē 'ilm meyṇ iẓāfa farmā)*.

The Urdu translation is almost superfluous and acts like an unnecessary caption, since the Arabic phrase in question is a very famous verse of the Qur'an (20:114, Sura Taha), extensively quoted to emphasize the value Islam places on learning. Many Pakistanis are likely to know this Arabic phrase, and those who don't probably cannot read the Urdu translation either. Nonetheless, the association of children with learning and knowledge seems fairly straightforward, except that it is accompanied in

this case by very strong signifiers. The exclusive use of Arabic (with the exception of an easily overlooked translation), the close association with Allah, Muhammad, the Qur'an, and the sacred geography of Islam, and the dressing of the children in romanticized Arab attire all go to enforce the idea that learning is a sacred injunction and that it is essentially and ultimately religious. The divine command to learn is therefore actually to read the Qur'an—to learn more is to learn more about Islam (not about mathematics, for example), and to have knowledge is to pray.

OF GIRL-WOMEN

The diptych in figure 22 is a poster dedicated to the great Sufi figure 'Abd al-Qadir Jilani (d. 1166), the eponymous founder of the globally widespread Qadiri Sufi order. In Pakistan, he is referred to as Ghaws-i A'zam or Ghaws-i Pāk (The Great Protector, or Pure Succor) and is essential to establishing the spiritual pedigrees of numerous Sufis, even those who do not belong to his order.[41] This poster locates Jilani in an atemporal pantheon of saints employing a pastiche of components. In the lefthand image, he is flying above an imagined landscape (perhaps representing Iran or Iraq where he lived), accompanied by doves and angels, some of which are borrowed directly from popular European religious art. His flying carpet is flanked on one side by Buraq, the celestial winged horse that carried Muhammad to heaven, and on the other by Shahbaz Qalandar on a mythical bird. The righthand panel shows him enthroned and watched over by the Virgin Mary (with angels' wings added), an open book and candle above her head, and religious panoramas to either side of Jilani. By his right hand in the background is another image taken from European religious art—this one of a woman with her hands joined in front of her in prayer. Below Jilani, in the foreground, are two of the most respected figures in Pakistani Sufism, Data Ganjbakhsh 'Ali Hujwiri and Mu'in al-din Chishti (d. 1236). Hujwiri, historically the first significant Muslim scholar to have made his home in South Asia, is credited with having popularized Islam in the Indus Valley. Chishti gives his name to a widespread South Asian Sufi order that has enjoyed close ties with the ruling classes while simultaneously popularizing Sufi ideas in non-Muslim populations. The third male figure is Guru Gobind Singh (d. 1708), the tenth Sikh guru as well as a poet and warrior who is responsible for many of the reforms that led to Sikhism being the religion it is today. Gobind Singh is integrated

FIGURE 22. Poster of a girl and boy petitioning 'Abd al-Qadir Jilani (Museum Fünf Kontinente, Munich, No. 06–327 965).

into the popular tradition of Punjabi Sufi poetry, and his inclusion as a disciple of 'Abd al-Qadir Jilani alongside two highly venerated South Asian Muslim saints makes a clear ecumenical comment about Jilani's sainthood and the nature of Sufism.[42]

This poster demonstrates the dynamic and un-self-conscious nature of religious poster arts in Pakistan. The figure of Mary in the right panel of the diptych is Our Lady of Fatima; the girl in the background with her hands joined in supplication is also from an earlier representation of a famous scene depicting the appearance in 1917 of an apparition of Our Lady of Fatima to three Portuguese children, two of whom were girls named Jacinta and Lucia. The image has been reworked so that, instead of directing her gaze at Mary, the girl appears to be praying toward 'Abd al-Qadir Jilani. Similarly, the left panel of the diptych copies elements from a modern popular Catholic print: the female winged figure wearing a violet robe is a guardian angel who watches over children traveling through a landscape. The star above the angel's head is a guiding star, and a cross is prominently embroidered on the front of her robe. Her hands are held at waist level to bless and protect children,

although this function is obscured by what looks like an orb but is actually a carved stone Islamic talisman that has been made to look disproportionately oversized. One may be tempted to think that there is a significance to the selection of these specific images for this Sufi poster, but it is far more likely that the artist was unaware of their particular connotations. Even the association with children has been removed in the case of the guiding angel, despite the presence of children in the scene as represented in the poster, and Mary's association with the girl in the right panel has been severed through the presence of Jilani. Pakistani poster arts, like the much more visible artistic practices of truck decoration, are very open to innovation and appropriation, and the iconography, associations, and visual forms used in them change rapidly.

The little boy and young woman in the bottom lefthand corner of figure 22 are supplicating before the great Sufi saint, a common practice at shrines in Pakistan and elsewhere. As in figure 20, the boy is very young and cute, and is dressed in a festive looking outfit. The young woman's status is unclear: she could be his mother, though that is highly unlikely since actual motherhood is almost never explicitly represented by young women in Pakistani popular religious art. She might also be his elder sister. Most likely, she represents an undefined stage of female life, the indeterminate state of postpubescent girlhood running into womanhood before the latter is socially acknowledged through marriage and motherhood. The same female figure appears alone in the righthand panel without any identifiers of her status as an adult woman. In fact, the act of supplication on the part of a girl-woman would very probably be a request for the ultimate blessing represented by having a good marriage that results in children, reinforcing the likelihood that this female figure portrays an unmarried woman, and therefore a girl.

The elision of unmarried nonmothers into the broad category of girl-hood comes through clearly in the next three images. Figure 23 depicts a young woman at the shrine of Hujwiri. The writing across the top of the poster is the Muslim statement of faith *(shahāda)*, and captioned, iconic representations of Allah and Muhammad appear in medallions on either side of it. Below them is a famous Persian couplet in praise of Hujwiri: "Treasure giver, bounty of the world, mirror of divine light / To the flawed a perfect master, to the perfected a guide *(Ganj bakhsh fayz-i 'ālam mazhar-i nūr-i khudā / nāqiṣān rā pīr-i kāmil kāmilān rā rahnumā).*" A second couplet at the bottom declares in Punjabi: "All

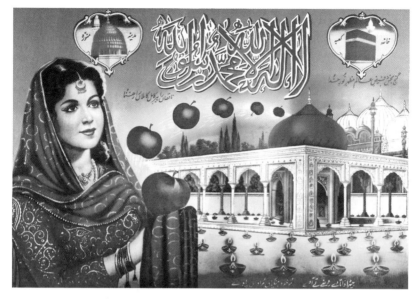

FIGURE 23. Poster of a young woman at the shrine of Data Ganj Bakhsh (Museum Fünf Kontinente, Munich).

who come to Data's shrine / Utter a wish and find it granted *(Jehrā Dātā dē rōzē tē āwē / mūṇ mangiyāṇ murādāṇ pāwē)."*

The young woman is receiving blessings from the shrine in the form of apples, which most probably represent children, the interpretation being reinforced by her dress and jewelry, both of which suggest a newly married woman. But nothing in the image clearly signifies her marital status, and even if the apples signify the *barkat* of being blessed with offspring, that doesn't necessarily imply that the person represented is a woman rather than a girl, since (virtuous) motherhood is the state to which all girls are encouraged to aspire.

The link between girlhood, virtue, and womanhood is made clear in figures 24 and 25. The first image shows a girl-woman sitting with a Qur'an in a context very similar to the little girls and boys in figures 17 and 18. Her attire is modest and she is beautiful, which, in the link between beauty, virtue, and innocence, connects her directly to the cute child. Rather than actually reading the Qur'an or holding her hands in a supplicatory pose, she is staring off into the distance. Her gaze suggests thought and aspiration, and is brimming with affective possibilities that cannot be parsed out, such that they all exist simultaneously, as much the aspirations of the viewer as they are of the person in the image. She

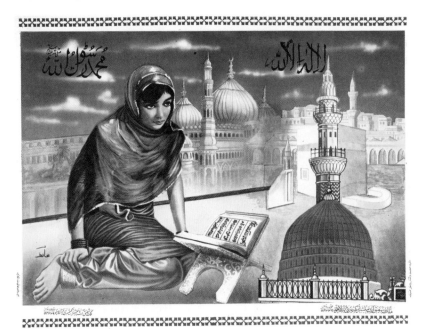

FIGURE 24. Poster of a young woman reading the Qur'an (Museum Fünf Kontinente, Munich).

hopes for religious, personal, familial, financial, and social success, just as the viewer does. Through an informal exchange of her virtue and piety, she both *hopes for* and *represents hope* for *barkat* and all it implies.

The girl-woman in figure 25 has elements of several of the images discussed above: she is dressed in modest attire fully appropriate for prayer, is holding her hands in a pose of supplication, and is accompanied by representations of the Qur'an and the Ka'ba, and the writing in blue and red across the top is the Qur'anic exhortation to knowledge encountered in figure 21. In this instance, however, the Urdu translation is written in large letters at the bottom left, and the poster is devoid of any references to saints or even the Prophet. The lack of such signifiers is noteworthy since it constitutes an iconographic marker of the probable religious outlook of the manufacturer and consumers of this poster. The clear message is that all prayers and petitions should be directed to God without intermediaries, reflecting a nonintercessory religious ideology that is almost as common in Pakistan as is the one endorsing intercession. The message, as in figure 21, is that knowledge and prayer are the same thing and, consequently, so too are wisdom and piety.

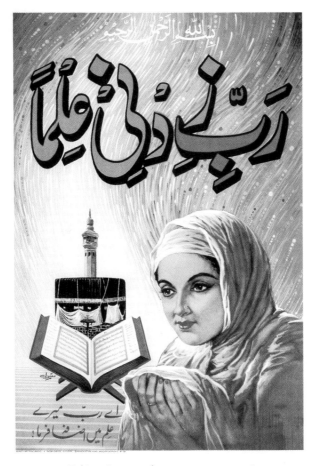

FIGURE 25. Pakistani poster of a young woman praying
(Museum Fünf Kontinente, Munich).

CONCLUSION

This chapter includes only a small selection of religious posters representing children and women. There are many variations on these themes—some posters are explicitly from a Shi'i point of view, others graft pictures of the same little children onto a variety of posters celebrating a number of regional Sufi figures. But there are noteworthy consistencies that speak to the significance of children and to the ways in which womanhood is constructed as inseparable from childhood. I have yet to encounter a Pakistani poster of this religious sort in which a

young man is featured in a pose similar to that of the young women. There is no boy-man equivalent to the girl-woman—men and older boys appear in posters as Sufi figures, their children, or disciples, but they are actual named human beings, not types. Among representations of small children appearing by themselves, boys outnumber girls by a large margin, which reflects an important aspect of male-normative practices and cultural values. And when boys and girls appear together, there is a notable skewing of their ages, with the girls being significantly older. At its extremes, this gender-based skewing holds infant and toddler boys at one pole and girls who are young women at the other. The relatively rare representation of very young girls is attributable to the excuse that they are substantially redundant with their male counterparts, in the sense that there are no gendered activities in which they can be represented, beyond a difference in dress. At the other end of the age spectrum, young women display the ways in which sexuality and piety intersect in the construction of pious femininity. Sexuality is an unactualized aspect of virtuous females until it is manifested through motherhood, which is publicly constructed (if not explicitly discussed) as occurring within the socially blessed confines of marriage. Since marriage, sexual intercourse, and biological aspects of reproduction are never addressed or directly alluded to in these contexts, the evidence of adult womanhood is the fact of motherhood, manifested through the presence of children or recognizable motherly acts. In their absence, there are no integral markers to differentiate the virginal woman from the girl-child, which allows the unproblematic use of young women in contexts very similar to those in which small, male children are affectively deployed.

The tiny writing on the lefthand margin of the poster in figure 24 requests that no one touch this object unless she or he is in a state of ritual purity. The direct implication of the caption is that the presence of images of the Qur'an, the Prophet's Mosque, and the *shahāda* render the poster sacred in the same way that actual copies of the Qur'an are sacred. For those who read the warning in the margin and heed it, sacrality necessarily extends to the person in the picture: she becomes absolutely and eternally pure, suspended in a state of nonwomanhood, since actual women, by dint of their biological bodies, are not forever ritually pure. As an image, the virtuous woman exists as an ideal, linked to the idealized child in two ways: first, childhood and female adult virginality are inseparable because they exist on a continuum with no markers, and because they are constructed in a conceptual space where sexuality

resides only as an unspoken potentiality. And second, idealized virtuous womanhood exists in a conceptualization of motherhood that is completely exorcised of any biological qualities and persists as an imagined and performed ideal of virtue. This topic and other aspects of the representation of gender-based virtue are discussed further in the next chapter.

Toy Guns and the Real Dead in Iran

As outlined already, Iran differs from the other two case studies in this book for several important reasons. Even so, as in Turkey and Pakistan, the 1980s were a decade of religious change for Iran. The Iranian Revolution of 1979 not only transformed the country's political structure but also placed a revolutionary form of Islam at the center of visual and material culture. The public religious rhetoric of Iran became inseparable from the war with Iraq (1980–1988), which was framed in religious terms as one between good and evil, and where religion was used extensively to mobilize the Iranian population and to make sense of the high numbers of casualties suffered by an exhausted nation. The state was actively involved in producing visual and material cultural objects and performative events furthering this ideology, many of which featured children, and it also engaged in comprehensive revisions to the educational structure at all levels.

EDUCATION IN IRAN

The history of modern education in Iran shares aspects with the educational histories of Turkey and Pakistan. Like Turkey, Iran was an independent monarchy through the nineteenth century, one with an acute sense of its need to modernize in order to be competitive in the world and to resist Western encroachment. Consequently, the government tried to promulgate modern education, first by sending cadres to Europe

for higher education and later (beginning in 1851) by opening institutions in the country staffed with imported faculty, and finally by opening the first modern primary school in 1887.[1] However, Iranian attempts at promoting universal modern education came later than those in the Ottoman Empire and were not as effective, marred in no small part by the religious establishment, which used a variety of tactics (including violence) to prevent the spread of an educational system that it perceived as foreign, threatening, and inappropriate. Interestingly, the religious establishment was less opposed to the presence of foreign missionary schools than it was to a national educational plan, in all probability because its members realized that such foreign schools were restricted to urban elites, almost exclusively in the capital, and did not presage a societal change.

Very substantial attempts were made to bring about universal education during the Pahlavi period (1925–1979), with notable results for both men and women. In 1956 Iran had a literacy rate of 15.4 percent, which had risen to 50.8 percent by 1978. An important indicator of the success of the universal primary educational plan was the remarkable growth in rural literacy: during this period, urban literacy rates almost doubled, from 34.6 percent (45.9 percent for males and 22.4 percent for females) to 68.3 percent (76.7 percent for males and 58.8 percent for females); but rural rates grew more than fivefold (from 6.1 percent to 33.6 percent), and an astonishing twentyfold for females (from 1.2 percent to 19.7 percent).[2]

As one would expect, the Iranian Revolution of 1979 had a great impact on all spheres of education. For young children, the overall emphasis on literacy and basic education continued as it had during the Pahlavi era, and might even have become stronger. The prerevolutionary period had seen a replacement of traditional religious schools with modern public ones, and even though the revolutionary government undertook broad changes to bring religion into most aspects of civil society, it remained committed to the project of comprehensive public education on a modern model. What changed was the emphasis and content of the textbooks used in classes related to the teaching of identity, ideology, and history. The focus on Islam increased severalfold, with a simultaneous decrease in the teaching of the pre-Islamic period of Iranian history. This went hand in hand with a greater emphasis on religious aspects of culture in subjects such as literature, and a greater use of Arabic sources. Such transformations were—for the most part—changes in teaching materials and their content, not blatantly

ideological ones in which the pre-Islamic Persian past or the West were criticized. Such alternative cultural subjects were ignored in many parts of the curriculum, and other, more Islamic materials were taught.[3]

EDUCATION AFTER THE REVOLUTION

The Iranian clergy had not been fully supportive of the national policy of modern universal education and, in particular, of the identical education provided to girls and boys. Immediately after the revolution, the new religious government began to unravel many of the educational programs of the previous regime, including disbanding the Literacy Corps *(Sipāh-i dānish)*, an organization for spreading literacy in rural areas staffed with young men who could choose this as an alternative to two years of compulsory military service. The new regime also revised all textbooks in order to Islamicize them. The new comprehensive attitude toward the relationship between religion, education, and nationhood was described succinctly by an official in charge of the Islamicization of education:

> Islamization of textbooks . . . is not confined to books on religious instruction. The point of view that governs the rewriting of textbooks is this: everything must be Islamic. In . . . the past, only two hours were devoted to religious instruction. . . . we believe today that our sociology, our economics, our history, all of these and other subjects must be Islamized.[4]

This mission is articulated even more strongly in a publication of the Ministry of Education from 1987, which declared that the purpose of schooling was to "strengthen the spiritual beliefs of school children through the explanation and instruction of the principles . . . of Islam and Shi'ism on the basis of reason, the Qur'an and the traditions of the Innocent Ones [a reference to the descendants of the Prophet revered by Shi'is]."[5]

The commitment to universal education itself did not diminish significantly after the Iranian Revolution; what changed was the subject matter that was emphasized and the new presence of a deep awareness of the power of education and propaganda in shaping ideology. Studies of textbooks from this period reveal several priorities in shaping the minds of children, most of which have to do with replacing a monarchical and ethnically Persian concept of the national self with a religious one that, in the case of Iran, implied a specifically Shi'i view of history. Textbooks and other materials promoted the system of religious government being

promulgated in Iran, extolled the virtues of Khomeini, and glorified martyrdom as a religious ideal that was still relevant to the world today. It also involved the establishment of quasi-governmental organizations designed to further the new ideology, including so-called Islamic Societies *(Anjuman-i Islāmī)*, which were established at the high school and higher levels as a mechanism to purge academic institutions of supposedly disloyal teachers and students. Their mission was expanded by Khomeini in 1980, when he officially declared the beginning of a Cultural Revolution, which formally discriminated against faculty and students who did not support the regime's ideology. The editor of a prominent newspaper *Iṭṭilāʿāt* had the following to say about the educational relevance of the Islamic Revolution:

> We . . . had education during the time of *Ṭāghūt* [a reference to the Pahlavi monarchs, likening them to self-declared false gods]. Our educational venues were primary and high schools and the universities. . . . During the last 57 years, indeed since the founding of the *Dar Al-Funun* [the first university], the educational policies followed in this country have been carbon copies of Western policies. Before this half-century of misery, we had our own educational methods. . . . [We] must rediscover our own educational heritage. In my view this is the most important function of the Cultural Revolution.[6]

The Islamic revolutionary regime of modern Iran might be consciously reorienting the content and emphasis of the educational system, but the regime's awareness of and attitudes toward education and its relationship to reform and revolutionary change are soundly rooted in the Iranian project of modernization, which goes back over a century. The overt use of ideology in the classroom and in extracurricular activities follows an existing pattern of using education to foster nationalism and serve as the glue of state formation.[7]

The focus of almost all scholarship on the educational and social policies of the period has been on the adult population, including university students. In actual fact, the regime's own focus on children and the impact of policies on them was considerable. The Iranian secondary school curriculum ranks among the highest in the world in terms of the number of hours per week that are devoted to the study of religion.[8] In Iran's case, however, religion is inextricable from the country's revolutionary political ideology, which is explicitly introduced in textbooks from the beginning of primary school. This program is not limited to textbooks on religion or social studies; it is even there in elementary Persian textbooks. These language books are essential tools in the state's attempt to forge a new kind of citizen, because they provide children

with their first controlled exposure to the ideologies of the revolutionary Islamic state. Arguably, the creation of a new kind of citizen has been a main social goal of the new regime, a citizen who is "religious, politically aware and involved, proud of his/her heritage, ready for self-sacrifice for Islam and the revolution, respectful and obedient to his/her country's religious and political leaders." Such a citizen would be one who "hates the pre-revolutionary regime, rejects any form of dependence on the West, mistrusts the non-Muslim world and is highly critical of Western ways, and sympathizes with all oppressed peoples, especially Muslims."[9]

A study of Persian textbooks from the postrevolutionary period in Iran demonstrates a process of the idealization of childhood and simultaneous efforts to instill a sense of international politicization in children. Books written during the early years of the regime prominently feature rural life and landscapes as the ideal Iranian societal space; this subsequently gave way to urban, classroom settings, which are much more representative of the realities of Iranian life as a largely urban society. Also, children and childhood were not featured in the formal Persian curriculum between 1979 and 1997, and were only introduced after the curriculum was revised substantially in 2003.[10] During the first period of roughly two decades, the Palestinian-Israeli conflict figured prominently in Iranian primary school textbooks. As early as the second year of school, textbooks featured the plight of the Palestinians, highlighting how young Palestinians were deprived of a proper childhood.[11]

Emphasis on the Palestinian struggle and the idyll of rural Iran gave way in the revised curriculum to a focus on the experience of childhood itself, and to the series of transitions a child undergoes in the process of becoming an adult. Iranian childhood was reimagined to resemble global constructions of idealized childhood, and became generalized to suggest that a normative childhood is shared by all human beings regardless of gender or ethnicity.[12] Before this time, for the most part, Iranian textbooks presented adulthood as the normative human state and treated children as miniature adults. The ideological transformations of books during this period are reflected in textbook covers: from the Iranian Revolution until 1986, the front and back covers of Persian textbooks for grades one to three were devoid of political sloganeering. By the mid-1980s (with the Iran-Iraq War in full swing), the front covers remained unchanged but the backs were repurposed to promote state ideology, using photographic images of groups of boys and girls melding together into one mass. The boys marched with their fists raised, and the girls stood quietly wearing the black chadors promoted

by the new regime. The images were captioned with a slogan in support of the revolution: "We with faith in God, with purity and honesty, with gainful knowledge, with hard work, sacrifice, thrift, independence, and freedom, the Islamic Republic of Iran do defend."[13]

As representations of children entered the curriculum in the 1990s, textbooks also started depicting children engaged in nonadult activities, and shifted toward inculcating nonpoliticized ideals of good behavior. The version of the second-year Persian textbook published in 1997 has a cover that depicts children engaged in risky behavior such as touching hot pans, handling knives, and jumping into a fire; this is accompanied by a caption telling them to be careful. Similarly, the back cover of the third-year book from 1996 shows children engaged in active play (running, playing soccer, riding bicycles) and carries the written message "Let's all exercise together."[14] Despite these changes, political ideology remained an essential element of primary school textbooks. They began to include an image of Ayatollah Khomeini, frequently represented as a kindly old man surrounded by his own grandchildren and called "The Kind Imam." And references to the Palestinians remained in the books: the first appearance was in the second-year book in a lesson (which has since been removed from the curriculum) titled "Letter from a Displaced Child" *(Nāmeh az yek kūdak-i āwāreh)*. It was written in the first person from the perspective of a Palestinian boy sharing his disturbing experiences of Israeli occupation with his Iranian counterparts, to whom he was tied through the filial bond of a shared religion. "You live in your own country and in your own home. But we are displaced in the deserts. The enemy has destroyed our home and homeland."[15] Another primary school chapter that linked the moral and political destinies of Iranian children with those of their Palestinian counterparts was titled "An Adolescent in Palestine," and was kept unchanged in textbooks from 1979 to 1986. In this essay, the Palestinian child informs his Iranian counterpart of the extent of his suffering, and attempts to instill a sense of moral outrage in the Iranian primary school student and inspire him to become a potential savior of the suffering Palestinians. The chapter was substantially revised in 1987, when it recast the Palestinian as a warrior rather than a victim.[16] Arguably, this change is symptomatic of a wider shift in the state's ideology, from one that had a narrow, apocalyptic vision of persecution at the hands of the West to a broader one of global revolution, in which Iran serves as a leader but not the sole actor.

Although religious values and worldviews feature prominently across the Iranian primary and secondary curriculum, they are promoted most

forcefully in the textbooks and classes specifically dedicated to teaching Islam. Classes focused on the study of religion start at the beginning of elementary school and continue through all years of primary and secondary education. A study of such textbooks from the year 2003–2004 for all class grades (covering ages six to seventeen) demonstrates that, although there are significant changes in the pedagogical approach across the different grades, the overall message consistently promotes a religious view of modern Iranian Shiʿism as the normative form of Islam, and fosters a culture of martyrdom and political struggle. Middle school textbooks supplement knowledge of basic religious doctrines and history with lessons on eschatological accountability for one's actions, with stories about martyrs and holy warriors, and about the virtues of pilgrimage to their graves, and lessons on the excellence of the prevailing Iranian system of government by jurisprudential rule *(wilāyat-i faqīh)*, the importance of the Shiʿi concept of the Imamate framed as a struggle between good and evil, and the duty to holy war *(jihād)* and martyrdom *(shahādat)*, which accompanies the obligation incumbent on all Muslims to defend their religion. In the final three years of secondary school (classes nine to twelve), these lessons are reinforced with exercises presenting the *wilāyat-i faqīh* form of government as "a definite truth in Islam," further lauding the spirit of *jihād*, and regarding martyrdom as "bliss," and teaching that "commanding the good and forbidding the evil" are individual religious duties.[17]

The overall mission of providing formal religious education to Iranian children is imbricated in the political realities of Iran's place in the world and in events such as the Iran-Iraq War, the confrontational relationship with the United States, and other regional maneuverings. But the explicit goal of curricular materials is to inculcate values such as kindness, honesty, respect, generosity, courage, discipline, and cleanliness. These aims are best expressed in the instructions for teachers using the primary school series of religious textbooks, urging them to bring about a "cultural revolution" and transform the children into "competent, committed, honest, benevolent, kind, diligent, scholarly, and pious men and women of tomorrow who, filled with faith, will rise to spread the tradition of Islam and the Islamic revolution throughout the world. They will cultivate the great community of Islam, rush to assist the oppressed and struggle against the oppressors, and mobilize the weak and dispossessed peoples of the world."[18]

Overall, in the period under review, Iran's centralized system of universal education functioned as an indispensable instrument for the

fostering of national ideology, for which children were simultaneously a primary target and a symbol. Topics that were taught in schools—such as anti-imperialist struggle, martyrdom, and revolution—were reinforced by other means of visual and textual propaganda. Some, such as postage stamps, were produced by the state, while others, like posters and picture books for children, by parastatal organizations.

GENDERING IRANIAN CHILDHOOD

Parallel to a curriculum that was intended to politicize children in the revolutionary and religious ideology of post-1979 Iran, the government innovated and introduced a number of children's festivals, which were celebrated in the schools as a matter of policy. Several of these were significant in their impact on girls, for whom they functioned as rites of passage. Among these is *Jashn-i 'ibādat* (Celebration of Worship), sometimes called *Jashn-i taklīf* (Celebration of Religious Obligation), which occurs as a graduation ceremony of sorts but is more significant for its religious symbolism. As mentioned in chapter 4, the age of nine is often understood in traditional Muslim thinking as that at which girls transition from ungendered childhood to early (or at least potential) womanhood. Many families impose restrictions on their daughters at this time, sometimes to the point that they take them out of school. The "Celebration of Worship" or of "Religious Obligation" is held for both boys and girls, but its significance for girls is much greater since it more directly acknowledges this age marker as a transition into maturity for them. *Taklīf* is the Islamic legal term for the state of responsibility to fulfill one's ritual obligations, meaning this is the age at which children are expected to start praying, fasting, and engaging in other religious acts in the same manner as adults do. By taking the girl's transition into gendered adult society out of the home and placing it in the civic, public context of the school, the state takes upon itself the right and responsibility of sanctioning womanhood itself as a public identity. It is a conscious governmental policy to keep girls in school, and has been very successful in that regard.[19]

Alongside such collective activities, Iranian textbooks promote a highly gendered notion of the ideal modern Iranian citizen, and these values are reinforced in the schools through dress codes, organized activities, and other forms of exhortation. Boys are taught to be brave and girls to be modest. Female gender roles in religious textbooks are limited to Khadija—the Prophet's wife and first convert to Islam—and Fatima, the daughter of the Prophet and Khadija, and mother to the

Shiʻi Imams. Fatima is praised as the "exemplary lady of Islam" who was an ideal wife to her husband, ʻAli (the first Imam), and ideal mother to her children. Even though she historically has occupied an active role in Shiʻi understandings of the early formation of the religion, in textbooks she appears in the capacity of a traditional homemaker, taking care of children and doing household chores. She is explicitly praised for her piety and virtue, as reflected in her prayerfulness and wearing of hijab. These qualities—rather than the more active and political ones for which she is known—are taught to young girls as the ideals to which they should aspire. They are strongly encouraged to veil and "cover their body and hair" from the predatory gazes of men, and told that veiling "strengthens the foundation of the family" and prevents women from becoming corrupt in the way they are in Western societies. Such versions of ideal femininity are reinforced with frequent illustrations of fully veiled women engaged in laudable acts, such as taking care of their homes and children, praying, and reading the Qur'an. This is a strong contrast to the manner of gendering boys: whereas textbooks (particularly those from the early years of the revolution) overwhelmingly represent females in the role of mothers, males are almost always depicted as working. In contrast, women are almost never depicted as working in professions, and men are rarely shown as fathers.[20]

VISUAL RELIGION IN IRAN

Visual materials perform a central function in the Iranian construction of modern childhood and its place in the revolutionary state. Visual religious art plays a much more pervasive role in Shiʻism in general than it does in Sunnism. This holds true across Twelver Shiʻi communities globally, but is especially noticeable in the case of modern Iran, where the state actively participates in public and visual religious culture in ways that it does not in Pakistan, Turkey, India, or most other societies with substantial Shiʻi populations. Much of this has to do with the place of public visual religious art and performance in Iranian society over the last two centuries, with dramatized mourning ceremonies, storytelling with visual props, a robust tradition of religious portraiture, and other such forms thriving over this era.[21] However, the period from the Islamic Revolution to the present has witnessed a dramatic growth in an ideological visual culture of a religious and political nature. Revolutionary and propagandistic art is pervasive in Iran, represented in formal instruments of the government such as postage stamps and programs on state-

owned television, as well as in more ephemeral but equally public media such as posters, billboards (hoardings), and murals produced by the government, parastatal organizations, or other interested parties. The start of the war with Iraq a few short years after the Iranian Revolution energized its propagandistic agenda, such that the legitimization of the regime became inseparable from a war of "sacred defense," subsequently resituated in a global struggle against imperialism and evil and in the evocation of potent Shi'i symbols and narratives of persecution, martyrdom, and virtue. These interventions by the state tap into an existing aesthetic social imagination, which is further developed to create an emotive regime in which a variety of emotions are actively evoked.

With the start of the Iran-Iraq war, a governmental department called the Organization for Islamic Propagation (Sāzemān-i tablīghāt-i islāmī) was charged with promoting regime ideology, and very soon thereafter, in 1982, the Center for Thought and Islamic Art was brought under it. Originally, the latter had been an independent organization; it was pressed into the ideological service of the regime with some resistance from its member artists.[22] Simultaneously with the patronizing of the Organization for Islamic Propagation, the Foundation of the Martyr (Bunyād-i Shahīd) was given extensive responsibilities for mobilizing society in support of the war effort. This institution had been established by Ayatollah Khomeini himself right after the revolution as a welfare organization for victims of the previous regime, but in short order it became a powerful political entity charged with building an all-pervasive national cult of martyrdom and victimhood.

Although some artists left the Center for Thought and Islamic Art, others remained and put their talent and training to the service of the state, coming to be referred to as "committed" (muta'ahhid) artists. Murals proliferated in all major cities and especially in Tehran during this time, with the dominant theme being the representation of the martyr (shahīd) as an archetypal and ideal citizen. The Bunyād-i Shahīd was responsible for the majority of the murals, which explains their subject matter to some extent. Even the official logo of this organization glorifies martyrdom, by directly quoting a Qur'anic verse that is commonly understood as making the sacrifice of one's own life a religious duty: "Among the believers are men who have been true to what they have promised to Allah. Among them is he who has fulfilled his vow and among them is he who is still waiting. And they have altered not at all" (Qur'an 33:23, Al-Aḥzāb).[23]

Throughout the period in question, the Bunyād-i Shahīd and the Organization for Islamic Propagation—through its art division now

named the Hūzeh-i Hunarī (Art Bureau, later transferred to the Ministry of Culture)—also produced a large number of commemorative and propagandistic posters. Many of them featured the work of regime artists, but others reproduced paintings by independent artists that had been appropriated by the regime and that were copied and modified freely, often without the consent of the original artists.[24] Like commemorative postage stamps, propagandistic posters were printed in conjunction with new public events such as the anniversary of the Week of Sacred Defense (Hafteh-i difā'-i muqaddas), which commemorates the start of the Iran-Iraq war and has continued to be marked annually. Many of the posters (such as the example in figure 26) betray the training of the artists and are reminiscent of the revolutionary and nationalistic art of earlier states, in particular the Soviet Union but also China, Spain, and others.[25]

A significant portion of Iranian propaganda either features or has been directed at children. In its self-appointed role as champion of the downtrodden peoples of the world, the Iranian government regularly prints postage stamps championing various categories of oppressed peoples. Figure 27 depicts a stamp commemorating World Health Day in 1985; it juxtaposes a drawing of a healthy blonde-haired child eating dessert at a table from a full bowl against a starving African child holding out an empty bowl, with a bomb falling above his head.

In condemning the wealthy Euro-American world for its hypocrisy and cruelty, this juxtaposition actively plays on the tension between ideal childhood as a time of safety and freedom from want on the one hand and the antichildhood lived by many children on the planet on the other. The majority of representations of children and childhood in governmental and parastatal Iranian art focus on Iranian children and childhood, and they appear in a variety of media, including video games.[26] Of them all, children's books are most obviously directed at children but, as I have already tried to establish, adults are also important audiences for children's materials, just as children are for many things ostensibly directed at adults.

In addition to textbooks, a large number of children's picture books were published in Iran after the revolution. Among the ones with very obvious ideological intent, a significant portion were printed with high production qualities by the parastatal press Sitāreh (Star), which is associated with the Mashhad-based Congress in Commemoration of Martyred Commanders (Kongreh-i buzurgdāsht-i sardārān-i shahīd, sometimes referred to by the shorter name Kongreh-i sardārān-i shahīd, and

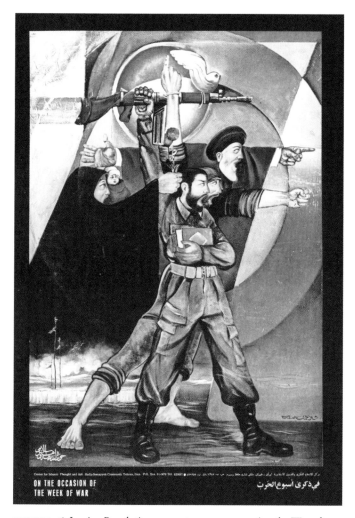

FIGURE 26. Iranian Revolutionary poster commemorating the War of Sacred Defense, featuring the artwork of Husayn Khusrojerdi (Middle East Posters Collection, University of Chicago Library. Courtesy of the University of Chicago).

at other times by the longer title Congress in Commemoration of Martyred Commanders and of the 23,000 Martyrs of the Shrine of Khurasan). These books target all age groups of children, from first readers to teenagers, and cover a range of themes, although some dominate: the glorification of warfare through war comics, the promotion among young boys of the desire to become soldiers, and coming to

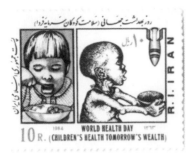

FIGURE 27. Iranian postage stamp marking World Health Day, 1984 (collection of the author).

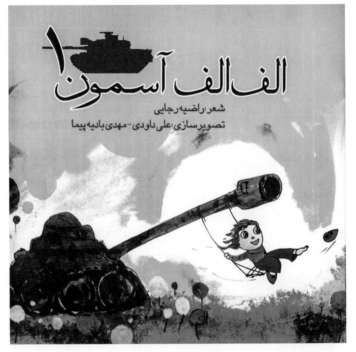

FIGURE 28. Cover page of Raziyeh Rajai, 'Ali Daudi and Mahdi Badiyeh-Payma (2009), *Alif Alif Āsemūm-1* (Mashhad: Nashr-i Sitareh).

terms with the deaths of martyred fathers or sons. Most of these books rely heavily on the juxtaposition of cuteness with the seriousness of the subject matter, especially when they are representing younger children.

Figure 28 is the cover of a first reader titled *Alif Alif Āsemūn*.[27] Although intended for young children, it features a very realistic silhouette of a tank as a logo in the top-left corner (other volumes in the

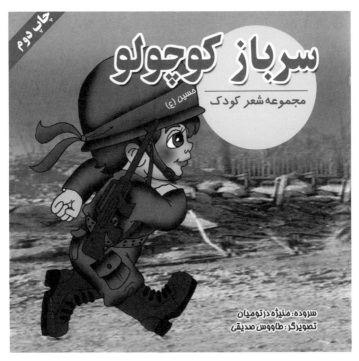

FIGURE 29. Cover page of Manizheh Dartumiyan, and Tavus Siddiqi (2003, rpt. 2005), *Sarbāz-i kūchūlū (Cute Little Soldier): majmū'a-yi shi'r-i kūdak* (Mashhad: Kongreh-i buzurgdāsht-i sardārān-i shahīd).

series feature other weapons of war, such as grenades). The painting is of a meadow full of flowers, in which a cute child of indeterminate gender plays on a swing hanging from the barrel of a derelict enemy tank.

Iranian ideological literature blends the exigencies of the modern war against Iraq with the story of Karbala, which sits at the center of Shi'i religious history and ritual. The evocation of Karbala carries into children's picture books, eliding the demarcation between the world of idealized childhood—in which death and disease have no place—and the world of adults at war. Figure 29 shows the cover of a versified picture book titled *Cute Little Soldier (Sarbāz-i kūchūlū)*.[28]

The first poem in the collection, which gives the book its title, follows a cute little boy as he plays at being a soldier, rearranging his family living room as a fort and fighting battles against his toys, using oranges as grenades: "Attacking from all sides, I target the enemy; I am the guardian of the faith and the homeland, I am the noble warrior of the Guide!" (figure 30).

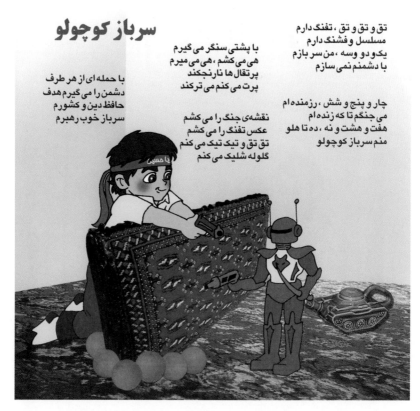

FIGURE 30. Boy play fighting in Manizheh Dartumiyan, and Tavus Siddiqi (2003, rpt. 2005), *Sarbāz-i kūchūlū (Cute Little Soldier): majmūʿa-yi shiʿr-i kūdak* (Mashhad: Kongreh-i buzurgdāsht-i sardārān-i shahīd), 1.

Even at play with his robot (figure 30), the little boy in *Cute Little Soldier* is wearing a religious headband like those worn by soldiers and irregular volunteers, emblazoned in this case with the slogan "Oh Husayn!" And the poem (a section of which is translated above) explicitly advocates that children regard themselves as being in the service of Khomeini, who is referred to as the Guide *(rahbar)*. The cover image depicts the little boy transformed into a soldier with a real gun and uniform, still wearing his red headband, standing against the background of a ruined battlefield.

Another book titled *Qulak-i sifālī* (Piggy Bank, lit. "little clay jar") features a very similar boy in a versified story that runs for the entire book.[29] Also cute and young, this boy passionately longs for the toy gun displayed in a shop window. For months, he patiently saves his coins

آن را زودی خریدم

با آن شدم رزمنده

از شادی توی قلبم

پر می زند پرنده

FIGURE 31. Boy soldier from Hamideh Najjarian and Iman Nasirian (2009), *Qulak-i sifālī (Piggy Bank)* (Mashhad: Kongreh-i sardārān-i shahīd and Intishārāt-i Sitareh), 15.

until he has enough money, and then he breaks open his piggy bank and buys the gun. The story tells us how happy he is (figure 31):

> I hurried and bought it
> And with that I became a warrior
> Out of happiness
> A bird fluttered in my heart[30]

The same picture of the boy dressed in a military uniform with his toy gun appears on the cover of the book with a smiling sun in the background. The primary difference is that the cover has him standing over his broken piggybank surrounded by a scattering of coins and fluttering butterflies. There is nothing in the story line to suggest why he wishes to become a soldier, and no guns appear apart from the toy one. On the contrary, his only other toys are stuffed animals, and he has a child's painting of a happy home overseen by a smiling sun taped to his wall. When he finally gets the toy gun, he immediately has a soldier's uniform,

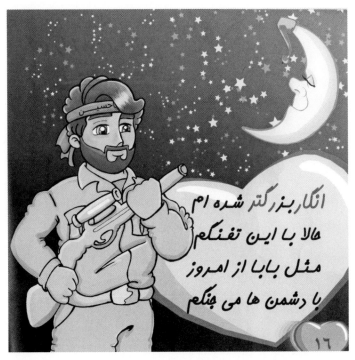

FIGURE 32. Boy soldier turned into a man, from Hamideh Najjarian and Iman Nasirian (2009), *Qulak-i sifālī (Piggy Bank)* (Mashhad: Kongreh-i sardārān-i shahīd and Intishārāt-i Sitareh), 16.

complete with a red headband emblazoned with the slogan "Oh Mahdi!" The message is clear: a cute and happy boy desires a gun and will strive to get it in order to be a soldier, implying that being a soldier for God and country is built into the constitution of good little boys. The final page of the story (figure 32) shows him as a bearded young man in a military uniform holding a real gun and wearing a headband that says "Oh Husayn!" The accompanying text declares:

> I imagine I have grown up
> Now, I am with this gun
> Just like Daddy, from tomorrow
> I will battle against the enemies[31]

Boys figure prominently in the representation of soldiers and in reinforcing the idea of self-sacrifice as a male religious virtue. During the Iran-Iraq war, a combination of revolutionary zeal and diminishing military resources resulted in the creation of a substantial volunteer force, the

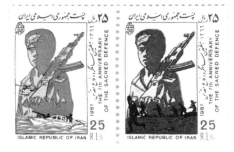

FIGURE 33. Child soldier on an Iranian postage stamp commemorating the "Seventh Anniversary of the Sacred Defense," 1987 (collection of the author).

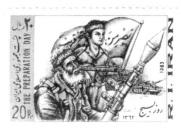

FIGURE 34. Iranian postage stamp depicting a boy and an old man as members of the Basij (collection of the author).

Basij irregulars, which drew men outside of the age of conscription (as well as some women) actively into the war effort. A network of clergymen affiliated with the Basij went from town to town, exhorting everyone eligible to join, with enormous emotional and moral pressure being placed on teenage boys and old men urging them to enlist. The broad mobilization of relatively untrained and ill-equipped volunteers to go to the battlefront, where they cleared mines and attacked Iraqi military positions in human waves, resulted in very high casualties, making the human costs of war even more of a social reality than they otherwise would have been.[32]

Boys are regularly depicted in visual commemorations of the Basij's participation in the war, which is itself central to the ongoing memorialization of sacrifice and martyrdom, especially on the annual holiday of Sacred Defense. Figure 33 shows two stamps issued in 1987 to mark the seventh anniversary of this holiday. The most prominent feature of both is the colored silhouette of a young boy with a gun, the image of whom is identical except that in the one on the left his headband reads "Oh Mahdi!" and in the right "Oh Husayn!"

Other stamps mark Preparation Day, which commemorates the Basij itself. The example from 1983 reproduced in figure 34 shows a boy at war, in this case together with an old man. The lack of helmets is

symbolically significant not only because it allows them to be shown with the religious headbands tied directly on their heads but also because the Basij volunteers were famous for scoffing at the idea of wearing armor (perhaps because there was not enough equipment to give them).

MARTYRDOM AND KARBALA

Such representations are ubiquitous and, through a very self-conscious visual and textual evocation of Shi'i Muslim collective memory and doctrine, they attempt to collapse history in a way that renders the present timelessly apocalyptic. The cute little boys in figures 29 and 31 display signifiers tying them to religious themes of sacrifice and martyrdom. The toy guns are aspirational of real guns, as made explicit in the text. In particular, the headbands are a regular feature in the visual representation of Iranian soldiers, and directly evoke the history of martyrdom in the formation of Twelver Shi'ism, the form of Islam that dominates in Iran.

The episode of Karbala comprises the central event of early Shi'i history: in 680 CE the Prophet's grandson Husayn and granddaughter Zaynab were besieged at Karbala by the armies of the caliphal claimant Yazid as they traveled with a small retinue of family members and loyal followers. Although this confrontation was of very small proportions when compared to several other battles in early Islamic history, it resonates as a formative moment in the history of Islam. Husayn was killed at the hands of the proto-Sunni army as was his infant son 'Ali-yi Asghar, half-brother 'Abbas, and approximately seventy other individuals who are remembered by Shi'is as having been loyal to the Prophet. Muhammad's granddaughter and Husayn's sister, Zaynab, along with the remaining survivors, who were mostly women and very young children, were taken captive and marched to Yazid's court.

The memory of Karbala is kept alive in Iranian public culture both through its ritual reenactment in the month of Muharram and through its pervasive evocation at other times in a variety of contexts. Karbala was visually and textually at the symbolic forefront of the buildup to the Islamic Revolution. The influential religious intellectual 'Ali Shari'ati wrote eloquently about the nature of martyrdom (shahādat) as a revolutionary role of cosmic significance, in which the martyr (shahīd) is a witness (shāhid) to the prevalence of evil, and the struggle against the Shah was routinely likened to the battle against Yazid.[33]

With the Iran-Iraq War, the comparisons to Karbala were so varied and pervasive that the period of the war can be viewed in apocalyptic

terms, with time folding between Karbala and the 1980s, when a Sunni Arab tyrant (Saddam Hussein), an oppressor of Shiʿis in the same Iraq where Karbala is located, engaged in an unprovoked and vicious attack against innocents. As such, it was not simply the deed of *fighting* in defense of the virtuous motherland, but the act of *dying* in the war that became the most complete method of reenacting sacred history. This phenomenon is reflected widely in the visual materials related to the war. For example, the poster in figure 35 includes the reproduction of a painting by Kazim Chalipa in which a motherly woman carries the body of a dead young man in a posture that is derivative of a Christian Pietà with Mary, but that is more likely to evoke memories of Fatima or Zaynab in the minds of most Shiʿis. She stands in front of an ethereal host of headless soldiers—these being the Martyrs of Karbala led by ʿAli on his white horse. The foreground is occupied by modern soldiers with guns, while the middle is filled with the corpses of soldiers, cruelly hoisted on posts.

Such Shiʿi symbols were actively deployed in the push to overthrow the Shah, who was likened to mythic oppressors such as Pharaoh, with whom parallels were drawn in terms of both his hubris and his enslavement of people. Religious institutions were at the center of the revolution and, after the start of the Iran-Iraq war, they were mobilized both in the service of the revolutionary state and to drum up broad support for the war. Members of the ʿulama held machine guns at their sides while delivering Friday sermons, the more important of which were advertised in newspapers and broadcast on television and radio.[34] Such activities were especially pronounced during the month of Muharram, which is a time of public, ritualized mourning leading to its apex on the tenth of the month, marking the martyrdom of Imam Husayn. On this occasion in particular, but actually throughout the year, the memory of Karbala was evoked as a model applicable to contemporary life, and all Iranians were encouraged to commemorate martyrdom not only through ritual but through actually reenacting it as well. The evocation of Karbala in the postrevolutionary period represents an amalgamation of different religious and cultural strains: it brings together public mourning in a time period when the religious state encourages a culture of blood-letting violence in war but forbids the more bloody aspects of Shiʿi ritualized mourning, such as self-flagellation with a bladed cat-o'-nine-tails *(zanjīr zanī)*. It draws together the tradition of publicly recounting the tragedy of Karbala *(rawzeh khwānī)* with multimedia sermonizing; and it uses a multitude of means to connect this most evocative moment of Shiʿi collective memory with events in the present and the future.

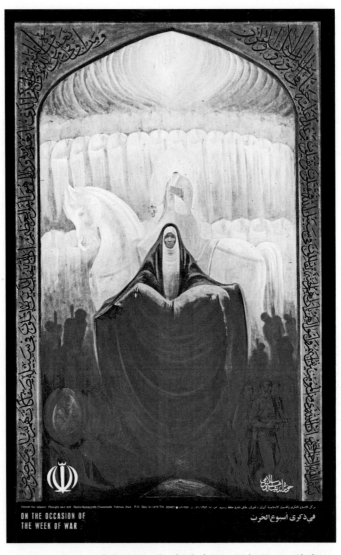

FIGURE 35. Poster titled "Certitude of Belief *(Yaqīn)*" by Kazim Chalipa, ca. 1981 (Middle East Posters Collection, University of Chicago Library. Courtesy of the University of Chicago).

Martyrology and the fetishization of self-sacrifice became a central feature of public life in Iran, enacted in elementary school plays and enshrined in a Martyr's Museum.[35] The centrality afforded to martyrdom is best observed, perhaps, in the way cemeteries have been transformed as social theaters. Across Iran, cemeteries of all sizes were restyled as gardens in which the martyrs were the flowers. The most famous of these is the large cemetery south of Tehran called Bihisht-i Zahra (The Garden of Fatima), which was informally anointed as *the* national martyr's cemetery by the fact that it was visited by Khomeini immediately after his return from exile in 1979 as a gesture of gratitude toward those who had died fighting the previous regime. Martyrs' cemeteries became adorned with signs and banners featuring images of fighting soldiers and quotations from prominent religious figures and from scripture, as well as with pictures of children and women mourning for lost loved ones.[36]

CHILDREN AND SACRIFICE

There are two main ways in which children get incorporated into the affective systems of martyrdom and self-sacrifice. The first is through being the sacrificial offerings themselves, and the second is as the virtuous witnesses to the act. The centrality of children to sacrifice is deeply ingrained in Islam, just as it is in Judaism and Christianity, through the story of Ibrahim (Abraham). As has been discussed by a number of authors in other contexts, the Abrahamic sacrifice has multifaceted and ambivalent implications.[37] It encapsulates the concept of sacrifice as the ultimate gift, in this particular case both on the part of the father who gives his beloved son and on the part of the son who willingly offers his life. God's ultimate test of devotion is precisely this: that parents be ready to offer their children's lives simply to prove their devoutness, and for children to be ready to die for God and for filial piety.

The problematic implications of human sacrifice, infanticide, and the sacralization of violence that are central to the Abrahamic religious moment are beyond the ambit of this book. But two relevant issues are reinforced by this key religious memory that underlies the majority cultures of most countries in the world today (inasmuch as they are Muslim or Christian in population). First, that the gift of death is ultimately laudable, especially for children, and second, that the one honored by the possibility of offering this gift is normatively male.

During the war with Iraq, the ideal of the boy soldier depicted in picture books reinforced a nationwide movement encouraging boys to

join the Basij. They were formally told to do so only with the explicit permission of their parents. However, as has been seen time and again in numerous contexts (the First World War and Second World War being notable examples), there is a thinly veiled admiration for boys who defy their parents and lie to military recruiters about their age, making their way to the battlefront.

The virtuous Iranian child par excellence in this model is Muhammad Husayn Fahmideh, who attached grenades to his body and threw himself under an Iraqi tank at the Battle of Khorramshahr in 1981. He was twelve years old, and had disobeyed his parents and lied in order to join the Basij. The memory of Fahmideh is kept alive in Iranian national culture through lessons about him in schools, stories about him in popular media, and recurring uses of him in state discourse. He was introduced in Iranian third-year textbooks in a lesson titled "Fadākārān" (The Devoted). Interestingly however, even though he was very much part of the public and visual culture of Iran from immediately after his death, he only entered the curriculum two decades later, and represents the first instance of an actual Iranian historical figure—rather than a fictional Palestinian—being featured in such lessons about war, struggle, and self-sacrifice.[38] Fahmideh was inserted into an existing story about a devoted farmer *(Dehqān-i fadākār)* named 'Ali Khajavi who is celebrated for saving the passengers of a train that was headed toward a washed-out bridge. The two heroes subsequently appeared together in a variety of contexts, including commemorative stamps celebrating self-sacrifice.

Figure 36 shows such a commemorative pair of stamps from 2012 titled "Dedication and Sacrifice" *(fadākārī wa īşār)*. The stamp on the right celebrates the aforementioned tenant farmer Riz 'Ali Khajavi, who, in 1962, saw that a landslide had blocked the railroad tracks in front of an approaching passenger train. Khajavi tore off his coat in freezing weather, attached it to a stick, set it alight, and then ran toward the approaching train. The driver saw him and successfully stopped the train without any casualties. This famous "Dedicated Farmer" is a staple of Iranian social studies classes, and has been joined by Fahmideh, who is represented in the second of the pair of stamps. As in the case of the farmer Khajavi, Fahmideh needs only visual cues to tell his story (a soldier crouching in the desert, an exploding tank), evidence of the level to which this story is familiar to its audience. Unlike the farmer, Fahmideh is shown in portrait style, a common way in which martyrs are represented visually in Iran. His status as a martyr is reinforced by the white doves flying in the top-left corner above him.

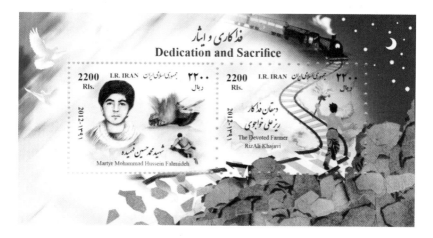

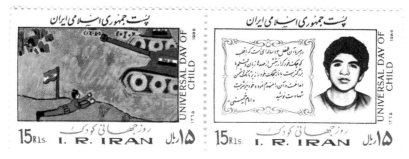

FIGURE 36 (Top). Commemorative Iranian postage stamp featuring Fahmideh and Khajavi (collection of the author).

FIGURE 37 (Bottom). Iranian postage stamps marking the Universal Day of the Child featuring Fahmideh (collection of the author).

Fahmideh's role as a national hero is even more readily apparent from a pair of commemorative stamps marking the 1986 Universal Day of the Child (figure 37).[39] The pair comprises a child's painting acknowledging his heroism on the left, and a portrait on the right, accompanied by Khomeini's words in praise of Fahmideh. The painting evokes his story iconically (a crouching soldier and tanks with Iraqi flags), whereas Khomeini's words are morally descriptive: "Our guide *(rahbar)* is that boy of twelve years of age. The worth of his little heart is greater than could be described by hundreds of tongues and pens. He threw himself under an enemy tank with a grenade and destroyed it. And he drank the sweet elixir of martyrdom."

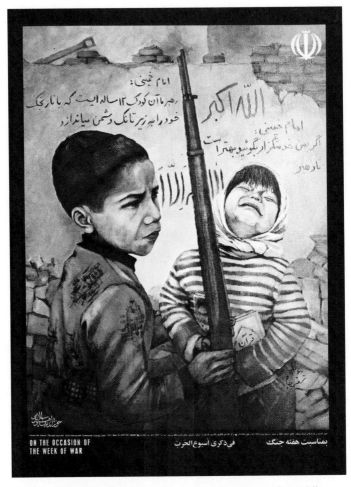

FIGURE 38. Poster of boy and girl by Muhammad Taraqijah (Middle
Eastern Posters Collection, University of Chicago Library. Courtesy
of the University of Chicago).

The word *rahbar* for guide was used as a title for Khomeini; his own
use of it in a formal statement concerning Fahmideh consciously places
the boy in a position of religious and moral leadership of the Islamic
Republic of Iran, complicating ideas concerning childhood innocence
and irresponsibility. This elision of moral innocence into the visual is
demonstrated further in the poster in figure 38.

The painting in this poster shows Fahmideh ostensibly at the moment
of his departure for the front. The image is decidedly sad—the boy's face

displays grim determination, not enthusiasm and excitement for the prospect of battle and its glories, while the girl wails as she clutches the Qur'an. In this representation, the boy and girl stand in for adult anxieties and emotions very explicitly. The graffiti on the wall is of statements by Khomeini (including the one concerning Fahmideh translated above), and the overall message is an apocalyptic evocation of the martyrdom of Husayn. As is retold every year in popular commemoration, he and his mother Fatima (and, in some versions, his sister Zaynab as well) knew all along what fate awaited him, yet he went through with the events of his life out of cosmic necessity. Like Husayn's grieving mother and sister, the girl in this poster takes solace in her faith and makes no attempt to alter the course of the religious guide's (that is, the *rahbar*'s) martyrdom.

In the example of this poster, the innocence of children is used as an affective multiplier in a situation that, sadly, has been repeated throughout history, except that it characteristically involves adults. The way in which visual innocence exists in an affective relationship with virtue is best illustrated, perhaps, by observing the intersection of gender with virtue and innocence, especially as it is inflected by age. As I have already mentioned in the previous chapter, with very few exceptions, the paradigm of virtue as sinlessness twins younger males with older females. This is attributable, in part, to the ways in which an infantile female is redundant with the males of her age cohort. The more import factor, however, is that, as illustrated directly by the example of Fahmideh and somewhat less overtly by the cute boy soldiers in figures 29 and 31, the ultimate act of virtue is that of sacrificing oneself, which is treated stereotypically as a male prerogative.

There are very few images of women or girls with guns paralleling the ones of men and boys. Those that do exist depict them not as soldiers but rather as fully veiled women (and even small girls in black veils) who have taken up the gun, using the juxtaposition of the prescribed appearance—and consequently the implied role—of women with the symbolism of guns to emphasize how exigent the times are that they require *even women* to take up arms. Self-sacrifice as martyrdom is constantly reinforced as a male prerogative. One notable exception is Marwah Sherbini, an Egyptian woman who, in 2009, was stabbed to death in a hate crime in front of her husband and two-year-old son while she was in a German courtroom (her husband was stabbed multiple times as he tried to protect her, and was shot by police who mistook him for the attacker, who was actually a white, German man).

The stamp in figure 39 was issued very shortly after Sherbini's death and celebrates her as a martyr, reminiscent of the manner in which the

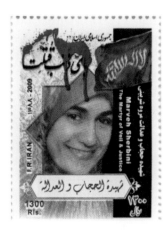

FIGURE 39. Iranian postage stamp recognizing
the "Martyr of Veil and Justice"
(collection of the author).

suffering of the Palestinians is evoked as a nationally relevant issue in
Iran. But, as the text on the stamp makes clear in three languages (Per-
sian, English, and Arabic), she is a martyr to the "veil and justice"
(shahīdeh-i hijāb wa 'adālat). Her headscarf is prominent in her mar-
tyrological portrait, as is a green banner above her with the Islamic
profession of faith *(shahāda)* upon it, emphasizing her virtuous reli-
gious character. This is underscored further by the Qur'anic verse under
the dripping blood, which reads, "For what sin was she killed?" *(bi-ayy
dhanb qutilat,* 81:9, Al-Takwīr). This famous verse condemns the prac-
tice of female infanticide among pre-Islamic Arabs, and its use here
links her killing to a murderous act condemned in the Qur'an. But it
does much more than that because, in condemning her murder, it con-
nects her innocence and virtue—evident from her sweet smile and prop-
erly covered head—to the absolute innocence of the newborn infant.
Twinned with the baby girl, the adult woman is infantilized in the very
process of being acknowledged.

The message that martyrs are male is pervasive in children's picture
books, which simultaneously glorify death and routinize the lives of sur-
vivors, who do not *grieve* for their dead so much as they *miss* them.
Children's picture books prepared by Sitāreh and other publishers often
focus on the loss of a father and the preservation of his memory, and
feature titles such as *Good Memories of Battle (Yādash bakhayr-i jang),
Haven't You Seen My Father? (Bābāmo tū nadīdī?), Come in Our Dreams
Sometimes (Gāhī beh khwāb-i mā biyā),* and *Thoughts of Daddy
(Khāṭirāt-i Bābā).* Many of these follow predictable patterns, and in most
cases, the protagonist who pines for the martyr is a young boy.

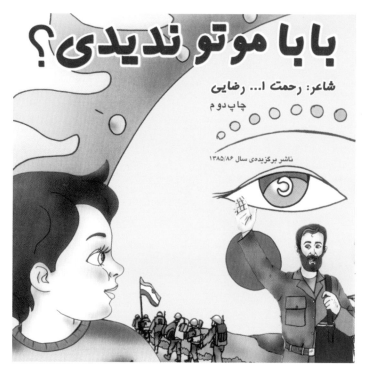

FIGURE 40. Cover page of Rahmatullah Razai and Bahnush Zamani (2007), *Bābāmo tū nadīdī? (Haven't You Seen My Father?)*, 2nd ed. (Mashhad, Kongreh-i sardārān-i shahīd and Nashr-i Sitareh).

Haven't You Seen My Father? (figure 40) features a young boy who wanders around and asks natural phenomena, such as trees, stars, and flowers, if they have seen his father since he left for war. It starts with the following verses:

Ever since my father has not been at my side
My heart is heavy and I look for signs of him
He went to fight the enemy and I have not seen him again
I am asking after a sign of my father
From everyone and everywhere[40]

The cover of the book shows the cute boy watching his father leave. Notably, the man is not dressed in full military garb, and at no point in this particular book do we see soldiers enthusiastically fighting the enemy. In other words, one is tempted to read it as a book that affectively attempts to reflect the boy's sadness rather than his pride in his father

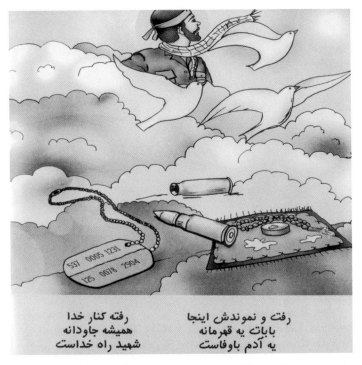

رفته کنار خدا رفت و نموندش اینجا
همیشه جاودانه بابات یه قهرمانه
شهید راه خداست یه آدم باوفاست

FIGURE 41. Final page of Rahmatullah Razai and Bahnush Zamani (2007), *Bābāmo tū nadīdī? (Haven't You Seen My Father?)*, 2nd ed. (Mashhad, Kongreh-i sardārān-i shahīd and Nashr-i Sitareh).

and his enthusiasm to follow him. The final page (figure 41) shows the father dressed as a soldier but with a scarf he was not wearing before, high above the clouds and surrounded by birds, with bullets, dog tags, and the ritual objects of prayer floating in the foreground. His status as a martyr is reinforced by the final lines of the poem, which are spoken by the sun as it tells the boy that his father has gone to heaven. This task is accomplished without in any way indicating what impact knowledge of this fact has (or should have) on the little boy:

> He has gone and no longer remains here
> Your father is a hero, a man of fidelity
> He has gone to the side of God
> Immortal and everlasting, he is a martyr on God's path[41]

A similar lack of extreme emotions either of grief or of joy characterizes other such books as well. *Khāṭirāt-i Bābā* relates the story of a boy who accompanies his widowed mother to his uncle's house. As the two

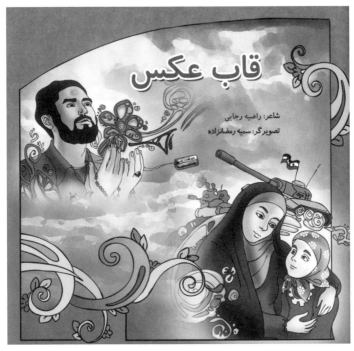

FIGURE 42. Cover page of Raziyeh Rajai and Samiyeh Ramzanzadeh (2011), Qāb-i ʿaks (Picture Frame) (Mashhad, Kongreh-i sardārān-i shahīd and Nashr-i Sitareh).

males sit and look at a photo album with images of war (actual printed photographs in the case of this book), the uncle relates how the boy's father was a hero among soldiers whose memory lives on eternally, that he was a believing man who always did good deeds and was considered a pious model by his fellow soldiers, and finally that every Thursday night the Basij soldiers sit by his grave and pray.[42]

The majority of such books feature a young boy. When the protagonist is a girl, the story also gives prominence to her mother. An example of such a work is Qāb-i ʿaks (Picture Frame). This book features many scenes of gallantry in war, and the cover depicts what is presumably the martyred father praying in heaven amid a scene with Iraqi tanks and smoke, while the little girl, with her head covered, sits in her mother's embrace in the foreground (figure 42).[43] The book ends with the mother and daughter standing hand in hand in a martyr's cemetery with their veiled backs to the viewer as they gaze at the portraits of dead soldiers in the flag-filled graveyard (figure 43):

FIGURE 43. Mother and daughter in a martyrs' cemetery, from Raziyeh Rajai and Samiyeh Ramzanzadeh (2011), *Qāb-i ʿaks (Picture Frame)* (Mashhad, Kongreh-i sardārān-i shahīd and Nashr-i Sitareh), 19.

I know for certain that the kind angels
Have lifted up my Daddy and carried him high in the heavens
Every Friday, Mummy and I go to the martyrs—
I like them just as much as I like Daddy[44]

The affective value of the pictures illustrating this story and of the poem itself is obvious: femaleness is a constant state in which little girls are inseparable from widowed women. They are characterized by modesty and virtue, and by a passive acceptance of their fate, thereby reflecting the virtuous quality of trust in God *(tawakkul)*. And finally, their selflessness is demonstrated by the way the little girl is willing to share her love for her father with the other martyrs. The implication is that her relationship with her father gets transformed from that of a daughter to one of a mother, since virtuous mothers are mothers to *all* soldiers of the nation.

The self-effacing sacrifice of motherhood is the subject of the book *Kabūtarān-i bī ṣadā* (Silent Doves), which tells the story of the mother of

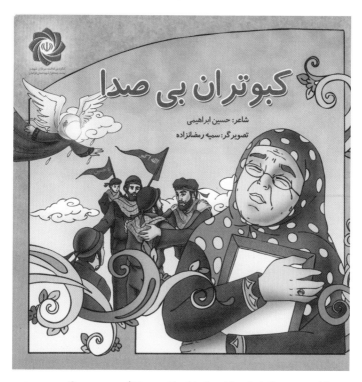

FIGURE 44. Cover page of Husayn Ibrahimi and Samiyeh Ramzanzadeh (2008), *Kabūtarān-i bī ṣadā (Voiceless Doves)* (Mashhad, Kongreh-i sardārān-i shahīd and Nashr-i Sitareh).

a martyred soldier.[45] The poem relates how she cries inconsolably when her young son decides to go to war but, when she hears news of his martyrdom, she no longer cries and finds peace. The story carries an additional message by juxtaposing those who willingly sacrifice themselves for their country and faith with impious, selfish, and materialistic people. The cover of the book (figure 44) shows the mother clutching a framed photograph in the foreground while her son is being greeted by his martyred comrades in heaven, with an angel and a weeping cloud among them.

VIRTUOUS MOTHERS AND WIDOWS

Socially validated forms of female sacrifice are distinct from male ones, and come at a later stage in life, where they are linked symbiotically either with virginal purity or with motherhood, two states that are not entirely dissimilar. Figure 45 depicts a postage stamp issued in 1987 on

FIGURE 45. Iranian postage stamp commemorating the Birth of Zaynab (collection of the author).

FIGURE 46. Iranian postage stamp commemorating the Basij (collection of the author).

the occasion of Nurse's Day, which, in Iran, is celebrated on the birthday of the Prophet's granddaughter Zaynab. The image of a female nurse—her face barely visible—completely clad in pure white and comforting a male child is exemplary in juxtaposing the standards of male and female virtue, where the adult female serves as a chaste and pure, self-effacing caregiver (reminiscent of Zaynab) to a good-looking boy whose injuries and green bandage are evocative of a self-sacrificing soldier.

The ultimate analog to the boy soldier in the virtuous act of sacrifice is the son-sacrificing mother. She exemplifies female virtue in this act, in that she is willing to give her son as a gift of sacrifice and to bear willingly the suffering and grief that inevitably accompany his loss to martyrdom. The theme of the martyr's mother appears again and again in Iranian visual art in this period, epitomized by the Pietà-like mother in figure 35 and in storybooks such as *Silent Doves*. It also appears repeatedly in postage stamps, such as the one in figure 46, which depicts a photograph of a mother sending her son off to the Basij.

FIGURE 47. Iranian postage stamp commemorating the eighth anniversary of "Sacred Defense" (collection of the author).

FIGURE 48. Postage stamp issued on Iranian Woman's Day, 1986 (collection of the author).

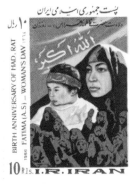

The comparison between figures 47 and 48 make this female role clear. The postage stamp in figure 47 celebrates the Basij on the occasion of the eighth anniversary of the start of the Iran-Iraq war. It depicts three generations of male soldiers gazing out of the frame, with a veiled woman standing off in the background, looking outward, toward the men as well as the viewer.[46]

The stamp in figure 48 is explicit in juxtaposing male and female roles and linking them to religious virtues. It commemorates Woman's Day, which, in Iran, is celebrated on the birthday of Fatima, the Prophet's daughter and mother of the martyred Imam Husayn. The main feature of the image—situated above a two-tone group of protesting women, is a veiled woman holding a little boy in her arms. The boy (ostensibly her son) is wearing the headband characteristic of males going off to war, this one bearing the slogan "Oh Zahra!" (an epithet for Fatima). Above them is the religious slogan "God is Great!" *(Allahu*

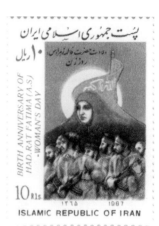

FIGURE 49. Postage stamp commemorating Iranian Woman's Day, 1987 (collection of the author).

akbar). In this instance, the collapsing of the modern Iranian moment into the seventh-century event of Karbala is complete, in that the woman directly and simultaneously evokes both Fatima and her infant son Husayn, who is destined for martyrdom, *and* Zaynab, who holds Husayn's son, the martyr-to-be 'Ali-yi Asghar. To put the message in terms popularized in revolutionary Iran by Shari'ati, the male bears witness (does *shahādat*) through his death, and the woman bears witness by living on and being a continued witness to the martyrdom.[47]

The ultimate female role continues to be represented as a transcendent and timeless religious function of serving as mother to self-sacrificing males. The stamp in figure 49 commemorates Woman's Day (and Fatima's birthday) in 1987. An oversized woman in a green cloak, certainly evocative of Fatima, hovers protectively over a group of young male soldiers, while a banner declaring *"Allahu Akbar"* ("God is Great") flutters above them all.

CONCLUSION

The virtue of self-sacrifice clearly signifies different things for males and females: males sacrifice themselves by embracing death for the sake of religion and country, while females engage in self-effacement, or, when they do actually die themselves, it is not through the active embracing of death but as a passive martyr who is killed because she upholds virtue. This passivity is actually complex and ambiguous, in that active choices are inherent in it, as is the concept of gift giving. But these

choices of emotively performing dedication, loyalty, obedience, modesty, and chastity result in the ultimate virtuous act of sacrifice not by active design but through innate character.

The notion of sacrifice in the service of religion or the nation is, of course, not limited to Iran, nor is it specific to Islam. Neither is the specifically gendered way in which boys are encouraged and rewarded as soldiers and martyrs while girls sacrifice as mothers particular to this context. Excellent examples of this phenomenon are evident in nationalistic messaging directed at children both from the early Turkish republic and from the present. The image in figure 50 is from an issue of the Turkish humor periodical *Akbaba* dating from 1926, before the shift to the Latin script. It depicts a mother and her two children in forms of dress that mark them as ideal citizens of the modern Turkish republic, with the mother and daughter wearing fashionable European skirts and hats, and the boy a sailor's uniform with short pants. The mother is carrying on a conversation with her children as they walk alongside a group of marching soldiers, their enthusiasm evident from the boy's dress as well as from the bouquet in the girl's hands. The Ottoman Turkish caption records the conversation among the three of them: the boy says, "Mother, when I grow up, I'll also be a soldier, isn't that right?" to which the mother replies, "Yes, my child, if God wills it!" The girl then says, "And me, Mother? Won't I also be a soldier?" The mother replies, "As for you, you'll be the mother of a soldier, my child!"[48]

Stepping forward almost a century, we find Turkish society demonstrating changed national priorities, with the symbolic value of Western-style secular modernity having been replaced by a quest for Islamic authenticity in many aspects of governmental and public life. The official department responsible for religious affairs (Diyanet İşleri Başkanlığı) publishes a range of religious books and audiovisual materials, a notable portion of which are directed at children, including an illustrated periodical titled *Diyanet Çocuk Dergisi*. The issue of this magazine from April 2016 featured a two-page article teaching children about the glories of martyrdom.[49] The specific motivation behind running such a story at this particular time is unclear, although Turkey's active support of Sunni militias in Syria and a domestic flare-up in terrorist attacks are likely to have played a part in the decision.

The article depicts a conversation in the ideal nuclear family of a father and mother with one boy and one girl. Emblazoned across the top above the first graphic frame is the prayer "May Allah be pleased with our martyrs, may their graves be filled with light *(Şehitlerimizden Allah*

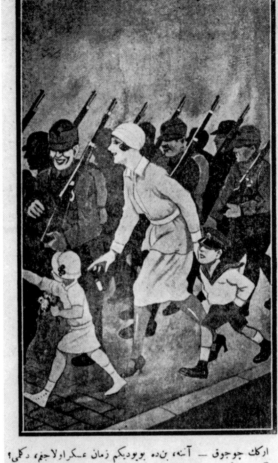

اركك جوجوق — آنه، بندە بويودبكم زمان عسكراولاجمِ، دكلى؟

آنه — أوت ، ياورم .. انشاالله !

قِز جوجوق — يا ، بن آنه ؟.... بن عسكر اولامى‌جقمى‌م ؟

آنه — سندە عسكر آنەسى اولاجقسك ياوروم !

FIGURE 50. Turkish mother with children, from *Akbaba* 407
(October 28, 1926, courtesy of the Atatürk Library, Istanbul).

razı olsun, kabirleri nur ile dolsun)." The first frame portrays the father
telling his son how beautiful martyrdom is, and how everyone would
very naturally wish for martyrdom since it guarantees entry into heaven.
The second frame shows the mother (with her head covered) talking to
her two children. The daughter says, "If only I could also be a martyr!"
to which her brother retorts, *"You* can't join the army!" The mother

finally responds to her daughter by saying, "If that's how badly you want it, my girl, God willing, Allah will surely grant you that reward."[50]

Despite the inclusion of the girl and the acknowledgment that she, too, could be granted the divine gift of martyrdom, the story proceeds to focus exclusively on martyrdom as a male privilege imbricated with military service. After describing a family visit to a military cemetery where the children learn that martyrs are spared the pain of death and that they are forgiven their sins, the story ends some years later when the boy is a soldier, with the father proudly telling his own father that the boy is on sentry duty that night. The pleased grandfather replies that the son's military service will prevent the fires of hell from ever touching him. In other words, being a soldier gets elevated beyond a purely patriotic act to an intercessory eschatological one of religiously defined self-sacrifice so great that it pardons the sins of the sacrificial son. Unlike the nationalist illustration from 1926 in figure 50, the modern story does not give a prominent role to the mother, most likely because of a dramatic social shift from a time when the modern Turkish woman was being promoted as someone who was empowered, in the public eye, and the primary educator of her children, to a different socioreligious ideal of the paradigmatic woman as much more of a self-effacing nurturer in a home. But the lesson is clear, nevertheless, that true self-sacrifice is an essentially male prerogative that is to be inculcated and celebrated in boys, whereas girls are to be taught that it is not really for them except in their relationship to males.

Of Children, Adults, and Tomorrow

A Conclusion

The will to sacrifice provides a suitable frame within which to view sociocultural constructions of meaning through emotive responses to images. By referring to *will,* I am attempting to relate the willingness to sacrifice oneself or one's cherished children and property, as well as the willingness to receive a sacrifice or to benefit from it. Sacrifice, in these senses, can be analyzed within the context of gift giving, but I am subsuming the construction of moral, economic, and ritual worlds into an emotive regime, by which I mean a framework centered on the experience and performance of emotion. In such a construct, there is certainly a place for the moral and the ritualistic, just as there is for the act of offering and receiving sacrifice. But this framework is one in which the will to sacrifice is shaped by a range of emotions and emotives such as virtue, piety, promise, and aspiration. Sacrifice might reflect a moral contract, but it is one in which individual and collective aspirations are not separate from the concept of promise. Promises, as Derrida reminds us, are restless: "a promise must promise to be kept, that is, not to remain 'spiritual' or 'abstract,' but to produce events, new effective forms of action, practice, organisation and so forth."[1]

Emotive constructs such as the will to sacrifice should be seen as promises or moral contracts that are the consequences and instruments of shaping societies as pious communities. In this sense virtues are aspirational, in that they anticipate the fulfillment of expectation; and inasmuch as emotion is linked to virtue, emotion is aspirational as well.

THE MESSINESS OF EMOTION

As I have discussed at length in chapter 2, my understanding of emotion and affect does not treat them as precognitive or even as prereflective bodily consciousness. For the purposes of sociocultural studies, I consider emotion to be bodily and somatic, and its affects to be the intentional and unintentional perception, understanding, and performance of feelings and emotions. Emotions make embodied action at the same time as somatic activity makes emotion. My definitions of *emotion* and *affect* are imprecise because emotions themselves are messy, defying easy classification.

I have attempted to make a twofold assertion, which informs my analysis of the representations of children undertaken in this book: that the enactment or performance of emotion cannot be divorced from its experience, and that emotives and emotions can never be understood properly when separated from the lived environments in which they occur. Yet many questions remain unresolved regarding the nature of emotion and affect as it relates to visual and material culture. It is beyond argument that emotions are culturally constructed, but are they gendered or age-defined? The many cases of specific ways in which male and female actors are depicted in the examples from Iran, Pakistan, and Turkey discussed in the preceding chapters suggest that constructed emotion and affect are very clearly inflected by gender. Similarly, the impatience that characterizes common representations of the young contrasts with the forbearance of the old and the patience of adult parents as they deal with children. These examples reflect on the culturally constructed nature of public emotion, but they do not answer the question of whether or not there are biological differences in emotion between gender and age groups.

Central to my study is the position that the word *emotion* must extend beyond a narrow meaning and embrace a variety of other human experiences and characteristics. These include what might be labeled as secondary or second-order emotions such as aspiration or hope. Crucially, it must also include moral qualities since, as demonstrated in my analysis of visual materials in all three contexts, emotions are central to moral formation. The moral aspects of emotion occur through secondary causes, such as when the evocation or representation of shame and honor externalizes both emotion and virtue. But these aspects of emotion also occur directly, when the conscious evocation of emotion in oneself or in others not only demonstrates one's virtuous character but also engenders virtue.

That emotion is enacted in a sociocultural space—which one might call an emotional *habitus,* ecosystem, or an emotional regime—helps explain how public emotional acts shape the lives of more than the individual who enacts them. Emotions are kinetic and directional, directed inward at the individual's sense of self at the same time as they are directed at other members of society. This quality allows them to function morally as well as aspirationally.

An important example of the aspirational function of emotion is in the construction of morale, which can signify a number of different things beyond its narrow meaning of a collective disposition of possessing (or lacking) a sense of confidence and good spirits in relation to the social whole. Morale is diffuse as an emotional construct, since it neither possesses identifiable causes nor is identifiable in its outcomes—having high morale doesn't make me smile or jump up in the air, even though sports teams frequently attribute their performance to their morale. More than an identifiable emotion or emotive, morale functions as part of the overall makeup of the social unit, as the indicator of the condition and functioning of individual bodies within the group, of their mental condition, and of the collective disposition to which the group aspires in acknowledgment of morale's social vitality.[2] The examples of official and parastatal visual materials from Iran discussed in the previous chapter provide very clear examples of the construction of an emotive regime with the conscious purpose of effecting and affecting morale. But even the images of virtuous children in Pakistan and the religious lessons on civic Muslim citizenship in Turkey demonstrate the way in which an aesthetic social imagination and societal goals are combined in an attempt to shape collective—but undefined—emotions, or what can be called morale.

It is precisely this indeterminate and contingent nature of morale that makes it an indispensable part of collective life and an object of attention for those attempting to shape public opinions and dispensations. Morale becomes linked to aspiration for a better future populated by finer individuals, including oneself. As such, the quest for morale becomes imbricated in the desire to shape childhood and to use children to shape adult society.

CHILDREN ARE OUR FUTURE

As many of the examples discussed in this book demonstrate, children stand in for adults in a variety of ways: as emotional actors, virtuous

exemplars, sentimental and neoromantic symbols of the past, and understudies and stand-ins for when adult discomfort in a situation is too great.[3] Adult anxieties and aspirations are projected upon and experienced through children; and through the construct that is childhood, the representation of children and the production and consumption of literature for and about them become repositories of adult intentionalities.

Visual representations of children in the forms that have been discussed here serve as the sites of discursive mediation and emotive response, simultaneously displaying and constructing the relationships between their agents and subjects at the same time as they create the social, cultural, religious, and historical contexts in which these visual and material objects are produced, circulated, and consumed.[4] At their center lies the concept of the child and of childhood, and the varied understandings of religion that shape individual and collective identities, relationships, and emotive regimes in which the visual images circulate. Visual representation functions as a (sometimes unconscious) discursive strategy in which children serve as affective multipliers of the emotive acts and aspirations of adults.

The image becomes the site in which visual emotions are manifested or, perhaps more accurately, where they are affected and performed. The relationship between emotions and their visual, written, spoken, and other representations is ambiguous and volatile, and certainly is not one that lends itself to stable interpretation across cultural contexts. Within specific systems of representation and performance—such as in the rasa theory of gesture and expression employed in Indian classical dance or in the conventions of representing emotion in Persianate miniature painting—there is an expectation that participants in the cultural system share an understanding of the relationship between visual cues and the emotions they reflect.[5] I argue that it is the generation and propagation of precisely this like-mindedness that underlie the ubiquitous use of children in a variety of ethical and sociopolitical media.

The materiality of the visual object both shapes and participates in the materiality of the emotive regime, fashioning it through networks of social relations and the societal narratives that circulate broadly within them and that form an aesthetic social imagination and serve as sites for the generation and reinforcement of social, political, and religious meanings. These networks and narratives subsequently bring about their own subjects within the broader framework of their own structures.

Representations of children function in precisely such ways, reflecting sociocultural understandings and reactions to existing situations but

also generating them and serving as multipliers of affect. Through its images, the ideal child gains an "emergent authenticity," a form of validation and legitimacy that is accrued through repetition, imitation, emulation, and admiration.[6] Childhood first gets idealized, and then treated contradictorily, as a state of innocence that gets corrupted by society and simultaneously as a state of wildness that is tamed through socialization; and finally, childhood is made the repository of societal aspirations that find their expression in the visual affect of cuteness and the moral and emotional one of innocence.

But the use of children to signify the emotional and moral lives of adults is not a simple case of appropriation or neoromantic sentimentality. The extensive use of children and childhood as stand-ins for adulthood and adults also reflects a vulnerability on the part of the agents of such constructions. Ethical and moral agency has to be based on the willingness of the actor to acknowledge his or her own vulnerability. Ethical responsibility is made up of an openness to others, since ethical practice derives from some combination of an awareness of the needs of others and an acknowledgment of one's own vulnerability.[7] The broad-based evocation of children in sociopolitical and religious situations therefore helps shape adult and juvenile members of a pious community at the same time as it reaffirms the belief in such a community's existence and in the presence and trust concerning its continuation into the future.

Notes

CHAPTER I

1. For a discussion of representations of childhood in film, see David Mac-Dougall (2006), *The Corporeal Image: Film, Ethnography, and the Senses* (Princeton, Princeton University Press): 68–70.

2. Rosalind Evans (2007), "The Impact of Concepts of Childhood on Children's Participation in Bhutanese Refugee Camps," *Children, Youth and Environments* 17 (1), *Pushing the Boundaries: Critical International Perspectives on Child and Youth Participation—Focus on Southeast Asia, East Asia, the Pacific, South and Central Asia, and Japan*: 171–197, p. 173.

3. Evans (2007): 173–174.

4. Evans (2007): 174.

5. Rachel Freudenburg (1998), "Illustrating Childhood—'Hansel and Gretel,'" *Marvels and Tales* 12 (2): 263–318, p. 263.

6. Richard Mizerski (1995), "The Relationship between Cartoon Trade Character Recognition and Attitude toward Product Category in Young Children," *Journal of Marketing* 59 (4): 58–70, p. 59.

7. Mizerski (1995): 59.

8. Liat Sayfan and K.H. Lagattuta (2009), "Scaring the Monster Away: What Children Know about Managing Fears of Real and Imaginary Creatures," *Child Development* 80 (6): 1756–1774, p. 1756.

9. A.S. Winston, B. Kenyon, J. Stewardson, and T. Lepine (1995), "Children's Sensitivity to Expression of Emotion in Drawings," *Visual Arts Research* 21 (1): 1–14.

10. Jacqueline D. Woolley (1997), "Thinking about Fantasy: Are Children Fundamentally Different Thinkers and Believers from Adults?" *Child Development* 68 (6): 991–1011, p. 992. See also Jacqueline D. Wolley, Katrina E. Phelps, Debra L. Davis, and Dorothy J. Mandell (1999), "Where Theories of

211

Mind Meet Magic: The Development of Children's Beliefs about Wishing," *Child Development* 70 (3): 571–587.

11. Woolley (1997): 992.

12. Woolley (1997): 995.

13. Pierre Bourdieu (2000), *Pascalian Meditations*, trans. Richard Nice (Stanford, Stanford University Press): 166.

14. Megan Watkins (2010), "Desiring Recognition, Accumulating Affect," in *The Affect Theory Reader*, ed. M. Gregg and G.J. Seigworth, 269–85 (Durham, Duke University Press): 275.

15. Judith Butler (1993), *Bodies That Matter: On the Discursive Limits of "Sex"* (London, Routledge): xix.

16. Virginia Postrel (2003), *The Substance of Style: How the Rise of Aesthetic Value Is Remaking Commerce, Culture, and Consciousness* (New York, HarperCollins): 6.

17. Alexander Gottlieb Baumgarten (2000a): "Aesthetics and the Sublime," in *Art and Theory, 1648–1815: An Anthology of Changing Ideas*, ed. Charles Harrison, Paul Wood, and Jason Gaiger, 489–91 (Malden, MA, Blackwell): 489.

18. Terry Eagleton (1990), *The Ideology of the Aesthetic* (Oxford, Blackwell): 13.

19. Ben Highmore (2010), "Bitter after Taste: Affect, Food and Social Aesthetics," in Gregg and Seigworth, *The Affect Theory Reader*, 118–137, p. 122.

20. Baumgarten (2000a): 490; Baumgarten (2000b), "Reflections on Poetry" in Harrison, Wood, and Gaiger, *Art and Theory*, 487–489; Highmore (2010): 122.

21. David Morgan (1998), *Visual Piety: A History and Theory of Popular Religious Images* (Berkeley, University of California Press): 17–18; Jamal J. Elias (2012), *Aisha's Cushion: Religious Art, Perception and Practice in Islam* (Cambridge, MA, Harvard University Press): 140–144.

22. Elias (2012): 149–160.

23. *Munāsib li-al-nafs al-mudrika fa-taltadhdhu bi-idrāk mulā'imihā* and *kamāl al-munāsaba wa-al-wad' wa-dhalika huwa ma'nā al-jamāl wa-al-ḥusn fī-kulli madrak.* Ibn Khaldun (n.d.), *Al-Muqaddima* (Cairo, Maṭba'a Mustafa Muhammad): 423–428, chapter on singing *(fī-ṣinā' al-ghinā)*. Doris Behrens-Abouseif (1998), *Beauty in Arabic Culture*, Princeton Series on the Middle East (Princeton, Marcus Wiener): 38, note 65.

24. Ibn Khaldun (n.d.): 423–428, chapter on singing *(fī-al-ghinā)*; Ibn Khaldun (2005), *The Muqaddimah*, trans. F. Rosenthal, abridged N.J. Dawood (Princeton, Princeton University Press): 329, "The Craft of Singing and Music."

25. Morgan (1998): 30; Elias (2012): 147–149.

26. Elias (2012): 148–149; W.J.T. Mitchell (1986), *Iconology: Image, Text, Ideology* (Chicago, University of Chicago Press): 151, 157–158.

27. Nigel Thrift (2010), "Understanding the Material Practices of Glamour," in Gregg and Seigworth *The Affect Theory Reader*, 292.

28. For discussions of the place of aesthetics in religious visual culture, see, among others, S. Brent Plate, ed. (2002), *Religion, Art and Visual Culture* (New York, Palgrave): 18–24; B. Meyer, ed. (2009), *Aesthetic Formations: Media, Religion, and the Senses* (New York, Palgrave Macmillan): 6–11; Birgit Meyer and

Jojada Verrips (2008), "Aesthetics," in *Key Words in Religion, Media, and Culture*, ed. David Morgan (London, Routledge): 20–30, and Elias (2012): chap. 5.

29. For a discussion of visuality in Islamic history that goes beyond the specifics of figural representation, see Elias (2012). There are many works that deal with various specific aspects of visuality and Islamic society, some of which appear in the bibliography.

30. The website for the comic is found at www.the99kids.com but is frequently hacked; it is archived at https://web.archive.org/web/20150408015508 /http://www.the99kids.com:80/, viewed August 3, 2017. See also "Author Looks to the Koran For 99 New Superheroes," *Washington Post*, June 11, 2004, www .washingtonpost.com/wp-dyn/content/article/2008/06/10/AR2008061002762 .html, viewed August 13, 2017; Florence Villeminot, "Muslims Fighting Evil," *Newsweek*, February 26, 2007, https://wwrn.org/articles/24335/, viewed August 13, 2017; H. Saleem Ali, "The All-Islamic Super-Heroes: Muslim Children Love 'The 99' Comics, but Hardliners Loathe Their Creator—Whose Trial for Heresy Is Looming," *Independent*, March 11, 2015, www.independent.co.uk /arts-entertainment/books/features/the-all-islamic-super-heroes-muslim-children-love-the-99-comics-but-hardliners-loathe-their-creator-10101891.html, viewed August 13, 2017; Susanne Enderwitz (2011), "'The 99': Islamic Superheroes—A New Species?" in *Transcultural Turbulences: Towards a Multi-Sited Reading of Image Flows*, ed. C. Brosius and R. Wenzlhuemer (Berlin, Heidelberg, Springer): 83–95.

31. Comixology, www.comixology.com/THE-99/comics-series/2782?Issues_ pg = 3, viewed August 3, 2017.

32. The website for the cartoon is at www.burkaavenger.com. See also Nita Bhalla, "Pakistan's Cartoon 'Burka Avenger' Swoops into India to Empower Girls," *Reuters*, April 14, 2015, www.reuters.com/article/us-india-women-entertainment-idUSKBN0N50ZU20150414, viewed August 13, 2017.

33. Hafiz M. Kamal Butt and Qamr-un-Nisa (2001), *Firūzsunz islāmiyāt, pehlī jamā'at kē liyē* (Ferozsons Islamiyat for Class One) (Lahore, Ferozsons); H. M. K. Butt and Rehana Begum (2001), *Firūzsunz islāmiyāt, dūsrī jamā'at kē liyē* (Ferozsons Islamiyat for Class Two) (Lahore, Ferozsons); Khalid Mahmood Bhatti, Qamar-un-Nisa, and Abdus Salam Asim (2001), *Firūzsunz islāmiyāt, tīsrī jamā'at kē liyē* (Ferozsons Islamiyat for Class Three) (Lahore, Ferozsons).

34. M. Yaşar Kandemir, personal communication, July 7, 2007, Üsküdar, Istanbul, Turkey. "Dinim Serisi" (My Religion) is a book series intended for children from six to nine years of age; according to the press, it utilizes modern pedagogical theories to teach children about God, the Prophet, and Islam and to establish love for them in the children's hearts. The series includes short books with titles like "Straight to Faith" *(Dine Doğru)* and "Our Prophet with Children" *(Peygamberimiz Çocuklarla)*.

35. Peter L. Berger (1967; rpt. 1990), *The Sacred Canopy: Elements of a Sociology of Religion* (New York, Anchor): 25.

36. Robert A. Orsi (2006), *Between Heaven and Earth: The Religious Worlds People Make and the Scholars Who Study Them* (Princeton, Princeton University Press): 73–74.

37. For a discussion of the tension between secularized notions of art and the place of religion in visual culture, see Sally M. Promey (2003), "The 'Return' of Religion in the Scholarship of American Art," *Art Bulletin* 85 (3): 581–603.

38. Wish images are discussed in Mandana Limbert (2007), "Oman: Cultivating Good Citizens and Religious Virtue," in *Teaching Islam: Textbooks and Religion in the Middle East,* ed. Eleanor Abdella Doumato and Gregory Starrett (Boulder, Lynne Rienner): 103–24. Important aspects of Protestant religious images have been discussed in Morgan (1998).

39. David Morgan (2012), *The Embodied Eye: Religious Visual Culture and the Social Life of Feeling* (Berkeley, University of California Press): 67, 70–81.

40. Maurice Merleau-Ponty (1962), *Phenomenology of Perception,* trans. Colin Smith (London, Routledge): 273.

41. Merleau-Ponty (1962): xviii.

42. Merleau-Ponty (1962): 165–166.

43. For more on this topic, see Martin Jay (1988), "Scopic Regimes of Modernity," in *Vision and Visuality,* ed. Hal Foster (Seattle, Bay): 3–23.

44. Nicole Boivin (2008; rpt. 2010), *Material Cultures, Material Minds: The Impact of Things on Human Thought, Society and Evolution* (Cambridge, Cambridge University Press): 20. There are certainly scholars who maintain that visual and material objects signify and lend themselves to interpretation in a linguistic way. See, for example, Christopher Tilley (1991), *Material Culture and Text: The Art of Ambiguity* (London, Routledge), and Ian Hodder (1989), "This Is Not an Article about Material Culture as Text," *Journal of Anthropological Archaeology* 8 (3): 250–269.

45. Talal Asad (2006), "Responses," in *Powers of the Secular Modern: Talal Asad and His Interlocutors,* ed. David Scott and Charles Hirschkind (Stanford, Stanford University Press): 213; Sally M. Promey (2014), "Religion, Sensation, and Materiality: An Introduction," in *Sensational Religion: Sensory Cultures in Material Practice,* ed. Sally M. Promey (New Haven, Yale University Press): 8.

46. Jane Bennet (2010), *Vibrant Matter: A Political Ecology of Things* (Durham, Duke University Press): viii.

47. Christine R. Yano (2013), *Pink Globalization: Hello Kitty's Trek across the Pacific* (Durham, Duke University Press): 20.

48. The term *affecting presence* was coined (as far as I know) by Robert Plant Armstrong to refer to a narrower range of artifacts. I am stretching its meaning to include the entire spectrum of objects with which human beings interact. See Robert P. Armstrong (1981), *The Power of Presence: Consciousness, Myth, and Affecting Presence* (Philadelphia, University of Pennsylvania Press).

49. Jean Baudrillard (1996, rpt. 2005), *The System of Objects,* trans. James Benedict (London, Verso): 96; Yano (2013): 20.

50. Sara Ahmed (2010), "Happy Objects," in Gregg and Seigworth, *The Affect Theory Reader,* 34–35.

51. An index can be nothing more than an indicator in the simplest sense but it has been taken to mean much more by several theorists. Peirce considered indexes to be "indicators" that "show something about things, on account of their being physically connected with them." C. S. Peirce (1998), "What Is a Sign?" in *The Essential Peirce: Selected Philosophical Writings,* vol. 2, *1893–*

1914, ed. Peirce Edition Project (Bloomington, Indiana University Press): 5. For Alfred Gell, the concept is a cornerstone of his argument that objects are analogous to persons in terms of their possession of agency. Alfred Gell (1998), *Art and Agency: An Anthropological Theory* (Oxford, Clarendon): 27.

52. I have discussed the relationship between visual objects and emotional affective responses in Jamal J. Elias (2017), "Mevlevi Sufis and the Representation of Emotion in the Arts of the Ottoman World," in *Emotion and Subjectivity in the Art and Architecture of Early Modern Muslim Empires,* ed. Kishwar Rizvi (Leiden, Brill): 185–209.

53. Gell (1998): 13–14.

54. For a concise overview of abduction as it relates to the study of visual objects, see Sandra E. Moriarty (1996), "Abduction: A Theory of Visual Interpretation," *Communication Theory* 6 (2): 167–187. For a general overview of the logic of abduction, especially as it relates to semiotics, see Lucia Santaella (2005), "Abduction: The Logic of Guessing," *Semiotica* 153 (1–4): 175–198; Ilkka Niiniluoto (2007), "Structural Rules for Abduction," *Theoria: An International Journal for Theory, History and Foundations of Science* 20 (3): 325–329; Claudine Tiercelin (2005), "Abduction and the Semiotics of Perception," *Semiotica* 153 (1–4): 389–412; and Patricia Turrisi (2005), "The Abduction in Deduction and the Deduction in Abduction: Remarks on Mixed Reasonings," *Semiotica* 153 (1–4): 309–323.

CHAPTER 2

1. For a brief overview of the subject, see Anthony W. Price (2009), "Emotions in Plato and Aristotle," in *The Oxford Handbook of Philosophy and Emotion,* ed. Peter Goldie (Oxford, Oxford University Press): 121–142.

2. William James (1884), "What Is an Emotion?" *Mind* 9 (34): 188–205, p. 193.

3. Jan Plamper (2015), *The History of Emotions: An Introduction,* trans. Keith Tribe (Oxford, Oxford University Press): 32.

4. Plamper (2015): 8, 222–237.

5. Joseph LeDoux's *The Emotional Brain: The Mysterious Underpinnings of Emotional Life,* published in 1998, is often quoted by scholars looking for a physiological basis for emotion; Antonio Damasio's *Looking for Spinoza: Joy, Sorrow, and the Feeling Brain* (2003) not only makes a conscious counter foray from science into humanistic intellectual history, but it is arguably also a major instigator for making many affect theorists go beyond their presentist biases and straining to look for psychological precedents in at least one premodern scholar. The more recent publications of these writers, especially those of Damasio, are referred to frequently in writings on emotion and affect.

6. Plamper (2015): 149, after Paul Ekman (1998), "Afterward: Universality of Emotional Expression? A Personal History of the Dispute," in *The Expression of the Emotions in Man and Animals,* by Charles Darwin, 3rd ed. (New York, Oxford University Press): 363–393, p. 373. At times in the development of his theory, Ekman has also suggested that shame, embarrassment, guilt, contempt, and awe might also be basic emotions.

7. For more information, see www.paulekman.com, viewed August 14, 2017.

8. For a comprehensive discussion of the problems with Ekman's methodology, see Plamper (2015): 149–163. Ruth Leys, whose critique of central aspects of affect theory is referred to on pp. 46–47, is particularly relevant for pointing out systemic errors in Ekman's work (cf. [2010], "How Did Fear Become a Scientific Object and What Kind of Object Is It?" *Representations* 110: 66–104).

9. David Freedberg's book *The Power of Images: Studies in the History and Theory of Response* (Chicago, University of Chicago Press, 1991) might well be the most influential work marking the turn in art history toward attempting to understand the agency of objects.

10. David Freedberg (2011), "Memory in Art: History and the Neuroscience of Response," in *The Memory Process: Neuroscientific and Humanistic Perspectives,* ed. Suzanne Nalbantian, Paul M. Matthews, and James L. McClelland (Cambridge, MA, MIT Press): 337–358, p. 337.

11. Freedberg (2011): 345.

12. Plamper (2015): 231–232.

13. Anna Wierzbicka (1999), *Emotions across Languages and Cultures: Diversity and Universals* (Cambridge: Cambridge University Press): 34, 36.

14. Wierzbicka (1999): 41.

15. Wierzbicka (1999): 275–276.

16. Wierzbicka (1999): 306–307.

17. Plamper (2015): 10–11.

18. Robert B. Zajonc (1980), "Feeling and Thinking: Preferences Need No Inferences," *American Psychologist:* 35 (2): 151–175; Plamper (2015): 204–205.

19. Zajonc (1980): 151.

20. Lila Abu-Lughod (1986), *Veiled Sentiments: Honor and Poetry in a Bedouin Society* (Berkeley, University of California Press).

21. Catherine A. Lutz (1988), *Unnatural Emotions: Everyday Sentiments on a Micronesian Atoll and Their Challenge to Western Theory* (Chicago, University of Chicago Press): 3.

22. Lutz (1988): 149–152, 219–220.

23. Lutz (1988): 5, italics in the original.

24. Karl G. Heider (1991), *Landscapes of Emotion: Mapping Three Cultures of Emotion in Indonesia* (Cambridge, Cambridge University Press): 13.

25. Heider (1991): 7.

26. Heider (1991): 98.

27. Kövecses's classification of emotional language has one more level of complexity than I have outlined here, that of basic versus nonbasic literal language on the one hand and metaphorical and metonymic figurative language on the other. See Z. Kövecses (2000), *Metaphor and Emotion: Language, Culture and Body in Human Feeling* (Cambridge, Cambridge University Press): 5–6; G. Lakoff and Z. Kövecses (1987), "The Cognitive Model of Anger Inherent in American English," in *Cultural Models in Language and Thought,* ed. Dorothy Holland and Naomi Quinn (Cambridge, Cambridge University Press): 195–221, pp. 197–198, 200.

28. Kövecses (2000): 165.

29. Kövecses (2000): 85.

30. Kövecses (2000): 183.

31. William M. Reddy (1997), "Against Constructionism: The Historical Ethnography of Emotions," *Current Anthropology* 38 (3): 330. Reddy is relying here on the theory of speech acts first proposed by the philosopher of language J. L. Austin.

32. Reddy (1997): 331.

33. Reddy (1997): 331–332.

34. Barbara Rosenwein critiques Reddy for the close connection he draws between emotional and political regimes, pointing out that Reddy's conception of the typical political regime is the modern state, which is typical neither for human history nor even for many modern societies: B. Rosenwein (2002), review of William M. Reddy, *The Navigation of Feeling, American Historical Review* 107 (4): 1181–1182.

35. Plamper (2015): 253–254; Linda C. Garro (1997), "Comment on William M. Reddy, *Against Constructionism: The Historical Ethnography of Emotions,*" *Current Anthropology* 38 (3): 341–342.

36. William M. Reddy (2001), *The Navigation of Feeling* (Cambridge: Cambridge University Press): 21.

37. Plamper (2015): 257.

38. M. Watkins (2010), "Desiring Recognition, Accumulating Affect," in *The Affect Theory Reader,* ed. M. Gregg and G. J. Seigworth (Durham, Duke University Press): 269–285, p. 269.

39. Michelle Z. Rosaldo (1984), "Toward an Anthropology of Self and Feeling" in *Culture Theory: Essays on Mind, Self, and Emotion,* ed. Richard A. Shweder and Robert A. LeVine (New York, Cambridge University Press): 137–157, p. 143; also see Rosaldo (1989), *Knowledge and Passion: Ilongot Notions of Self and Social Life* (New York, Cambridge University Press); Rosemary Hennessy (2013), *Fires on the Border: The Passionate Politics of Labor Organizing on the Mexican Frontera* (Minneapolis, University of Minnesota Press): 38. There are other ways of understanding the simultaneously embodied and social nature of affect; for example, see Donovan O. Schaefer (2015), *Religious Affects: Animality, Evolution, and Power* (Durham, Duke University Press), especially pp. 36–59.

40. Hennessy (2013): 66–67.

41. Gregg and Seigworth (2010).

42. Two seminal articles in this regard are Brian Massumi (1995), "The Autonomy of Affect," *Cultural Critique* 31, *The Politics of Systems and Environments, Part II*: 83–109; and Eve K. Sedgwick and Adam Frank (1995), "Shame in the Cybernetic Fold: Reading Silvan Tomkins," *Critical Inquiry* 21 (2): 496–522. Sedgwick's ideas in this and other works have been very influential in inspiring new areas of thinking among queer theorists, prominent among them Sara Ahmed and Jasbir Puar.

43. Silvan Soloman Tomkins (2008), *Affect, Imagery, Consciousness: The Complete Edition* (New York, Springer): 619; Hennessy (2013): 45.

44. Tomkins (2008): 619–620; Hennessy (2013): 45.

45. Tomkins (2008): 15, 179. "Tompkins borrows his logic of affect from systems theory—namely, the notion that the basic principle of a system is the distinction between an inside (the system) and an outside (environment), as well as the establishment of a feedback loop that takes in the result of an act in order to modify it." Hennessy (2013): 45–46.

46. Gregory J. Seigworth and Melissa Gregg (2010), "An Inventory of Shimmers," in Gregg and Seigworth (2010): 1–25, p. 6.

47. Baruch Spinoza, *Ethics*, III, 2, scholia, in Benedict Spinoza (1959), *Ethics; On the Correction of Understanding*, trans. Andrew Boyle (London, Everyman's Library): 87. Spinoza's *Ethics* was very influential for several modern philosophers in addition to Deleuze: Michel Foucault and, arguably, Antonio Negri relied on Spinoza's thought in formulating their critiques of historical materialism and making a philosophical turn that emphasized various aspects of the body's importance. Hennessy (2013): 39.

48. Seigworth and Gregg (2010): 3.

49. Watkins (2010): 269.

50. Spinoza (1959): 84.

51. Massumi (1995): 86; and Massumi (2002b), *Parables of the Virtual: Movement, Affect, Sensation* (Durham, Duke University Press): 25.

52. Massumi (2002b): 60–62.

53. Patricia T. Clough (2010), "The Affective Turn: Political Economy, Biomedia, and Bodies," in Gregg and Seigworth (2010): 206–225, p. 209.

54. Massumi (2002b): 25.

55. Massumi (2002b): 29; Clough (2010): 209.

56. Massumi (2002b): 37–39; Hennessy (2013): 42.

57. Massumi (1995): 92; Massumi (2002b): 37–39. John Jervis (2015), *Sensational Subjects: The Dramatization of Experience in the Modern World* (London, Bloomsbury): 147.

58. Clough (2010): 209; Massumi (2002b): 37.

59. Massumi (2002b): 35–37.

60. Massumi (2002b): 9.

61. Hennessy (2013): 45.

62. Jonathan Flatley (2008), *Affective Mapping: Melancholia and the Politics of Modernism* (Cambridge, MA, Harvard University Press): 60–61.

63. Flatley (2008): 12–17; Hennessy (2013): 46.

64. For a critique of the turn to the life sciences, and to the neurosciences in particular, see Ruth Leys (2011b), "The Turn to Affect: A Critique," *Critical Inquiry* 37 (3): 434–472. The topic is also discussed in Plamper (2015): 236–244.

65. Plamper (2015): 19–21. The habilitation of Spinoza at the expense of Descartes is obvious in the titles of Damasio's books—*Descartes' Error* and *Looking for Spinoza*.

66. Leys (2011b): 434–435. Another very insightful critique of these trends in affect theory is found in Claire Hemmings (2005), "Invoking Affect: Cultural Theory and the Ontological Turn," *Cultural Studies* 19 (5): 548–67. For a concise analysis of the problems in adopting scientific research in attempts to theorize affect and emotion, see Constantina Papoulias and Felicity Callard (2010),

"Biology's Gift: Interrogating the Turn to Affect," *Body and Society* 16 (1): 29–56.

67. Leys (2011b): 436.

68. Massumi (2002b): 28; Leys (2011b): 437.

69. Ruth Leys (2011a), "Critical Response II: Affect and Intention: A Reply to William E. Connolly," *Critical Inquiry* 37 (4): 803.

70. Massumi (2002b): 27.

71. Massumi (2002b): 28.

72. Hennessy (2013): 45.

73. Eric Shouse (2005), "Feeling, Emotion, Affect," *M/C Journal* 8 (6). paragraph 15, http://journal.media-culture.org.au/0512/03-shouse.php, viewed August 4, 2017.

74. Shouse (2005), paragraphs 2, 5, italics in the original.

75. Brian Massumi (2002a), "Introduction: Like a Thought," in *A Shock to Thought: Expression after Deleuze and Guattari*, ed. B. Massumi (London: Routledge): xxxi, emphasis in the original.

A similarly dissatisfactory obscurity characterizes the writing of the editors of *The Affect Theory Reader* when they declare: "Affect arises in the midst of *in-between-ness*: in the capacities to act and be acted upon. . . . Affect, at its most anthropomorphic, is the name we give to those forces—visceral forces beneath, alongside, or generally *other than* conscious knowing, vital forces insisting beyond emotion—that can serve to drive us toward movement, toward thought and extension, that can likewise suspend us (as if in neutral) across a barely registering accretion of force-relations, or that can even leave us overwhelmed by the world's apparent intractability. Indeed, affect is persistent proof of a body's never less than ongoing immersion in and among the world's obstinacies and rhythms, its refusals as much as its invitations. . . . Affect is born in *in-between-ness* and resides as accumulative *beside-ness*." Seigworth and Gregg (2010): 1–2.

76. Steven Shaviro (2010), *Post-Cinematic Affect* (Winchester, Zero): 3, emphasis in the original. Following Massumi, Shaviro contrasts affect to emotion, which is "derivative, conscious, qualified, and meaningful, a 'content' that can be attributed to an already-constituted subject. . . . Subjects are overwhelmed and traversed by affect, but they *have* or *possess* their own emotions."

77. Massumi (2002b): 40.

78. Seigworth and Gregg (2010): 24, emphasis in the original.

79. Sianne Ngai (2005), *Ugly Feelings* (Cambridge, MA, Harvard University Press): 26.

80. Hemmings (2005): 548–550.

81. Teresa Brennan (2004), *The Transmission of Affect* (Ithaca, Cornell University Press): 6, 133–135. On the "thickness" of emotions, see Sara Ahmed (2015), *Cultural Politics of Emotion*, 2nd ed. (New York, Routledge).

82. Brennan (2004): 6.

83. Lawrence Grossberg (1992), *We Gotta Get Out of the Place: Popular Conservatism and Postmodern Culture* (New York, Routledge): 82. Brennan draws on a concept she calls "mattering maps" to refer to the process of articulation and disarticulation of affects in a way that controls peoples "investments."

Brennan (2004): 6. Grossberg relies heavily on the concept of "affective invest-ment," which constitutes an important difference between his theories and those of Massumi, since for Massumi there can be no such investments, considering that affect remains inaccessible. Hennessy (2013): 48.

84. Grossberg (1992): 83.

85. Grossberg (1992): 83.

86. Hennessy (2013): 57. "Because human existence is always social, the ontology of affect is radically social, too. It lies in organisms' physiological states and the social relations of labor that sustain them: the energies and sensa-tions that inform attention and interaction in care and the labor that enables group survival. Affects also adhere to the ways we make sense of our existence and how we know and name reality, how we assess truth, belief, and judg-ment. . . . As a component of our social bonds and knowledge production, affect is both ontological and epistemological. In short, a materialist approach to affect sees it as a human capacity intrinsic to the fabric of biological-social life and articulated through historically variable meanings and practices, many of which adhere to the labor of meeting needs. Needs are corporeal—they involve keeping the body alive—but they are not natural, because meeting them always takes place through social relationships. Basic human needs bind us to nonhu-man animals and to the planet" (57–58, emphasis in the original).

87. Hennessy (2013): 50.

88. Hennessy (2013): 64.

89. Reddy (2001): 80, 114.

90. Reddy (2001): 94.

91. "II.ii. Concerning the constitution of colours. And since we have men-tioned above what was necessary to precede it concerning the potency of the actions of the strings [of the lute], and the rhythms, and their moving the facul-ties of the soul by the way of the sense of hearing, we shall now mention what results to the soul through this sense of sight from the potencies of the mixture of colours. And if it [the mingling] be a resembling what we have said above, we say that if redness merges into yellowness, the feeling of pride is engendered. And if yellowness approaches to blackness, the sensation of abasement is excited. And if blackness passes into redness, yellowness, and whiteness together, the generous sentiment is created. And if reddish black becomes a derived yellowness, the feeling of endurance is also evoked. And if rosiness is nigh unto orange and the violet hue, the sense of joy and pleasure are aroused together. And if white which has become yellow. . . . advances to red, the feeling of pleasure is stirred together with the excitement of passionate love. And if all the colours approach one to the other, like the mingled beauty of the cheek of maidens, all of the emotions are excited, and the imagination; thought, fancy, and memory are kindled until there arise the regal, proud, generous, meek fac-ulties, and the rest of what we have described of the faculties. Then you will behold a diving deep into the sea of intellectual pleasures. And when two or three of these colours are mingled, and there is a contradiction between the colours, there appears from the potency of every colour, according to what we have mentioned." H.G. Farmer (1957), "Al-Kindī on the 'Ethos' of Rhythm, Colour, and Perfume," in *Transactions of the Glasgow University Oriental*

Society, Years 1955 to 1956, in Honour of the Rev. James Robertson Buchanan, ed. C. J. M. Weir (Hertford, Stephen Austin and Sons for Glasgow University Oriental Society): 16:29–38.

92. For more on the discussion of beauty and its relationship to emotion and psychology in medieval Islamic thought, see Jamal J. Elias (2012), *Aisha's Cushion: Religious Art, Perception and Practice in Islam* (Cambridge, MA, Harvard University Press): 139–162.

Music is an excellent example of the nature of affect and its relevance, in the sense that it results in perceptible sensations in an individual that the person cannot articulate. As the case of music demonstrates, affect can be transmitted in ways that emotions or feelings cannot precisely because it is unstructured and unformed, and it is sociopolitically effective because it doesn't follow the processes of conventional discourse. Music is a favorite example for several affect theorists since, arguably, music has physical effects that can be identified and discussed, yet it cannot be said to possess meaning. "In a lot of cases, the pleasure that individuals derive from music has less to do with the communication of meaning, and far more to do with the way that a particular piece of music 'moves' them. While it would be wrong to say that meanings do not matter, it would be just as foolish to ignore the role of biology as we try to grasp the cultural effects of music. Of course, music is not the only form of expression that has the potential to transmit affect. Every form of communication where facial expressions, respiration, tone of voice, and posture are perceptible can transmit affect, and that list includes nearly every form of mediated communication other than the one you are currently experiencing." Shouse (2015): paragraph 13; Hennessy (2013): 47–48.

93. Edward C. Sachau (1888, rpt. 2005), *Alberuni's India,* Elibron Classics (Boston, Adamant Media): 1:111.

94. Plamper (2015): 87; Ruth Benedict (1946), *The Chrysanthemum and the Sword: Patterns of Japanese Culture* (Boston, Houghton Mifflin).

95. Ruth Leys (2007), *From Guilt to Shame: Auschwitz and After* (Princeton, Princeton University Press): 9, 150.

96. See, for example, J. Keith Vincent (2012), "Shame Now: Ruth Leys Diagnoses the New Queer Shame Culture," *Criticism* 54 (4): article 6, http://digitalcommons.wayne.edu/criticism/vol54/iss4/6, viewed August 12, 2017. Several writers have argued that shame is primarily a phenomenon of self-evaluation, therefore an interior capacity. In the context of affect theory, Deleuze and his writings have been used to argue that shame is both internal and social. "Shame is subjective in the strong sense of bringing into being an entity or an idea through the specific explosion of mind, body, place, and history . . . [it] comes from a complex disposition: it combines the inherent and the lived experience of social structures—the biology and biography of a person." Elspeth Probyn (2010), "Writing Shame," in Gregg and Seigworth (2010): 71–90, pp. 81–82.

97. Lila Abu-Lughod (1986), esp. 152–167. Part 2 of her book treats a variety of emotions in specific detail.

98. Benedicte Grima (1992), *The Performance of Emotion among Paxtun Women: "The Misfortunes Which Have Befallen Me"* (Oxford, Oxford University Press): 41.

99. For the relationship between emotion, culture, and performance in the context of Pashtun women, see Grima (1992): 6–11. Amineh Ahmed goes into great ethnographic detail in describing the nature of interactions surrounding the paradigmatic events of *gham-khādi,* these being marriages and funerals. Her work is noteworthy in that a substantial portion of her research was conducted with more affluent and cosmopolitan sections of the Pakistani Pashtun population. Amineh Ahmed (2006), *Sorrow and Joy among Muslim Women: The Pukhtuns of Northern Pakistan* (Cambridge, Cambridge University Press).

100. M. Bakhtiar (2015), "Cognitive Model of GHEIRAT in Persian," *Cognitive Linguistic Studies* 2 (2): 258.

101. Bakhtiar (2015): 262–263. Transliteration has been modified to conform to the system used in this book—the original is GHEIRAT—and boldface terms have been changed to italics. For more on broader issues of the expression of emotion in Persian culture, see William O. Beeman (2001), "Emotion and Sincerity in Persian Discourse: Accomplishing the Representation of Inner States," *International Journal of the Sociology of Language* 148: 31–57.

102. For more on the evocation of wonderment and its relationship to religion and aesthetics, see Elias (2012), esp. chap. 6. For a succinct discussion of wonderment in European history, see Caroline W. Bynum (1997), "Wonder," *American Historical Review* 102 (1): 1–26.

103. For a study of negative emotions, see Sianne Ngai (2005), *Ugly Feelings* (Cambridge, MA, Harvard University Press). The term *outlaw emotion* is coined and developed in Alison M. Jaggar (1989), "Love and Knowledge: Emotion in Feminist Epistemology," *Inquiry* 32 (2): 151–176.

104. For a brief introduction to Sufism, see (among other options) William C. Chittick (2007), *Sufism: A Beginner's Guide* (Oxford, Oneworld).

105. Examples of such emotive practices abound in Islamic religious history. The most celebrated figure of this sort is probably Hallaj (d. 922), who made outrageous statements that were taken to be blasphemous and resulted in his death. In the classical period he is joined by Bistami (d. 848 or 875), also famous for his shocking utterances. Among other famous Sufis, there is Shaykh Sam'an, who—as a venerable old man—debased himself by herding the pigs of a young Christian woman. Transgressive behavior as a means of eliciting opprobrium and revulsion was formalized in some Sufi groups: see Ahmet Karamustafa (2006), *God's Unruly Friends: Dervish Groups in the Islamic Middle Period, 1200–1550* (Oxford, Oneworld); and Annemarie Schimmel (1978), *Mystical Dimensions of Islam* (Chapel Hill, University of North Carolina Press).

106. Reddy (2001): 125–126, 314–315.

107. The term *ecological phenomenology* was developed by Maria Heim in collaboration with Chakravarthi Ram-Prasad. See Maria Heim (2018), "Emotions," in *The Oxford History of Hinduism: Hindu Law,* ed. Patrick Olivelle and Donald R. Davis, Jr. (Oxford, Oxford University Press): 419–431.

108. Flately (2008): 23; Hennessy (2013): 53.

109. I am influenced in this regard by Monique Scheer's attempts at constructing a holistic history of emotions: M. Scheer (2012), "Are Emotions a Kind of Practice (and Is That What Makes Them Have a History)? A Bourdieuan Approach to Understanding Emotion," *History and Theory* 51 (2): 193–220.

110. Scheer (2012): 207. Issues related to the circulation of emotion are addressed by Sara Ahmed, for whom emotion and affect are entirely cultural, not only transmitted but also constructed through cultural systems of signification. Ahmed suggests that the circulation, repetition, and interaction of signs result in the accumulation of affective value, and that affect does not reside in the signs themselves, but is generated within this process of circulation: S. Ahmed (2015), *Cultural Politics of Emotion,* 2nd ed. (New York, Routledge): 55.

CHAPTER 3

1. Philippe Ariès (1962), *Centuries of Childhood: A Social History of Family Life,* trans. Robert Baldick (New York, Knopf). Some of Ariès's assertions concerning the attitude of adults toward children in medieval Europe have been dismissed as inaccurate by the majority of recent historians. See, for example, Shulamith Shahar (1990), *Childhood in the Middle Ages* (London and New York, Routledge); see also Kathryn A. Kamp (2001), "Where Have All the Children Gone? The Archaeology of Childhood," *Journal of Archaeological Method and Theory* 8 (1): 4. For studies of childhood in medieval Europe, see Harry Hendrick (1997), *Children, Childhood and English Society, 1880–1990* (Cambridge, Cambridge University Press); and Peter Hunt (1994), *An Introduction to Children's Literature* (Oxford, Oxford University Press).

2. Carolyn L. Burke and Toby G. Copenhaver (2004), "Animals as People in Children's Literature" *Language Arts* 81 (3), *Explorations of Genre:* 208.

3. Kamp (2001): 4; Fergus P. Hughes (1991), *Children, Play and Development* (Boston, Allyn and Bacon).

4. Kamp (2001): 4.

5. Sue Ruddick (2003), "The Politics of Aging: Globalization and the Restructuring of Youth and Childhood," *Antipode* 35 (2): 334–362, pp. 342–343.

6. For more on the sentimental way in which adults imagine childhood and are uncomfortable with many aspects of children's agency and awareness, especially in terms of sexuality, see D. MacDougall (2006), *The Corporeal Image: Film, Ethnography, and the Senses* (Princeton, Princeton University Press): 70, 76–78.

7. Patricia Holland (1992), *What is a Child? Popular Images of Childhood* (London, Virago): 16.

8. One could argue that the centrality of childhood innocence and cuteness to the neoromantic view of the past is crucial to the entire Disney enterprise as well as to the economy of cuteness in Japan, a topic treated at some length in chapter 5; see also Sharon Kinsella (1995), "Cuties in Japan," in *Women, Media and Consumption in Japan,* ed. Lise Skov and Brian Moeran (Richmond, Surrey, Curzon): 220–254, p. 241.

9. Ruddick (2003): 340.

10. Bruce Grant (2001), "New Moscow Monuments, or, States of Innocence," *American Ethnologist* 28 (2): 335–336.

11. Margot Peppers, "'70 is the new 50!' Martha Stewart on Aging Gracefully and 'Maintaining a Tiny Waist,'" *Daily Mail,* April 29, 2013, www.dailymail .co.uk/femail/article-2316769/70-new-50-Martha-Stewart-aging-gracefully-maintaining-tiny-waist.html, viewed August 5, 2017.

12. Carolyn L. Burke and Toby G. Copenhaver (2004), "Animals as People in Children's Literature," *Language Arts* 81 (3), *Explorations of Genre*: 205–213, p. 210.

13. Burke and Copenhaver (2004): 213, quoting A. Applebee (1978), *The Child's Concept of Story: Ages Two to Seventeen* (Chicago, University of Chicago Press).

14. Patricia Holland (2004), *Picturing Childhood: The Myth of the Child in Popular Imagery* (New York, I. B. Taurus): xiii.

15. Daniel Harris (1992), "Cuteness," *Salmagundi* 96 (Fall): 177–186, p. 181.

16. E. B. Freeman (1998), "Children's Books: Universals of Childhood," *Reading Teacher* 51 (5): 426–433, p. 424.

17. Ruddick (2003): 341.

18. Ruddick (2003): 342.

19. For examples of cartoons featuring Alan Kurdi, see Aoife Ryan Christensen, "9 Artists Respond to the Death of Aylan Kurdi," *Evoke*, September 3, 2015, http://evoke.ie/news/9-artists-respond-to-the-death-of-aylan-kurdi-in-the-most-poignant-way, viewed August 4, 2017; Louise Ridley, "Aylan Kurdi, Drowned Syrian 3-Year-Old, Mourned with Poignant Cartoons Using 'Humanity Washed Ashore' Hashtag," *Huffington Post (UK)*, September 3, 2015, www .huffingtonpost.co.uk/2015/09/03/aylan-kurdi-drowned-syrian-boy-turkey-cartoons_n_8081458.html, viewed August 4, 2017. The French satirical publication *Charlie Hebdo* was broadly criticized for using Aylan Kurdi in cartoons addressing the sexual harassment of European women by immigrants, and on broader issues of Muslim immigration and European identity: "Charlie Hebdo Cartoon Depicting Drowned Child Alan Kurdi Sparks Racism Debate," *Guardian*, January 14, 2016, www.theguardian.com/media/2016/jan/14/charlie-hebdo-cartoon-depicting-drowned-child-alan-kurdi-sparks-racism-debate, viewed August 4, 2017; Sara C. Nelson, "Charlie Hebdo Reopens Freedom of Speech Debate with Cartoons Depicting Death of Aylan Kurdi," *Huffington Post (UK)*, September 14, 2015, www.huffingtonpost.co.uk/2015/09/14/charlie-hebdo-reopens-freedom-speech-debate-cartoons-depicting-death-aylan-kurdi-_n_8133118.html, viewed August 4, 2017.

There were several responses on the political front, in addition to numerous official statements of shock and outrage. The French and German governments drew up a joint initiative to address the refugee crisis: "Hollande et Merkel s'accordent sur des quotas contraignants d'accueil de migrants," *Le Monde*, September 3, 2015, www.lemonde.fr/europe/article/2015/09/03/hollande-et-merkel-se-mettent-d-accord-sur-des-quotas-contraignants-d-accueil-des-migrants_4745055_3214.html, viewed August 4, 2017. The British prime minister (in response to a signature campaign) announced that his country would increase the number of Syrian refugees it would accept: "David Cameron Announces Britain Will Accept 'Thousands More' Syrian Refugees," *Independent*, September 4, 2015, www.independent.co.uk/news/uk/politics/david-cameron-announces-britain-will-accept-thousands-more-syrian-refugees-10486136.html, viewed August 4, 2017; and the Turkish prime minister offered citizenship to the boy's father, who had lost his wife and other child along with Aylan Kurdi: "Aylan'ın

babası: Erdoğan vatandaşlık teklif etti," *Milliyet,* September 8, 2016, www
.milliyet.com.tr/aylan-in-babasi-erdogan-gundem-2114275/, viewed August 4,
2017.

20. Examples include R. D. Kaplan (1984), "Bloodbath in Iraq: The Ayatol-
lah's Child Soldiers vs Saddam Hussein's Entrenched Army," *New Republic,*
190 (13): 21–23; I. Brown (1990), *Khomeini's Forgotten Sons: The Story of
Iran's Boy Soldiers* (London, Grey Seal); and J. M. Davis (2003), *Martyrs: Inno-
cence, Vengeance, and Despair in the Middle East* (New York, Palgrave Mac-
millan). For more on this subject, see Maryam Elahi (1988), "The Rights of the
Child under Islamic Law: Prohibition of the Child Soldier," *Columbia Human
Rights Law Review* 19 (2): 259–279.

21. Nasrin Mosaffa (2007), "Does the Covenant of the Rights of the Child
in Islam Provide Adequate Protection for Children Affected by Armed Con-
flicts?" *Muslim World Journal of Human Rights* 8 (1): ISSN (Online) 1554–
4419, DOI: https://doi.org/10.2202/1554-4419.1220; pp. 6–7.

22. "The Facts on Child Soldiers and the CSPA," *Humanrights.Gov,* U.S.
Department of State, Washington, DC, November 26, 2014, www.humanrights
.gov/the-facts-on-child-soldiers-and-the-cspa.html, viewed April 15, 2017; "Traf-
ficking in Persons Report—Child Soldiers Prevention Act List," US Department
of State, July 2015, www.state.gov/j/tip/rls/tiprpt/2015/245236.htm, viewed
August 13, 2017.

23. A. M. Agathangelou and K. D. Killian (2011), "(Neo) Zones of Violence:
Reconstructing Empire on the Bodies of Militarized Youth," in *The Militariza-
tion of Childhood: Thinking beyond the Global South,* ed. J. M. Beier (New
York, Palgrave Macmillan): 17–41.

24. Changing attitudes toward 'Aisha in Western writing (and, to some
degree, in Muslim scholarship) are addressed in Kecia Ali (2014), *The Lives of
Muhammad* (Cambridge, MA, Harvard University Press), esp. chaps. 4 and 5.

25. "Permission from Earlier Wives Not Required for New Marriage: Sherani,"
Dawn, March 25, 2015, www.dawn.com/news/1171757, viewed August 4, 2017.

26. Peer Muhammad, "Marital Matters: Underage Marriage (Nikkah [sic])
not un-Islamic: CII," *Express Tribune,* March 12, 2014, http://tribune.com.pk
/story/681784/marital-matters-underage-marriage-nikkah-not-un-islamic-cii/,
viewed August 14, 2017; see also Kalbe Ali, "NA Body Terms Minimum
Marriage Age 'Un-Islamic,'" *Dawn,* January 15, 2016, www.dawn.com/news
/1233131, viewed August 14, 2017.

27. Apart from its relevance to issues of child marriage and sexuality, the
debate over the age of 'Aisha at the time of her marriage is a notable modern
instance of sustained textual criticism in Islamic society. Some modern scholars
argue that the reports that she was nine years old must be erroneous, and that
the correct age should be nineteen. The rationalist explanation for this position
is that she was a respected religious authority early in her marriage, and there-
fore must have been older than a preteen. The second justification is based on
hadith criticism, arguing that the account in the authoritative compendium of
al-Bukhari that specifies her age is derived on the authority of Hisham ibn
'Urwa. This transmitter of the account, it is argued, was not completely reliable
for several reasons, most importantly that all the transmitters of the hadith from

him are Iraqi but that he was a very old man when he moved from Medina to Iraq, and also that the respected authority Malik ibn Anas criticized his later hadith transmissions. Such commentators note that both the *Mizān al-i'tidāl* of Shams al-din al-Dhahabi (d. 1348) and the *Tahdhīb al-tahdhīb* of Ibn Hajar al-'Asqalani (d. 1449) list Hisham ibn 'Urwa as having lost his memory in later life, or that his Iraqi hadith are unreliable: Shams al-din Muhammad ibn Ahmad al-Dhahabi (1995), *Mīzān al-i'tidāl fī-naqd al-rijāl*, ed. 'Ali Muhammad Mu'awwad et al. (Beirut: Dār al-Kutub al-'ilmiyya): 7:85; Ahmad ibn 'Ali ibn Hajar al-'Asqalani (1995) *Tahdhīb al-tahdhīb*, ed. Ibrahim al-Zaybaq et al. (Beirut: Mu'assasat al-Risāla): 4:275–276. Other modern scholars engage in a close reading of the Qur'an, various other hadith sources, and biographical *(sīra)* works to suggest that 'Aisha would have been eighteen at the time of the Hijra (the migration from Mecca to Medina), and therefore that she would have been twenty-one when she moved into the Prophet's house.

For more on the topic, see Jonathan A. C. Brown (2014), *Misquoting Muhammad: The Challenge and Choices of Interpreting the Prophet's Legacy* (Oxford, Oneworld). For a sample of the extensive modern examples of Muslim apologetic writing on the subject in English alone, see "What was Ayesha's (ra) Age at the Time of Her Marriage," *Islam Awareness Net,* www.islamawareness.net/FAQ /what_was_ayesha.html, viewed August 4, 2017; Myriam Francois-Cerrah, "The Truth about Muhammad and 'Aisha," *Guardian,* September 17, 2012, www .theguardian.com/commentisfree/belief/2012/sep/17/muhammad-aisha-truth, viewed August 4, 2017; David Liepert, "Rejecting the Myth of Sanctioned Child Marriage in Islam," *Huffington Post,* January 29, 2011, www.huffingtonpost .com/dr-david-liepert/islamic-pedophelia_b_814332.html, viewed August 14, 2017.

28. "Turkey's Constitutional Court Stirs Outrage by Annulling Child Sex Abuse Clause," *Hurriyet Daily News,* www.hurriyetdailynews.com/turkeys-constitutional-court-stirs-outrage-by-annulling-child-sex-abuse-clause.aspx? PageID=238&NID=101607&NewsCatID=509, viewed August 4, 2017. In the case of Iran, the legal age of marriage is fifteen for girls and eighteen for boys, but the courts can—through the approval of the Expediency Discernment Council of the System *(Majma'-i tashkhīṣ-i maṣlaḥāt-i niẓām)*—grant exceptions that allow girls over the age of thirteen and boys over fifteen to marry: Article 1041 of Iran's Civil Law Code: Domestic Relations, Book VII, Marriage and Divorce, the Civil Law of the Islamic Republic of Iran, §1.2.1041, http:// rc.majlis.ir/fa/law/show/92778, viewed August 14, 2017.

29. Supplementary Norms on Criminal Law Matters, the Pontifical Commission for the Vatican State, §Law N. VIII, www.vaticanstate.va/content/dam /vaticanstate/documenti/leggi-e-decreti/Normative-Penali-e-Amministrative /Law%20N.%20VIII%20-%20Supplementary%20Norms%20on%20Criminal %20Law.pdf, viewed August 14, 2017.

30. Domestic Relations, Title XLIII, Marriages, New Hampshire Statues and Codes, §457:4, www.gencourt.state.nh.us/rsa/html/xliii/457/457-mrg.htm, viewed August 14, 2017. An attempt to raise the age of marriage to eighteen in New Hampshire failed on March 10, 2017.

31. Alan Prout and Allison James (1997), "A New Paradigm for the Sociology of Childhood? Provenance, Promise and Problems," in *Constructing and Reconstructing Childhood: Contemporary Issues in the Sociological Study of Childhood,* ed. A. James and A. Prout (London and New York: Routledge Falmer): 7–33, p. 8; Rosalind Evans (2007), "The Impact of Concepts of Childhood on Children's Participation in Bhutanese Refugee Camps," *Children, Youth and Environments* 17 (1): 174.

CHAPTER 4

1. Masoud Rajabi-Ardeshiri (2009), "The Rights of the Child in the Islamic Context: The Challenges of the Local and the Global," *International Journal of Children's Rights* 17 (3): 475–489, p. 476.

2. The Organization of the Islamic Conference (OIC) was established in 1969, and is the largest Islamic intergovernmental organization (and the second largest such organization, after the United Nations). It has fifty-seven member states, and casts itself as "the collective voice of the Muslim world . . . it endeavors to safeguard and protect the interests of the Muslim world in the spirit of promoting peace and harmony among various people of the world." www.oic-oci.org/page/?p_id=52&p_ref=26&lan=en, viewed August 5, 2016.

3. Rajabi-Ardeshiri (2009): 477.

4. The most explicit Qur'anic verse on the subject is as follows: "We have enjoined on man kindness to his parents: in pain did his mother bear him and in pain did she give him birth. The carrying of the (child) to his weaning is a (period of) thirty months. At length when he reaches the age of full strength and attains forty years he says 'O my Lord! Grant me that I may be grateful for Your favor which You have bestowed upon me and upon both my parents that I may work righteousness such as You may approve; and be gracious to me in my issue.'" Qur'an 46:15.

5. Rajabi-Ardeshiri (2009): 479. Prominent governmental and religious figures across the Islamic world routinely speak about child rights in terms echoing these values. See, for example, Muhammad Abdelkebir Alaoui M'Daghri (1995), "The Code of Children's Rights in Islam," trans. Moncef Lahlou, in *Children in the Muslim Middle East,* ed. Elizabeth Warnock Fernea (Austin, University of Texas Press): 30–41. See also Maryam Elahi (1998), "The Rights of the Child under Islamic Law: Prohibition of the Child Soldier," *Columbia Human Rights Law Review* 19 (2): 259–279; an abridged version of this article is published in Elizabeth Warnock Fernea, ed. (1995), *Children in the Muslim Middle East* (Austin, University of Texas Press): 367–374.

6. Rajabi-Ardeshiri (2009): 482.

7. Cairo Declaration on Human Rights in Islam, http://hrlibrary.umn.edu/instree/cairodeclaration.html, viewed August 5, 2017; Rajabi-Ardeshiri (2009): 482–483. For a discussion of reactions to the Convention on the Rights of the Child at an international, diplomatic level among Muslim-majority countries, see Imran Ahsan Nyazee (2003), "Islamic Law and the CRC (Conventions on the Rights of the Child)," *Islamabad Law Review* 1 (1–2): 65–121, and Ebrahim Moosa (2012), "Children's Rights in Modern Islamic and International

Law: Changes in Muslim Moral Imaginaries," in *Children, Adults, and Shared Responsibilities: Jewish, Christian, and Muslim Perspectives*, ed. Marcia J. Bunge (Cambridge, Cambridge University Press): 292–308.

8. Rajabi-Ardeshiri (2009): 483.

9. Rajabi-Ardeshiri (2009): 484.

10. "Covenant on the Rights of the Child," Organisation of the Islamic Conference, 2004, www.oic-iphrc.org/en/data/docs/legal_instruments/OIC%20Instruments/OIC%20Covenant%20on%20the%20Right%20of%20the%20Child/OIC%20Convention-%20Rights%20of%20the%20Child%20In%20Islam%20-%20EV.pdf, viewed August 5, 2017. See also Nasrin Mosaffa (2007), "Does the Covenant of the Rights of the Child in Islam Provide Adequate Protection for Children Affected by Armed Conflicts?" *Muslim World Journal of Human Rights* 8 (1): 1–19.

11. "Covenant on the Rights of the Child"; Mosaffa (2007): 9.

12. See, for example, Imran Ahsan Nyazee (2009), "Islamic Law Is International Law," https://ssrn.com/abstract=2407040 or http://dx.doi.org/10.2139/ssrn.2407040, viewed August 5, 2017.

13. Subhi al-Salih (1975), *Ma'ālim al-sharī'a* (Beirut, Dār al-kutub al-milāiyyīn): 232.

14. Shirin Ebadi (1994), *The Rights of the Child: A Study on Legal Aspects of Children's Rights in Iran*, trans. M. Zaimaran (Tehran, UNICEF). Childhood is defined in varied ways in Iran, depending on whether the focus is religious, political, or legal. Legal adulthood occurs at the age of eighteen, when an Iranian gains the rights of adult citizenship, such as opening a bank account or acquiring a passport: Shervin Malekzadeh (2012), "Children without Childhood, Adults without Adulthood: Changing Conceptions of the Iranian Child in Postrevolutionary Iranian Textbooks (1979–2008)," *Comparative Studies of South Asia, Africa and the Middle East* 32 (2): 339–360, p. 343, note 21.

15. Qur'an 2:128, 3:34, 4:9, 6:133, 7:172.

16. For a brief overview of Qur'anic references to various issues of childhood viewed through a contemporary religious lens, see Farid Esack (2012), "Islam, Children, and Modernity: A Qur'anic Perspective," in *Children, Adults, and Shared Responsibilities: Jewish, Christian, and Muslim Perspectives*, ed. Marcia J. Bunge (Cambridge, Cambridge University Press): 99–118.

17. Avner Gil'adi (1992), *Children of Islam: Concepts of Childhood in Medieval Muslim Society* (New York, St. Martin's): 4; Ishaq ibn Hunayn (1911), "Waṣiyyat Aflāṭūn fi-ta'dīb al-aḥdāth," ed. L. Cheikho, in *Maqālāt falsafiyya qadīma li-ba'ḍ mashāhīr falāsifat al-'arab*, ed. L. Ma'luf et al. (Beirut, al-Maṭba'a al-Kāthūlīkiyya li-ābā'i al-Yasū'īn): 52–58. Gil'adi remains the foremost authority on childhood in the premodern Muslim Arabic written tradition, and this section of the chapter follows his scholarship closely. Earlier versions of several of the topics discussed by Gil'adi in *Children of Islam* appear in Gil'adi (1988), "Some Notes on *Tahnik* in Medieval Islam," *Journal of Near Eastern Studies* 47 (3): 175–179; Gil'adi (1989a), "Concepts of Childhood and Attitudes towards Children in Medieval Islam: A Preliminary Study with Special Reference to Reactions to Infant and Child Mortality," *Journal of the Economic and Social History of the Orient* 32 (2): 121–152; Gil'adi (1989b), "On

the Origin of Two Key-Terms in al-Ghazzālī's Iḥyā' 'Ulūm al-Dīn," *Arabica* 36 (1): 81–92; Gil'adi (1989c), "Sabr (Steadfastness) of Bereaved Parents: A Motif in Medieval Muslim Consolation Treatises and its Origins," *Jewish Quarterly Review,* New Series 80 (1–2): 35–48; Gil'adi (1990), "Infants, Children and Death in Medieval Muslim Society: Some Preliminary Observations," *Social History of Medicine* 3 (3): 345–368; Gil'adi (1995), "Islamic Consolation Treatises for Bereaved Parents: Some Bibliographical Notes," *Studia Islamica* 81 (1): 197–202.

18. Gil'adi (1992): 4; Ahmad ibn Muhammad Ibn Miskawayh (1966), *Tahdhīb al-akhlāq wa-taṭhīr al-a'rāq* (Beirut, American University Beirut); Abu Hamid Muhammad al-Ghazali (1957), *Iḥyā' 'ulūm al-dīn,* 4 vols., ed. Badawi Tabana (Cairo, Dār iḥyā' al-kutub al-'arabiyya): 3:47–76.

19. Gil'adi (1992): 5. For a discussion of birth and childhood in more recent history, see Hilma N. Granqvist (1947), *Birth and Childhood among the Arabs: Studies in a Muhammadan Village in Palestine* (Helsingfors, Söderström).

20. Gil'adi (1992): 6. Other Islamic medical works dealing with infant pathology treat it as inseparable from obstetrics and gynecology. Examples of such early works include the *Kitāb khalq al-janīn wa-tadbīr al-ḥabālā wa-al-mawlūdīn* (Book on the Reaction of the Fetus and Treatment of Pregnant Women and Infants) by the tenth-century Andalucian 'Arīb ibn Sa'īd al-Qurtubi, and the *Kitāb tadbīr al-ḥabāla wa-al-aṭfāl* (Book on the Treatment of Pregnant Women and Offspring) by the tenth-century Iraqi scholar at the Fatimid court Ahmad ibn Muhammad ibn Yahya al-Baladi.

21. Gil'adi (1992): 10.

22. Gil'adi (1992): 84–85.

23. Gil'adi (1992): 21–23; Muhammad ibn Abi Bakr ibn Qayyim al-Jawziyya (2010) *Ṭuḥfat al-mawdūd bi-aḥkām al-mawlūd,* ed. 'Uthman ibn Jum'a Dumayriyya (Riyadh, Dār 'ilm al-fawā'id): 409–424.

24. Gil'adi (1992): 23. Ibn Qayyim al-Jawziyya (2010): 402–409. For more on the importance of dreaming, see J. J. Elias (2012), *Aisha's Cushion: Religious Art, Perception and Practice in Islam* (Cambridge, MA, Harvard University Press): 198–210; and John C. Lamoreaux (2002), *The Early Muslim Tradition of Dream Interpretation* (Albany, State University of New York Press).

25. Gil'adi (1992): 31–32; Ibn Qayyim al-Jawziyya (2010): 349–354.

26. Ghazali (1957): 3:69–72. Gil'adi's discussion of Ghazali's attitudes toward childhood is somewhat reductive and misleading, in that he overstates Ghazali's elucidation of the faults of children: Gil'adi (1992): 47, 58–59.

27. Ghazali (1957): 3:168, 4:64.

28. Ghazali (1957): 4:112–113.

29. Ghazali (1957): 3:70–71; Gil'adi (1992): 58–59.

30. Gil'adi (1992): 58–59.

31. Ghazali (1957): 4:61–62. Ibn Sina (Avicenna) also stresses the importance of daily play for children; see Abu 'Ali al-Husayn ibn 'Ali ibn Sina (1987), *Al-Qanūn fī-al-ṭibb,* ed. Idwar Alqish, 4 vols. (Beirut, Mu'assasat 'Izz al-Din): 1:208–209.

32. Ghazali (1957): 4:94–96, 220–223; Gil'adi (1992): 59.

33. Ghazali (1957): 2:25; Gil'adi (1992): 48–49.

34. There are no good studies of this practice; the overwhelming majority of studies of eroticism in Sufism—be they in Western or Islamic languages—consciously deemphasize the embodied nature of homoerotic references and interpret them as allusions to divine love. For a discussion of the topic as it relates to Persian literature, see Leonard Lewisohn (2010), "Prolegomenon to the Study of Ḥāfiẓ 2: The Mystical Milieu: Ḥāfiẓ's Erotic Spirituality," in *Hafiz and the Religion of Love in Classical Persian Poetry*, ed. L. Lewisohn (London and New York: I.B. Tauris and the Iran Heritage Foundation): 3–73.

35. Subhi al-Salih (1975): 246.

36. Ashraf 'Ali Thanwi (1971), *Ādāb-i zindagī* (Karachi, Dār al-ishā'at): 11. Thanwi is extremely influential in forming attitudes toward virtue, piety, and right action among South Asian Muslims. His best-selling book *Bahishtī zēwar* (Heavenly Ornaments) is a comprehensive guide to life aimed primarily at women, and is included as part of women's dowries in Muslim South Asia with notable regularity.

37. Heidi Morrison (2015), *Childhood and Colonial Modernity in Egypt* (Houndsmills, Basingstoke, Hampshire, UK, Palgrave Macmillan): 87–88. Important class-related factors impact the transitions through such phases of life. For a detailed discussion of child-rearing practices and their intersection with class in late-nineteenth- and early-twentieth-century Egypt, see Morrison (2015): 62–84.

38. Kenneth Hoskisson and Donald S. Biskin (1979), "Analyzing and Discussing Children's Literature Using Kohlberg's Stages of Moral Development," *Reading Teacher* 33 (20): 141–147, pp. 141–142. Subsequent stages in Kohlberg's model are as follows: "(2) The instrumentalist relativist orientation. Right action consists of that which instrumentally satisfies one's own needs and occasionally the needs of others. Human relations are viewed in terms like those of the market place. Elements of fairness, reciprocity, and equal sharing are present, but they are always interpreted in a physical or pragmatic way. Reciprocity is a matter of 'you scratch my back and I'll scratch yours,' not of loyalty, gratitude, or justice.

"(3) The interpersonal concordance or 'good boy—nice girl' orientation. Good behavior is that which pleases or helps others and is approved by them. There is much conformity to stereotypical images of what is majority or 'natural' behavior. Behavior is frequently judged by intention: 'He means well' becomes important for the first time. One earns approval by being 'nice.' (4) The law and order orientation. There is orientation toward authority, fixed rules, and the maintenance of the social order. Right behavior consists of doing one's duty, showing respect for authority and maintaining the given social order for its own sake. (5) The social-contract legalistic orientation. Generally with utilitarian overtones. Right action tends to be defined in terms of general individual rights and in terms of standards which have been critically examined and agreed upon by the whole society. There is a clear awareness of the relativism of personal values and opinions and a corresponding emphasis upon procedural rules for reaching consensus. Aside from what is constitutionally and democratically agreed upon, the right is a matter of personal values and opinion. The result is an emphasis upon the legal point of view, but with an emphasis upon the possibility of changing the law in terms of rational considerations of social utility (rather than rigidly maintaining it in terms of Stage 4 law and order)." The sixth

and final stage is oriented by universal ethical principles, in which "right is defined by the decision of conscience in accord with self-chosen ethical principles appealing to logical comprehensiveness, universality, and consistency. These principles are abstract and ethical (the Golden Rule, the categorical imperative) and are not concrete moral rules like the Ten Commandments. At heart, these are universal principles of justice, of reciprocity and equality of human rights, and of respect for the dignity of human beings as individual persons." Hoskisson and Biskin (1979): 142–143; Lawrence Kohlberg and Elliot Turiel (1971), "Moral Development and Moral Education," in *Psychology and Educational Practice*, ed. Gerald S. Lesser (Glenview, IL: Scott, Foresman): 415–416. Kohlberg's theory of moral development has been criticized on several grounds, in particular for emphasizing morality in terms of justice, and legality at the expense of other standards and motivators. Nevertheless, it remains one of the most influential psychological theories for the study of moral development and education.

39. Bruce Van Sledright and Jere Brophy (1992), "Storytelling, Imagination, and Fanciful Elaboration in Children's Historical Reconstructions," *American Educational Research Journal* 29 (4): 837–859.

40. Alec Ellis (1969), *A History of Children's Reading and Literature* (Oxford, Pergamon): 2–3.

41. Carolyn L. Burke and Toby G. Copenhaver (2004), "Animals as People in Children's Literature," *Language Arts* 81 (3), *Explorations of Genre*: 205–13, p. 208.

42. Maria Nikolajeva (1996), *Children's Literature Comes of Age: Toward a New Aesthetic* (New York and London, Garland): 3.

43. Julinda Abu Nasr (1996), "The Arab World," in *International Companion Encyclopaedia of Children's Literature*, ed. Peter Hunt and Sheila Ray (London, Routledge): 789–794, p. 789.

44. Sabeur Mdallel (2003), "Translating Children's Literature in the Arab World: The State of the Art," *Meta: Journal des Traducteurs/Translator's Journal* 48 (1–2): 298–306; Abu Nasr (1996): 789. See also S. Mdallel (2004), "The Sociology of Children's Literature in the Arab World," *Looking Glass: New Perspectives on Children's Literature* 8 (2), http://the-looking-glass.net/index .php/tlg/article/view/177/176v, viewed August 14, 2017.

45. Mdallel (2003): 301, quoting Abdel-Tawab Youssef (1985), *Kutub al-aṭfāl fī -'ālaminā al-muʿāṣir* (Cairo and Beirut, Dār al-kitāb al-maṣrī and Dār al-kitāb al-lubnānī): 13. Youssef's book on the life of Muhammad— in which animals, plants, and stones act as characters and narrators—has been immensely popular, having been printed at least twenty times and translated into English and other languages.

46. Mdallel (2003): 303, referring to Aziza Manaa (2001), "Al-adab al-mutarjam li-ṭifl: dirāsa tahlīliyya li-al-madhmūn al-tarbawī" (Translated Literature for Children: An Analytical Study of the Educational Content), *Arab Journal of Education* 21 (2): 201–226, p. 201. Youssef makes similar points concerning both the objectionable content of children's materials that get translated into Arabic and their potential for harmful cultural colonization by the West: Youssef (1985): 20, from Mdallel (2003): 303.

47. For a short introduction to such normativist notions of Islamic education, see J.M. Halstead (2004), "An Islamic Concept of Education," *Comparative Education* 40 (4): 517–529. For a discussion of education as a comprehensive process, and of how education, rationality, control over emotions, and virtue are related in modern Islamic societies, see Mana Kia (2015), "Moral Refinement and Manhood in Persian," in *Civilizing Emotions: Concepts in Nineteenth-Century Asia and Europe*, ed. Margrit Pernau and Helge Jordheim et al. (Oxford: Oxford University Press): 146–165; and in the same book Einar Wigen, "The Education of Ottoman Man and the Practice of Orderliness": 107–125, and Orit Bashkin, "Journeys between Civility and Wilderness: Debates on Civilization and Emotions in the Arab Middle East, 1861–1939": 126–145.

48. There are numerous works in a variety of languages on children's education and upbringing advocating Islamic perspectives. The vast list of ones in English includes H. Abdl Al Ati (1977; rpt. 1995), *The Family Structure in Islam* (Baltimore, American Trust); S. Al-Faifi (2004), *Guidelines for Raising Children* (Riyadh, Maktaba Dar al-Islam); Al-Azhar University and UNICEF (2005), *Children in Islam: Their Care, Upbringing and Protection* (Cairo and New York, Islamic International Centre for Demographic Studies and Research, Al-Azhar University, and Office of Public Partnerships, UNICEF); A. Hussain (2003), *Muslim Parents, Their Rights and Duties* (New Delhi, Adam). Books *for* children are too numerous to mention. For studies of such Islamic literature outside Muslim-majority countries, see Muhammad Manazir Ahsan (1979), *The Children's Book of Islam: Part One* (Markfield, UK, Islamic Foundation); Dilara Hafiz, Imran Hafiz, and Yasmine Hafiz (2007), *The American Muslim Teenager's Handbook* (Phoenix, Acacia); and Torsten Janson (2012), "Imaging Islamic Identity: Negotiating Norms of Representation in British-Muslim Picture Books," *Comparative Studies of South Asia, Africa and the Middle East* 32 (2): 325–338.

49. Morrison (2015): 48. For more on the history of children's books and poetry in Egypt, see pp. 48–51.

50. S.M. Zaman (1988), "Islamization and Strategies of Change—in the Perspective of Education," *Islamic Studies* 27 (4): 339–353. This work is not academically rigorous but it demonstrates the kinds of concerns driving the Islamization of knowledge. See also Eleanor Abdella Doumato (2003), "Manning the Barricades: Islam According to Saudi Arabia's School Texts," *Middle East Journal of Culture and Communication* 57 (2): 230–247.

51. For more on secondary education in Saudi Arabia, see Doumato (2003); Doumato (2007), "Saudi Arabia: From 'Wahhabi' Roots to Contemporary Revisionism," in *Teaching Islam: Textbooks and Religion in the Middle East*, ed. E.A. Doumato and G. Starrett (Boulder, Lynne Rienner): 153–176; Jerine B. Bird (1995), "Revolution for Children in Saudi Arabia," in *Children in the Muslim Middle East*, ed. E.W. Fernea (Austin, University of Texas Press): 276–294; and Michaela Prokop (2003), "Saudi Arabia: The Politics of Education," *International Affairs* 79 (1): 77–89.

52. Edith Szanto (2012), "Illustrating an Islamic Childhood in Syria: Pious Subjects and Religious Authority in Twelver Shi'i Children's Books," *Comparative Studies of South Asia, Africa and the Middle East* 32 (2): 361–393, p. 362.

The books she studied included "one Arabic primer series, several series on the lives of the *ahl al-bayt* [family of the Prophet] in both English and Arabic, an ongoing Arabic series on the immanence of the Mahdi (the hidden twelfth imam who is expected to return at the end of time), several ritual and prayer manuals, abridged and illustrated versions of canonical texts, and four out of a six-booklet set on *al-Wilaya* (spiritual governance)."

53. Szanto (2012): 363–364.

54. Bradley J. Cook (1999), "Islamic Versus Western Conceptions of Education: Reflections on Egypt," *International Review of Education* 45 (3): 339–357.

55. Gregory Starrett (1998), *Putting Islam to Work: Education, Politics and Religious Transformation in Egypt* (Berkeley, University of California Press): 134–136; Starrett (1996), "The Margins of Print: Children's Religious Literature in Egypt," *Journal of the Royal Anthropological Institute* 2 (1): 117–139, p. 120.

56. Starrett (1996): 120–121.

57. Starrett (1996): 127.

58. Starret (1996): 131.

59. Starrett (1996) 130–131; Starrett (1998): 147–150.

60. The infantilization of young men is touched upon, albeit with reference to one urban South Asian community, in T.M. Luhrmann (1996), *The Good Parsi: The Fate of a Colonial Elite in a Postcolonial Society* (Cambridge, MA, Harvard University Press): 132–133.

61. Morrison (2015): 89.

62. Morrison (2015): 91.

63. Morrison (2015): 90–91.

64. Morrison (2015): 86. For a discussion of the importance of watches and other items as signifiers of modernity in the context of Pakistan, see Jamal J. Elias (2011), *On Wings of Diesel: Trucks, Identity and Culture in Pakistan* (Oxford, Oneworld): 178–184.

65. For example, the Egyptian reformer Qasim Amin declared in his book *The Liberation of Women* (1899) that the reason children were ignorant was because their mothers were ignorant (Morrison [2015]: 147, note 14). For more on motherhood and reform in early-twentieth-century Egyptian society, see Omnia Shakry (1998), "Schooled Mothers and Structured Play: Child Rearing in Turn-of-the-Century Egypt," in *Remaking Women: Feminism and Modernity in the Middle East*, ed. Lila Abu-Lughod (Princeton: Princeton University Press): 126–170.

66. Ruby Lal suggests using the term *girl-child/woman* as a means of reconceptualizing the inseparability of girlhood from womanhood in the reformist imagination: Ruby Lal (2013), *Coming of Age in Nineteenth-Century India: The Girl-Child and the Art of Playfulness* (Cambridge, Cambridge University Press): 33–36. For a description of modern Muslim girlhood through one person's experience, see Lal (2013): 1–31.

CHAPTER 5

1. For a concise history of the development of Turkey's education system until the 1980s, see Sabahaddin Zaim (1989), "The Impact of Westernization

on the Educational System in Turkey," in *At the Crossroads: Education in the Middle East*, ed. A. Badran (New York, Paragon House): 18–42.

2. For more on the history of women during the late Ottoman Empire, see Madeline C. Zilfi, ed. (1997), *Women in the Ottoman Empire: Middle Eastern Women in the Early Modern Era* (Leiden, Brill).

3. Zaim (1989): 27. See also Yasemin Gencer (2012), "We Are Family: The Child and Modern Nationhood in Early Turkish Republican Cartoons," *Comparative Studies of South Asia, Africa and the Middle East* 32 (2): 294–309.

4. Zaim (1989): 29.

5. Zaim (1989): 29.

6. Şerif Mardin (2006), *Religion, Society and Modernity in Turkey* (Syracuse, Syracuse University Press): 277–278; Hakan Yavuz (2003), *Islamic Political Identity in Turkey* (New York, Oxford University Press): 127–128. For an extensive set of tables on Turkish educational statistics until the 1980s, see Zaim (1989).

7. Sam Kaplan (2006), *The Pedagogical State: Education and the Politics of National Culture in Post-1980 Turkey* (Stanford, Stanford University Press): 78. A detailed study of the seventh-year religious textbook is found on pp. 78–89. A more extensive survey of Turkish textbooks on religion is carried out in Özlem Altan (2007), "Turkey: Sanctifying a Secular State," in *Teaching Islam: Textbooks and Religion in the Middle East*, ed. Eleanor Abdella Doumato and Gregory Starrett (Boulder, Lynne Rienner): 197–214.

8. Yavuz (2003): 111, 127.

9. Ömer Demir (2011), "'Anadolu Sermayesi' ya da 'İslâmcı Sermaye,'" in *Modern Türkiye'de Siyasî Düşünce: İslâmcılık*, ed. T. Bora and M. Gültekingil, vol. 6 (Istanbul: İletişim Yayınları): 870–887, p. 872; Yavuz (2003): 98; A. Ekber Doğan (2006), "Siyasal Yansımalarıyla İslamcı Sermayenin Gelişme Dinamikleri ve 28 Şubat Süreci," *Mülkiye Dergisi* 30 (252): 47–68, pp. 56–57.

10. Devran K. Öçal (2013), "The Development and Transformation of the Islamic Publishing Field: The Cases of Nesil and Timaş," MA thesis, Department of Political Science, İstanbul Teknik Üniversitesi, Istanbul: 81.

11. Öçal (2013): 104.

12. Öçal (2013): 82. Other publishing houses include ones whose works are studied in this chapter as well as a variety of others with Sufi or more mainstream Sunni affiliations, such as İnsan, Dergah, Pınar, Beyan, Vadi, and İz; see Yavuz (2003): 111.

13. Öçal (2013): 103–104, 107–108. These changes were spurred to no small degree by government policies targeting religious publishers as part of a wider purge of religious institutions in 1997.

14. Öçal (2013): 103.

15. Öçal (2013): 110–111. This attitude was expressed in interviews given to Öçal by a number of highly placed people in the Timaş publishing group, including by the then managing editor, Emine Eroğlu.

16. Öçal (2013): 116–117. For a brief overview of the rise of Islamic broadcast media and its impact on youth behavior, especially on young women, see Abe Ruri (2012), "Media, Islam and Gender in Turkey," *Kyoto Bulletin of Islamic Area Studies* 5 (1–2): 38–46.

17. Öçal (2013): 117.

18. Personal communication, Faris Kaya, Chairman of the Executive Board, İstanbul İlim ve Kültür Vakfı, December 24, 2015, Istanbul.

19. Kenan Çayır (2007), *Islamic Literature in Contemporary Turkey: From Epic to Novel* (New York, Palgrave Macmillan): 10–14.

20. Çayır (2007): 7, quoting an interview İsmail gave in 2002 (Cemal A. Kalyoncu, "Hekimoğlu İsmail ile söylesi," *Aksiyon*, July 1).

21. Personal communication, Istanbul, July 7, 2007; M. Yaşar Kandemir (1995), "My Religion Series," trans. Akilé Gürsoy, in *Children in the Muslim Middle East*, ed. Elizabeth Warnock Fernea (Austin, University of Texas Press): 116–117.

22. For the role played by the Gülen movement in Turkish religious education until the last decade of the previous century, see Bekim Agai (2007), "Islam and Education in Secular Turkey: State Policies and the Emergence of the Fethullah Gülen Group," in *Schooling Islam: The Culture and Politics of Modern Muslim Education*, ed. Robert W. Hefner and M. Qasim Zaman (Princeton: Princeton University Press): 149–171; on the idea of the "Golden Generation," see Yavuz Çobanoğlu (2012), *'Altın Nesil"in Peşinde: Fethullah Gülen'de Toplum, Devlet, Ahlak, Otorite* (Istanbul, İletişim): 401–448.

23. The main book-selling interest related to the Gülen movement has historically been NT, a large seller of books and stationery with a substantial focus on children. NT maintains a sophisticated online shop as well as retail outlets across Turkey and in some other countries; it does not produce books itself but is supplied by publishers including Timaş and Nesil. NT has also been deliberately unclear about its relationship to the Gülen movement to the point of dissimulation, even before the crackdown on the Gülen movement in 2016.

24. Öçal (2013): 146–147.

25. Öçal (2013): 128.

26. Yavuz (2003): 103.

27. Yavuz (2003): 105–110.

28. For a discussion of the etymological nuances of the word *cute*, see M. Brzozowska-Brywczyńska (2007), "Monstrous/Cute: Notes on the Ambivalent Nature of Cuteness," in *Monsters and the Monstrous: Myths and Metaphors of Enduring Evil*, ed. N. Scott (Amsterdam and New York: Rodopi): 213; and F. Richard, (2001), "Fifteen Theses on the Cute," *Cabinet* 4, *Animals*, www.cabinetmagazine.org/issues/4/cute.php, viewed August 7, 2017.

29. Richard (2001).

30. For a study of Hello Kitty and the globalization of its popularity and marketing, see Christine R. Yano (2013), *Pink Globalization: Hello Kitty's Trek across the Pacific* (Durham, Duke University Press). The product's marketing success is also outlined in Ken Belson and Brian Bremner (2004), *Hello Kitty: The Remarkable Story of Sanrio and the Billion Dollar Feline Phenomenon* (Singapore, John Wiley and Sons).

31. Brzozowska-Brywczyńska (2007): 217.

32. Anne Allison (2003), "Portable Monsters and Commodity Cuteness: Pokemon as Japan's New Global Power," *Postcolonial Studies* 6 (3): 381–395, p. 385.

33. Sharon Kinsella (1995), "Cuties in Japan," in *Women, Media and Consumption in Japan*, ed. Lise Skov and Brian Moeran (Richmond, UK, Curzon): 220, quoting Kasuma Yamane (1990), *Gyaru no Kōzō* (Structure of the Girl) (Tokyo, Sekaibundasha).

34. Yano (2013): 56.

35. Anne Allison (2006), *Millennial Monsters: Japanese Toys and the Global Imagination* (Berkeley, University of California Press): 43; Kinsella (1995): 221. Yano argues that although the societal pressures of adulthood are shared by men as well as women, culturally sanctioned forms of escapism are gendered, and that *kawaii* allows women the opportunity to be both "childlike" *and* "maternal" (Yano [2013]: 57). Japanese studies of cuteness also suggest that seeing cuteness has a positive impact on behavior and concentration. See H. Nittoni, M. Fukushima, A. Yano, and H. Moriya (2012), "The Power of *Kawaii*: Viewing Cute Images Promotes a Careful Behavior and Narrows Attentional Focus," *PLUS ONE* 7 (9): 1–7.

36. Yano (2013): 46.

37. Allison (2003): 387. See also M. Burdelski and K. Misuhashi (2010), "'She Thinks You're Kawaii': Socializing Affect, Gender, and Relationships in a Japanese Preschool," *Language in Society* 39 (1): 65–93. This article connects modern notions of cuteness to a thousand-year-old aesthetic of the adorable expressed in the *Makura no Sooshi* (Pillow Book) of the court lady Sei Shonagon.

38. Kinsella (1995): 237; Yano (2013): 56.

39. Allison (2003): 387.

40. Allison (2006): 16. The emergence of the fashion for cute handwriting coincides with the development of *kawaii*. In the mid-1970s, significant numbers of Japanese teenage girls and young women started writing using rounded, somewhat childish characters; the new style proved immensely popular, such that, by 1985, over five million people were estimated to be using the script even though it was not accepted in schools. This cute, childish style of writing came to be known by several names, including *koneko ji* (kitten writing), *manga ji* (comic writing), *marui ji* (round writing), and *burikko ji* (fake-child writing), the last of which proved most popular (Kinsella [1995]: 221). Cute handwriting is closely associated with other aspects of babylike or childlike cute fashion, including wearing childish (virginal) clothes, and speaking in a baby voice. "Young people dressing themselves up as innocent babes in the woods in cute styles were known as *burikko* (fake-children), a term coined by teen star Yamada Kuniko in 1980. The noun spawned a verb, *burikko suru* (to fake-child it), or more simply *buri buri suru* (to fake it). Another 80s term invented to describe cute pop-idols and their fans is *kawaiikochan* which can be roughly translated as 'cutie-pie-kid'" (Kinsella [1995]: 225).

41. Yano (2013): 6. For a nuanced discussion of the place of sexuality in the cute and girl culture of Japan, see chapter 1 of Yano's work.

42. Allison (2003): 390; Allison (2006): 205.

43. Allison (2003): 394. For a visually rich study illustrating the pervasiveness of cute culture in Japan, see Manami Okazaki and Geoff Johnson (2013), *Kawaii! Japan's Culture of Cute* (Munich, Prestel).

44. Yano (2013): 15; Kinsella (1995): 225. "Typical fancy goods sold in cute little shops were stationary *[sic]*, cuddly toys, and gimmicks, toiletries, lunch boxes, and cutlery, bags, towels, and other personal paraphernalia. "The crucial ingredients of a fancy good are that it is small, pastel, round, soft, loveable, *not* traditional Japanese style but a foreign—in particular European or American—style, dreamy, frilly and fluffy. Most fancy goods are also decorated with cartoon characters. The essential anatomy of a cute cartoon character consists in its being small, soft, infantile, mammalian, round, without bodily appendages (e.g. arms), without bodily orifices (e.g. mouths), non-sexual, mute, insecure, helpless and bewildered." Kinsella (1995): 226. See also C.R. Yano (2009), "Wink on Pink: Interpreting Japanese Cute as It Grabs the Global Headlines," *Journal of Asian Studies* 68 (3): 681–688.

45. Allison (2006): 88; Allison (2003): 386–387. For an analysis of Japanese values directed at children from immediately before this period, particularly comparing the lessons put forth in folktales with fantasy fiction, see Motoko Fujishiro Huthwaite (1978), "Japanese Values: A Thematic Analysis of Contemporary Children's Literature," *Japanese Journal of Religious Studies* 5 (1): 59–74.

46. Allison (2006): 88; Allison (2003): 387.

47. For a discussion of issues of religion and fan-culture as they relate to anime and manga, see Jolyon Baraka Thomas (2012), *Drawing on Tradition: Manga, Anime and Religion in Contemporary Japan* (Honolulu, University of Hawai'i Press).

48. Allison (2003): 382–383.

49. The latter point was made by the Japanese cultural critic Okada Tsuneo (Allison [2003]: 383). It may be overstating the nature of *Pokémon*'s appeal to attribute it to shared notions of cuteness rather than to the power of consumerist fads and fashion. Allison's research with American children suggests that *Pokémon*'s popularity resulted from it being perceived as "cool" (Allison [2003]: 384). The more recent viral appeal of *Pokémon Go* might also combine a variety of aspirations and interests, including a new intersection of notions of cuteness, pleasure, and consumerism.

50. Allison (2006): 226. In the export market, particularly the United States, Pikachu did not receive the same degree of importance; the focus remained on Ash (Satoshi in the original), under the assumption that American children would be drawn more to a heroic character (Allison [2003]: 386).

51. There is a small but notable trend of "Muslim Lolita" fashion, which is overtly modeled on aspects of *kawaii* culture ("Lolita Fashion Travels Overseas! 'Muslim Lolita' is the New Intersection of the Kawaii Culture," *Tokyo Girls' Update*, July 29, 2015, http://tokyogirlsupdate.com/musulim-lolita-fashion-20150752829.html, viewed August 7, 2017; "Muslim Lolita Fashion Is a New Trend Inspired by Japan," *Bored Panda*, July 28, 2015, www.boredpanda.com/muslim-lolita-hijab-japanese-fashion-anime/, viewed August 7, 2017.

52. Allison (2003): 382.

53. Yano (2013): 47.

54. Daniel Harris (1992), "Cuteness," *Salmagundi* 96:177–86, p. 179.

55. Richard (2001).

56. Harris (1992): 179–80.

57. The majority of Muslims believe that Jesus did not die on the cross, with most believing in some process of substitution through which God either created the illusion of Jesus's crucifixion or else made another victim look like Jesus. In either version, the audience would have been witness to a crucifixion, therefore choices concerning how to represent it visually are important.

CHAPTER 6

1. Federal Bureau of Statistics, Government of Pakistan, Population Census Organization, "50 Years Statistics Section 11—Population," p. 173, table 11.10, www.pbs.gov.pk/sites/default/files/50_years_statistics/vol1/11.pdf, viewed August 13, 2017. For more on issues related to gender and education, see Rashida Qureshi and Jane F. A. Rarieya, eds. (2007), *Gender and Education in Pakistan* (Karachi, Oxford University Press).

2. Pakistan's literacy figures are almost certainly optimistic, with actual literacy levels being much lower. By way of illustrating the unreliability of the statistical indicators, one reads that, in 1981, 38 percent of Pakistanis supposedly could read the Qur'an (Census 1984, table 4.7, p. 33, quoted from Tariq Rahman [2002], *Language, Ideology and Power: Language-Learning among the Muslims of Pakistan and North India* [Karachi, Oxford University Press]: 11). This is impossible because, were it to be true, it would mean that only 26.2 percent of the population could read *any* language, but 38 percent could read a *foreign* language, since Arabic is spoken or understood by a negligible number of Pakistanis.

According to the most recent report on global literacy, in Pakistan the literacy rate among poor rural males is 64 percent compared with 14 percent among females. In terms of spending, in 2014 Pakistan allocated only 11.3 percent of the benchmarked amount needed for it to meet its long-term educational targets. See Global Education Monitoring Report (2016), "Education for People and Planet: Creating Sustainable Futures for All," UNESCO (United Nations Educational, Scientific and Cultural Organization), Paris, UNESCO: 74, 136. Comparative data on global education is found in table 2, pp. 409–416, http://unesdoc.unesco.org/images/0024/002457/245752e.pdf, viewed August 13, 2017.

3. Jamal J. Elias (2011), *On Wings of Diesel: Trucks, Identity and Culture in Pakistan* (Oxford, Oneworld): 42–54.

4. For more on Pakistan's stratified educational system, see Tariq Rahman (2004), *Denizens of Alien Worlds: A Study of Education, Inequality and Polarization in Pakistan* (Karachi, Oxford University Press); and Rahman (2002), esp. chaps. 8 and 9. See also Muhammad Khalid Masud (2002), "Religious Identity and Mass Education," in *Islam in the Era of Globalization: Muslim Attitudes towards Modernity and Identity,* ed. Johan Meuleman (London and New York, Routledge Curzon): 233–245.

5. Rahman (2002): 287.

6. Rahman (2004): 24.

7. M. D. Zafar's *A Textbook of Pakistan Studies* claims that Pakistan "came to be established for the first time when the Arabs under Muhammad bin Qasim

occupied Sind and Multan" (quoted from Ayesha Jalal [1995], "Conjuring Pakistan: History as Official Imagining," *International Journal of Middle East Studies* 27[1]: 73–89, p. 79). Concerning the teaching of nationalistic ideologies, see also M. Ayaz Naseem (2010), "Textbooks and the Construction of Militarism in Pakistan," in *Shaping a Nation: An Examination of Education in Pakistan,* ed. Stephen Lyon and Iain R. Edgar, Oxford in Pakistan Readings in Sociology and Social Anthropology (Karachi, Oxford University Press): 148–157.

8. See Rahman (2002): 293–298 for statistics on the disparities in expenditure on education in Pakistan.

9. Rahman (2002): 296. An Urdu-medium boys high school in Islamabad cost Rs. 6.52 million at that time.

10. Rahman (2002): 297–298.

11. *The 9/11 Commission Report* has the following to say about the role of *madrasas* in Pakistani society: "Pakistan's endemic poverty, widespread corruption, and often ineffective government create opportunities for Islamic recruitment. Poor education is a particular concern. Millions of families, especially those with little money, send their children to religious schools, or madrassahs. Many of these schools are the only opportunity available for an education, but some have been used as incubators for violent extremism. According to a Karachi's police commander [sic], there are 859 madrassahs teaching more than 200,000 youngsters in his city alone." National Commission on Terrorist Attacks upon the United States, *The 9/11 Commission Report* (New York, W.W. Norton): sec. 12.2, 367. A similar position is held by an influential report by the International Crisis Group: "Madrasas provide free religious education, boarding and lodging and are essentially schools for the poor. Over one and a half million children attend madrasas. These seminaries run on public philanthropy and produce indoctrinated clergymen of various Muslim sects. Some sections of the more orthodox Muslim sects have been radicalized by state sponsored exposure to jihad, first in Afghanistan, then in Kashmir. However, the madrasa problem goes beyond militancy. Students at more than 10,000 seminaries are being trained in theory, for service in the religious sector. But their constrained worldview, lack of modern civic education and poverty make them a destabilizing factor in Pakistani society. For all these reasons, they are also susceptible to romantic notions of sectarian and international jihads, which promise instant salvation." "Pakistan: Madrasahs, Extremism and the Military," *International Crisis Group,* Asia Report No. 36, July 29, 2002. The report had originally claimed that "about a third of all children in Pakistan in education attend madrasas," but this was changed after it was proved to be wrong.

12. Ahmed Rashid (2000), *Taliban: Militant Islam, Oil and Fundamentalism in Central Asia* (New Haven, Yale University Press): 89.

13. The latter figure was published by C. Kraul in "Dollars to Help Pupils in Pakistan," *Los Angeles Times,* April 14, 2003. Another example of the way sensationalistic and poorly substantiated scholarship characterizes much of the writing on religious education in Pakistan, an article on the subject in *Foreign Affairs* placed the number of madrasas in Pakistan between forty thousand and fifty thousand without listing any sources for the figure. Jessica Stern (2000), "Pakistan's Jihad Culture," *Foreign Affairs* 79 (6): 115–126. For more on the

way Pakistani religious education is covered in major English-language newspapers, see Tahir Andrabi and Jishnu Das et al. (2006), "Religious School Enrollment in Pakistan: A Look at the Data," *Comparative Education Review* 50 (3): 446–477, esp. appendix A, table A1.

14. The landmark study of religious school enrollment in Pakistan by Andrabi and Das et al. makes clear that, at the beginning of the twenty-first century, religious schools accounted for less than 1 percent of total school enrollment in Pakistan, a percentage that did not increase significantly in the years after 9/11. Even in districts bordering Afghanistan, which have the highest rate of madrasa enrollment, the figure remained less than 7.5 percent. T. Andrabi and J. Das et al. (2006): 447. The percentage of students attending madrasas in the Pashtun-majority areas bordering Afghanistan is undoubtedly much higher than it is in other parts of the country. The ten districts with the highest madrasa enrollment rates are all Pashtu-speaking, and all fourteen districts with madrasa enrollment figures above 2 percent of total school enrollment are either in Pashtu-speaking parts of Khyber-Pakhtunkhwa province or in Pashtun-majority parts of Baluchistan. See also Saleem H. Ali (2010), "Madrasas and Violence: Is There a Connection?," in *Shaping a Nation: An Examination of Education in Pakistan,* ed. Stephen Lyon and Iain R. Edgar, Oxford in Pakistan Readings in Sociology and Social Anthropology (Karachi, Oxford University Press): 73–95.

15. Andrabi and Das et al. (2006): 466.

16. Andrabi and Das et al. (2006): 463, italics added.

17. The Ahmadi movement is officially regarded as heretical in Pakistan and is subject to legal and vigilante patterns of discrimination and persecution.

18. For more on *barkat* in Pakistani society, see Elias (2011): 28–30; Katherine P. Ewing (1997), *Arguing Sainthood: Modernity, Psychoanalysis and Islam* (Durham, Duke University Press); Charles Lindholm (1998), "Prophets and *Pirs:* Charismatic Islam in the Middle East and South Asia," in *Embodying Charisma: Modernity, Locality and the Performance of Emotion in Sufi Cults,* ed. P. Werbner and H. Basu (London, Routledge): 209–233; and M. Geijbels (1978), "Aspects of the Veneration of Saints in Islam, with Special Reference to Pakistan," *Muslim World* 68 (3): 176–186. The broader topic of charisma in Islamic society is treated in Michael A. Williams, ed. (1982), *Charisma and Sacred Biography,* Journal of the American Academy of Religion, Thematic Series, 48 (3–4) (Chico, Scholars Press).

19. For more on the Barelwi movement, see Usha Sanyal (1999), *Devotional Islam and Politics in British India: Ahmad Riza Khan Barelwi and His Movement, 1870–1920* (New York and Delhi, Oxford University Press); and Sanyal (2005), *Ahmad Riza Khan Barelwi: In the Path of the Prophet* (Oxford, Oneworld).

20. For an introduction to the divisions among Pakistani Sunnis, see Barbara D. Metcalf (2002), "'Traditionalist' Islamic Activism: Deoband, Tablighis, and Talibs," *ISIM Paper No. 4,* Leiden, ISIM (open access); and Elias (2011): 24–37.

21. I have attempted to demonstrate the impact of societal indicators on the culture surrounding truck decoration in Elias (2011), esp. chaps. 8 and 9.

22. Very little research has been published on Pakistani poster and calendar arts, especially in comparison to the substantial work done on chromolithogra-

phy in India. The only book devoted to the subject remains Jürgen W. Frembgen, (2006), *The Friends of God: Sufi Saints in Islam, Popular Poster Art from Pakistan* (Karachi: Oxford University Press in cooperation with the Museum of Ethnology, Munich). Shorter studies of religious posters include Jamal J. Elias (2009), "Islam and the Devotional Image in Pakistan," in *Islam in South Asia in Practice,* ed. Barbara D. Metcalf (Princeton: Princeton University Press): 120–134.

23. Jamal J. Elias (2012), *Aisha's Cushion: Religious Art, Perception and Practice in Islam* (Cambridge, MA, Harvard University Press): 41–42; Christopher Pinney (2004), *"Photos of the Gods": The Printed Image and Political Struggle in India* (London: Reaktion): 190.

24. Although religious images are used by some sections of Muslim society in Pakistan, especially among Shi'is, and practices of visualization and induced dreaming are employed in Sufism, there is no established tradition among the country's Sunni majority of using religious images for didactic purposes directed at either adults or children. The case of Pakistani society invites comparison with that of modern Protestantism, which has a similar ambivalence toward visual religious imagery. For a detailed study of the religious image and its popular usages in modern American Protestantism, see David Morgan (1998), *Visual Piety: A History and Theory of Popular Religious Images* (Berkeley, University of California Press), esp. 23–24, 31–41, 55–57, 183–185.

25. Frembgen (2006): 128.

26. Frembgen (2006): 131.

27. Pinney (2004).

28. Knut A. Jacobsen (2004), "The Child Manifestation of Śiva in Contemporary Hindu Prints," *Numen* 51 (3): 237–264, p. 238.

29. Jacobsen (2004): 256, 261.

30. Pinney (2004): 167–180.

31. I have addressed the iconology of these images in Elias (2011): 113–114, 122–126.

32. Sharon Kinsella (1995), "Cuties in Japan," in *Women, Media and Consumption in Japan,* ed. Lise Skov and Brian Moeran (Richmond, UK, Curzon): 240.

33. For more on gender and God in Islam, see Sachiko Murata (1992), *The Tao of Islam: A Sourcebook on Gender Relationships in Islamic Thought* (Albany, State University of New York Press, 1992).

34. For a longer discussion of the relationship between beauty, virtue, and aesthetics in Islamic thought, see Elias (2012), esp. chap. 5.

35. Muhammad is upheld in hagiographical literature as the most beautiful of God's creations with the nicest face; see, for example, Ibn al-Qayyim al-Jawziyya (2008), *Rawḍat al-muḥibbīn wa-nuzhat al-mushtāqīn,* ed. Rabi Yusuf (Cairo, Dār al-Farūq): 275, 273–274.

36. Abu Hamid al-Ghazali, (1975; rpt. 2001), *Kīmiyā-yi sa'ādat,* ed. Husayn Khadivjam (Tehran, Shirkat-i intishārāt-i 'ilmi wa farhangi): 1:45–46; Ghazali (1909; rpt. 1997), *The Alchemy of Happiness,* trans. Claud Field (Lahore, Sh. Muhammad Ashraf): 10; Elias (2012): 164.

37. Ghazali (1957; rpt. 1985), *Iḥyā' 'ulūm al-dīn,* 4 vols. (Cairo: Dār iḥyā' al-kutub al-'arabiyya; rpt. Istanbul: Çağrı Yayınları): 4:292; Elias (2012): 166.

38. Ghazali; (1975; rpt. 2001): 2:576.

39. Ghazali; (1975; rpt. 2001): 2:586; Ghazali (1909; rpt. 1997): 78; Elias (2012): 164.

40. Ghazali (1957; rpt. 1985): 2:291.

41. For more on 'Abd al-Qadir Jilani's importance to the development of Sufi orders, see John S. Trimingham (1971), *Sufi Orders in Islam* (Oxford, Clarendon). For a history of Sufi orders in Pakistan, see S. A. A. Rizvi (1978), *A History of Sufism in India*, 2 vols. (New Delhi, Munshiram Manoharlal).

42. For a discussion of the hybridity of religious identities in the Punjab, particularly as it pertains to Islam and Sikhism, see Hajrot Oberoi (1994), *The Construction of Religious Boundaries: Culture, Identity and Diversity in the Sikh Tradition* (Oxford, New York, and New Delhi, Oxford University Press), esp. pp. 92–203.

CHAPTER 7

1. For a detailed study of the multipronged approach to the modernization of education in nineteenth- and early-twentieth-century Iran, see Monica M. Ringer (2001), *Education, Religion, and the Discourse of Cultural Reform in Qajar Iran* (Costa Mesa, Mazda). See also Jalal Matini (1989), "The Impact of the Iranian Revolution on Education in Iran," in *At the Crossroads: Education in the Middle East*, ed. A. Badran (New York, Paragon House): 43–55.

2. Matini (1989): 47.

3. Patricia J. Higgins and Pirouz Shoar-Ghaffari (1995), "Changing Perceptions of Iranian Identity in Elementary Textbooks," in *Children in the Muslim Middle East*, ed. Elizabeth Warnock Fernea (Austin, University of Texas Press): 337–363. See also Matini (1989).

4. Matini (1989): 49, quoting Ali Haddad Adil Ghulam, "Interview," *Nashr-i Dānish*, Winter 2001:2:8.

5. Golnar Mehran (2007), "Iran: A Shi'ite Curriculum to Serve the Islamic State," in *Teaching Islam: Textbooks and Religion in the Middle East*, ed. E. A. Doumato and G. Starrett (Boulder, Lynne Rienner): 53–70, p. 54.

6. Matini (1989): 51, quoting Shams Al Ahmad, "Guftugū bā Shams Al Ahmad . . .," *Payām-i Inqilāb* (Khurdad 25, 1359/June 15, 1980): 20–21. The author of this statement, Shams Al Ahmad, was the brother of Jalal Al Ahmad, a prominent Iranian intellectual famous for writing *Gharbzadegī*, a book about how Iranians were infatuated with and intoxicated by the West and its values.

7. For a discussion of the role of education in Iranian state formation and the emergence of national consciousness, see Afshin Marashi (2008), *Nationalizing Iran: Culture, Power, and the State, 1870–1940* (Seattle, University of Washington Press); and Haggay Ram (2000), "The Immemorial Iranian Nation? School Textbooks and Historical Memory in Post-Revolutionary Iran," *Nations and Nationalism: Journal of the Association for the Study of Ethnicity and Nationalism* 6 (1): 68–90.

8. Mehran (2007): 53.

9. Golnar Mehran (1989), "Socialization of Schoolchildren in the Islamic Republic of Iran," *Iranian Studies* 22 (1): 35–50, p. 49. Other studies of the school curriculum in postrevolution Iran include Higgins and Shoar-Ghaffari (1995); Muhammad Razai (2008), *Tahlīlī az zindagī-yi rūzmarreh-i dānish āmūzishī: nāsāzehā-yi guftemān-i madraseh* (Tehran: Mu'assaseh-i bayn al-millalī-yi pazhūhashī-yi farhangi wa hunarī); and M. Mobin Shorish (1988), "The Islamic Revolution and Education in Iran," *Comparative Education Review* 32 (1): 58–75.

10. Shervin Malekzadeh (2012), "Children without Childhood, Adults without Adulthood: Changing Conceptions of the Iranian Child in Postrevolutionary Iranian Textbooks (1979–2008)," *Comparative Studies of South Asia, Africa and the Middle East* 32 (2): 339–360, pp. 340, 342.

11. Malekzadeh (2012): 342.

12. Malekzadeh (2012): 342.

13. Malekzadeh (2012): 344.

14. Malekzadeh (2012): 345.

15. Malekzadeh (2012): 350–351.

16. Malekzadeh (2012): 352–353.

17. Mehran (2007): 54.

18. Mehran (2007): 55.

19. For an analysis of this ritual, see Azam Torab (2007), *Performing Islam: Gender and Ritual in Iran* (Leiden, Brill): 169–193; Malekzadeh (2012): 358.

20. Adele K. Ferdows (1995), "Gender Roles in Iranian Public School Textbooks," in *Children in the Muslim Middle East*, ed. E. W. Fernea (Austin, University of Texas Press): 325–336. According to Ferdows's survey of textbooks from grades six through twelve during this period, as a percentage of female roles, motherhood was represented 72.9 percent of the time while working women appeared 1.3 percent of the time. In contrast, the figures for fathers were 12.9 percent and workingmen 77.6 percent respectively (p. 329). See also Mehran (2007): 55, 67–68.

21. For more on visuality and religion in Shi'ism, see Ingvild Flaskerud (2012), *Visualizing Belief and Piety in Iranian Shiism* (London, Continuum); and Pedram Khosronejad, ed. (2012), *The Art and Material Culture of Iranian Shi'ism: Iconography and Religious Devotion in Shi'i Islam*, (London and New York, I. B. Taurus in association with the Iran Heritage Foundation). The theater and performance of mourning in Iran is discussed in Peter Chelkowski (1979), *Ta'ziyeh: Ritual and Drama in Iran* (New York, New York University Press). The tradition of coffeehouse paintings used in Iranian storytelling is illustrated and discussed in Hadi Seyf (1990), *Naqqāshī-yi qahweh khāneh* (Tehran, Wizārat-i farhang wa āmūzeh-i 'ālī and Riza Abbasi Museum); and M. Moallem (2014), "Aestheticizing Religion: Sensorial Visuality and Coffeehouse Painting in Iran," in *Sensational Religion: Sensory Cultures in Material Practice*, ed. S. M. Promey (New Haven and London, Yale University Press): 297–320.

22. Alice Bombardier (2013), "Iranian Mural Painting: New Trends," in *Cultural Revolution in Iran: Contemporary Popular Culture in the Islamic Republic*, ed. Annabelle Sreberny and Massoumeh Torfeh (London, I. B. Taurus): 217–229, p. 220.

23. Ulrich Marzolph (2013), "The Martyr's Fading Body: Propaganda vs. Beautification in the Tehran Cityscape," in *Visual Culture in the Modern Middle East: Rhetoric of the Image,* ed. Christiane J. Gruber and Haugbolle Sune (Bloomington and Indianapolis, Indiana University Press): 164–185, pp. 167–168. For more on religious murals in Iran, see Christiane J. Gruber, "Images of the Prophet Muhammad *in and out* of Modernity: The Curious Case of a 2008 Mural in Tehran," in the same work, pp. 2–31.

24. Christiane J. Gruber (2009), "Media/Ting Conflict: Iranian Posters of the Iran-Iraq War," in *Crossing Cultures: Conflict, Migration and Convergence: Proceedings of the 32nd International Congress in the History of Art,* ed. Jaynie Anderson (Melbourne, the Miegunyah Press and Melbourne University Press): 687.

25. The most comprehensive collection of examples of Iranian regime art from the first two decades after the Islamic Revolution is found in Peter Chelkowski and Hamid Dabashi (2002), *Staging a Revolution: The Art of Persuasion in the Islamic Republic of Iran* (London: Booth-Clibborn). Poster art from the early years is discussed in William L. Hanaway (1985), "The Symbolism of Persian Revolutionary Posters," in *Iran since the Revolution: Internal Dynamics, Regional Conflict, and the Superpowers,* ed. Barry M. Rosen (Boulder and New York, Social Science Monographs, distributed by Columbia University Press): 31–50. An electronic exhibition of Iranian propaganda posters can be seen at "The Graphics of Revolution and War: Iranian Poster Arts," www.lib.uchicago.edu/e/webexhibits/iranianposters/, viewed August 10, 2017.

26. The Tibyān Cultural and Informative Institute was formed in 2001 as an affiliate of the Organization for Islamic Propagation, with the specific charge "to explain, develop and promote Islamic culture and educate the new generation religiously, socially and practically by the means of information technology." They produce "religiously and culturally oriented" software and video games to fill a perceived need and to combat socially harmful options that are broadly available. Vit Šisler (2013), "Digital Heroes: Identity Construction in Iranian Video Games," in *Cultural Revolution in Iran: Contemporary Popular Culture in the Islamic Republic,* ed. Annabelle Sreberny and Massoumeh Torfeh (London: I.B. Taurus): 171–191, pp. 174–175.

27. Raziyeh Rijai, ʿAli Daudi and Mahdi Badiyeh-Payma (2009), *Alif Alif Āsemūm-1* (Mashhad, Nashr-i Sitareh).

28. Manizheh Dartumiyan and Tavus Siddiqi (2003, rpt. 2005), *Sarbāz-i kūchūlū: majmūʿa-yi shiʿr-i kūdak* (Mashhad, Kongreh-i buzurgdāsht-i sardārān-i shahīd).

29. Hamideh Najjarian and Iman Nasirian (2009), *Qulak-i sifālī* (Mashhad, Kongreh-i sardārān-i shahīd and Intishārāt-i Sitareh).

30.

ān rā zūdī kharīdam
bā ān shudam razmandeh
az shādī tū-yi qalbam
par mīzanad parandeh (Najjarian and Nasirian [2009]: 15)

31.

angār buzurgtar shudeh am
ḥala bā īn tufangam
miṣl-i bābā az imrūz
bā dushmanhā mī jangam (Najjarian and Nasirian [2009]: 16)

32. The participation of Iranian children in the Iran-Iraq war is an emotion-
ally charged topic for many who have discussed it. See, for example, Ian Brown
(1990), *Khomeini's Forgotten Sons: The Story of Iran's Boy Soldiers* (London,
Grey Seal). For an analysis of the criticism Iran has undergone for its use of
child soldiers, see Maryam Elahi (1988), "The Rights of the Child under Islamic
Law: Prohibition of the Child Soldier," *Columbia Human Rights Law Review*
19 (2): 259–279, abridged version in E. W. Fernea, ed. (1995), *Children in the
Muslim Middle East* (Austin, University of Texas Press): 367–374. For the most
comprehensive study of the history and role of the Basij to date, see Saied
Golkar (2015), *Captive Society: The Basij Militia and Social Control in Iran*
(New York, Columbia University Press).

33. Some of Shari'ati's writings on the subject of martyrdom are found in
Mahmud Taleqani, Murtada Mutahhari, and Ali Shari'ati (2005), *Jihād and
Shahādat: Struggle and Martyrdom in Islam,* ed. Mehdi Abedi and Gary Legen-
hausen (North Haledon, NJ, Islamic Publications International). The reenact-
ment of the events of Karbala plays a significant role in the gendering of revolu-
tionary identities in modern Iran; cf. Minoo Moallem (2005), *Between Warrior
Brother and Veiled Sister: Islamic Fundamentalism and the Politics of Patriar-
chy in Iran* (Berkeley, University of California Press).

34. Kamran S. Aghaie (2004), *The Martyrs of Karbala: Shi'i Symbols and
Rituals in Modern Iran* (Seattle and London, University of Washington Press):
133. A discussion of the gendered aspects of the commemoration of Karbala is
found in Kamran S. Aghaie (2005), "Gendered Aspects of the Emergence and
Historical Development of Shi'i Symbols and Rituals," in *The Women of Kar-
bala: Ritual Performance and Symbolic Discourses in Modern Shi'i Islam,* ed.
K. S. Aghaie (Austin, University of Texas Press): 1–21.

35. For a discussion of the Martyr's Museum in Tehran, see Christiane J.
Gruber (2012), "The Martyrs' Museum in Tehran: Visualizing Memory in Post-
Revolutionary Iran," *Visual Anthropology* 25 (1–2): 68–97.

36. Aghaie (2004): 136.

37. For comparative studies of the Abrahamic sacrifice and its links to social
violence, see Larry Powell and William R. Self (2007), *Holy Murder: Abraham,
Isaac, and the Rhetoric of Sacrifice* (Lanham, MD, University Press of America);
Bruce Lincoln (2008), *Abraham's Curse: Child Sacrifice in the Legacies of the
West* (New York, Doubleday); and Carol Delaney (1998), *Abraham on Trial:
The Social Legacy of Biblical Myth* (Princeton, Princeton University Press).
The implications of sacrifice as the true gift, which has to lie outside any
explicit or implicit system of exchange, is explored in broad terms in Jacques
Derrida (2007), *The Gift of Death,* trans. David Wills (Chicago, University of
Chicago Press). (A second edition of this book was published in 2008.)

38. Malekzadeh (2012): 355.

39. For a large-scale mural representing Fahmideh as a hero of Iranian society, see Christiane J. Gruber (2008), "The Message on the Wall: Mural Arts in Post-Revolutionary Iran," *Persica* 22:15–46, figure 8, p. 31.

40.

az ūn zamān ke bābām nayūmadeh kināram
kheylī dilam tang shudeh surāghashu mī gīram
rafteh beh jang-i dushman dīgeh nadīdamesh man
wāseh dīdan-i Bābā az har kas wa az har jā

Rahmatullah Rizai and Bahnush Zamani (2007), *Bābāmo tū nadīdī?*, 2nd ed. (Mashhad, Kongreh-i sardārān-i shahīd and Nashr-i Sitareh): 1.

41.

raft wa namūnadesh īnjā
bābāt yeh qahramāneh, yeh ādam-i bā wafāst
rafteh kinār-i khudā
hamīsheh jāwīdāneh
shahīd-i rāh-i khudāst

42. 'Ali Bahar and Samiyeh Ramzanzadeh (2007), *Khāṭirāt-i Bābā*, 2nd ed. (Mashhad, Kongreh-i sardārān-i shahīd and Nashr-i Sitareh).

43. Raziyeh Rajai and Samiyeh Ramzanzadeh (2011), *Qāb-i 'aks* (Mashhad, Kongreh-i sardārān-i shahīd and Nashr-i Sitareh).

44.

atal matal mī dūnam
ferishteh-hā-yi mahrbūn
jism-i Bābā ru burdeh
ūn bālā tū āsmūn
har jum'eh man bā Māmān
mīrīm pīsh-i shahīdā
dūst dāram ūnhā ru man
beh andāzeh-i Bābā (R. Rajai and S. Ramzanzadeh [2011]: 18–19)

45. Husayn Ibrahimi and Samiyeh Ramzanzadeh (2008), *Kabūtarān-i bī ṣadā* (Mashhad, Kongreh-i sardārān-i shahīd and Nashr-i Sitareh).

46. This image was originally printed as a poster titled *Muqāwamat* (Resistance) and made by the artist Jamal Khorrami Nejad. The slogan appearing on the poster was omitted from the postage stamp: "Standing Tall and Firm to offer our Martyrdom/Shouting 'Fight, Fight until Victory!'" Faegheh Shirazi (2010), "The Islamic Republic of Iran and Women's Images: Masters of Exploitation," in *Muslim Women in War and Crisis: Representation and Reality,* ed. F. Shirazi (Austin, University of Texas Press): 114.

47. There are examples of the female self-sacrificial model of participating in war in non-Muslim societies. Toward the end of the First World War, concern over the marital futures of returning disabled soldiers in the United Kingdom prompted at least one clergyman to establish an organization to find wives for them. Marrying physically disabled men constituted a manner of

sacrificing oneself for the national cause in a physical sense, but it also represented the establishment of a moral high ground, since physically disabled men who had sacrificed themselves for the nation were judged to be better than the physically able ones who had stayed behind. Seth Koven (1994), "Remembering the Dismemberment: Crippled Children, Wounded Soldiers, and the Great War in Great Britain," *American Historical Review* 99 (4): 1167–1202, pp. 1189–1190.

48. *Akbaba* 407 (October 28, 1926): 4 (courtesy of the Atatürk Library, Istanbul).

"Erkek çocuk—'Anne, bende buyuduğum zaman asker olacağım, değil mi?'
Anne—'Evet, yavrum, inşallah!'
Kız çocuk—'Ya, ben Anne? . . . Ben asker olmayacak mıyım?'
Anne—'Sen de asker annesi olacağın yavrum!'"

Yasemin Gencer (2012), "We Are Family: The Child and Modern Nationhood in Early Turkish Republican Cartoons," *Comparative Studies of South Asia, Africa and the Middle East* 32 (2): 303–304.

49. Hatice İpek and Yaşar Fırat (2016), "Peygamberimiz ve Küçük Ümmeti" (Our Prophet and the Community of Little Ones), *Diyanet Çocuk Dergisi* 429:4–5, www2.diyanet.gov.tr/DiniYay%C4%B1nlarGenelMudurlugu/Dergi Dokumanlar/Cocuk/2016/cocuk_nisan_2016.pdf, viewed August 11, 2017. The glorification of martyrdom in a publication explicitly directed at children and in a way that encouraged them to become martyrs was controversial for some sections of Turkish society: "Diyanet'in çocuk dergisi: 'Keşke ben de şehit olabilsem'" (Diyanet's Children's Magazine: "If Only I Could Also Be a Martyr"), *Milliyet*, March 30, 2016, www.milliyet.com.tr/diyanet-in-cocuk-dergisi-keske-gundem-2218307/, viewed August 11, 2017.

50. Daughter: "Keşke ben de şehit olabilseydim!" Son: "Sen askere gidemezsin ki!" Mother: "O kadar çok istersen, Allah sana o sevabı verecektir inşallah kızım." The article features several sayings of the Prophet in contextually relevant text balloons.

CHAPTER 8

1. Jacques Derrida (2006), *Specters of Marx: The State of the Debt, the Work of Mourning and the New International*, trans. Peggy Kamuf (London, Routledge): 111–112.

2. Benedict Anderson (2010), "Modulating the Excess of Affect: Morale in a State of 'Total War,'" in *The Affect Theory Reader*, ed. M. Gregg and G. J. Seigworth (Durham, Duke University Press): 161–185, p. 182.

3. For specific examples of how children stand in for adults in Iran, particularly in film, see B. Cardullo (2000), "Mirror Images, or Children of Paradise," *Hudson Review* 52 (4): 649–656.

4. Minoo Moallem (2014), "Aestheticizing Religion: Sensorial Visuality and Coffeehouse Painting in Iran," in *Sensational Religion: Sensory Cultures in Material Practice*, ed. Sally M. Promey (New Haven and London, Yale University Press): 297–320, pp. 298–299.

5. Monica Juneja has tried to demonstrate how artistic compositional factors such as the use of color and brush stroke play a greater role than facial expression in the depiction of emotion in early modern miniature paintings from South Asia. M. Juneja (2011), "Translating the Body into Image: The Body Politic and Visual Practice at the Mughal Court during the Sixteenth and Seventeenth Centuries," in *Images of the Body in India,* ed. Alex Michaels and Christof Wulf (New Delhi, Routledge): 235–260.

6. Christine R. Yano (2013), *Pink Globalization: Hello Kitty's Trek across the Pacific* (Durham, Duke University Press): 22.

7. Judith Butler (1993), *Bodies That Matter: On the Discursive Limits of "Sex"* (London, Routledge): 88–93.

Bibliography

Abu-Lughod, Lila. *Veiled Sentiments: Honor and Poetry in a Bedouin Society.* Berkeley: University of California Press, 1986.

Abu Nasr, Julinda. "The Arab World." In *International Companion Encyclopaedia of Children's Literature,* edited by Peter Hunt and Sheila Ray, 789–794. London: Routledge, 1996.

Agai, Bekim. "Islam and Education in Secular Turkey: State Policies and the Emergence of the Fethullah Gülen Group." In *Schooling Islam: The Culture and Politics of Modern Muslim Education,* edited by Robert W. Hefner and Muhammad Qasim Zaman, 149–171. Princeton: Princeton University Press, 2007.

Agathangelou, Anna M., and Kyle D. Killian. "(Neo) Zones of Violence: Reconstructing Empire on the Bodies of Militarized Youth." In *The Militarization of Childhood: Thinking beyond the Global South,* edited by J. Marshall Beier, 17–41. New York: Palgrave Macmillan, 2011.

Aghaie, Kamran Scot. "Gendered Aspects of the Emergence and Historical Development of Shi'i Symbols and Rituals." In *The Women of Karbala: Ritual Performance and Symbolic Discourses in Modern Shi'i Islam,* edited by Kamran Scot Aghaie, 1–21. Austin: University of Texas Press, 2005.

———. *The Martyrs of Karbala: Shi'i Symbols and Rituals in Modern Iran.* Publications on the Near East. Seattle and London: University of Washington Press, 2004.

Ahmed, Amineh. *Sorrow and Joy among Muslim Women: The Pukhtuns of Northern Pakistan.* University of Cambridge Oriental Publications 63. Cambridge: Cambridge University Press, 2006.

Ahmed, Sara. *Cultural Politics of Emotion.* 2nd ed. New York: Routledge, 2015.

———. "Happy Objects." In Gregg and Seigworth, *The Affect Theory Reader,* 29–51.

Al-Azhar University and UNICEF. *Children in Islam: Their Care, Upbringing and Protection.* Cairo: Al-Azhar University and UNICEF, 2005.

Ali, Kalbe. "NA Body Terms Minimum Marriage Age 'Un-Islamic.'" *Dawn,* January 15, 2016. www.dawn.com/news/1233131, viewed August 14, 2017.

Ali, Saleem H. "The All-Islamic Super-Heroes: Muslim Children Love 'The 99' Comics, but Hardliners Loathe Their Creator—Whose Trial for Heresy Is Looming." *Independent,* March 11, 2015. www.independent.co.uk/arts-entertainment/books/features/the-all-islamic-super-heroes-muslim-children-love-the-99-comics-but-hardliners-loathe-their-creator-10101891.html, viewed August 13, 2017.

———. "Madrasas and Violence: Is There a Connection?" In *Shaping a Nation: An Examination of Education in Pakistan,* edited by Stephen Lyon and Iain R. Edgar, 73–95. Oxford in Pakistan Readings in Sociology and Social Anthropology. Karachi: Oxford University Press, 2010.

Allison, Anne. *Millennial Monsters: Japanese Toys and the Global Imagination.* Berkeley: University of California Press, 2006.

———. "Portable Monsters and Commodity Cuteness: Pokemon as Japan's New Global Power." *Postcolonial Studies* 6:3 (2003): 381–395.

Altan, Özlem. "Turkey: Sanctifying a Secular State." In *Teaching Islam: Textbooks and Religion in the Middle East,* edited by Eleanor Abdella Doumato and Gregory Starrett, 197–214. Boulder: Lynne Rienner, 2007.

Anderson, Benedict. "Modulating the Excess of Affect: Morale in a State of 'Total War.'" In Gregg and Seigworth, *The Affect Theory Reader,* 161–185.

Andrabi, Tahir, Jishnu Das, et al. "Religious School Enrollment in Pakistan: A Look at the Data." *Comparative Education Review* 50:3 (2006): 446–477.

Appadurai, Arjun. "Introduction: Commodities and the Politics of Value." In Appadurai, *The Social Life of Things: Commodities in Cultural Perspective,* 3–63.

———, ed. *The Social Life of Things: Commodities in Cultural Perspective.* Cambridge: Cambridge University Press, 1986.

Ariès, Philippe. *Centuries of Childhood: A Social History of Family Life.* Translated by Robert Baldick. New York: Knopf, 1962.

Armstrong, Robert Plant. *The Power of Presence: Consciousness, Myth, and Affecting Presence.* Philadelphia: University of Pennsylvania Press, 1981.

Arslan, Savaş. "Projecting a Bridge for Youth: Islamic 'Enlightenment' versus Westernization in Turkish Cinema." In *Youth Culture in Global Cinema,* edited by Timothy Shary and Alexandra Seibel, 157–172. Austin: University of Texas Press, 2007.

'Asqalani, Ahmad ibn 'Ali ibn Hajar al-. *Tahdhīb al-tahdhīb.* 4 vols. Edited by Ibrahim al-Zaybaq et al. Beirut: Mu'assasat al-risāla, 1995.

"Author Looks to the Koran For 99 New Superheroes." *Washington Post,* June 11, 2004. www.washingtonpost.com/wp-dyn/content/article/2008/06/10/AR2008061002762.html, viewed August 13, 2017.

Bahar, 'Ali and Samiyeh Ramzanzadeh. *Khāṭirāt-i Bābā.* 2nd ed. Mashhad: Kongreh-i sardārān-i shahīd and Nashr-i Sitareh, 2007.

Bakhtiar, Mohsen. "Cognitive model of GHEIRAT in Persian." *Cognitive Linguistic Studies* 2:2 (2015): 257–288.

Bashkin, Orit. "Journeys between Civility and Wilderness: Debates on Civilization and Emotions in the Arab Middle East, 1861–1939." In *Civilizing Emotions: Concepts in Nineteenth-Century Asia and Europe,* edited by Margrit Pernau and Helge Jordheim et al., 126–145. Oxford: Oxford University Press, 2015.

Baudrillard, Jean. *The System of Objects.* Translated by James Benedict. 1996; London: Verso, 2005.

Baumgarten, Alexander Gottlieb. "Aesthetics and the Sublime." In *Art and Theory, 1648–1815: An Anthology of Changing Ideas,* edited by Charles Harrison, Paul Wood, and Jason Gaiger, 489–491. Malden, MA: Blackwell, 2000.

———. "Reflections on Poetry." In *Art and Theory, 1648–1815: An Anthology of Changing Ideas,* edited by Charles Harrison, Paul Wood, and Jason Gaiger, 487–489. Malden, MA: Blackwell, 2000.

Beeman, William O. "Emotion and Sincerity in Persian Discourse: Accomplishing the Representation of Inner States." *International Journal of the Sociology of Language* 148 (2001): 31–57.

Behrens-Abouseif, Doris. *Beauty in Arabic Culture.* Princeton Series on the Middle East. Princeton: Marcus Wiener, 1998.

Beier, J. Marshall, ed. *The Militarization of Childhood: Thinking Beyond the Global South.* New York: Palgrave Macmillan, 2011.

Bennet, Jane. *Vibrant Matter: A Political Ecology of Things.* Durham: Duke University Press, 2010.

Berger, Peter L. *The Sacred Canopy: Elements of a Sociology of Religion.* 1969; New York: Anchor, 1990.

Berlant, Lauren. "Cruel Optimism." In Gregg and Seigworth, *The Affect Theory Reader,* 93–117.

Bertelsen, Lone, and Andrew Murphie. "An Ethics of Everyday Infinities and Powers: Félix Guattari on Affect and the Refrain." In Gregg and Seigworth, *The Affect Theory Reader,* 138–157.

Bhalla, Nita. "Pakistan's Cartoon 'Burka Avenger' Swoops into India to Empower Girls." *Reuters,* April 14, 2015. www.reuters.com/article/us-india-women-entertainment-idUSKBN0N50ZU20150414, viewed August 13, 2017.

Bhatti, Khalid Mahmood, Qamar-un-Nisa, and Abdus Salam Asim. *Firūzsunz islāmiyāt, tīsrī jamā'at kē liyē* (Ferozsons Islamiyat for Class Three). Lahore: Ferozsons, 2001.

Bird, Jerine B. "Revolution for Children in Saudi Arabia." In *Children in the Muslim Middle East,* ed. E. W. Fernea, 276–294. Austin: University of Texas Press, 1995.

Boivin, Nicole. *Material Cultures, Material Minds: The Impact of Things on Human Thought, Society and Evolution.* 2008; Cambridge: Cambridge University Press, 2010.

Bombardier, Alice. "Iranian Mural Painting: New Trends." In *Cultural Revolution in Iran: Contemporary Popular Culture in the Islamic Republic,* edited by Annabelle Sreberny and Massoumeh Torfeh, 217–229. London: I. B. Taurus, 2013.

Born, Georgina. "Music: Ontology, Agency, Creativity." In Chua and Elliot, *Distributed Objects,* 130–154.

Bourdieu, Pierre. *Pascalian Meditations.* Translated by Richard Nice. Stanford: Stanford University Press, 2000.

Bozcan, Tuba. *Sevimli Tırtıl ile: Dinimin Değerlerini Öğreniyorum.* Istanbul: Damla Yayınevi, 2013.

Brennan, Teresa. *The Transmission of Affect.* Ithaca: Cornell University Press, 2004.

Brocklehurst, Helen. "Education and the War on Terror: The Early Years." In *The Militarization of Childhood: Thinking beyond the Global South,* edited by J. Marshall Beier, 77–94. New York: Palgrave Macmillan, 2011.

———. *Who's Afraid of Children? Children, Conflict and International Relations.* Aldershot, UK: Ashgate, 2006.

Brown, Bill. "Thing Theory." *Critical Inquiry* 28:1 (Autumn 2001): 1–22.

Brown, Ian. *Khomeini's Forgotten Sons: The Story of Iran's Boy Soldiers.* London: Grey Seal, 1990.

Brown, Steven D., and Ian Tucker. "Eff the Ineffable: Affect, Somatic Management, and Mental Health Service Users." In Gregg and Seigworth, *The Affect Theory Reader,* 229–249.

Brzozowska-Brywczyńska, Maja. "Monstrous/Cute: Notes on the Ambivalent Nature of Cuteness." In *Monsters and the Monstrous: Myths and Metaphors of Enduring Evil,* edited by Niall Scott, 213–228. Amsterdam and New York: Rodopi, 2007.

Burdelski, Matthew, and Koji Misuhashi. "'She Thinks You're Kawaii': Socializing Affect, Gender, and Relationships in a Japanese Preschool." *Language in Society* 39:1 (2010): 65–93.

Burke, Carolyn L., and Toby G. Copenhaver. "Animals as People in Children's Literature." *Language Arts* 81:3 (2004), *Explorations of Genre:* 205–213.

Butler, Judith. *Bodies That Matter: On the Discursive Limits of "Sex."* London: Routledge, 1993.

Butt, Hafiz M. Kamal, and Qamr-un-Nisa. *Firūzsunz islāmiyāt, pehlī jamāʿat kē liyē* (Ferozsons Islamiyat for Class One). Lahore: Ferozsons, 2001.

Butt, H. M. K., and Rehana Begum. *Firūzsunz islāmiyāt, dūsrī jamāʿat kē liyē* (Ferozsons Islamiyat for Class Two). Lahore: Ferozsons, 2001.

Bynum, Caroline Walker. "Wonder." *American Historical Review* 102:1 (February 1997): 1–26.

Cardullo, Bert. "Mirror Images, or Children of Paradise." *Hudson Review* 52:4 (Winter 2000): 649–656.

Çayır, Kenan. *Islamic Literature in Contemporary Turkey: From Epic to Novel.* New York: Palgrave Macmillan, 2007.

Cevik, Neslihan. *Muslimism in Turkey and Beyond: Religion in the Modern World.* New York: Palgrave Macmillan, 2016.

Chelkowski, Peter. "Iconography of the Women of Karbala: Tiles, Murals, Stamps, and Posters." In *The Women of Karbala: Ritual Performance and Symbolic Discourses in Modern Shiʿi Islam,* edited by Kamran Scot Aghaie, 119–138. Austin: University of Texas Press, 2005.

———. "In Ritual and Revolution: The Image in the Transformation of Iranian Culture." *Views* 10 (Spring 1989): 7–11.

———. "Iran: Mourning Becomes a Revolution." *Asia* 3:5 (May 1980): 30–37, 44–45.

———. *Ta'ziyeh: Ritual and Drama in Iran.* New York: New York University Press, 1979.

Chelkowski, Peter, and Hamid Dabashi. *Staging a Revolution: The Art of Persuasion in the Islamic Republic of Iran.* London: Booth-Clibborn, 2002.

Chilton, Bruce. *Abraham's Curse: The Roots of Violence in Judaism, Christianity and Islam.* New York: Doubleday, 2008.

Christensen, Aoife Ryan. "9 Artists Respond to the Death of Aylan Kurdi." *Evoke*, September 3, 2015. http://evoke.ie/news/9-artists-respond-to-the-death-of-aylan-kurdi-in-the-most-poignant-way, viewed August 4, 2017.

Chua, Liana, and Mark Elliot. "Adventures in the Art Nexus." In Chua and Elliot, *Distributed Objects*, 1–24.

———, eds. *Distributed Objects: Meaning and Mattering after Alfred Gell.* New York and Oxford: Berghahn, 2013.

Civil Law of the Islamic Republic of Iran (*Qānūn-i madanī*). §1.2.1041. Domestic Relations, Book VII: Marriage and Divorce. http://rc.majlis.ir/fa/law/show/92778, viewed August 14, 2017.

Cizre, Ümit, ed. *Secular and Islamic Politics in Turkey: The Making of the Justice and Development Party.* Routledge Studies in Middle Eastern Politics 6. London and New York: Routledge, 2008.

Clough, Patricia T. "The Affective Turn: Political Economy, Biomedia, and Bodies." In Gregg and Seigworth, *The Affect Theory Reader*, 206–225.

Çobanoğlu, Yavuz. *"Altın Nesil" 'in Peşinde: Fethullah Gülen'de Toplum, Devlet, Ahlak, Otorite.* Istanbul: İletişim Yayınları, 2012.

Cohen, Jeffrey Jerome, ed. *Monster Theory: Reading Culture.* Minneapolis: University of Minnesota Press, 1996.

Cook, Bradley J. "Islamic versus Western Conceptions of Education: Reflections on Egypt." *International Review of Education* 45:3 (1999): 339–357.

Damla, Nurdan. *Peygamberlerin Mucizeleri.* Istanbul: Nesil Çocuk, 2007.

Dartumiyan, Manizheh, and Tavus Siddiqi. *Sarbāz-i kūchūlū: majmū'a-yi shi'r-i kūdak.* 2003; Mashhad: Kongreh-i buzurgdāsht-i sardārān-i shahīd, 2005.

Davis, Joyce M. *Martyrs: Innocence, Vengeance, and Despair in the Middle East.* New York: Palgrave Macmillan, 2003.

Deeb, Mary-Jane. "The 99: Superhero Comic Books from the Arab World." *Comparative Studies of South Asia, Africa and the Middle East* 32:2 (2012): 391–401.

Delaney, Carol. *Abraham on Trial: The Social Legacy of Biblical Myth.* Princeton: Princeton University Press, 1998.

Demir, Ömer. "'Anadolu Sermayesi' ya da 'İslâmcı Sermaye.'" In *Modern Türkiye'de Siyasî Düşünce: İslâmcılık*, vol. 6, edited by Tanıl Bora and Murat Gültekingil, 870–886. Istanbul: İletişim Yayınları, 2011.

Derrida, Jacques. *The Gift of Death.* Translated by David Wills. Chicago: University of Chicago Press, 2007. 2nd edition published in 2008.

———. *Specters of Marx: The State of the Debt, the Work of Mourning and the New International.* Translated by Peggy Kamuf. London: Routledge, 2006.

Dhahabi, Shams al-din Muhammad ibn Ahmad al-. *Mīzān al-i'tidāl fī-naqd al-rijāl.* 8 vols. Edited by 'Ali Muhammad Mu'awwad et al. Beirut: Dār al-kutub al-'ilmiyya, 1995.

Doğan, A. Ekber. "Siyasal Yansımalarıyla İslamcı Sermayenin Gelişme Dinamikleri ve 28 Şubat Süreci." *Mülkiye Dergisi* 30:252 (2006): 47–68.

Doogan, Bailey. "Logo Girls." *Art Journal* 60:1 (Spring 2001): 98–101.

Doumato, Eleanor Abdella. "Manning the Barricades: Islam According to Saudi Arabia's School Texts." *Middle East Journal of Culture and Communication* 57:2 (2003): 230–247.

———. "Saudi Arabia: From 'Wahhabi' Roots to Contemporary Revisionism." In *Teaching Islam: Textbooks and Religion in the Middle East,* edited by E. A. Doumato and G. Starrett, 153–176. Boulder: Lynne Rienner, 2007.

Doumato, Eleanor Abdella, and Gregory Starret, eds. *Teaching Islam: Textbooks and Religion in the Middle East.* Boulder: Lynne Rienner, 2007.

Durmuş, Alpaslan, Dudu Ekinci and Hatice Işılak. *Ev Okulu, ilmihâl-2.* Istanbul: EDAM—Eğitim Danışmanlığı ve Araştırmaları Merkezi, 2008.

Ebadi, Shirin. *The Rights of the Child: A Study on Legal Aspects of Children's Rights in Iran.* Translated by M. Zaimaran. Tehran: UNICEF, 1994.

Elahi, Maryam. "The Rights of the Child under Islamic Law: Prohibition of the Child Soldier." *Columbia Human Rights Law Review* 19:2 (1988): 259–279. Abridged version in Fernea, *Children in the Muslim Middle East,* 367–374.

Elias, Jamal J. *Aisha's Cushion: Religious Art, Perception and Practice in Islam.* Cambridge, MA: Harvard University Press, 2012.

———. "Islam and the Devotional Image in Pakistan." In *Islam in South Asia in Practice,* edited by Barbara D. Metcalf, 120–134. Princeton: Princeton University Press, 2009.

———. "Mevlevi Sufis and the Representation of Emotion in the Arts of the Ottoman World." In *Emotion and Subjectivity in the Art and Architecture of Early Modern Muslim Empires,* edited by Kishwar Rizvi, 185–209. Leiden: Brill, 2017.

———. *On Wings of Diesel: Trucks, Identity and Culture in Pakistan.* Oxford: Oneworld, 2011.

Eligür, Banu. *The Mobilization of Political Islam in Turkey.* New York: Cambridge University Press, 2010.

Ellis, Alec. *A History of Children's Reading and Literature.* Oxford: Pergamon, 1969.

Emberly, Julia. "A Child Is Testifying: Testimony and the Cultural Construction of Childhood in a Trans/National Frame." *Journal of Postcolonial Writing* 45:4 (2009): 378–388.

Enderwitz, Susanne. "'The 99': Islamic Superheroes—a New Species?" In *Transcultural Turbulences: Towards a Multi-Sited Reading of Image Flows,* edited by C. Brosius and R. Wenzlhuemer, 83–95. Berlin and Heidelberg: Springer, 2011.

Esack, Farid. "Islam, Children, and Modernity: A Qur'anic Perspective." In *Children, Adults, and Shared Responsibilities: Jewish, Christian, and Muslim Perspectives,* edited by Marcia J. Bunge, 99–118. Cambridge: Cambridge University Press, 2012.

Evans, Janet, ed. *What's in a Picture? Responding to Illustrations in Picture Books*. London: Paul Chapman, 1998.

Evans, Rosalind. "The Impact of Concepts of Childhood on Children's Participation in Bhutanese Refugee Camps." *Children, Youth and Environments* 17:1 (2007), *Pushing the Boundaries: Critical International Perspectives on Child and Youth Participation—Focus on Southeast Asia, East Asia, the Pacific, South and Central Asia, and Japan*: 171–197.

Ewing, Katherine P. *Arguing Sainthood: Modernity, Psychoanalysis and Islam*. Durham: Duke University Press, 1997.

Farmer, H. G. "Al-Kindī on the 'Ethos' of Rhythm, Colour, and Perfume." In *Transactions of the Glasgow University Oriental Society, Years 1955 to 1956, in Honour of the Rev. James Robertson Buchanan*, vol. 16, edited by C. J. M. Weir. Hertford, 29–38. Glasgow: Stephen Austin and Sons for Glasgow University Oriental Society, 1957.

Federal Bureau of Statistics, Government of Pakistan, Population Census Organization. "50 Years Statistics, Section 11—Population." www.pbs.gov.pk/sites /default/files/50_years_statistics/vol1/11.pdf, viewed August 13, 2017.

Ferdows, Adele K. "Gender Roles in Iranian Public School Textbooks." In Fernea, *Children in the Muslim Middle East*, 325–336.

Fernea, Elizabeth Warnock, ed. "Childhood in the Muslim Middle East." In Fernea, *Children in the Muslim Middle East*, 3–16.

———. *Children in the Muslim Middle East*. Austin: University of Texas Press, 1995.

Fischer, Michael, and Mehdi Abedi. "Revolutionary Posters and Cultural Signs." *Middle East Report* 159 (July–August 1989), *Popular Culture*: 29–32.

Flaskerud, Ingvild. *Visualizing Belief and Piety in Iranian Shiism*. London: Continuum, 2012.

Flatley, Jonathan. *Affective Mapping: Melancholia and the Politics of Modernism*. Cambridge, MA: Harvard University Press, 2008.

Flood, Barry F. "Bodies and Becoming: Mimesis, Mediation, and the Ingestion of the Sacred in Christianity and Islam." In *Sensational Religion: Sensory Cultures in Material Practice*, edited by Sally M. Promey, 459–493. New Haven and London: Yale University Press, 2014.

Foran, Jessica E. "Interrogating 'Militarized' Images and Disrupting Sovereign Narratives in the Case of Omar Khadr." In *The Militarization of Childhood: Thinking beyond the Global South*, edited by J. Marshall Beier, 195–216. New York: Palgrave Macmillan, 2011.

Foucault, Michel. *Discipline and Punish: The Birth of the Prison*. London: Penguin, 1991.

Francois-Cerrah, Myriam. "The Truth about Muhammad and 'Aisha." *Guardian*, September 17, 2012. www.theguardian.com/commentisfree/belief/2012 /sep/17/muhammad-aisha-truth, viewed August 4, 2017.

Freedberg, David. "Memory in Art: History and the Neuroscience of Response." In *The Memory Process: Neuroscientific and Humanistic Perspectives*, edited by Suzanne Nalbantian, Paul M. Matthews, and James L. McClelland, 337–358. Cambridge, MA: MIT Press, 2011.

————. *The Power of Images: Studies in the History and Theory of Response.* Chicago: University of Chicago Press, 1991.

Freeman, Evelyn B. "Children's Books: Universals of Childhood." *Reading Teacher* 51:5 (February 1998): 426–433.

Frembgen, Jürgen Wasim. *The Friends of God: Sufi Saints in Islam, Popular Poster Art from Pakistan.* Karachi: Oxford University Press in cooperation with the Museum of Ethnology, Munich, 2006.

Freudenburg, Rachel. "Illustrating Childhood—'Hansel and Gretel.'" *Marvels & Tales* 12:2 (1998): 263–318.

Garro, Linda C. "Comment on William M. Reddy, *Against Constructionism: The Historical Ethnography of Emotions.*" *Current Anthropology* 38:3 (1997): 341–342.

Geijbels, M. "Aspects of the Veneration of Saints in Islam, with Special Reference to Pakistan." *Muslim World* 68:3 (1978): 176–186.

Gell, Alfred. *Art and Agency: An Anthropological Theory.* Oxford: Clarendon, 1998.

————. "The Network of Standard Stoppages." In Chua and Elliot, *Distributed Objects,* 88–89.

Gencer, Yasemin. "We Are Family: The Child and Modern Nationhood in Early Turkish Republican Cartoons." *Comparative Studies of South Asia, Africa and the Middle East* 32:2 (2012): 294–309.

Genette, Gérard. *Narrative Discourse: An Essay in Method.* Translated by Jane E. Lewin. Foreword by Jonathan Culler. Ithaca: Cornell University Press, 1990.

Ghazali, Abu Hamid al-. *The Alchemy of Happiness.* Translated by Claud Field. 1909; Lahore: Sh. Muhammad Ashraf, 1997.

————. *Iḥyā' 'ulūm al-dīn.* Edited by Badawi Tabana. 4 vols. 1957; Cairo: Dār iḥyā' al-kutub al-'arabiyya, 1985.

————. *Kīmiyā-yi sa'ādat.* Edited by Husayn Khadivjam. 1975; Tehran: Shirkat-i intishārat-i 'ilmi wa farhangi, 2001.

————. *Marriage and Sexuality in Islam: A Translation of al-Ghazzālī's Book on the Etiquette of Marriage from the Iḥyā'.* Translated by Madelain Farah. Salt Lake City: University of Utah Press, 1984.

Gibbs, Anna. "After Affect: Sympathy, Synchrony, and Mimetic Communication." In Gregg and Seigworth, *The Affect Theory Reader,* 186–205.

Gil'adi, Avner. *Children of Islam: Concepts of Childhood in Medieval Muslim Society.* Basingstoke and Oxford: St. Anthony's and Macmillan, 1992.

————. "Concepts of Childhood and Attitudes towards Children in Medieval Islam: A Preliminary Study with Special Reference to Reactions to Infant and Child Mortality." *Journal of the Economic and Social History of the Orient* 32:2 (1989): 121–152.

————. "Infants, Children and Death in Medieval Muslim Society: Some Preliminary Observations." *Social History of Medicine* 3:3 (1990): 345–368.

————. "Islamic Consolation Treatises for Bereaved Parents: Some Bibliographical Notes." *Studia Islamica* 81:1 (1995): 197–202.

————. "On the Origin of Two Key-Terms in al-Ġazzālī's Iḥyā' 'Ulūm al-Dīn." *Arabica* 36:1 (1989): 81–92.

————. "Sabr (Steadfastness) of Bereaved Parents: A Motif in Medieval Muslim Consolation Treatises and its Origins." *Jewish Quarterly Review*, New Series, 80:1–2 (1989): 35–48.

————. "Some Notes on *Tahnik* in Medieval Islam." *Journal of Near Eastern Studies* 47:3 (1988): 175–179.

Gilligan, Chris. "'Highly Vulnerable? Political Violence and the Social Construction of Traumatized Children." *Journal of Peace Research* 46:1 (2003): 119–134.

Golkar, Saied. *Captive Society: The Basij Militia and Social Control in Iran.* New York: Columbia University Press, 2015.

Granqvist, Hilma. *Birth and Childhood among the Arabs.* Helsingfors: Söderström, 1947.

Grant, Bruce. "New Moscow Monuments, or, States of Innocence." *American Ethnologist* 28:2 (2001): 332–362.

Gregg, Melissa, and Gregory J. Seigworth, eds. *The Affect Theory Reader.* Durham: Duke University Press, 2010.

Grima, Benedicte, *The Performance of Emotion among Paxtun Women: "The Misfortunes Which have Befallen Me."* Austin: University of Texas Press, 1992.

Grossberg, Lawrence. "Affect's Future: Rediscovering the Virtual in the Actual." In Gregg and Seigworth, *The Affect Theory Reader*, 289–308.

————. *We Gotta Get Out of the Place: Popular Conservatism and Postmodern Culture.* New York: Routledge, 1992.

Gruber, Christiane J. "Images of the Prophet Muhammad *in and out* of Modernity: The Curious Case of a 2008 Mural in Tehran." In *Visual Culture in the Modern Middle East: Rhetoric of the Image*, edited by Christiane J. Gruber and Haugbolle Sune, 2–31. Bloomington and Indianapolis: Indiana University Press, 2013.

————. "The Martyrs' Museum in Tehran: Visualizing Memory in Post-Revolutionary Iran." *Visual Anthropology* 25:1–2 (2012): 68–97.

————. "Media/Ting Conflict: Iranian Posters of the Iran-Iraq War." In *Crossing Cultures: Conflict, Migration and Convergence: Proceedings of the 32nd International Congress of the History of Art*, edited by Jaynie Anderson, 684–689. Melbourne: Melbourne University Press, 2009.

————. "The Message on the Wall: Mural Arts in Post-Revolutionary Iran." *Persica* 22 (2008): 15–46.

Halstead, J. Mark. "An Islamic Concept of Education." *Comparative Education* 40:4 (2004): 517–529.

Hanaway, William L. "The Symbolism of Persian Revolutionary Posters." In *Iran since the Revolution: Internal Dynamics, Regional Conflict, and the Superpowers*, edited by Barry M. Rosen, Brooklyn College Studies on Society in Change 47, 31–50. Boulder and New York: Social Science Monographs, distributed by Columbia University Press, 1985.

Hansen, Suzy. "Super Muslims." *Atlantic Monthly* (May 2010): 25–26.

Haque, Ziaul. "Muslim Religious Education in Indo-Pakistan." *Islamic Studies* 14:4 (1975): 271–292.

Harris, Daniel. "The Cute and the Anti-Cute." *Harper's Magazine* (July 1993): 26–28.

———. "Cuteness." *Salmagundi* 96 (Fall 1992): 177–186.

Hayashi, Akiko, Mayumi Karasawa, and Joseph Tobin. "The Japanese Pre-school's Pedagogy of Feeling: Cultural Strategies for Supporting Young Children's Emotional Development." *Ethos* 37:1 (2009): 32–49.

Heider, Karl G. *Landscapes of Emotion: Mapping Three Cultures of Emotion in Indonesia.* Cambridge: Cambridge University Press, 1991.

Heim, Maria. "Emotions." In *The Oxford History of Hinduism: Hindu Law,* edited by Patrick Olivelle and Donald R. Davis, Jr., 419-431. Oxford: Oxford University Press, 2018.

Hemmings, Claire, "Invoking Affect: Cultural Theory and the Ontological Turn." *Cultural Studies* 19:5 (2005): 548–567.

Hennessy, Rosemary. *Fires on the Border: The Passionate Politics of Labor Organizing on the Mexican Frontera.* Minneapolis: University of Minnesota Press, 2013.

Heo, Angie. "The Divine Touchability of Dreams." In *Sensational Religion: Sensory Cultures in Material Practice,* edited by Sally M. Promey, 435–440. New Haven and London: Yale University Press, 2014.

Higgins, Patricia J., and Pirouz Shoar-Ghaffari. "Changing Perceptions of Iranian Identity in Elementary Textbooks." In Fernea, *Children in the Muslim Middle East,* 337–363.

Highmore, Ben. "Bitter after Taste: Affect, Food and Social Aesthetics." In Gregg and Seigworth, *The Affect Theory Reader,* 118–137.

Higonnet, Anne. *Pictures of Innocence: The History and Crisis of Ideal Childhood.* Interplay: Theory Arts History. London: Thames and Hudson, 1998.

Hirsch, Eric. "Art, Performance and Time's Presence: Reflections on Temporality in *Art and Agency.*" In Chua and Elliot, *Distributed Objects,* 176–200.

Hodder, Ian. "This Is Not an Article about Material Culture as Text." *Journal of Anthropological Archaeology* 8:3 (1989): 250–269.

Holland, Patricia. *Picturing Childhood: The Myth of the Child in Popular Imagery.* New York: I. B. Taurus, 2004.

———. *What Is a Child? Popular Images of Childhood.* London: Virago, 1992.

Hoskisson, Kenneth, and Donald S. Biskin. "Analyzing and Discussing Children's Literature using Kohlberg's Stages of Moral Development." *Reading Teacher* 33:2 (November 1979): 141–147.

Hughes, Fergus P. *Children, Play and Development.* Boston: Allyn and Bacon, 1991.

Hunt, Peter. *An Introduction to Children's Literature.* Oxford: Oxford University Press, 1994.

Huthwaite, Motoko Fujishiro. "Japanese Values: A Thematic Analysis of Contemporary Children's Literature." *Japanese Journal of Religious Studies* 5:1 (1978): 59–74.

Ibn Miskawayh, Ahmad ibn Muhammad. *Tahdhīb al-akhlāq wa-taṭhīr al-aʿrāq.* Beirut: American University Beirut, 1966.

Ibn Qayyim al-Jawziyya, Muhammad ibn Abu Bakr. *Rawḍat al-muḥibbīn wa-nuzhat al-mushtāqīn.* Edited by Rabi Yusuf. Cairo: Dār al-Faruq, 2008.

———. *Ṭuḥfat al-mawdūd bi-aḥkām al-mawlūd*. Edited by ʻUthman ibn Jumʻa Dumayriyya. Riyadh: Dār ʻilm al-fawāʼid, 2010.

Ibn Sina, Abu ʻAli al-Husayn ibn ʻAli. *Al-Qanūn fī-al-ṭibb*. Edited by Idwar Alqish. 4 vols. Beirut: Muʼassasat ʻIzz al-Din, 1987.

İbrahimhakkıoğlu, Belkis, and Cem Kızıltuğ. *Hazreti Adem*. Peygamber Öyküleri. Istanbul: Timaş Çocuk, 2013.

———. *Hazreti İsa*. Peygamber Öyküleri. Istanbul: Timaş Çocuk, 2013.

Ibrahimi, Husayn, and Samiyeh Ramzanzadeh. *Kabūtarān-i bī ṣadā*. Mashhad: Kongreh-i sardārān-i shahīd and Nashr-i Sitareh, 2008.

İpek, Hatice, and Yaşar Fırat. "Peygamberimiz ve Küçük Ümmeti" (Our Prophet and the Community of Little Ones). *Diyanet Çocuk Dergisi* 429 (April 2016): 4–5. www2.diyanet.gov.tr/DiniYay%C4%B1nlarGenelMudurlugu /DergiDokumanlar/Cocuk/2016/cocuk_nisan_2016.pdf, viewed August 11, 2017.

Ishaq ibn Hunayn. "*Waṣiyyat Aflāṭūn fī-ta'dīb al-aḥdāth*." Edited by L. Cheikho. In *Maqālāt falsafiyya qadīma li-baʻḍ mashāhīr falāsifat al-ʻarab*, edited by L. Maʻluf et al., 52–58. Beirut: al-Maṭbaʻa al-Kāthūlīkiyya li-ābāʼi al-Yasūʼīn, 1911.

Jacobsen, Knut A. "The Child Manifestation of Śiva in Contemporary Hindu Prints." *Numen* 51:3 (2004): 237–264.

Jaggar, Alison M. "Love and Knowledge: Emotion in Feminist Epistemology." *Inquiry* 32:2 (1989): 151–176.

Jain, Kajri. *Gods in the Bazaar: The Economies of Indian Calendar Art*. Durham: Duke University Press, 2007.

Jalal, Ayesha. "Conjuring Pakistan: History as Official Imagining." *International Journal of Middle East Studies* 27:1 (1995): 73–89.

James, William. "What Is an Emotion?" *Mind* 9:34 (April 1957): 188–205.

Jansen, Marius B. "Education, Values and Politics in Japan." *Foreign Affairs* 35:4 (1957): 666–678.

Janson, Torsten. "Imaging Islamic Identity: Negotiating Norms of Representation in British-Muslim Picture Books." *Comparative Studies of South Asia, Africa and the Middle East* 32:2 (2012): 325–338.

Jay, Martin. "Scopic Regimes of Modernity." In *Vision and Visuality*, edited by Hal Foster, Dia Art Foundation Discussions in Contemporary Culture 2, 3–23. Seattle: Bay Press, 1988.

Jay, Nancy. *Throughout Your Generations Forever: Sacrifice, Religion, and Paternity*. Chicago: University of Chicago Press, 1992.

Jervis, John. *Sensational Subjects: The Dramatization of Experience in the Modern World*. London: Bloomsbury Academic, 2015.

Juneja, Monica. "Translating the Body into Image: The Body Politic and Visual Practice at the Mughal Court during the Sixteenth and Seventeenth Centuries." In *Images of the Body in India*, edited by Alex Michaels and Christof Wulf, 235–260. New Delhi: Routledge, 2011. Originally published in *Paragrana: Internationale Zeitschrift für Historische Anthropologie* 18:1 (2009): 243–266.

Kamp, Kathryn A. "Where Have All the Children Gone? The Archaeology of Childhood." *Journal of Archaeological Method and Theory* 8:1 (2001): 1–34.

Kandemir, M. Yaşar. "My Religion Series." Translated by Akilé Gürsoy. In Fernea, *Children in the Muslim Middle East,* 116–117.

Kaplan, Robert D. "Bloodbath in Iraq: The Ayatollah's Child Soldiers vs Saddam Hussein's Entrenched Army." *New Republic* (April 9, 1984): 21–23.

Kaplan, Sam. *The Pedagogical State: Education and the Politics of National Culture in Post-1980 Turkey.* Stanford: Stanford University Press, 2006.

Karimi, Pamela, and Christiane J. Gruber. "Introduction: The Politics and Poetics of the Child Image in Muslim Contexts." *Comparative Studies of South Asia, Africa and the Middle East* 32:2 (2012): 273–393.

Khosrokhavar, Farhad. *L'islam des Jeunes.* Paris: Flammarion, 1997.

Khosronejad, Pedram, ed. *The Art and Material Culture of Iranian Shi'ism: Iconography and Religious Devotion in Shi'i Islam.* Iran and the Persianate World. London and New York: I. B. Taurus in association with Iran Heritage Foundation, 2012.

———, ed. *Unburied Memories: The Politics of Bodies of Sacred Defense Martyrs in Iran.* London and New York: Routledge, 2013. Reprint of *Visual Anthropology* 25:1–2 (2012).

Kia, Mana. "Moral Refinement and Manhood in Persian." In *Civilizing Emotions: Concepts in Nineteenth-Century Asia and Europe,* edited by Margrit Pernau and Helge Jordheim et al., 146–165. Oxford: Oxford University Press, 2015.

Kinsella, Sharon. "Cuties in Japan." In *Women, Media and Consumption in Japan,* edited by Lise Skov and Brian Moeran, Consumasian Book Series, 220–254. Richmond, UK: Curzon, 1995.

Kocamaner, Hikmet. "The Rise of 'Islamic' Broadcasting in Turkey." *Immanent Frame* (August 31, 2010). https://tif.ssrc.org/2010/08/31/islamic-broadcasting-in-turkey/, viewed August 14, 2017.

Koçer, Hasan Ali. *Türkiye'de Modern Eğitim Doğuşu ve Gelişimi (1723–1923).* Araştırma-İnceleme Dizisi 16. Istanbul: Milli Eğitim Bakanlığı Yayınları, 1992.

Kohlberg, Lawrence, and Elliot Turiel. "Moral Development and Moral Education." In *Psychology and Educational Practice,* edited by Gerald S. Lesser, 410–465. Glenview, IL: Scott, Foresman, 1971.

Kövecses, Zoltán. *Metaphor and Emotion: Language, Culture and Body in Human Feeling.* Cambridge: Cambridge University Press, 2000.

Koven, Seth. "Remembering and Dismemberment: Crippled Children, Wounded Soldiers, and the Great War in Great Britain." *American Historical Review* 99:4 (1994): 1167–1202.

Kozma, Liat. "Girls, Labor, and Sex in Precolonial Egypt, 1850–1882." In *Girlhood: A Global History,* edited by Jennifer Helgren and Colleen A. Vasconcellos, Rutgers Series in Childhood Studies, 344–362. New Brunswick: Rutgers University Press, 2010.

Küchler, Susanne. "Threads of Thought: Reflections on *Art and Agency.*" In Chua and Elliot, *Distributed Objects,* 25–38.

Lakoff, George, and Zoltán Kövecses. "The Cognitive Model of Anger Inherent in American English." In *Cultural Models in Language and Thought,* edited by Dorothy Holland and Naomi Quinn, 195–221. Cambridge: Cambridge University Press, 1987.

Lal, Ruby. *Coming of Age in Nineteenth-Century India: The Girl-Child and the Art of Playfulness*. Cambridge: Cambridge University Press, 2013.

Lekesiz, Ömer. "İslam Türk Edebiyatı'nın Değişen Yüzü." In *Modern Türkiye'de Siyasî Düşünce: İslâmcılık*, vol. 6, edited by T. Bora and M. Gültekingil, 962–978. Istanbul: İletişim, 2011.

Lewis, David. *Reading Contemporary Picturebooks: Picturing Text*. London and New York: Routledge Falmer, 2001.

Leys, Ruth. "Affect and Intention: A Reply to William E. Connolly." *Critical Inquiry* 37:4 (2011): 799–805.

———. *From Guilt to Shame: Auschwitz and After*. Princeton: Princeton University Press, 2007.

———. "How Did Fear Become a Scientific Object and What Kind of Object Is It?" *Representations* 110 (Spring 2010): 66–104.

———. "The Turn to Affect: A Critique." *Critical Inquiry* 37:3 (2011): 434–472.

Liepert, David. "Rejecting the Myth of Sanctioned Child Marriage in Islam." *Huffington Post*, January 29, 2011. www.huffingtonpost.com/dr-david-liepert/islamic-pedophelia_b_814332.html, viewed August 14, 2017.

Limbert, Mandana. "Oman: Cultivating Good Citizens and Religious Virtue." In *Teaching Islam: Textbooks and Religion in the Middle East*, edited by Eleanor Abdella Doumato and Gregory Starrett, 103–124. Boulder: Lynne Rienner, 2007.

Lincoln, Bruce. *Abraham's Curse: Child Sacrifice in the Legacies of the West*. New York: Doubleday, 2008.

Lindholm, Charles. "Prophets and *Pirs*: Charismatic Islam in the Middle East and South Asia." In *Embodying Charisma: Modernity, Locality and the Performance of Emotion in Sufi Cults*, edited by P. Werbner and H. Basu, 209–233. London: Routledge, 1998.

Linton, Anna. "Accounts of Child Sacrifice in German Bibles for Children, 1600–1900." *Modern Language Review* 105:2 (2010): 455–478.

Lonbom, Kathleen C. "Drawing on Imagination: Children's Art in the Academic Library." *Art Documentation: Journal of the Art Libraries Society of North America* 29:1 (2010): 11–15.

Lubar, Steven, and W. David Kingery, eds. *History from Things: Essays on Material Culture*. Washington: Smithsonian Institution Press, 1993.

Luhrmann, T. M. *The Good Parsi: The Fate of a Colonial Elite in a Postcolonial Society*. Cambridge, MA: Harvard University Press, 1996.

Lutz, Catherine A. *Unnatural Emotions: Everyday Sentiments on a Micronesian Atoll and Their Challenge to Western Theory*. Chicago: University of Chicago Press, 1988.

MacDougall, David. *The Corporeal Image: Film, Ethnography, and the Senses*. Princeton: Princeton University Press, 2006.

Macmillan, Lorrain. "The Child Soldier in North-South Relations." *International Political Sociology* 3:1 (2009): 36–52.

Malekzadeh, Shervin. "Children without Childhood, Adults without Adulthood: Changing Conceptions of the Iranian Child in Postrevolutionary Iranian Textbooks (1979–2008)." *Comparative Studies of South Asia, Africa and the Middle East* 32:2 (2012): 339–360.

Marashi, Afshin. *Nationalizing Iran: Culture, Power, and the State, 1870–1940.* Seattle: University of Washington Press, 2008.

Marcus, Leonard S. *Ways of Telling: Conversations on the Art of the Picture Book.* New York: Dutton Children's Books, 2002.

Mardin, Şerif. *Religion, Society and Modernity in Turkey.* Syracuse: Syracuse University Press, 2006.

Marinis, Vasileios. "Piety, Barbarism, and the Senses in Byzantium." In *Sensational Religion: Sensory Cultures in Material Practice,* edited by Sally M. Promey, 321–340. New Haven and London: Yale University Press, 2014.

Marzolph, Ulrich. "The Martyr's Fading Body: Propaganda vs. Beautification in the Tehran Cityscape." In *Visual Culture in the Modern Middle East: Rhetoric of the Image,* edited by Christiane J. Gruber and Haugbolle Sune, 164–185. Bloomington and Indianapolis: Indiana University Press, 2013.

Massumi, Brian. "The Autonomy of Affect." *Cultural Critique* 31 (Autumn 1995), *The Politics of Systems and Environments, Part II:* 83–109.

———. "The Future Birth of the Affective Fact: The Political Ontology of Threat." In Gregg and Seigworth, *The Affect Theory Reader,* 52–70.

———. "Introduction: Like a Thought." In *A Shock to Thought: Expression after Deleuze and Guattari,* edited by B. Massumi, xii–xxxix. London: Routledge, 2002.

———. *Parables for the Virtual: Movement, Affect, Sensation.* Durham: Duke University Press, 2002.

Masud, Muhammad Khalid. "Religious Identity and Mass Education." In *Islam in the Era of Globalization: Muslim Attitudes towards Modernity and Identity,* edited by Johan Meuleman, 233–245. London and New York: Routledge Curzon, 2002.

Matini, Jalal. "The Impact of the Iranian Revolution on Education in Iran." In *At the Crossroads: Education in the Middle East,* edited by A. Badran, 43–55. New York: Paragon House, 1989.

McLelland, Mark. "(A)Cute Confusion: The Unpredictable Journey of Japanese Popular Culture." *Intersections: Gender and Sexuality in Asia and the Pacific* 20 (April 2009). http://intersections.anu.edu.au/issue20/mclelland .htm, viewed August 14, 2017.

M'Daghri, Muhammad Abdelkebir Alaoui. "The Code of Children's Rights in Islam." Translated by Moncef Lahlou. In Fernea, *Children in the Muslim Middle East,* 30–41.

Mdallel, Sabeur. "The Sociology of Children's Literature in the Arab World." *Looking Glass: New Perspectives on Children's Literature* 8:2 (2004). www .lib.latrobe.edu.au/ojs/index.php/tlg/article/view/177/176, viewed August 14, 2017.

———. "Translating Children's Literature in the Arab World: The State of the Art." *Meta: Journal des Traducteurs* 48:1–2 (2003): 298–306.

Mehran, Golnar. "Iran: A Shi'ite Curriculum to Serve the Islamic State." In *Teaching Islam: Textbooks and Religion in the Middle East,* edited by Eleanor Abdella Doumato and Gregory Starrett, 53–70. Boulder: Lynne Rienner, 2007.

———. "Socialization of Schoolchildren in the Islamic Republic of Iran." *Iranian Studies* 22:1 (1989): 35–50.

Merleau-Ponty, Maurice. *Phenomenology of Perception.* Translated by Colin Smith. London and New York: Routledge, 1962.

Metcalf, Barbara D. "'Traditionalist' Islamic Activism: Deoband, Tablighis, and Talibs." *ISIM Paper No. 4,* Leiden, ISIM, 2002. https://openaccess .leidenuniv.nl/handle/1887/10068, viewed August 14, 2017.

Mitchell, W. J. T. *Iconology: Image, Text, Ideology.* Chicago: University of Chicago Press, 1986.

Mizerski, Richard. "The Relationship between Cartoon Trade Character Recognition and Attitude toward Product Category in Young Children." *Journal of Marketing* 59:4 (1995): 58–70.

Moallem, Minoo. "Aestheticizing Religion: Sensorial Visuality and Coffeehouse Painting in Iran." In *Sensational Religion: Sensory Cultures in Material Practice,* edited by Sally M. Promey, 297–320. New Haven and London: Yale University Press, 2014.

———. *Between Warrior Brother and Veiled Sister: Islamic Fundamentalism and the Politics of Patriarchy in Iran.* Berkeley: University of California Press, 2005.

Moosa, Ebrahim. "Children's Rights in Modern Islamic and International Law: Changes in Muslim Moral Imaginaries." In *Children, Adults, and Shared Responsibilities: Jewish, Christian, and Muslim Perspectives,* edited by Marcia J. Bunge, 292–308. Cambridge: Cambridge University Press, 2012.

Morgan, David. *The Embodied Eye: Religious Visual Culture and the Social Life of Feeling.* Berkeley: University of California Press, 2012.

———. *Visual Piety: A History and Theory of Popular Religious Images.* Berkeley: University of California Press, 1998.

Moriarty, Sandra E. "Abduction: A Theory of Visual Interpretation." *Communication Theory* 6:2 (1996): 167–187.

Morrison, Heidi. *Childhood and Colonial Modernity in Egypt.* Houndsmills, Basingstoke, Hampshire, UK: Palgrave Macmillan, 2015.

Mosaffa, Nasrin. "Does the Covenant of the Rights of the Child in Islam Provide Adequate Protection for Children Affected by Armed Conflicts?" *Muslim World Journal of Human Rights* 8:1 (2007): 1–19.

Muhammad, Peer. "Marital Matters: Underage Marriage (Nikkah [sic]) not un-Islamic: CII." *Express Tribune,* March 12, 2014. http://tribune.com.pk /story/681784/marital-matters-underage-marriage-nikkah-not-un-islamic-cii/, viewed August 14, 2017.

Najjarian, Hamideh, and Iman Nasirian. *Qulak-i sifālī.* Mashhad: Kongreh-i sardārān-i shahīd and Intishārāt-i Sitareh, 2009.

Nalbant, Mehmet, and Betül Aytaç. *Kurban Öyküsü, Hz. İbrahim.* 2nd ed. Istanbul: Semerkend, Mavi Ucurtma Series, 2006.

Naseem, M. Ayaz. "Textbooks and the Construction of Militarism in Pakistan." In *Shaping a Nation: An Examination of Education in Pakistan,* edited by Stephen Lyon and Iain R. Edgar, Oxford in Pakistan Readings in Sociology and Social Anthropology, 148–157. Karachi: Oxford University Press, 2010.

National Commission on Terrorist Attacks upon the United States, *The 9/11 Commission Report.* New York: W. W. Norton, 2004.

Nelson, Sara C. "Charlie Hebdo Reopens Freedom of Speech Debate with Cartoons Depicting Death of Aylan Kurdi." *Huffington Post (UK)*, September 14, 2015. www.huffingtonpost.co.uk/2015/09/14/charlie-hebdo-reopens-freedom-speech-debate-cartoons-depicting-death-aylan-kurdi-_n_8133118.html, viewed August 4, 2017.

New Hampshire Statues and Codes. §457:4. Domestic Relations. Title XLIII: Marriages. www.gencourt.state.nh.us/rsa/html/xliii/457/457-mrg.htm, viewed August 14, 2017.

Ngai, Sianne. *Ugly Feelings*. Cambridge, MA: Harvard University Press, 2005.

Niiniluoto, Ilkka. "Structural Rules for Abduction." *Theoria: An International Journal for Theory, History and Foundations of Science* 20:3 (2007): 325–329.

Nikolajeva, Maria. *Children's Literature Comes of Age: Toward a New Aesthetic*. New York and London: Garland, 1996.

Nittoni, H., M. Fukushima, A. Yano, and H. Moriya. "The Power of *Kawaii*: Viewing Cute Images Promotes a Careful Behavior and Narrows Attentional Focus." *PLUS ONE* 7:9 (September 2012): 1–7.

Nyazee, Imran Ahsan. "Islamic Law and the CRC (Conventions on the Rights of the Child)." *Islamabad Law Review* 1:1–2 (2003): 65–121.

Öçal, Devran Koray. "The Development and Transformation of the Islamic Publishing Field: The Cases of Nesil and Timaş." MA thesis, Department of Political Science, İstanbul Teknik Üniversitesi, Istanbul, 2013.

Okazaki, Manami, and Geoff Johnson. *Kawaii! Japan's Culture of Cute*. Munich: Prestel, 2013.

Oncu, Elif Celebi, and Aysegul Metindogan Wise. "The Effects of the 1999 Turkish Earthquake on Young Children: Analyzing Traumatized Children's Completion of Short Stories." *Child Development* 81:4 (2010): 1161–1175.

Onur, Bekir. *Dünyada ve Türkiye'de Değişen Çocukluk* (Changing Childhood in the World and in Turkey). III. Ulusal Çocuk Kültürü Kongresi Bildirileri, October 16–18, 2000. Ankara: Ankara Üniversitesi Basımevi, 2001.

op de Beeck, Nathalie. *Suspended Animation: Children's Picture Books and the Fairy Tale of Modernity*. Minneapolis: University of Minnesota Press, 2010.

Organization of the Islamic Conference. Cairo Declaration on Human Rights in Islam (CDHRI). Cairo, 5 August 1990. http://hrlibrary.umn.edu/instree/cairodeclaration.html, viewed August 5, 2017.

———. "Covenant on the Rights of the Child." 2004. www.oic-iphrc.org/en/data/docs/legal_instruments/OIC%20Instruments/OIC%20Covenant%20on%20the%20Right%20of%20the%20Child/OIC%20Convention-%20Rights%20of%20the%20Child%20In%20Islam%20-%20EV.pdf, viewed August 5, 2017.

Orsi, Robert A. *Between Heaven and Earth: The Religious Worlds People Make and the Scholars Who Study Them*. Princeton: Princeton University Press, 2006.

Pedersen, Jon, and Tone Sommerfelt. "Studying Children in Armed Conflict: Data Production, Social Indicators and Analysis." *Social Indicators Research* 84:2 (2007): 251–269.

Peppers, Margot. "'70 is the new 50!' Martha Stewart on Aging Gracefully and 'Maintaining a Tiny Waist.'" *Daily Mail*, April 29, 2013. www.dailymail

.co.uk/femail/article-2316769/70-new-50-Martha-Stewart-aging-gracefully-maintaining-tiny-waist.html, viewed August 5, 2017.

Pernau, Margrit, Helge Jordheim et al., eds. *Civilising Emotions: Concepts in Nineteenth-Century Asia and Europe.* Oxford: Oxford University Press, 2015.

Pinney, Christopher. *"Photos of the Gods": The Printed Image and Political Struggle in India.* London: Reaktion, 2004.

———. "What's Photography Got to Do with It?" In *Photography's Orientalism: New Essays on Colonial Representation,* edited by Ali Behdad and Luke Gartlan, Getty Research Institute: Issues & Debates, 33–52. Los Angeles: Getty Research Institute, 2013.

Plamper, Jan. *The History of Emotions: An Introduction.* Translated by Keith Tribe. Emotions in History. Oxford: Oxford University Press, 2015.

Pontifical Commission for the Vatican State. §Law N. VIII (passed July 2013). Supplementary Norms on Criminal Law Matters. www.vaticanstate.va/content/dam/vaticanstate/documenti/leggi-e-decreti/Normative-Penali-e-Amministrative/Law%20N.%20VIII%20-%20Supplementary%20Norms%20on%20Criminal%20Law.pdf, viewed August 14, 2017.

Postrel, Virginia. *The Substance of Style: How the Rise of Aesthetic Value Is Remaking Commerce, Culture, and Consciousness.* New York: HarperCollins, 2003.

Powell, Larry, and William R. Self. *Holy Murder: Abraham, Isaac, and the Rhetoric of Sacrifice.* Lanham, MA: University Press of America, 2007.

Price, Anthony W. "Emotions in Plato and Aristotle." In *The Oxford Handbook of Philosophy and Emotion,* edited by Peter Goldie, 121–142. Oxford: Oxford University Press, 2009.

Probyn, Elspeth. "Writing Shame." In Gregg and Seigworth, *The Affect Theory Reader,* 71–90.

Prokop, Michaela. "Saudi Arabia: The Politics of Education." *International Affairs* 79:1 (2003): 77–89.

Promey, Sally M. "Religion, Sensation, and Materiality: An Introduction." In *Sensational Religion: Sensory Cultures in Material Practice,* edited by Sally M. Promey, 1–21. New Haven and London: Yale University Press, 2014.

———. "The 'Return' of Religion in the Scholarship of American Art." *Art Bulletin* 85:3 (2003): 581–603.

———, ed. *Sensational Religion: Sensory Cultures in Material Practice.* New Haven and London: Yale University Press, 2014.

Prout, Alan, and Allison James. "A New Paradigm for the Sociology of Childhood? Provenance, Promise and Problems." In *Constructing and Reconstructing Childhood: Contemporary Issues in the Sociological Study of Childhood,* edited by A. James and A. Prout, 7–33. London and New York: Routledge Falmer, 1997.

Qureshi, Rashida, and Jane F. A. Rarieya, eds. *Gender and Education in Pakistan.* Karachi: Oxford University Press, 2007.

Rahman, Tariq. *Denizens of Alien Worlds: A Study of Education, Inequality and Polarization in Pakistan.* Karachi: Oxford University Press, 2004.

———. *Language, Ideology and Power: Language-Learning among the Muslims of Pakistan and North India*. Karachi: Oxford University Press, 2002.

Rajabi-Ardashiri, Masoud. "Children and Conflict: Exploring Children's Agency at UK Mosque Schools." *International Journal of Children's Rights* 19:4 (2011): 691–704.

———. "The Rights of the Child in the Islamic Context: The Challenges of the Local and the Global." *International Journal of Children's Rights* 17:3 (2009): 475–489.

Rajai, Raziyeh, 'Ali Daudi and Mahdi Badiyeh-Payma. Alif Alif Āsemūm-1. Mashhad: Nashr-i Sitareh, 2009.

Rajai, Raziyeh, and Samiyeh Ramzanzadeh. *Qāb-i 'aks* (Picture Frame). Mashhad: Kongreh-i sardārān-i shahīd and Nashr-i Sitareh, 2011.

Ram, Haggay. "The Immemorial Iranian Nation? School Textbooks and Historical Memory in Post-Revolutionary Iran." *Nations and Nationalism: Journal of the Association for the Study of Ethnicity and Nationalism* 6:1 (2000): 68–90.

Rashid, Ahmed. *Taliban: Militant Islam, Oil and Fundamentalism in Central Asia*. New Haven: Yale University Press, 2000.

Rauh, Elizabeth L. "Thirty Years Later: Iranian Visual Culture from the 1979 Revolution to the 2009 Presidential Protests." *International Journal of Communication* 7 (2013): 1316–1343.

Razai, Muhammad. *Tahlīlī az zindagī-yi rūzmarreh-i dānish āmūzishī: nāsāzehā-yi guftemān-i madraseh*. Tehran: Mu'assaseh-i bayn ul-millalī-yi pazhūheshī-yi farhangi wa hunarī, 2008.

Razai, Rahmatullah, and Bahnush Zamani. *Bābāmo tū nadīdī?* 2nd ed. Mashhad: Kongreh-i sardārān-i shahīd and Nashr-i Sitareh, 2007.

Reddy, William M. "Against Constructionism: The Historical Ethnography of Emotions." *Current Anthropology* 38:3 (1997): 327–351.

———. *The Navigation of Feeling*. Cambridge: Cambridge University Press, 2001.

Reider, Noriko T. "Transformation of the Oni: From the Frightening and Diabolical to the Cute and Sexy." *Asian Folklore Studies* 62:1 (2003): 133–157.

Reinelt, Janelle G., and Joseph R. Roach, eds. *Critical Theory and Performance*. 2007; Ann Arbor: University of Michigan Press, 2010.

Reynolds, Kimberly. "Words about War for Boys: Representations of Soldiers and Conflict in Writing for Children before World War I." *Children's Literature Association Quarterly* 34:3 (2009): 255–271.

Richard, Frances. "Fifteen Theses on the Cute." *Cabinet* 4 (Fall 2001), *Animals*. www.cabinetmagazine.org/issues/4/cute.php, viewed August 7, 2017.

Ridley, Louise. "Aylan Kurdi, Drowned Syrian 3-Year-Old, Mourned with Poignant Cartoons Using 'Humanity Washed Ashore' Hashtag." *Huffington Post (UK)*, September 3, 2015. www.huffingtonpost.co.uk/2015/09/03 /aylan-kurdi-drowned-syrian-boy-turkey-cartoons_n_8081458.html, viewed August 4, 2017.

Ringer, Monica M. *Education, Religion, and the Discourse of Cultural Reform in Qajar Iran*. Costa Mesa: Mazda, 2001.

Rispler-Chaim, Vardit. *Disability in Islamic Law*. Edited by Law International Library of Ethics, and the New Medicine. Dordrecht: Springer, 2007.

Romero-Jódar, Andrés. "Comic Books and Graphic Novels in their Generic Context: Towards a Definition and Classification of Narrative Iconical Texts." *Atlantis* 35:1 (2013): 117–135.

Rosaldo, Michelle Z. *Knowledge and Passion: Ilongot Notions of Self and Social Life.* New York: Cambridge University Press, 1989.

———. "Toward an Anthropology of Self and Feeling." In *Culture Theory: Essays on Mind, Self, and Emotion,* edited by Richard A. Schweder and Robert A. LeVine. New York: Cambridge University Press, 1984.

Rose, Gillian. *Visual Methodologies: An Introduction to the Interpretation of Visual Materials.* 3rd ed. London: Sage, 2012.

Rosenwein, Barbara. Review of William M. Reddy, *The Navigation of Feeling. American Historical Review* 107:4 (2002): 1181–1182.

Ruddick, Sue. "The Politics of Aging: Globalization and the Restructuring of Youth and Childhood." *Antipode* 35:2 (2003): 334–362.

Ruri, Abe. "Media, Islam and Gender in Turkey." *Kyoto Bulletin of Islamic Area Studies* 5:1–2 (2012): 38–46.

Sachau, Edward C. *Alberuni's India.* Elibron Classics. 1888; Boston: Adamant Media, 2005.

Saktanber, Ayşe. "'We Pray Like You Have Fun': New Islamic Youth in Turkey between Intellectualism and Popular Culture." In *Fragments of Culture: The Everyday of Modern Turkey,* edited by Deniz Kandiyoti and Ayşe Saktanber, 254–276. New Brunswick, NJ: Rutgers University Press, 2002.

Salih, Subhi al-. *Ma'ālim al-sharī'a.* Beirut: Dār al-kutub al-milāiyyīn, 1975.

Santaella, Lucia. "Abduction: The Logic of Guessing." *Semiotica* 153:1–4 (2005): 175–198.

Sanyal, Usha. *Ahmad Riza Khan Barelwi: In the Path of the Prophet.* Oxford: Oneworld, 2005.

———. *Devotional Islam and Politics in British India: Ahmad Riza Khan Barelwi and His Movement, 1870–1920.* New York and Delhi: Oxford University Press, 1999.

Sayfan, Liat, and K.H. Lagattuta. "Grownups Are Not Afraid of Scary Stuff, but Kids Are: Young Children's and Adults' Reasoning about Children's, Infants', and Adults' Fears." *Child Development* 79:4 (2008): 821–835.

———. "Scaring the Monster Away: What Children Know about Managing Fears of Real and Imaginary Creatures." *Child Development* 80:6 (2009): 1756–1774.

Schaefer, Donovan O. *Religious Affects: Animality, Evolution and Power.* Durham: Duke University Press, 2015.

Scheer, Monique. "Are Emotions a Kind of Practice (and Is That What Makes Them Have a History? A Bourdieuan Approach to Understanding Emotion." *History and Theory* 51:2 (2012): 193–220.

Schwenger, Peter. *The Tears of Things: Melancholy and Physical Objects.* Minneapolis and London: University of Minnesota Press, 2006.

Scott, David, and Charles Hirschkind, eds. *Powers of the Secular Modern: Talal Asad and His Interlocutors.* Stanford: Stanford University Press, 2006.

Scott, Niall, ed. *Monsters and the Monstrous: Myths and Metaphors of Enduring Evil.* Amsterdam and New York: Rodopi, 2007.

Sedgwick, Eve K., and Adam Frank. "Shame in the Cybernetic Fold: Reading Silvan Tomkins." *Critical Inquiry* 21:2 (1995): 496–522.

Seigworth, Gregory J., and Melissa Gregg. "An Inventory of Shimmers." In Gregg and Seigworth, *The Affect Theory Reader*, 1–25.

Serajiantehrani, Maryam. "Children's Literature: Effective Means of Islamic Education in Iran." In *Reforms in Islamic Education: International Perspectives*, edited by C. Tan, 231–243. London: Bloomsbury, 2014.

Shahar, Shulamith. *Childhood in the Middle Ages*. London and New York: Routledge, 1990.

Shaikh, Farzana. *Making Sense of Pakistan*. New York: Columbia University Press, 2009.

Shakry, Omnia. "Schooled Mothers and Structured Play: Child Rearing in Turn-of-the-Century Egypt." In *Remaking Women: Feminism and Modernity in the Middle East*, edited by Lila Abu-Lughod, 126–170. Princeton: Princeton University Press, 1998.

Shalem, Avinoam. "Histories of Belonging and George Kubler's Prime Object." *Getty Research Journal* 3 (2011): 1–14.

Shaviro, Steven. *Post-Cinematic Affect*. Winchester: Zero, 2010.

Sherif, Mohamed Ahmed. *Ghazali's Theory of Virtue*. Studies in Islamic Philosophy and Science. Albany: State University of New York Press, 1975.

Shirazi, Faegheh. "The Islamic Republic of Iran and Women's Images: Masters of Exploitation." In *Muslim Women in War and Crisis: Representation and Reality*, edited by Faegheh Shirazi, 109–138. Austin: University of Texas Press, 2010.

Shorish, M. Mobin. "The Islamic Revolution and Education in Iran." *Comparative Education Review* 32:1 (1988): 58–75.

Shouse, Eric. "Feeling, Emotion, Affect." *M/C Journal* 8:6 (2005). http://journal.media-culture.org.au/0512/03-shouse.php, viewed August 14, 2017.

Šisler, Vit. "Digital Heroes: Identity Construction in Iranian Video Games." In *Cultural Revolution in Iran: Contemporary Popular Culture in the Islamic Republic*, edited by Annabelle Sreberny and Massoumeh Torfeh, 171–191. London: I. B. Taurus, 2013.

Spinoza, Benedict. *Ethics; On the Correction of Understanding*. Translated by Andrew Boyle. London: Everyman's Library, 1959.

Sreberny, Annabelle, and Massoumeh Torfeh, eds. *Cultural Revolution in Iran: Contemporary Popular Culture in the Islamic Republic*. London: I. B. Taurus, 2013.

Starks, Brian, and Robert V. Robinson. "Who Values the Obedient Child Now? The Religious Factor in Adult Values for Children, 1986–2002." *Social Forces* 84:1 (2005): 343–359.

Starrett, Gregory. "The Margins of Print: Children's Religious Literature in Egypt." *Journal of the Royal Anthropological Institute* 2:1 (1996): 117–139.

———. *Putting Islam to Work: Education, Politics, and Religious Transformation in Egypt*. Comparative Studies on Muslim Societies. Berkeley: University of California Press, 1998.

Stearns, Peter N. *Childhood in World History*. Themes in World History. New York: Routledge, 2006.

Stokrocki, Mary, and Olcay Kirisoglu. "An Exploratory Microethnographic Study of a Secondary Art Lesson on Miniature Painting in Turkey." *Visual Arts Research* 26:2 (2000): 51–62.

Subaşı, N. "1960 Öncesi İslam Neşriyat: Sindirilme, Tahayyül ve Tefekkür." In *Modern Türkiye'de Siyasî Düşünce: İslâmcılık*, vol. 6, edited by T. Bora and M. Gültekingil, 217–235. Istanbul: İletişim Yayınları, 2011.

Szanto, Edith. "Illustrating an Islamic Childhood in Syria: Pious Subjects and Religious Authority in Twelver Shi'i Children's Books." *Comparative Studies of South Asia, Africa and the Middle East* 32:2 (2012): 361–393.

Taleqani, Mahmud, Murtada Mutahhari, and Ali Shari'ati. *Jihād and Shahādat: Struggle and Martyrdom in Islam*, ed. Mehdi Abedi and Gary Legenhausen. North Haledon, NJ: Islamic Publications International, 2005.

Tan, Charlene, ed. *Reforms in Islamic Education: International Perspectives*. London: Bloomsbury, 2014.

Tanner, Jeremy. "Figuring Out Death: Sculpture and Agency at the Mausoleum of Halicarnassus and the Tomb of the First Emperor of China." In Chua and Elliot, *Distributed Objects*, 58–87.

Thanwi, Ashraf 'Ali. *Ādāb-i zindagī*. Karachi: Dār al-ishā'at, 1971.

Thomas, Jolyon Baraka. *Drawing on Tradition: Manga, Anime, and Religion in Contemporary Japan*. Honolulu: University of Hawai'i Press, 2012.

Thrift, Nigel. "Understanding the Material Practices of Glamour." In Gregg and Seigworth, *The Affect Theory Reader*, 289–308.

Tiercelin, Claudine. "Abduction and the Semiotics of Perception." *Semiotica* 153:1–4 (2005): 389–412.

Tilley, Christopher. *Material Culture and Text: The Art of Ambiguity*. London: Routledge, 1991.

Tompkins, Silvan Soloman. *Affect, Imagery, Consciousness: The Complete Edition*. New York: Springer, 2008.

Torab, Azam. *Performing Islam: Gender and Ritual in Islam*. Middle East and the Islamic World, no. 4. Leiden: Brill, 2007.

Turrisi, Patricia. "The Abduction in Deduction and the Deduction in Abduction: Remarks on Mixed Reasonings." *Semiotica* 153:1–4 (2005): 309–323.

UNESCO (United Nations Educational, Scientific and Cultural Organization). Global Education Monitoring Report. *Education for People and Planet: Creating Sustainable Futures for All*. Paris: UNESCO, 2016. http://unesdoc .unesco.org/images/0024/002457/245752e.pdf, viewed August 13, 2017.

US Department of State. "The Facts on Child Soldiers and the CSPA." *Humanrights.Gov*. US Department of State, Washington, DC, November 26, 2014. www.humanrights.gov/the-facts-on-child-soldiers-and-the-cspa.html, viewed April 15, 2017.

———. "Trafficking in Persons Report—Child Soldiers Prevention Act List." US Department of State, Washington, DC, July 2015. www.state.gov/j/tip /rls/tiprpt/2015/245236.htm, viewed August 13, 2017.

Uysal, Mürşide. *Peygamberimizin Hayatı, 1: Hz. Muhammed'in Doğumu.* Istanbul: Uysal Yayınevi, n.d.

Van Sledright, Bruce, and Jere Brophy. "Storytelling, Imagination, and Fanciful Elaboration in Children's Historical Reconstructions." *American Educational Research Journal* 29:4 (1992): 837–859.

Varzi, Roxanne. "Iran's Pieta: Motherhood, Sacrifice and Film in the Aftermath of the Iran-Iraq War." *Feminist Review* 88 (2008), War: 86–98.

Villeminot, Florence. "Muslims Fighting Evil." *Newsweek,* February 26, 2007, https://wwrn.org/articles/24335/, viewed August 3, 2017.

Vincent, J. Keith. "Shame Now: Ruth Leys Diagnoses the New Queer Shame Culture." *Criticism* 54:4 (2012): article 6, http://digitalcommons.wayne.edu/criticism/vol54/iss4/6, viewed August 12, 2017.

Watkins, Megan. "Desiring Recognition, Accumulating Affect." In Gregg and Seigworth, *The Affect Theory Reader,* 269–285.

Watson, Alison M. S. *The Child in International Political Economy: A Place at the Table.* Abingdon: Routledge, 2009.

Wessels, Michael. *Child Soldiers: From Violence to Protection.* Cambridge, MA: Harvard University Press, 2006.

Wierzbicka, Anna. *Emotions across Languages and Cultures: Diversity and Universals.* Cambridge: Cambridge University Press, 1999.

Wigen, Einar. "The Education of Ottoman Man and the Practice of Orderliness." In *Civilizing Emotions: Concepts in Nineteenth-Century Asia and Europe,* edited by Margrit Pernau and Helge Jordheim et al., 107–125. Oxford: Oxford University Press, 2015.

Williams, Michael A., ed. *Charisma and Sacred Biography.* Journal of the American Academy of Religion, Thematic Series, 48 (3–4). Chico: Scholars Press, 1982.

Wilson, Brent. "Becoming Japanese: Manga, Children's Drawings, and the Construction of National Character." *Visual Arts Research* 25:2 (1999): 48–60.

Winston, Andrew S., Brenda Kenyon, Janis Stewardson, and Theresa Lepine. "Children's Sensitivity to Expression of Emotion in Drawings." *Visual Arts Research* 21:1 (1995): 1–14.

Woolley, Jacqueline D. "Thinking about Fantasy: Are Children Fundamentally Different Thinkers and Believers from Adults?" *Child Development* 68:6 (1997): 991–1011.

Woolley, Jacqueline D., Katrina E. Phelps, Debra L. Davis, and Dorothy J. Mandell. "Where Theories of Mind Meet Magic: The Development of Children's Beliefs about Wishing." *Child Development* 70:3 (1999): 571–587.

Wurtz, James F. "Representing the Great War: Violence, Memory, and Comic Form." *Pacific Coast Philology* 44:2 (2009), *Violence and Representation:* 205–215.

Yano, Christine R. *Pink Globalization: Hello Kitty's Trek across the Pacific.* Durham: Duke University Press, 2013.

———. "Wink on Pink: Interpreting Japanese Cute as It Grabs the Global Headlines." *Journal of Asian Studies* 68:3 (2009): 681–688.

Yashin, Y. N. "The Market for Identities: Secularism, Islamism, Commodities." In *Fragments of Culture: The Everyday of Modern Turkey,* edited by Deniz

Kandiyoti and Ayşe Saktanber, 221–253. New Brunswick, NJ: Rutgers University Press, 2002.

Yavuz, Hakan. *Islamic Political Identity in Turkey.* New York: Oxford University Press, 2003.

———. "Neo-Nurcular: Gülen Hareketi." In *Modern Türkiye'de Siyasî Düşünce: İslâmcılık,* vol. 6. edited by Tanıl Bora and Murat Gültekingil, 295–307. Istanbul: İletişim Yayınları, 2011.

Youssef, Abdel-Tawab. *Kutub al-aṭfāl fī-'ālaminā al-muʿāṣir.* Cairo and Beirut: Dār al-kitāb al-maṣrī and Dār al-kitāb al-lubnānī, 1985.

Zaim, Sabahaddin. "The Impact of Westernization on the Educational System in Turkey." In *At the Crossroads: Education in the Middle East,* edited by A. Badran, 18–42. New York: Paragon House, 1989.

Zajonc, Robert B. "Feeling and Thinking: Preferences Need No Inferences." *American Psychologist* 35:2 (1980): 151–175.

Zaman, S.M. "Islamization and Strategies of Change—in the Perspective of Education." *Islamic Studies* 27:4 (1988): 339–353.

Zilfi, Madeline C., ed. *Women in the Ottoman Empire: Middle Eastern Women in the Early Modern Era.* Leiden: Brill, 1997.

Index

abduction concept, 25–27

Abraham. *See* Ibrahim

Abrahamic sacrifice, 18fig. 1, 19, 130–133, 132fig. 12, 134fig. 13, 135fig. 14, 136fig. 15, 189. *See also* blood sacrifices

Adalet ve Kalkınma Partisi (AKP) (Justice and Development Party), 104–105

adolescence, 88; in Western societies, 65–66

adoption, 77

adult gaze, 67

advertising: children's susceptibility to, 4–5; visual representation in, 121, 122fig. 5

aesthetics: aesthetic social imagination, 10–15; Baumgarten on, 11–12; beauty and, 14; definitions of, 10–11; emotional responses and, 11, 14; Islamic, 8, 12–13, 15, 18, 24, 105, 110–112, 148–149, 153–154, 177, 208; Kant on, 12

affect: affect culture and social affect, 49–52, 223n110; affect theorists, 41–44, 215n5, 216n8, 219nn75–76, 221n92; affect theory, 31, 34, 41–44; affect theory critiques, 44–49, 216n8; affect-culture, 40, 51; affecting presence, 23; affective investment, 219–220n83; affective responses, 11, 193; affective value, 59–60, 158, 198, 223n110; centrality of, 25; communication and, 221n92; emotion and, 40–41, 219n76; *affecting presence,* 214n48; overview of,

27, 28–29, 41–44; power and, 48, 60; terminology, 57

Afghanistan, 17, 55, 139, 144, 239n11, 240n14

age of consent laws, 73–75, 175

age of majority, 72, 175. *See also bulūgh* (puberty)

'Aisha (Muhammad's wife), 73–74, 225n27

aisthesis, 14

AKP (Adalet ve Kalkınma Partisi) (Justice and Development Party), 104–105

Alchemy of Happiness (*Kīmiyā-yi sa'ādat*) (al-Ghazali), 153

'Ali ibn Abi Talib, 94, 176, 187

al-Tahtawi, Rifa'a, 98

Amin, Qasim, 97–98, 233n65

anime genre, 18, 118

anthropomorphism, 67–68

antichildhood/antichildren, 68–75

apocalyptic glance, 12

'aqīqa ceremony, 88

Aristotelian thought, 13, 14, 28–29

Ash/Satoshi (*Pokémon* character), 237n50

'Ashura, 94. *See also* Karbala, battle of

aspiration(s): affective value and, 157fig. 19, 158–160, 158fig. 20, 159fig. 21; centrality of, 25; emotion as, 206, 208; future aspirations, 101, 136–137, 208–209; and globalized cuteness, 117–121

authority, 9, 94, 146–147, 230n38